Photography

MW00991078

"Jae Emerling has done the near impossible: he has written an introduction to the history and theory of photography that also adds significantly to the ways in which we come to see, know, and understand the world. Here, by focusing on the 'and' between history and theory, photography itself becomes ingeniously a form of thinking. Photography is history, is theory, is technology, is archive, is document, is truth, is time, is knowledge, is a way to generate new worlds politically and aesthetically. Emerling writes that 'to study the history and theory of photography is to write and create alongside—and in the middle of—images.' He couldn't be more right."

Marquard Smith, *Director, Institute for Modern and Contemporary Culture, University of Westminster, UK*

"Jae Emerling has produced a timely and thoroughly useful book that shows how the history of photography and the theories encouraged by that history have shaped our experience of the photographic work of art. His writing eloquently and accessibly considers those debates that have led to the concepts through which contemporary practitioners and viewers alike now confront the 'impossible object' of an art photograph. This book is a must for anyone serious about the production, appreciation, or use of photographic images in the twenty-first century. Emerling's work beautifully defines artistic practice and theory as complementary but not identical, and points out that images are always already ensembles of history and ideas. For as he so succinctly states in his introduction, 'The footprint of a bird is not a bird.'"

William Wylie, *Professor of Art, University of Virginia, USA*

"*Photography: History and theory* offers the most complex limit case for understanding representation in our time. What Emerling has done in situating the discourse of art photography on the dual thresholds of aesthetics/ethics and theory/history, is to open up the field to the ontological complexity of its subject domain. This book is an astonishing performance, a nuanced and lucid argument addressed to all those interested in why photography matters today."

Claire Farago, *Professor of Art History, University of Colorado at Boulder, USA*

From its inception in the nineteenth century, photography has instigated a series of theoretical debates. In this new text, Jae Emerling therefore argues that the most insightful way to approach the histories of photography is to address simultaneously the key events of photographic history alongside the theoretical discourse that accompanied them.

While the nineteenth century is discussed, the central focus of the text is on modern and contemporary photographic theory. Particular attention is paid to key thinkers, such as Baudelaire, Barthes, and Sontag. In addition, the centrality of photography to contemporary art practice is addressed through the theoretical work of Allan Sekula, John Tagg, Rosalind Krauss, and Vilém Flusser. The text also includes readings of many canonical photographers and exhibitions, including Eugène Atget, Brassaï, August Sander, Walker Evans, *The Family of Man*, Diane Arbus, Lee Friedlander, Cindy Sherman, Bernd and Hilla Becher, Sebastião Salgado, Jeff Wall, and others.

In addition, Emerling provides close readings of key passages from some major theoretical texts. These glosses come between the chapters and serve as a conceptual line that connects them.

Glosses include:

- Roland Barthes, "The Rhetoric of the Image" (1964)
- Susan Sontag, *Regarding the Pain of Others* (2002)
- Michel Foucault, *The Archaeology of Knowledge* (1969)
- Walter Benjamin, "Little History of Photography" (1931)
- Vilém Flusser, *Towards a Philosophy of Photography* (1983)

A substantial glossary of critical terms and names, as well as an extensive bibliography, make this the ideal book for courses on the history and theory of photography.

Jae Emerling is Assistant Professor of modern and contemporary art at the University of North Carolina, Charlotte, USA. He is the author of *Theory for Art History* (Routledge 2005).

Photography
History and theory

Jae Emerling

Routledge
Taylor & Francis Group

LONDON AND NEW YORK

First published 2012
by Routledge
2 Park Square, Milton Park, Abingdon, Oxon OX14 4RN

Simultaneously published in the USA and Canada
by Routledge
711 Third Avenue, New York, NY 10017

Routledge is an imprint of the Taylor & Francis Group, an informa business

British Library Cataloguing in Publication Data
A catalogue record for this book is available from the British Library

Library of Congress Cataloging in Publication Data
Emerling, Jae.
 Photography : history and theory / Jae Emerling.
 p. cm.
 Includes bibliographical references and index.
 1. Photographic criticism. 2. Photography, Artistic--History.
 I. Title.
 TR187.E44 2012
 770.1--dc23
 2011023346

ISBN: 978-0-415-77854-1 (hbk)
ISBN: 978-0-415-77855-8 (pbk)
ISBN: 978-0-203-15321-5 (ebk)

Typeset in Garamond
by GreenGate Publishing Services, Tonbridge, Kent

Photography is like the art of another planet.

Henri Focillon, *The Life of Forms*

...the world of images has never been constituted to the sole end of behaving to properly facilitate the self-constitution of a history or a knowledge.

Georges Didi-Huberman, *Confronting Images*

It is through admiration that you will come to genuine critique.

Gilles Deleuze, "On Nietzsche and The Image of Thought"

Contents

List of figures viii
Acknowledgments xi
Preface xii

Introduction 1

1 The thing itself 17
 Gloss on Walter Benjamin, "Little History of Photography" (1931) 42

2 Frame (matter and metaphor) 48
 Gloss on Roland Barthes, "The Rhetoric of the Image" (1964) 76

3 Documentary, or instants of truth 82
 Gloss on Susan Sontag, *Regarding the Pain of Others* (2002) 114

4 The archive as producer 120
 Gloss on Michel Foucault, *The Archaeology of Knowledge* (1969) 159

5 Time-images 165
 Gloss on Vilém Flusser, *Towards a Philosophy of Photography* (1983) 191

Glossary 197
Notes 217
Bibliography 256
Index 269

Figures

0.1 Nicolaas Henneman, *The Chess Players* (1844) 1
Courtesy of the Gernsheim Collection, Harry Ransom
Humanities Research Center, The University of Texas at Austin

0.2 Walter Benjamin and Bertolt Brecht playing chess, Svendborg,
Summer 1934 (photographer unknown) 2
Courtesy of Akademie der Künste, Berlin, Bertolt-Brecht-
Archiv, BBA FA 7/26

1.1 William Henry Fox Talbot, *Plate 1. Part of Queen's College. Oxford*,
from *The Pencil of Nature* (1844) 19
Courtesy of the National Media Museum/SSPL

1.2 Benjamin Brecknell Turner, *Hawkhurst Church. Kent*,
(1852–4) 19
© Victoria and Albert Museum, London

1.3 Albert Renger-Patzsch, *Shoemaking Irons. Fagus Works.*
Alfeld (1928) 31
© Albert Renger-Patzsch Archiv/Ann und Jürgen Wilde,
Zülpich/VG Bildkunst, Bonn/DACS, London 2010

1.4 Laszlo Moholy-Nagy, *Untitled* (1923) 32
© Hattula Moholy-Nagy/DACS 2011

1.5 Walker Evans, *Man Standing Next to Wooden Shack. Tupelo.*
Mississippi (1936) 39
© Walker Evans Archive, The Metropolitan Museum of Art

2.1 Lee Friedlander, *New York City* (1964) 50

2.2 Claude Cahun, *Self-portrait Lying on Sand* (1930) 56
Courtesy of the Jersey Heritage Collections

2.3 Salvador Dali, *The Phenomenon of Ecstasy* (1933) 57
© Salvador Dali, Fundació Gala-Salvador Dalí, DACS, 2010

2.4 Jan Dibbets, *Perspective Correction* (1968) 75
© Jan Dibbets. Courtesy of Gladstone Gallery, New York
and Tate, London 2011

3.1 Hippolyte Bayard, *Self-portrait as a Drowned Man* (1840) 86

3.2 Brassaï, *Sleeping Tramp in Marseilles* (1935) 89
© ESTATE BRASSAÏ - RMN. Courtesy of Paris, Musée National
d'Art Moderne – Centre Georges Pompidou

3.3 Margaret Bourke-White, *At the Time of the Louisville Flood* (1937) 90
 © Estate of Margaret Bourke-White via Getty Images
3.4 Walker Evans, *Torn Movie Poster* (1931) 94
 © Walker Evans Archive, The Metropolitan Museum of Art,
 Ford Motor Company Collection, Gift of Ford Motor Company
 and John C. Waddell, 1987
3.5 Martha Rosler, *The Bowery in Two Inadequate Descriptive Systems* (1974–5) 100–1
 Courtesy of the artist
3.6 Matthew Brady (or staff), *Petersburg, Va. Dead Confederate soldier, in trench beyond a section of chevaux-de-frise* (1865) 103
 Courtesy of Library of Congress, Prints & Photographs Division
3.7 Sebastião Salgado, *Serra Pelada, Brazil* (1990) 104
 © Sebastião Salgado/Amazonas/nbpictures
3.8 Alex ____, *Cremation of gassed bodies in the open-air incineration pits in front of the gas chamber of crematorium V of Auschwitz* (August 1944) 110
 Courtesy of the photographic archives at the Auschwitz-Birkenau
 State Museum
3.9 Alan Cohen, *Auschwitz* (1994) from *On European Ground* (2001) 113
 Courtesy of the artist
4.1 The Atlas Group/Walid Ra'ad, *Civilizationally We Do Not Dig Holes to Bury Ourselves (Arc de Triomphe)* (1958–9) 125
 © The artist. Courtesy Anthony Reynolds Gallery, London
4.2 Rolf Petersen, Installation view of the exhibition *The Family of Man* (1955) 128
 © 2011. Digital image, The Museum of Modern Art,
 New York/Scala, Florence
4.3 Laszlo Moholy-Nagy, *Leda and the Swan* (1925) 130
 © Hattula Moholy-Nagy/DACS 2011
4.4 William Henry Fox Talbot, *Plate 3. Articles of China* from *The Pencil of Nature* (1844) 135
 Courtesy of the National Media Museum/SSPL
4.5 Ni Haifeng, *Self-Portrait as a Part of Porcelain Export History (no. 1)* (1999–2001) 135
 © Ni Haifeng. Courtesy of Gallery Lumen Travo, Amsterdam
4.6 Johann Kaspar Lavater, *Silhouette Machine* (1780) 137
 Courtesy of the Gernsheim Collection, Harry Ransom
 Humanities Research Center, The University of Texas at Austin
4.7 Alphonse Bertillon, *Instructions Signaletiques* (1893) 139
 Courtesy of Wellcome Library, London
4.8 Alphonse Bertillon, *Measuring the ear of a criminal* (1893) 139
 Courtesy of Wellcome Library, London

4.9 Carrie Mae Weems, *From Here I Saw What Happened/And
 I Cried* (1995–6) 143
 Courtesy of the artist and the Jack Shainman Gallery, New York
4.10 Joseph T. Zealy, *Jack. frontal. Guinea Plantation of
 B. F. Taylor. Esq.* (1850) 143
 Courtesy of the Peabody Museum of Archaeology and Ethnology,
 Harvard University, 35-5-10/53043
4.11 August Sander, *Railway Officers (Bahnbeamte)* (1910) 145
 © J. Paul Getty Trust
4.12 Bernd and Hilla Becher, *Water Towers* (1980) 148
 © Bernd Becher and Hilla Becher/Museum of Fine Arts,
 Houston, Texas, USA/The Bridgeman Art Library
4.13 Timothy O'Sullivan, *Ancient Ruins in the Canon de Chelle.
 New Mexico* (1873) 154
 Courtesy of George Eastman House, International Museum of
 Photography and Film
5.1 John Beasley Greene, *The Nile in front of the Theban Hills* (1853–4) 166
 © The Metropolitan Museum of Art/Art Resource, New York
5.2 Sze Tsung Leong, *Canale della Giudecca I. Venezia* (2007) 168
 © Sze Tsung Leong, Courtesy Yossi Milo Gallery, New York
5.3 Henri Cartier-Bresson, *Callejon of the Valencia Arena* (1933) 172
 Courtesy of Magnum Photos
5.4 Eugène Atget, *Bibliothèque Nationale* (1920–3) 178
 Eugène Atget (1856-1927)/Israel Museum, Jerusalem, Israel/
 Anonymous Gift to American Friends of the Israel Museum/
 The Bridgeman Art Library
5.5 Hippolyte Bayard, *The Madeleine. Paris* (c. 1845) 181
5.6 Louis Daguerre, *View of the Boulevard du Temple* (c. 1838) 190
 Courtesy of Bayerisches Nationalmuseum

Glosses

G.1 Jeff Wall, *Dead Troops Talk (A Vision After an Ambush of a
 Red Army Patrol. near Moqor. Afghanistan. Winter 1986)* (1992) 119
 Courtesy of the artist

Acknowledgments

Many people have helped in the conception and actualization of this book. First, I would very much like to thank my editor, Natalie Foster, who has shown admirable patience and only offered me the best advice and friendship. In addition, I would like to express my sincere gratitude to Ruth Moody and Emily Laughton for their work gathering and negotiating image permissions.

Professionally there are so many people I owe a debt of thanks, including William Wylie, Damon Willick, Claire Farago, Marquard Smith, Giorgio Agamben, Amelia Jones, Nora Wendl, Donald Preziosi, Richard Woodfield, and Michael Kelly. I would also like to thank the editors at both the *Journal of Visual Culture* and the Los Angeles-based *X-TRA: Contemporary Art Quarterly* for publishing my work and allowing me to think through many of the ideas present in this book. I am grateful to the faculty of the Department of Art & Art History in the College of Arts + Architecture at the University of North Carolina, Charlotte, for its continued support, particularly Eldred Hudson and Aspen Hochhalter. I would also like to acknowledge the support of the United States Holocaust Memorial Museum, which, through the Curt C. and Else Silberman fellowship program, offered me two consecutive fellowships in 2008 and 2009 to study photographic images in ways that have transformed much of my thinking about history, ethics, and aesthetics.

My largest debt of gratitude is to Ronna Gardner who, with the patience of a saint, listened to me talk and argue endlessly about photography and then still agreed to read drafts of the chapters and glosses. Finishing this book would have be unimaginable without her time and support.

Above all else, this book is dedicated to Courtney Lyder, who taught me how to live.

Preface

The essence of the image is to be altogether outside, without intimacy, and yet more inaccessible and mysterious than the thought of the innermost being; without signification, yet summoning up the depth of any possible meaning; unrevealed yet manifest, having the absence-as-presence that constitutes the lure and fascination of the Sirens.

Maurice Blanchot

Every book on photography is always marked by the same limitation: the absence of all the photographs discussed within the text. Even what is widely considered to be the "first" photograph or "Image taken from Nature," Niécephore Nièpce's *View from the Window at Gras* (1826–7) disappeared for over fifty years. From 1898–1952 the whereabouts of this small "heliograph" (sun-writing), which was taken with a camera obscura from the upper-story of Nièpce's summer house in Saint-Loup-de-Varennes, France, on a plate of polished pewter coated with bitumen of Judea, the cap removed for an eight-hour exposure time in full sun—and only then an image. But it was lost. Even after its rediscovery by the photographic historian Helmut Gernsheim in an attic in London, this "origin" remains irreproducible. Any version of this image that we see today, in textbooks or online, is a translation; it barely resembles the original, if there is one.

In other words, every historical and theoretical text on photography has blind spots, photographs that are missing, absent, untranslatable. Rather than see this as a shortcoming, perhaps it is better to reckon with these blind spots as openings, as disjunctive syntheses. This may be the most pressing lesson of Roland Barthes's *Camera Lucida: Reflections on Photography* (1980). For the "punctum" (the irrational, motivating factor, the singular point, the "prick" or "wound" or "cast of the dice" that sets our viewing experience in motion) is not something unique to photography; rather, it can be found in each and every discourse. For Barthes, it was the decision not to reproduce the *Winter Garden* photograph of his mother, whose death spurred the writing of his text. Every discourse has its own *Winter Garden* photograph, that is, an absence, an enabling limit. As Jacques Derrida writes in *The Work of Mourning* (2001), "Remaining as attentive as possible to all the differences, one must be

able to speak of a punctum in all signs (and repetition or iterability already structures it), in any discourse, whether literary or not" for

> it is the relation to some unique and irreplaceable referent that interests us and animates our most sound and studied readings; what took place only once, while dividing itself already, in the sights or in front of the lens of the Phaedo or Finnegan's Wake, the Discourse on Method or Hegel's Logic, John's Apocalypse or Mallarmé's Coup de dés.

This is not to suggest that the book before you is in the same set as those Derrida cites. It is not. It is, rather, only to note that there is always a gap between what we see and what we say. For this reason, the missing photographs are as significant, if not more so, than the ones that are present. Photography is a complex play of presence and absence, perception-image and recollection-image. In other words, invisibility and blindness are always preconditions of photography as Paul Strand, Walker Evans, Sebastião Salgado, and other photographers remind us.

Furthermore, I have chosen to begin each chapter with epigraphs that function analogously to the missing photographs. These quotations from other texts are not meant to be authoritative or definitive. On the contrary, they are also meant to serve as openings within the discourse of photography. They are small maps, lines venturing outside. I have thought of these epigraphs as small, troubling prefaces, as Eduardo Cadava explained in his *Words of Light: Theses on the Photography of History* (1997):

> There is no preface that is not an opening to light. Like the small window that lets in morning light or the aperture of a camera that gives way to images, the preface allows us to experience a kind of light. It casts a future tense on the significance of what has already been written.

Hence each epigraph serves as a preface, or opening to light, photogogós.

Introduction

All of this implies that the meaning of photography is still controversial.

Siegfried Kracauer[1]

When considering the history of photography one must be cognizant of the fact that one is addressing complex theoretical questions about representation: signs and objects, narratives and events, life and politics. In other words, to confront the history of photography is to face the double-bind of aesthetics and ethics. Let us begin with two photographs.

One forms a relation to the first decade of photographic practice. It shows William Henry Fox Talbot, the inventor of the calotype (the first practicable negative–positive photographic means), and Antoine Claudet, a French photographer who became a prominent daguerreotype portraitist in England. The dim, poorly-lit small image by Nicolaas Henneman captures Fox Talbot, in a melancholic pose, and Claudet playing chess. It was made in 1844, the same year that Talbot published the first photography book, *The Pencil of Nature*.

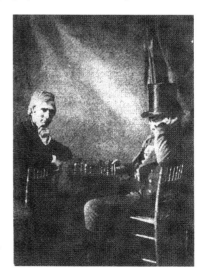

Figure 0.1 Nicolaas Henneman, *The Chess Players* (1844)

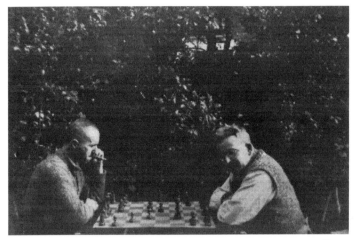

Figure 0.2 Walter Benjamin and Bertolt Brecht playing chess, Svendborg,
 Summer 1934 (photographer unknown)

The second image is also of poor quality; it was taken in the 1930s. It depicts
the German-Jewish philosopher Walter Benjamin playing chess with the
avant-garde playwright and writer Bertolt Brecht. Benjamin and Brecht are
key figures in the history of modern thought. Their work transformed the
way cultural production is conceived by focusing attention on the inextricable
links between aesthetic form and socio-political interests. "A Short History of
Photography" (1931), "The Author as Producer" (1934), "The Work of Art in
the Age of its Technological Reproducibility" (1936) comprise the set of three
essays that fundamentally changed the discourse of photography, all of which
were written by Benjamin against the backdrop of conversations with Brecht
and others. His argument that photography is not simply a form of art, but that
art itself becomes "a form of photography" shares much with Brecht's praxis.
 These images share the game of chess, an apt metaphor for discourse.
Discourse is the set of statements that defines the concept named "photog-
raphy." It is the structure into which specific, individual events are received,
discussed, explained, and critiqued; it is the framework through which we
understand and think photography. Simply put, there is no "photography"
without discourse. Discourse is the "conceptual field within which and around
which move various kinds of objects, activities, processes, ideas and theo-
ries, subcultures and movements, institutions and exhibition."[2] This is not to
say, however, that the discourse of photography is a coherent, unified frame-
work. Quite the contrary. Photographic discourse is a continual reworking
of positions: it creates by retracing lines of arguments, uncovering archives,
redacting histories, and drawing attention to aporias (gaps or impasses, para-
doxes) within the discourse itself. As in chess, there is a structure—a field or
board, pieces with fixed movements—and yet each enactment, each play (turn

or move), both reiterates the past (openings are repeated, entire games reenact strategies and counter-strategies from past matches) and demands variation. The opening, middle game, and endgame of a chess match are but structural divisions of time that obscure a more fluid, open, and smooth relation between players, the history of the game, and the immediate aim of winning. Discourse, as well, often seems repetitive, circumscribed, and plodding; however, it also includes the speed and athleticism of thought, that is, the ability to rethink a history as a way of creating a new discursive event. As Liz Wells astutely explains, "Ideas and positions do not supersede one another, or inter-act and synthesise in clear dialectical fashion. Rather we witness an accumulation of models and critical perspectives which sort of fold into one another, re-emerging in shifting formations." Hence, approaching the history and theory of photography as discourse should "allow us to better understand the references, ideological legacies and sociopolitical inheritances in relation to which we negotiate the contemporary."[3]

Chess here is a metaphor for discourse and as such it is meant to provide an "image of thought" that begins only between Fox Talbot and Benjamin, Claudet and Brecht. In other words, an "image of thought" (Benjamin's concept *Denkbild*) takes place only between images, never before or after them. Between these two images is inscribed a discourse of photography that enfolds formalism and postmodernism, beauty (Fox Talbot's *kalos*, the Greek for the beautiful as opposed to the useful), and critique (Brecht's use of art to defamiliarize or estrange the audience (*Verfremdungseffekt*), to contradict their expectations). Photographers, philosophers, historians, critics, curators—all take up positions within the discourse of photography. But only photographers—only the creation of an image—executes the "knight's move." "Like the discontinuous, L-shaped move of the 'knight' in the game of chess, the semantic structure of the artistic product executes a 'swerve', a side step, with respect to the real, thereby setting in motion a process of 'estrangement' (Bertolt Brecht understood this well)."[4] Discourse involves representation, codes, significations, and aesthetic affects.

To begin between these two photographs is to dislocate the origin of photography from the mid-nineteenth century to the present. Currently there is an intense interest in photography that stems from its use as a decisive instrument of postmodernism in the 1970s—a practice and a critical methodology that itself is being rethought in our current moment—and from a growing interest in the construction and affects of an image. In other words, this return to photography stems from a reevaluation of the use of photography to challenge both art institutions and aesthetics as such *and* from an attention to large-scale tableau photographs by Jeff Wall, Andreas Gursky, Gregory Crewdson, and others. This "directorial mode" of photography, at times involving the construction of expansive sets replete with stage dressings and actors, which began in the late 1970s, was one of the first serious challenges to the anti-aesthetic position voiced by critical postmodernism.

Critical postmodernism arose as a critique of the ways in which photography was being appropriated by art institutions in the 1960s. It was then that photography fully entered the institutions of art, particularly the Museum of Modern Art (MoMA) in New York City. Critical postmodernism, especially as it was espoused by influential historians and critics centered around the journal *October*, sought to recuperate avant-garde strategies and ideas from the 1920s that had been marginalized by preceding art historical narratives that were largely formalist. Formalism was severely critiqued as was aesthetics as such. In short, the critical postmodern position forwarded an anti-aesthetics in which traditional artistic and aesthetic criteria such as originality, autonomy, self-expression, and uniqueness were forfeited in order to salvage the possibility of staging a socio-political critique. This position was articulated along two fronts: the critique of the institutions of art (museums, galleries, the professional discipline of art history) and the constitution of subjects. Simply put, this radical approach to art and its histories began with Marxism and psychoanalysis (Sigmund Freud, Jacques Lacan) in order to understand the complex relations between art and ideology.

The height of the *"October* moment" in the 1970s and 1980s has undeniably changed the study of art history.[5] But what has become evident is the acute degree to which it functions negatively vis-à-vis a critique of the formalism promulgated by the influential art critic Clement Greenberg in the early 1960s. For example, Greenberg's medium-specific, formalist evolutionary model of art's history is directly actualized in photography in the work of John Szarkowski, the head of the Department of Photography at MoMA from 1968–91. The exhibitions and accompanying writings that Szarkowski produced, for example *The Photographer's Eye* (exhibition 1964, publication 1966), have indelibly colored the discourse of photography. He argued photography's case for greater inclusion within the museum and within the history of modern art as such by isolating photography from discourses and functions other than those of art proper. Hence he emphasized style, tradition, and photography *tout court* as a legitimate form, a continuation of the Western pictorial tradition that began in the Renaissance. Critical postmodern critics vehemently reject this formalist, medium-specific, approach to photography.

Insisting on the social and political functions of photography above all else, critics such as Allan Sekula focus on how photography exposes a series of interrelated ideological positions, including art, race, economics, and class. Sekula's "The Traffic in Photographs" (1981) challenges any history or theory of photography that willfully turns a blind eye to larger issues of the social and political context that, for him, *is* the discourse of photography. As he concludes his oft-cited essay, "Formalism collects all the world's images in a single aesthetic emporium, tearing them from all contingencies of origin, meaning, and use." Contrary to this false structure and order, Sekula asks "can photography be anything else?"[6]

Arguably one of the most astute and essential readings of both the history and theory of photography is Geoffrey Batchen's *Burning with Desire: The*

Conception of Photography (1997). This text challenged both formalist and post-modern perspectives on photography not only by clearly explaining these two as co-dependent views, but also by demonstrating that "history inhabits the present in very real ways; that the practice of history is always an exercise of power; that history *matters* (in all senses of this word)."[7] The entire field is indebted to Batchen's text, minimally for his coherent explications of the theoretical wagers and presumptions of both the medium-specific art historical pretensions of formalism and the theoretical positions of postmodernism.[8] Batchen, and many others, are convinced by the postmodern critique of the formalist position. A critique that centers on how meaning is determined by cultural, institutional contexts; how the production of the political and psychological subject is an effect of photographic representation; and on the claim that there is no discrete and fixed medium that could be named photography. Nevertheless, it is with the conclusions Batchen reaches that we must begin.

Although Batchen's own methodology shares a basis in the same critical theory that makes possible postmodernist positions on photography, his conclusions are not symptomatic of a simple choice between one of the two approaches: formalism or postmodernism.[9] Just as he persuades us to understand a more complex relation between the past and present as it is inscribed in discourse, Batchen encourages us to begin by conceiving a certain paradox:

> Is the difference between essentialist [formalist] and antiessentialist [postmodern] theories of photography quite as marked as it appears?... Despite appearances to the contrary, both share a presumption that, in the final analysis, photography's identity can be determined as a consequence of *either* nature *or* culture...The point is that postmodernism and formalism, at least in their dominant photographic manifestations, both avoid coming to terms with the historical and ontological complexity of the very thing they claim to analyze.[10]

The theoretical models in which Batchen grounds his methodology are themselves serious challenges to this structural, binary opposition because instead of accepting a false either/or decision, the work of Jacques Derrida and Michel Foucault that motivates Batchen's reading helps him to conclude that both the formalist and postmodern positions "presume that photography's identity can indeed be delimited, that photography is ultimately secured within the boundaries of *either* nature *or* culture."[11] Batchen returns to the multiple origin-points of the discourse of photography in the mid-nineteenth century in order to prove that this either/or is a historical effect rather than a determinative framework. In other words, he demonstrates how the discourse of photography is, at its origins, always more troubling and feverish than it is definitive and ordered. There is always another line to construct that passes through the origin of photography in the present.

I found the justification for my book in the openings created by Batchen's text. First, any contemporary approach to the history and theory of the photographic image must work to explain how and why "history inhabits the

present in very real ways; that the practice of history is always an exercise of power; that history *matters* (in all senses of this word)." Second, in the final words of his text, Batchen offers the following:

> Photographic history, it seems, always carries within itself the process of its own erasure. A singular point of origin, a definitive meaning, a linear narrative: all of these traditional historical props are henceforth displaced from photography's provenance. In their place we have discovered something far more provocative—a way of rethinking photography that persuasively accords with the medium's undeniable conceptual, political, and historical complexity.[12]

Perhaps the most pressing concern facing photography and whatever historical–theoretical approaches are being formed in the aftermath of postmodernism is the one that has haunted photography from its inception: coming to terms with "the historical and ontological complexity of the very thing" we claim to be analyzing. History is discursive; it is not as if history exists somewhere outside of discourse; it does not pre-exist it. Therefore, my work here will neither be a simple history of photography nor will it be a theory primer, that is, a text that will simply introduce and explain the key theorists whose work engendered the postmodern photographic discourse.

Photography: History and Theory takes as its premise that critical theory continues to offer new ways around and through the either/or—between the Scylla and Charybdis of formalism and postmodernism: new ways of recollecting photography.[13] As the discourse of postmodernism turns it is wise not to abandon the theoretical texts that enabled it because these texts continue to proffer new possibilities, new readings and strategies that were overlooked in the headlong rush to instrumentalize theory in the late 1970s and 1980s. The labor of this book is geared toward occupying a place between history and theory. Its aim is to work in this threshold in order to counter talk about the "end" of photography whether at the hands of digital means (technological determinism) or discursively. It aims to demonstrate that the study of photography—its singular images, its discourse, its socio-political affiliations—is a laboratory for how and why history and theory complicate one another. Another name for this complication is aesthetics.[14]

Resisting this type of eschatological talk is clearly one of the lessons that have not been learned from the philosopher Gilles Deleuze. As Alain Badiou makes perfectly clear, "Deleuze contrasted all thought of 'ends'…with the conviction that nothing was 'interesting' unless it was affirmative. Critique, impotencies, ends, modesties…none of that is as valuable as a single real affirmation."[15] This holds for the celebration of the digital as well. It is true that digital photography presents us with a new set of potentialities and issues, some unimaginable with analogue technology. However, the digital does not simply end the discourse of photography; instead, what has become evident is that the discourse (how we think and use photography, the statements made about it) continues to be operative despite the advent of digital photography. It will undoubtedly

change, as it should, but discourse is not solely dictated by technology. The beginnings of photography in the nineteenth century has proven as much. The means by which a photograph is made is only one factor among many, including how it is exhibited, its reception, how it is used by its audience, etc.

These factors are only secondary if one maintains an oversimplified notion of analogue photography as automatic, objective, unmanipulatable, and so on. A lot has to do with how we conceive of the photograph. It never was a natural, straightforward, representation void of artifice. This myth is only an effect of discourse. It is this myth that has allowed photography to be put to use in a variety of contradictory ways since its inception. But a photograph abstracts. Even the most clear, well-focused, well-lit one is an abstraction. It is separate from concrete existence; it filches and removes as it becomes impersonal and other. For this reason I have no desire to present photography as a means to put an end to aesthetics (meaning beauty, the autonomy of the artwork), a use endemic to both modern and contemporary art. Instead, a photographic image here will be presented as an essential element in rethinking what we mean by the term "aesthetics" as a multiplicity of strategies, affects, and "images of thought."

My approach in this book is to focus on art photography because it was art photography that played a crucial role in the critical postmodern position and because it has been art photography that has refocused our attention on the discourse itself. This is not to say that only art photography is addressed below, but it is a primary focus. Of course, there are many forms and practices that fall under the name "photography." However, each has a distinct, although at times shared, mode of address. How paparazzi photos address us, how we consume them as pictures, is not identical to how we read photographs presented to us as art. So vernacular photography, photojournalism, art photography, medical photography, family snapshots, social networking images are all part of the discourse of photography in its largest framework. However, the discourse of photography that has been generated within art history represents a particular intersection of visible and sayable forms of content (visibilities) and forms of expression (statements). Hence what I have written here is an art history text; it reads and maps the discourse of photography as it has taken form in the modern and contemporary period.

Photography is an event of modernism. As such art history is still the primary context in which most people and students encounter the discourse of photography. As Diarmuid Costello has commented, "Whenever we begin to talk about photography outside the art historical frame of reference, it's as if the conversation just dies. We don't know how what to say, or how to proceed."[16] Art history may very well not be the best situation in which to approach photography, but it very much remains the primary one in which we encounter debate on photography. Of course, art history is not the only viable framework in which to grasp the history of photography. The opposite is often more accurate in fact. Nevertheless, it is within the discipline of art history that photography has been most intensely and even perversely

constructed. For this reason, we must ask ourselves what we inherit—figures, modes of address, theories, and methodologies—as we rethink this inheritance as a set of problems rather than as givens.

This book, then, is an attempt to approach an "impossible object," an art photograph.[1] To do so I have not written a history of photography in the sense of a chronological narrative linked together under the name "Photography." There are already several comprehensive histories of photography from Beaumont Newhall's famous *The History of Photography* to Mary Warner Marien's *Photography: A Cultural History*. To address the predicament we are facing now, as we devise new conceptual personae and tools to face photography anew, I take it to be more productive to map out the discourse of photography—its statements and visibilities, its folds and potentialities. The discourse of photography defines not only a historical relation between images and temporality, but it also frames the theoretical discussions that surround and compose what we mean by the concept "photography." Discourse is comprised of statements that construct the artistic, historiographic, institutional, and aesthetic aspects of the photographic field. This attention to how photography has been conceived and reconceived in recent decades reveals the inextricability of history and theory: two concepts that are far from self-evident or simply defined. Situating the subject of photography as something between history and theory affords the opportunity to convey the sheer complexity of a photographic image, which is at once inhuman, fortuitous, and aleatory.

The work before you is also not a theory primer. Although I have attempted to introduce and explain some of the major theoretical figures and their concepts in both the body of the text and in the form of glosses on essential theoretical texts (glosses that serve to connect the issues discussed in each chapter, they are relays between the chapters), I have not addressed all the theory that fuels the discourse. Nor could I introduce the entirety of someone's philosophy in a few paragraphs. I have tried to frame each theorist's ideas on photography within the context of their work as a whole. Any shortcomings in doing so are my own. However, any encounter with theory requires a sustained engagement as these are complex issues and philosophical concepts that have their own discourse, one that intersects that of photography quite often. With that said, it is important to be aware of several references that will undoubtedly supplement the reader's knowledge of and fluency in critical theory. See my *Theory for Art History*, *Art: Key Contemporary Thinkers* edited by Diarmuid Costello and Jonathan Vickery, Robert Williams's *Art Theory: A Historical Introduction*, and *Encyclopedia of Aesthetics* edited by Michael Kelly. My aim is for as many readers as possible to join and contribute to this theoretical debate from a position of knowledge.

So as much as this book is not a traditional narrative history of photography but an analysis of the contemporary discourse of photography, it posits that contending theories of photography are its history. From its inception in the nineteenth century, photography has instigated a series of theoretical debates. Hence I argue the most insightful way to approach the histories of

photography is to address simultaneously the key events of photographic history alongside the theoretical discourse that accompanied them. However, what is crucial to understand is that an image exists within a discourse and yet it can transform it. This is the "knight's move." History and theory are not the only means of thinking photography. Photographers present us with unimagined "impossible objects"—images of thought—that *think* and create concepts. It is the image that has the potentiality to traverse the discourse, that is, to be "untimely" and create new sensations and experiences, new lines through the discourse thereby altering its history and theoretical presumptions. Artistic practice and theory are complementary but not identical.

As Deleuze explained, practice is "a set of relays from one theoretical point to another, and theory is a relay from one practice to another. No theory can develop without eventually encountering a wall, and practice is necessary for piercing this wall."[18] The goal of anyone studying or producing photographic images is to construct a new historical relation between the event (a photograph) and narrative (the discursive structure).[19] Theory functions as a relay, as the *and*. Here is Deleuze again:

> A theory is exactly like a box of tools. It has nothing to do with the signifier. It must be useful. It must function. And not for itself. If no one uses it…then the theory is worthless or the moment is inappropriate. We don't revise a theory, but construct new ones; we have no choice but to make others. It is strange that it was Proust, an author thought to be a pure intellectual, who said it so clearly: treat my book as a pair of glasses directed to the outside; if they don't suit you, find another pair.[20]

The key phrase here is that theory must be "directed to the outside." Theory helps us arrive at impasses and aporias that the existing discourse cannot surpass or address. Practice—the production of an image—then "pierces this wall," opening us to an outside. Art *is* and *opens* us to such a becoming, to such an experiment-experience that "goes beyond [anything] lived or livable" since "it exists only in thought and has no other result than the work of art."[21] This does not mean to abandon art or thought as ends-in-themselves, but rather to posit each as pure means because, as Deleuze reminds us, "thought and art are real, and disturb the reality, morality, and economy of the world."[22]

The relation between theory (*theoria*, contemplation) and sensory perception (*aisthesis*, sensory apprehension, the primary experience of art, the origin of aesthetics) is never settled. As a discourse is transformed, it exposes how and why it is possible to conceive a unity of photography without unification, without a shared ground. There is an essence of photography that is in no way a set of medium-specific characteristics or a repeated structure of cultural interpolations. Instead, there is a line that traverses the discourse itself: one comprised of singular photographs that have nothing to do with one another yet nevertheless communicate with one another. It is the tension between the image as a singularity and a larger discursive structure that must be maintained and traversed if we are to refuse the false choice between either social

practice (politics) or aesthetics. As Roland Barthes writes in his famous meditation on photography *Camera Lucida: Reflections on Photography*, when we are confronted with images it is "the same effort, the same Sisyphean labor" that is required: "to reascend, straining toward the essence, to climb back down without having seen it, and to begin all over again."[23]

Of course, the discourse of photography is marred by heated debates as to whether or not photography is a distinct medium. These debates circulate around whether the mechanical nature of photography trumps the human role in the production of a photograph. Automaticity is a hallmark of many, but not all, who argue for photography as a medium. In other words, the photochemical process that supposedly allows for a direct, unmediated record of the external world to be captured (or taken, selected, found but not made) sets its apart as unique. Many key figures in the discourse have forwarded this assumption, including Walter Benjamin and André Bazin. What this assumption has done is heighten the importance of a corollary concept, the index. An index is a type of sign that is created by cause and effect. In its simplest form, we could say that smoke is an index of fire or a footprint is an index of whatever left it. Within photographic discourse, the index is wielded as a guarantor of a material connection between the image and reality. But a photograph is neither automatic nor is it only indexical. Indexicality may be a condition of photography, but a photograph is certainly iconic and symbolic as well. This precondition does not stop one from being encountered by a photograph as an icon. The footprint of a bird is not a bird.

There is also nothing contemporary about the concept of indexicality. The notion that "nature impresses herself" via photography has been part of the discourse of photography from the Renaissance. The Renaissance fascination with the camera obscura, a "dark chamber" with a single, small aperture or opening to the outside, presents the outside world in an inverted (moving) image on the wall opposite the aperture. This natural phenomenon is fleeting and the discourse of photography (at once artistic, scientific, spiritual) from the Renaissance to Nicéphore Nièpce in 1826 is motivated by a desire to fix or capture the image created within the camera obscura. The invention of photography in the first half of the nineteenth century is seen as the fulfillment of the Enlightenment "promise of indexicality," that is, "the promise of a material connection between photography and truth…a transcendental correspondence between the material reality of the world out there with a fundamental truth or inner necessity that structures the material world."[24]

The crucial point is that automatism and indexicality in photography need to be complicated by referring to discourses outside photography (e.g. philosophy, literature) and we must be open to experiencing a photograph as an image. It requires us to no longer assume that there is a "similarity between the camera and the eye as optical systems"—there is nothing "human" about the camera's eye—and that "a photograph shows us (or ought to show us) 'what we would have seen if we had been there ourselves'."[25] Furthermore, even if we accept that a photograph "may not show us a scene as we ourselves

would have seen it," we must not make simple recourse to the indexicality of photography, that it is "a reliable index of what *was*."[26]

As Joel Snyder has argued for many years, physical objects "do not have a single 'image'—'their image'—but, rather, the camera can manipulate the reflected light to create an infinite number of images. An image is simply not a property which things naturally possess in addition to possessing size and weight. The image is crafted, not a natural, thing."[27] As a precondition of photography, an index is a trace of light moving and being refracted; it is not a trace of the object before the camera's lens. Snyder opposes any and all notions of automaticity and indexicality. He believes that both shed very little light on photography and the photographic image. In Deleuze's terms, they are ineffective tools that should be set aside or, if possible, remade to function better. In a passage that I have still not grown tired of, Snyder voices the absurdist logic of the automatic and mechanical position (that a photograph is what we would have seen with our own eyes):

> A photograph shows us "what we would have seen" at a certain moment in time, *from* a certain vantage point *if* we kept our head immobile and *closed* one eye *and if* we saw with the equivalent of a 150-mm or 24-mm lens *and if* we saw things in Agfacolor or in Tri-X developed in D-76 and printed on Kodabromide #3 paper.[28]

Moreover, our eyes are *never* still, even if their movement is imperceptible to us. Human vision does not produce a fixed image; instead, "the image is kept in constant involuntary motion: the eyeball moves, the image drifts away from the fovea and is 'flicked' back, while the drifting movement itself vibrates at up to 150 cycles per second."[29] The still photographic image is an image precisely because it is unnatural, inhuman. The camera is pointed outward, but its lens is *not* the eye behind the viewfinder. There is a non-coincidence, a movement toward the other without and within.

Despite relying too much on automaticity, even Benjamin begins here: "it is another nature which speaks to the camera rather than to the eye."[30] His "Work of Art" essay begins with the transformations inaugurated by mechanical or technological means. The advent of photography and film—mechanical means of reproduction—allow for multiple copies of an object or event. Thus, formerly unique objects, such as works of art, that one could only experience in a specific space and time lost their "authenticity" or their place within a traditional and secular ritual. Reproducibility, Benjamin argues, makes things accessible to masses of people in a multiplicity of different places and forms. Benjamin termed this transfiguration the "dissolution of aura" wherein "aura" refers to unique appearance and existence. The "dissolution of the aura" opens the artwork to new readings. For Benjamin, one essential new reading is a political one. The shattering of tradition that reproducibility signals, whereby a plurality of copies is substituted for a unique existence, offers a revolutionary potential. Photography, for Benjamin and others, is the epochal event of modernity.[31] Modernity refers to the consequences of capitalism and technology.

The radical changes of modernity coincide with the transformations wrought by photography. Benjamin studied the Second Empire in Paris (1852–70) because it provided a privileged context in which to analyze the extension of capitalism into new areas of everyday life. Even Baron von Haussmann's urban transformation of Paris into a "modern" city was undertaken as a series of viewpoints; it was the creation of an urban visual spectacle that sought to proffer greater control of the populace. The main thrust of Benjamin's work is to create a new relation between past and present, one not based on a linear conception of time as progress or development. Searching for traces of the "past in the present" Benjamin labors to counter modern spectacle—of which photography plays a major role—which "extends to all social life" because it is "the *false consciousness of time*," it is when "culture becomes nothing more than a commodity."[32] As Marx famously said, with modernity "all that is solid melts into air."

One of Benjamin's most haunting diagnoses of this state of things is found in a short essay "Experience and Poverty" (1933). He writes:

> Poverty of experience. This should not be understood to mean that people are yearning for new experience. No, they long to free themselves from experience; they long for a world in which they can make such pure and decided use of their poverty—their outer poverty, and ultimately also their inner poverty—that it will lead to something respectable. Nor are they ignorant or inexperienced. Often we could say the very opposite. They have "devoured" everything , both "culture and people," and they have had such a surfeit that it has exhausted them…We have become impoverished. We have given up one portion of the human heritage after another, and have often left it at the pawnbroker's for a hundredth of its true value, in exchange for the small change of "the contemporary."[33]

What Benjamin is responding to here is the "barbarism" of modernity, that is, the ways in which its spectacle destroys tradition by simulating its continuation, the ways in which it dazzles us "with a mishmash of styles and ideologies," as he writes. Interestingly, the reaction against this "mishmash of styles" led several Marxist philosophers and critics, such as Theodor W. Adorno and Clement Greenberg, to argue for the idea of artistic autonomy, for medium-specific criteria by which it would be possible to judge and historicize art.

This is precisely one of the insightful points Jacques Rancière has made recently in his writings on contemporary art and aesthetics. "Remarkably, modernism," he asserts, "that is, the conception of modern art as the art of autonomy," was "largely invented by Marxists. Why? Because it was a case of proving that, even if the social revolution had been confiscated, in art the purity of a rupture had been maintained, and with it the promise of emancipation…I do think this is what lies behind Adorno or Greenberg…a way of separating art radically from politics in order to preserve its political potential."[34] The discourse of photography, perhaps more than other areas, is overwhelmed by debates on whether or not photography is an autonomous medium.

These debates are discussed extensively in the chapters that follow. What I would like to foreground are two ideas. First, critical postmodern challenges to photography as a medium are inseparable from Greenberg's (mis)reading of Kantian aesthetics that separated aesthetics and ethics.[35] Hence Greenberg too often becomes a metonym for aesthetics as a whole, which is taken to mean questions of beauty, good taste, and formalism. Critical postmodernism largely defines itself through a sustained challenge to Greenberg and his followers. This is a narrow understanding of aesthetics that has held too much sway over the discourse of photography, let alone modern and contemporary art as a whole. Aesthetics is critical thinking as much as it is anything else. Second, we need affirmative, complex approaches to the question of a medium that exceeds the parameters Greenberg set. These types of approaches are operative outside of art history. In literature and music we do not find the same anxiety about medium, even about post-medium (interdisciplinary) work. A medium need not be a set of internal characteristics, essences, or anemic rhetoric. Rather, as Mary Ann Doane has argued in her essay "Indexicality and the Concept of Medium Specificity," medium specificity is not an essentialist idea but one that is resolutely historical, capable of changing in a variety of social and cultural contexts. What is specific to the medium becomes apparent as the medium itself changes. She notes how a medium is thought to be a material or technical means that, although limiting, nonetheless enable possibilities and variations. A medium is "an enabling impediment," she claims. It is an "impediment" because the material (matter) must be acted on and through in order to create a photograph, a sculpture, whatever. "Medium specificity names the crucial recursiveness of that structure that is a medium. Proper to the aesthetic, then, would be a continual reinvention of the medium through a resistance to resistance, a transgression of what are given as material limitations," she writes.[36] The materiality of the medium is resisted and transgressed to generate "forms and modes of aesthetic apprehension."

Aesthetics has always been a part of the discourse of photography (from Fox Talbot to Kracauer to Weston to Rancière). Talking about photography and aesthetics has been difficult in part because aesthetics was putatively the *deus ex machina* of the formalist position, which reduced it to questions of beauty, essentialism, artistic genius, and visual pleasure. The reduction of aesthetics to a set of ahistorical, apolitical interests is a gross simplification.[37] This reductive understanding was advanced in the 1970s and 1980s so as to translate a valuable insight from Marxist critical theory into the practices of art history: namely, that intellectual and creative work is a form of socially and politically useful labor and not simply entertainment or diversion or reflection. As a statement of critical and/or artistic practice it is fine, but demonstrating this fact through an anti-aesthetic position that wields photography as the primary instrument in dismantling aesthetics is unnecessary. Reducing aesthetics to an equation between beauty and morality was one strategy of postmodern praxis, a synonym of which is anti-aesthetics. The "abuse of beauty" enacted by the historical and neo-avant-garde—central to which is the status of the

photographic fragment in photomontage, for example—aimed at bankrupting only a single version of aesthetics.[38] In addition, anti-aesthetics plays a zero sum game in which only the complete and total, perhaps impossible, displacement of every aesthetic effect signals success.

The persistence of aesthetic effects, despite severe challenges to the audience of art and changes in the conception of a work of art in Conceptual and Post-Conceptual art beginning in the late 1960s, problematizes the anti-aesthetic position. As Hal Foster writes in the preface to *The Anti-Aesthetic: Essays on Postmodern Culture* (1983), the anti-aesthetics

> signals that the very notion of the aesthetic, its network of ideas, is in question here: the idea that aesthetic experience exists apart, without "purpose," all but beyond history, or that art can now effect a world at once (inter)subjective, concrete and universal—a symbolic totality. Like "postmodernism" then, "anti-aesthetic" marks a valid cultural position on the present: are categories afforded by the aesthetic still valid?[39]

It remains telling that Foster uses the singular, "the aesthetic," as if aesthetics is a single, monolithic set of categories. Nonetheless, the role played by photography—or at least by artists using photography supposedly as a neutral, automatic, anti-aesthetic instrument—in reinscribing cultural codes as a practice of resistance (the ultimate goal of critical postmodernism) is not in doubt. Rather than a simple negation of a nineteenth-century conception of the photographic image, premised on the photograph as a mirror-image resemblance, postmodernism in the second half of the twentieth century turned to the photograph in order to investigate the full complexity of representation and to articulate new narratives for the history of modernism. As a result, we have come to understand that representation is not merely an act of seeing; it is a socio-cultural encounter in which entities become visible, that is, recognizable and knowable. Moreover, the dominant narrative of modernism, which stressed the autonomy of art by positing the unique specificity of each artistic medium in order to justify narrating the supposed evolution of modern art from figuration to pure abstraction, has been displaced by narratives emphasizing how and why modernism is comprised of a more complex assemblage of socio-historical and artistic interests and codes. From the radical avant-garde practices of Dada to the use of black-and-white photographs to notate Conceptual art or to "document" performance art, photography has been wielded and put to uses aimed at dismantling art (as an autonomous field) and aesthetic categories (beauty, visual pleasure, etc.). But, there is a paradox at the very heart of the postmodern conception of photography.

The postmodern, anti-aesthetic, claim to expose the contingency and partiality of the photographic image and its institutional contexts cannot transcend artifice or representation. Attempting to do so still requires a representational—aesthetic—strategy. It solicits and engages the viewer as a political subject, as a reader; but also as a subject who receives affects and sensations from the encounter with the visual image or situation (even if they

are negative, displeasing, boring). The contemporary impasse of photography is, in large part, a result of this rejection of aesthetics, something which one finds throughout its discursive history.

I agree with Robin Kelsey and Blake Stimson who write that the "critical turn" made by postmodern critics and historians has "unquestionably left us much wiser in its wake" but questions have arisen, such as "whether the work of suspicion, and of the melancholy that may inevitably cling to it, is still the most important task to be undertaken, or whether photography has some new meaning—or some old meaning renewed—to offer us now."[40] The study of photography must begin here. One must proceed from a position of knowledge about the discourse as a whole.

The technical invention of photography—the mechanical device, the chemical solutions, the refinements of the lens, etc.—is not the definitive event of modernity, but the production of an image may very well be. An image is not a picture or a snapshot. Only an image defines a territory and possesses the ability to cut across and remark it. An image becomes visible by more than an act of physiology or even of artistic innovation: an image constructs a complex network of socio-cultural discourse that defines—not once and for all, but contingently—the framework through which both the image and ourselves as spectators become visible. Writing the history of images—however inexhaustible and incomplete a project it may be—must face the issues of epistemology (how and why is knowledge being produced by studying and representing the past events as happenings) and ethics (which includes the political). Knowledge is a relation between two forms (statements and visibilities). One relation may be termed scientific knowledge, but there are other relations that coexist with scientific knowledge within a given historical and cultural context. Other formations of the relation between statements (language) and visibilities include aesthetics and ethics. Both produce knowledge, but in ways that are different from science. An image only takes place in-between statements and visibilities; an image is a site of contest and confrontation. An image is a "non-relation" between statements and visibilities; it implies a "non-place" between the variable forms of knowledge *within* a given historical formation (culture, time period, etc.).[41] It is for this reason that images possess a radical untimeliness: thus their ability to haunt, which stems not from historicity but from their ability to trace a geography through the life of a culture. This geography is "interleaved" and "holed"; comprised of places of passage and forgetting; inscribed with fortuitous encounters and becomings that anticipate a material image-event—an untimely temporality of survival—that "crosscuts its history without being confused with it."[42]

As students and historians of images, we must ourselves undertake an apprenticeship in images that entails rethinking aesthetics neither as impressions or phantasms nor as a retreat from the world; but rather as a creative event that exposes how our becoming-image, becoming-other, demands a responsibility not only to images, but to the temporalities they open. To study the history and theory of photography is to write and create alongside—and

in the middle of—images. It requires us to comprehend the paradox that the untimely, the too-late, is only an opening to another temporality:

> The too-late conditions the work of art, and conditions its success, since the perceptible and sensual unity of nature and man is the essence of art *par excellence*, in so far as it is characteristic of it to arrive too late in all other respects except precisely this one: time regained.[45]

The time of the image is only conceivable if we can reinvest aesthetics as an act of creation alongside the image rather than as an act of interpretation (whether essentialist or historicist) and/or critique. Aesthetics is thus inextricably bound to the histories of the image we construct.

Lastly, an image is always already an ensemble of history and theory. It is a passage. "The point here is that history is present or embodied in art instead of being merely the phenomenon or condition that generates art without appearing. That is, art is not just a trace of history but is itself a mode of history; we experience history through one of its modes called art," as Michael Kelly has brilliantly written.[44] To face photography is to attempt to create an image of thought from within an encounter. It is to think how an image *decreates* the world. Only by doing so are the full implications of a "mirror with a memory" open to us.

1 The thing itself

Clouds, torsos, shells, peppers, trees, rocks, smoke stacks, are but interdependent, interrelated parts of a whole, which is Life. Life rhythms felt in no matter what, become symbols of the whole. The creative force in man, recognizes and records, these rhythms with the medium most suitable to him, to the object, or the moment, feeling the cause, the life within the outer form…To see the *Thing Itself* is essential: the quintessence revealed direct without the fog of impressionism…This then: to photograph a rock, have it look like a rock, but be *more* than a rock.

Edward Weston

…contrary to what our desire cannot fail to be tempted into believing, the thing itself always escapes.

Jacques Derrida[1]

Any questions regarding photographic representation are inseparable from complex issues of historiography and theory, in particular the ways in which the discourse of photography has been produced and elaborated in different historical and cultural contexts. Asking after the ontology of the photograph—what *is* a photograph? what is exceptional, unique about it?—is only another way of relearning how and why the history of photography has been written. In other words, it is a re-engagement with the study of the "terrifying archive" we call the history of photography. This ensemble of ontology, function, discourse, and event becomes apparent when one considers how a photograph is created and how it becomes visible and intelligible. Perhaps the meaning of photography is not singular, but a multiplicity of uses and functions? It is for this reason, among others, that when one considers the history of photography it is necessary to be cognizant that one is addressing complex theoretical questions about representation: signs *and* objects, events *and* narratives, life *and* politics. Because of its seeming simplicity—a photograph is supposedly a simple mimetic duplication or copy of a pre-existing reality, whether an object, person, or scene—photography is too often misread. But throughout the contentious and contradictory history of photography these misreadings of the

relation between the photographic image and its putative referent—this relation is often called "the thing itself"—have proven productive.

The desire to see in the photographic image "the thing itself" without intervention, mediation, or artifice was a primary aspect of its feverish discourse in the first decades of the nineteenth century. William Henry Fox Talbot, one of the inventors of photography, composed the first photography book in 1844 entitled *The Pencil of Nature*.[2] It is interesting to note the Latin motto Talbot chose for the title page: "Joyous it is to cross mountain ridges where there are no wheel ruts and earlier comers, and follow the gentle slope to Castalia." (Castalia, on the slope of Mt. Parnassus, is a spring dedicated to the Muses, a font of wisdom and knowledge.) In addition, his "Notice to the reader" gives us the following: "The plates of the present work are impressed by the agency of Light alone, without any aid whatever from the artist's pencil. They are sun-pictures themselves, and not, as some persons have imagined, engravings in imitation." Talbot repeatedly claimed that his invention—the first truly negative–positive process that forms the basis of analogue photography—presented images "impressed by Nature's hand," that is, "an Art of so great singularity, which employs processes entirely new." Thus the uniqueness, he claims, for his invention: no "wheel ruts and earlier comers" but only untrammeled, new territory. The ambition to "spontaneously" reproduce the image of nature appearing in the camera obscura that we read in Talbot, and Louis-Jacques-Mande Daguerre as well, evinces the desire to fix and retain an image that was conceived as given rather than to create or construct a representation. This willful attempt to deny the photograph and, by extension, the photographer, any creative role is, however, not to downplay its cultural and historical importance. What had already taken shape, well before 1844, is the very structure of photographic discourse. This includes the understanding that its "invention" was the result of pre-existing obsessions and inventions.

These supposedly automatic, unmediated reproductions of "Nature herself" were included in the publication along with reproductions of paintings and images of buildings in Oxford, England, both of which represented what Talbot called "important applications of the photographic Art." It is certain that one "application" or use Talbot imagined for his "calotypes" (ironically, from *kalos*, the Greek word for beauty that connotes being beyond use) was as a research tool and memory aid for historians and travelers. If we juxtapose Talbot's *Plate I. Part of Queen's College. Oxford* from *The Pencil of Nature* and Benjamin Brecknell Turner's *Hawkhurst Church. Kent. or A Photographic Truth* (1852–4), we see the "origin" of both automaticity *and* contingency (framing, the out-of-field) at once.

In the former, Talbot is intent on demonstrating an "application" of his calotype process. In morning light, he aimed his rudimentary camera at an old section of the college, one showing, in his words, "marks of the injuries of time." Surface damage to the stone façade is visible. At the end of the narrow street, the Church of St. Peter's, one of the oldest structures in Oxford,

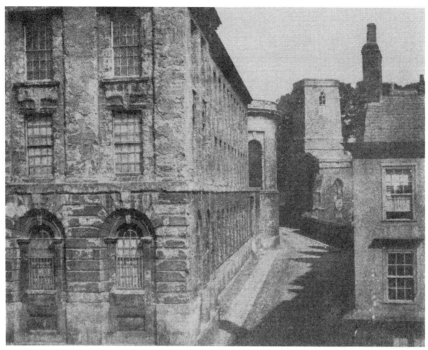

Figure 1.1 William Henry Fox Talbot, *Plate I. Part of Queen's College, Oxford* from *The Pencil of Nature* (1844)

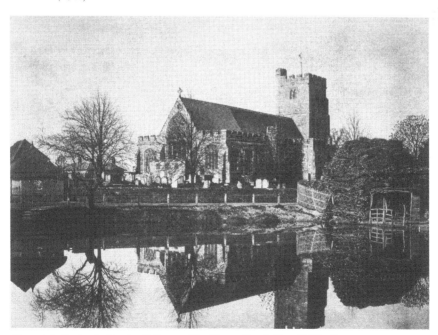

Figure 1.2 Benjamin Brecknell Turner, *Hawkhurst Church, Kent* (1852–4)

is just visible. But also notice how the chimney stack on the right side of the photograph draws the eye only because of its darkness. The arbitrariness of the photograph's frame and its technical recording of light and dark on the chemically-treated paper displace the whole, the "thing itself." Instead, we have to imagine the whole building, re-frame it, supplement this view with others. Moreover, we have to decide what is or is not an insignificant detail (the dark chimney) as well as navigate the complex relations between what is within the frame and the out-of-field. Inadvertently, perhaps, Talbot's first plate from *The Pencil of Nature* presents nothing like nature writing herself, but only a partial view, one that must be deciphered and interpreted.

Talbot's calotype renders suspect, in advance, Turner's "photographic truth," which claims to avoid the transfigurations of translation. If nature can reproduce herself (as in the church's reflection in the pond water), then what of the third remove, the bizarre photographic image that is the reflection of a reflection? Does the "thing itself" simply precede our perceptions of it, let alone our attempts to record those perceptions, or is it not caught up—made visible—in the play of representations themselves?

Claiming that this new invention is an art that automatically and faithfully duplicates nature (or reality itself), one useful for scholarship and industry, helped generate one of the earliest, brilliant, and most productive misreadings of the discourse that comes to be called the "history of photography." It was given by the nineteenth-century French poet Charles Baudelaire in his famously heated response to the public's obsession with the photographic image in "The Modern Public and Photography" (1859). Here Baudelaire focuses on the profanation of art (understood as imagination, soul, creativity) by the public's overvaluing reproductions of "external reality" such as photography. With some very well-known lines Baudelaire ridicules the emerging French middle-class of the Second Empire (1852–70) by dismissively characterizing their equation of art with naturalism (art as the mimetic representation of nature or the natural taken as a given) as well as their narcissism:

> In these deplorable times, a new industry [photography] has developed, which has helped in no small way to confirm fools in their faith…An avenging God has heard the prayers of this multitude; Daguerre [one of the inventors of modern photography] was his messiah. And then they said to themselves: "Since photography provides us with every desirable guarantee of exactitude" (they believe that, poor madmen!) "art is photography." From that moment onwards, our loathsome society rushed, like Narcissus, to contemplate its trivial image on the metallic plate. A form of lunacy, an extraordinary fanaticism, took hold of these new sun-worshippers. Strange abominations manifested themselves.[5]

Two aspects of Baudelaire's critique are important to note. First, his assuredness in defining photography as mimetic representation, even if he associates that reading with idolatrous "new sun-worshippers." His complaint is not that the public misunderstand photographic representation, but that they

confuse the "exact reproduction of nature" with art. Baudelaire tacitly agrees with them that photography is simple, mimetic reproduction—a copy of some pre-existing original—whereas art, for him, is a different order of creation altogether: art is the "sphere of the intangible and the imaginary," the abstract in fact, and as such it must stop "prostrating itself before external reality."[4] Second, note the clear distinction for him between art and industry. This distinction is not unique to Baudelaire, but is rather symptomatic of the historical and cultural discourse surrounding photography in the mid-nineteenth century. The public and artists themselves are the object of Baudelaire's invective because they debase art itself by confusing it with mere industry. He does not argue that photography is art—which was not a given by any means in the mid-nineteenth century but is a position that had to be discursively argued and constructed—but that art is becoming photographic, a change he clearly opposes. There are clear lines of division between art and industry for Baudelaire, which allow him to give photography "its true duty," which he assumed to be as a "humble handmaid of the arts and sciences":

> Let photography quickly enrich the traveler's album, and restore to his eyes the precision his memory may lack; let it adorn the library of the naturalist...Let it save crumbling ruins from oblivion, books, engravings, and manuscripts...which crave a place in the archives of our memories; in all these things, photography will deserve our thanks and applause.[5]

Photography's duty is not to create but rather, as Talbot himself had suggested, to be an archival instrument, a prosthetic memory for instrumental use in many arenas.

Despite oversimplifying the public's conception of photography and, inversely, presenting an exaggerated Romantic conception of art itself, Baudelaire's text is symptomatic of how photography comes to be understood, not as a single concept or even as a single medium, but rather as a troubling event that delimits the very parameters of modernism itself. Modernism was never a coherent, unified entity; rather, it is a construct produced by and through a variety of contiguous but by no means identical discourses, including literature, art history, criticism, museology, sociology, architecture, and economics, etc.[6] The discourse generated by photography—as technology, as entertainment, as commodity, as social investment, as politics, and as art—"revealed deep tensions within the hierarchical structures of bourgeois society, and raised questions, both epistemological and ideological, as to how the world should be viewed and comprehended."[7]

As mentioned above, the very idea of a photographic representation had been part of the European cultural imaginary since the invention of linear perspective and the camera obscura in the fifteenth century. The connections between early modern science and art both within and beyond Europe's borders are inscribed in Leon Battista Alberti's conceptual desire to organize the visual world into a geometric, symbolic form.[8] Linear perspective developed by Alberti and others during the Renaissance framed, arranged, and

domesticated the visual into an ideal mimetic representation, what Alberti called "a window on the world." Some historians of photography argue that this "window on the world" is actualized in the form of small glass plates that were photographs for much of the nineteenth century. It is debatable whether or not there is any connection between Renaissance perspective and these early photographs. (Perhaps a better metaphor is the "mirror-like" quality of a daguerreotype, which is, of course, not a mirror at all but an easily effaced image, one that must be held at an angle in order to properly view it.) Nonetheless, a figure/ground relation is maintained in a camera's viewfinder that can resemble the pictorial space designed in the Renaissance. But what is more important is that although the event of photography exceeds its own discursive frame, the trope of transparency rather than translation, illumination rather than opacity, evinces a persistent historical and cultural desire.

In the nineteenth century, then, photography was a feral event that was being domesticated by a series of supplementary and, at times, contending narratives, including those of science, criminology, law, education, travel, and art. However, this event and the global socio-cultural reverberations it generated—its sheer multiplicity and complexity—is domesticated, so to speak, by the persistent returns to the frame that interested Baudelaire and many others: photography and art. Even contemporary discourse on photography operates through a variation on this theme. In 1977, Susan Sontag writes:

> The history of photography is punctuated by a series of dualistic controversies [that are] a different form of the debate about photography's relation to art...The history of photography could be recapitulated as the struggle between two different imperatives: beautification, which comes from the fine arts, and truth-telling, which is measured not only by a notion of value-free truth, a legacy from the sciences, but by a moralized ideal of truth-telling, adapted from nineteenth-century literary models and from the (then) new profession of independent journalism.[9]

In many ways Sontag's recapitulation of the history of photography as an antagonism between art and documentary differs from and yet definitely echoes Baudelaire's concerns. So although the productive tension between mimesis and creation (abstraction)—photography and art in Baudelaire's terms—is no longer determinative of how we conceive and interpret an image, it is an oversimplification to assert that contemporary discussions of photography are no longer framed at all in this nineteenth-century manner, which circled around a naïve realism and the conceits of positivism (one cause equals one effect).

Of course, this is not to say that our discourse on photography is in no way distinct from this preceding framework. On the contrary, we must come to understand that what was constructed in the first moments of photographic modernity was a discourse that organized and defined the particular relationships between visible and sayable as it related to the photographic image. Within the discourse of photography there is repetition but also difference, change. Note the inversion that Sontag discerns in how photography

is understood in the late 1970s, a little less than a century after Baudelaire's comments above: "Instead of just recording reality, photographs have become the norm for the ways things appear to us, thereby changing the very idea of reality, and of realism" because photography's realism "creates a confusion about the real."[10] The focus of the discourse shifts from questions of whether or not photography is an art to how the "photography effect" begun in the nineteenth century, despite Baudelaire's warning, has in fact completely transformed how we imagine and understand the contemporary world. Photography has produced "confusion about the real," but these epistemological issues are coupled with the dissolution of the category of art as a practice and/or an object that is unique and exceptional.

Sontag's conclusion, however, that "all art aspires to the condition of photography" must be approached with caution.[11] While it has proven a prescient comment, it rests on an "anti-aesthetic" argument that is often overlooked. Before arriving at her conclusion, Sontag writes that "photography encapsulates art itself" but that photography "is not an art."[12] It is not, she continues, "an art form at all" because "like language, it is a medium in which works of art (among other things) are made." Sontag makes a distinction here between a traditional notion of art as a unique, specific object-process (such as painting or sculpture) and photography, which she takes as only a means rather than an end in itself. But this is not a simple division between means and ends because, for she adds, "from the beginning photography has also lent itself to that notion of art which says that art is obsolete. The power of photography—and its centrality in present aesthetic concerns—is that it confirms both ideas of art."[13] What Sontag is saying here is that photography simultaneously denies art (renders it obsolete) and affirms its continued existence and relevance (its afterlife, so to speak). Her ultimate choice to focus only on photography as a means that "heralds (and creates) new ambitions for the arts" because of its unique "powers" (i.e. "it is *not* dependent on an image-maker) is less than convincing: "But the way in which photography renders art obsolete is, in the long run, stronger."[14] Sontag's conclusion here is significant because it hints at, but never quite states, that perhaps both "ideas of art" are not embodied in the photograph as much as they generate a new category of the image as such. It is not that the photographic image is exceptional compared to other images, but it is certainly essential to arriving at a history and theory of the image, one capable of existing in the aftermath of that simultaneous denial and affirmation of art that Sontag diagnoses. Furthermore, her insights into the social history and aesthetics of photography allow us to draw a complex line between postmodern attempts to relocate photography at the center of a web of contending forces *and* formalist approaches to photography that insist on the uniqueness of the photographic image as art, that is, as a medium with its own (art) history.

Photography as a problematic for the visuality of the nineteenth and twentieth centuries is lessened whenever photography is viewed only as a primary development in the history of Western visual representation. Undoubtedly one

of the singular moments in this art historical interpretation of photography is Beaumont Newhall's *The History of Photography* (1937). In many ways this text and the discursive shift it represents is the hinge between the positions voiced above by Baudelaire in the nineteenth century and Sontag in the late twentieth. It is hard to underestimate the importance of Newhall's work and its institutional authority (the Museum of Modern Art in New York City) within the history and theory of photographic practice and criticism. As Douglas Nickel has astutely written: "We simply need to appreciate how the structure, the assumptions, the scope—to say nothing of the canon—of this work became something like the field's subconscious, so invariably did its ideas, directly or otherwise, before us."[15] The book Newhall composed accompanied an exhibition at MoMA entitled *Photography 1839–1937* that "threw together everything: daguerreotypes, Hill and Adamsons, Nadar's pictures of the catacombs, Disderi's *carte-de-visites*, Roentgen photographs, radio-produced photographs, fabulous pictures of shorelines taken from a height of 20,000 feet."[16] As Joel Snyder explains, it was as if Newhall was saying, "I can't tell you why these belong together at the Museum of Modern Art. I just know there is something aesthetic about each and every one of them. I don't have a coherent account of what makes this thing necessary. But here are 827 pieces."[17] Even though the exhibition itself was broad and unwieldy, it was in the essay, and ultimately the book, that Newhall attempts to give "a coherent account" of this history of photography, which in 1937 was still confused and untamed.

Although histories of photography had already been written in the first decades of the twentieth century, these texts were primarily process-based histories and celebrations of individual photographers.[18] They trace the "development" of representational strategies and technological means to improve them since the Renaissance. As a whole they presume that photography is the "legitimate child of the Western pictorial tradition."[19] This presumption immediately colors and frames these first histories, which are structured by stylistic periodization and techniques. Newhall's writing (both the initial catalogue and the subsequent textbook editions) certainly shares some of this perspective. In attempting to domesticate the disparity of the photographic imagery in the exhibition, he emphasizes the applications of photographic technology in the advancement (evolution) of Western art.[20] Hence he attempts to identify the "Basic Laws" of photography that transcend historical periods, cultures, and particular social uses of photographs. These so-called "basic laws" are the "detail" (a visual criterion) and the "mass" (a technological, chemical one). These two unique characteristics of photography are further elaborated by Newhall into a formalist history centered on the "cultural need for representational verisimilitude."[21]

By emphasizing photographic realism Newhall privileges one form of photographic practice. He constructs a history that is at once medium-specific and evolutionary, culminating in the high modernist work of the F.64 group, in particular Edward Weston, in the 1930s. The formalist qualities that Newhall foregrounds are generally referred to as "Westonian."[22] Consider Weston's

Clouds—Mexico (1926), a photograph that, despite Weston's insistence that the camera should record "the very substance and quintessence of the *thing itself*," alludes to Alfred Stieglitz's *Equivalents* (photographs of clouds that meant to discern the equivalence between nature and his own thoughts, desires, fears) from the late 1920s as well as to Weston's own formal studies of nudes.[23] The qualities deemed "Westonian" are evident here: a productive tension between realism and abstraction, bold planar structure, skill of composition, sharp focus, clarity of subject, perfection of final print quality, no manipulation of the image in the darkroom (i.e. straight photography), emphasis on photographic "genius" (vision) as evinced by originality of chosen subjects (especially details), and the necessity of vision and technique over social concerns as a way to argue that photography is a unique and new means of individual, creative expression. Consider as well Weston's *Pepper No. 30* (1930) where these qualities transform the commonplace into a work of formal beauty. These qualities are applicable to photographers as varied as Paul Strand, Walker Evans, Minor White, Aaron Siskind, and others.

Newhall sets a standard for formalist approaches to photography by positing that each medium has unique characteristics and should be judged according to its own internal, specific criteria. In the medium of photography, this ultimate criterion is objectivity because naturalism (verisimilitude) is the unique contribution and limitation of photographic representation.[24] Newhall and others argue that photography possesses unique formal properties; it is exceptional in the sense that no other artistic medium can address these specific properties and representational problematics as well as photography can.

A refinement of Newhall's approach (a formalist creation of a canon of great artist photographers such as Alfred Stieglitz, Ansel Adams, etc.) is *The Photographer's Eye*, an exhibition curated by John Szarkowski (director of the department of photography at MoMA from 1962 to 1991, successor of Newhall and Edward Steichen).[25] This exhibition, which opened in 1964, was supplemented by a text of the same name published two years later in which Szarkowski explains that he intended "to try to define certain issues, certain fundamental issues, that might begin to offer the armature for a credible vocabulary that really has to do with photography."[26] Szarkowski hoped to identify a "tradition" that combined vernacular and artistic photography by delineating its basic formal elements. As he explains:

> It is the thesis of this book that the study of photographic form must consider the medium's "fine art" tradition and its "functional" tradition as intimately interdependent aspects of a single history…Studying the history of photograph from this point of view required access to collections which were formed on the basis of criteria other than that of artistic merit, as well as collections which were consciously concerned with documenting the art of photography.[27]

In *The Photographer's Eye* he gives a preliminary list consisting of "The Thing Itself," "The Detail," "The Frame," "Time," and "Vantage Point." These five criteria

were posited as the means to identify and value the supposedly inherent, fundamental characteristics across the medium. Photography has an inherent nature, for Szarkowski, because it is a medium with "a singular, inherent identity."[28]

The dominant art historical agenda of the 1960s and 1970s—modernist formalism—underlies Szarkowski's thesis. Modernist formalism as adumbrated by Newhall is best represented by the work of the art historian and critic Clement Greenberg.[29] Perhaps most cogently outlined in his essay "Modernist Painting" (1961), Greenberg argues that in the modern era the traditional functions of art (read: painting and sculpture) have been usurped by kitsch and photography among other things. For art to survive it had to establish its value as an irreplaceable vehicle of heightened experience within an otherwise alienating culture. In order to do so each art medium must determine, through rigorous self-examination of its own operations and effects, those specific qualities unique to itself. What Greenberg posits, in a very seductive and enormously influential manner, is a formalism that articulates itself as a continual, autotelic search for each medium's fundamental, irreducible essence.[30]

There are aspects of Szarkowski's project that stem directly from Greenberg's position. For instance, he presents the history of photography as an inevitable progression towards self-knowledge and purity (what Greenberg termed the "fate" of a medium) and photos were usually displayed by Szarkowski in groups according to their presumed exhibition of these concepts, "resulting in a kind of modernist history of photographic picture making remarkably reminiscent of that propagated by Greenberg for painting."[31] Images were chosen to reflect their own process of production, as a result of which they are "significant beyond their limited intention." This is how Szarkowski justifies placing a nineteenth-century photograph alongside one by Lee Friedlander from the early 1960s: everything is subsumed in the medium's attempt to construct a "usable tradition" for itself. This is also why he consistently included pictures by anonymous photographers in all of his large survey exhibitions, including his 1989 historical overview *Photography Until Now*. He continuously sought out those photographs that, consciously or otherwise, exhibit "anonymous and untraceable gifts from photography itself."[32] Szarkowski believed that "there really is such a thing as photography" but the problem he faced was precisely how to define this "thingness."[33]

The problem was how to redefine anew for photography the essence or "thingness" of the medium with a formalist approach. The primary difference, as Szarkowski saw it, between photography and painting was that photography was a "radically new picture-making processs...based not on synthesis but on selection."[34] Hence he concludes that the

> pictures reproduced in this book [*The Photographer's Eye*]...were made over almost a century and a quarter...for various reasons, by men [*sic*] of different concerns and varying talent. They have in fact little in common except their success, and a shared vocabulary: these pictures are unmistakably photographs. The vision they share belongs to no school or aesthetic theory, but to photography itself.[35]

Photography as a medium trumps individual vision, talent, criticism/theory, whatever. The medium itself is the field in and through which photography exists and is legible. Neither its social effects nor its multiple relations with various discourses outside of itself (criminology, medicine, geography, for instance) are as determinative or significant as the "essence" or "thingness" of the medium itself.

Szarkowski constructs a history of photography that begins and ends with this "thingness," that is, how the "narrative poverty" of a photographic image is enriched when photography becomes a "learned" process, a "shared vocabulary." The "narrative poverty" of the photograph is not unique to Szarkowski, it had already been discussed in earlier considerations of it. Nevertheless, he puts it to great use, beginning in *The Photographer's Eye* where he defines it by noting that a photographer

> was tied to the facts of things…He could not, outside the studio, pose the truth: he could only record it as he found it, and it was found in nature in a fragmented and unexplained form—not as a story, but as scattered and suggestive clues. The photographer could not assemble these clues into a coherent narrative, he could only isolate the fragment, document it, and by doing so claim some special significance, a meaning which went beyond simple description.[36]

The concept of a photograph's "narrative poverty" allows Szarkowski to justify his construction of a "useable tradition" that can address the sheer abundance of photographic imagery produced since its nineteenth-century invention. The advent of picture-taking had no framework or guidelines in the mid-nineteenth century; it was, he argues, a "formless and accidental" shot-gun start in which the excitement and wonder produced by the new technological means of allowing "nature to reproduce herself" (as Talbot claimed) instigated a frenzy of activity and began "a massive assault on our traditional habits of seeing." But this unbounded, open, untamed, and undefined field of photographic practice—the opening of what we call "photography"—was fated in Szarkowski's narrative to be circumscribed and tamed. There had to be a learning process by which photography could become a field, a "useable tradition," a medium itself. Thus the photographer "learned in two ways: first, from a worker's intimate understanding of his tools and materials…and second he learned from other photographs, which presented themselves in an unending stream. Whether his concern was commercial or artistic, his tradition was formed by all the photographs that had impressed themselves upon his consciousness," he writes.[37] The bedrock of formalist art history is clearly present here in the emphasis on the material conditions of image-making, the "narrative poverty" of the photograph, and the supposed unfolding of a history of photographic imagery that is not presented through various contingent frameworks (publications, exhibitions, etc.) but rather "presented themselves."

Szarkowski's framework makes it easy to navigate the challenges that changing conceptions of art photography have posed. His work narrates a shift from

early modernist photographers such as Stieglitz and Ansel Adams and towards other characteristics (the fragmentary, the indeterminate) that are more prevalent in the work of postmodernist photographers such as Friedlander and Diane Arbus. The difference between high modernism and postmodernism becomes evident by contrasting statements made by Adams and Garry Winogrand.[38] Here is Adams from his "personal credo" written in 1948:

> The common term *"taking* a picture" is more than just an idiom; it is a symbol of exploitation. *"Making* a picture" implies a creative resonance which is essential to profound expression…I believe in growing things, and in the things which have grown and died magnificently. I believe in…affirming the "enormous beauty of the world" and acquiring the confidence to see and express this vision. And I believe in photography as one means of expressing this affirmation, and of achieving an ultimate happiness and faith.[39]

Consider the above alongside these two famous statements by Winogrand, a photographer Szarkwoski helped canonize: "I photograph to see what the world looks like in photographs" and "I like to think of photographing as a two-way act of respect. Respect for the medium, by letting it do what it does best, describe. And respect for the subject, by describing as it is. A photograph must be responsible to both."[40] The difference between these two positions—the shift from natural beauty and a biological metaphor premised on artistic "vision" to a more skeptical, less ambitious, desire to see what the world looks like as a photograph—is in part the difference between Newhall and Szarkowski. However, this difference is not necessarily indicative of a break; rather, for Szarkowski, it is indicative of how one essential characteristic of the medium itself, the "narrative poverty" of the photograph, is being used and reconceived at different historical moments by different photographers' eyes.

What is downplayed here is the politics that surrounds this "narrative poverty." Even though a photograph can "never convey a larger narrative meaning" it is not necessary "to seek a supplement to the image beyond the frame"; instead, photographs are deemed to be self-sufficient and should be "savored for their surprising conjunctions of formal coherence and narrative ambiguity," qualities that Szarkowski understands are "built into the images produced by the photographic medium."[41] The supposed self-presentation of a photograph as an expression of the medium-itself (the unique combination of "narrative poverty" and "symbolic power" as Szarkowski insists) belies the theoretical, historiographic, and institutional work—all clearly supplemental and outside the frame of the image itself—that went into the promotion of the medium of photography itself, which has proven institutionally successful if critically suspect.[42] In direct contrast to the modernist formalist position, there is critical postmodernism, which strives to expose points of contradiction—the repressed politics—within the deliberately *"narrow"* definition and history of photography that was written by Newhall and Szarkowski among others.[43]

If Newhall's *The History of Photography* and Szarkowski's *The Photographer's Eye* are cornerstones of the formalist position, then the anthology of essays

edited by Richard Bolton entitled *The Contest of Meaning: Critical Histories of Photography* (1989) is exemplary of a critical postmodernism aimed at deconstructing formalism and its consequences in the second half of the twentieth century. This anthology includes essays by some of the most well-known art historians and cultural historians associated with the idea of critical postmodernism in the visual arts, including Martha Rosler, Douglas Crimp, Rosalind Krauss, Allan Sekula, and Benjamin Buchloh. All of these figures published work in the influential art journal *October*, beginning in 1976. Many of the best articulations of the critical postmodern position were first read, and continue to be read, in the pages of *October*. The position voiced by the *October* group has been very influential, if not determinative, for our understanding of the visual arts for the last three decades.[44] It is important to note that critical postmodernism in no way reflects the entirety of the field named "postmodernism"; a caveat we should always recollect about formalism in the modern period as well.

There is no one, single postmodernism. The term came into currency within the humanities, particularly in architecture and visual art, in the mid-1970s. One text that ensured the prominence of this contentious, polysemous term was the publication of Jean-François Lyotard's *The Postmodern Condition* in 1979.[45] The concept has come to signify both a critical strategy and a style (particularly in architecture, visual art, and literature) that foregrounds aesthetic playfulness, subversion of tradition, irony, the mediated phenomena of subjectivity (self as other), and intertextuality. However, when these characteristics are presented as a list the concept of postmodernism becomes, what many considered it to be from its inception, an empty signifier. In contrast, it is better to focus on a particular text or coherent positions within the rubric named "postmodernism" if one desires to understand not only its historical and cultural importance but also its theoretical (philosophical) importance as well.

Notably, it is impossible to trace the development of postmodernism in the visual arts without photography. The relation of postmodernism to the visual arts passes through photographic discourse; it is the *fils conducteur* through which postmodernism is constructed, articulated, and developed as a non-unified set of critical perspectives. In many ways, it was the battleground on which contending forces (formalist and postmodernist) confronted each other. As Bolton insists, the writers he gathers in his anthology exemplify one (obviously privileged) form of postmodern practice, a "*politicized* postmodernism" that refuses to separate culture from society at-large and advocates a historical (contextual, interdisciplinary) approach to cultural production.[46] In turn, photographic theory has had to take account of the (political, psychological, etc.) production of the subject. However, postmodern criticism is "by no means homogenous in outlook, having been informed by a variety of sometimes competing theoretical models (Marxism, feminism, psychoanalysis, semiotics), but nevertheless, "a remarkably consistent view of the photograph has come to occupy the center stage of critical debate."[47] One element of this "consistent view" include maintaining that all meaning is determined by context (culture). Thus "photography as such" has no identity; its history is a

fiction for those who accept this "consistent view." Moreover, these positions were articulated in direct relation to artistic practice in the 1960s to 1990s.[48] So these positions coalesced into a "consistent view"—a "socially motivated, critical practice"—by reading art practices and by trying to actualize some of the lessons of critical theory, including, but not limited to, Lyotard's text.[49]

Critical theory refers to the disparate set of practices of interpretation, social research, and philosophy (ethical and political thought) that transformed the humanities and social sciences in the 1960s to 1980s. The term "critical theory" was first used by a group of German philosophers, sociologists, cultural historians, and social theorists in the European Marxist tradition known as the Frankfurt School, namely Theodor W. Adorno, Max Horkheimer, Herbert Marcuse, Jürgen Habermas, and others.[50] Adorno and Horkheimer founded the Institute for Social Research in 1929 in Frankfurt and moved it to the United States at the outbreak of the Second World War. The founding principles and approach of the Frankfurt School are presented in the influential book they co-authored entitled *Dialectic of the Enlightenment* (1947). According to these theorists, a theory is critical to the extent that it seeks human emancipation, "to liberate human beings from the circumstances that enslave them," including the illusory pleasure of the culture industry."[51] However, with the advent of post-structuralist thought in the late 1960s, much of which stems from the European leftist intellectual and political tradition of which the Frankfurt School is central, critical theory expanded into a broader name that covered any praxis (intellectual research conceived of as inseparable from practical, socio-political emancipatory aims), including feminism, critical race theory, post-colonial theory, and what we have referred to above as critical postmodernism in art history. Critical theory is therefore not one particular interpretative strategy or school; rather, it designates a set of postwar critical practices that combine, in different and distinct manners, the insights of linguistics, psychoanalysis, ethics, political philosophy, and the philosophy of history.

Critical theory includes a number of figures whose work so indelibly colors any form of critical postmodernism that the latter is inconceivable without them. For example, the work of the German-Jewish philosopher and cultural historian Walter Benjamin. In particular, a set of three essays he wrote has fundamentally transformed contemporary art historical practice and aesthetic thought: "A Little History of Photography" (1931), "The Work of Art in the Age of its Technological Reproducibility" (1936), and "The Author as Producer" (1934). (These essays were translated into English and published in art journals in the USA in the late 1970s, thereby exerting a tremendous influence on the advent of postmodern critique in the visual arts.) Benjamin's approach to material culture and representation coalesced into a unique philosophy of history that positions him as a hinge between Friedrich Nietzsche's critical philosophy of life and the post-structuralist thought of Michel Foucault, Jacques Derrida, and Giorgio Agamben. Approaching Benjamin's work, however, requires being attentive to the subtlety of his thought and positions, which often changed over time, thereby complicating his previous statements.

For instance, critical postmodernists place an inordinate amount of emphasis on the positions Benjamin articulates in "The Author as Producer" and "The Work of Art" essays, too often isolating them from Benjamin's larger research agenda and philosophy of history. Even between this set of three now canonical essays Benjamin's position is not entirely evident. What he does address is the nature of photography as a distinct creative act and form of representation. He posits that the reproducibility of images (lithography, photography, film) has an implicitly democratizing (if not socialist) political potentiality and he undertakes a sustained critique (especially in "The Author as Producer") of the photograph's ability to estrange the real world by aestheticizing it. This last position is one of the seeds of the anti-aesthetic position that goes hand-in-hand with critical postmodernism, that is, a reduction of aesthetics to a facile demand for beauty and good taste—the illusory aspects of art as opposed to their socio-political effects.

Benjamin's mediations on photography shift between positions conducive to critical theory and those at odds with its premium on empirical criticality. For example, in "The Author as Producer" Benjamin offers a Brechtian critique of New Objectivity, an approach to photography dominant in the 1920s to 1940s best exemplified by Albert Renger-Patzsch's photo-book *The World Is Beautiful* (1928). A perfect example of the type of work Renger-Patzsch made and included in his photo-book is *Shoemaking Irons, Fagus Works, Alfeld*. Renger-Patzsch's

Figure 1.3 Albert Renger-Patzsch, *Shoemaking Irons, Fagus Works, Alfeld* (1928)

work disregarded Pictorialism as well as avant-garde experiments with photography in favor of precise, objective, realism. In fact, Benjamin has this particular practice in mind when he indicts all photography as complicit in a dissimulation and beautification of the modern capitalist world. Photographers, he concludes, have "succeeded in transforming even abject poverty—by apprehending it in a fashionably perfected manner—into an object of enjoyment."[52] Benjamin condemns the inability of photography to "transfigure" the world; instead, it can only "record a tenement block or a refuse heap without transfiguring it," it can "convey" nothing about "a power station or factory other than, 'What a beautiful world!'"[53] The camera offers us only a surface appearance of things because it is unable to capture the social relations (economic, political) that intersect and comprise the social field that it represents. It translates a complex social system into a two-dimensional picture that alienates and fosters enjoyment (visual pleasure) without encouraging any critical faculty on the part of the viewer.

This is not to say that art, as understood by Benjamin and other modern thinkers and artists, was incapable of making the viewer attentive and socially aware. Brecht's alienation effect (*der Verfremdungseffekt*) and the Russian Formalist idea of estrangement (*ostranenie*) are primary examples to the contrary.[54] The complications of the art/non-art debate operative within the historical avant-garde are made clear in the similarities, and yet intractable differences, between the conception of a photograph and photography as such given by Weston and Lazslo Moholy-Nagy, for example.

Figure 1.4 Laszlo Moholy-Nagy, *Untitled* (1923)

Moholy-Nagy experimented with some of the earliest photographic means such as photogenic drawing (see his photograms (camera-less photos that he called the "raw material of all photography" such as *Untitled* (1923)) and took up unusual viewpoints (oblique angles, from atop radio towers, etc.). Both were intended to disrupt the plane of viewing inherited from Renaissance painting. Moholy-Nagy set to dismantle the rules of perspective and their cultural connotations; he challenged the premise that photography is a copy of nature. Rather than traditional forms, Moholy-Nagy was looking for "creative possibilities" by conceiving of the camera not as a reflection of nature or as a means to express an artistic vision or "genius" (i.e. Weston's position), but as an "optical instrument" that supplements the human eye. This supplement was a prosthesis for human vision that was meant to transcend the narrow, subjectivist notions of vision predominate in discussions of art-photography at the time. The ultimate aim of his experiments was to *produce*, not reproduce as in imitating representational art like painting, a "purely optical image" (objective) that would then prepare us for conceptual ones.

His invective in the essays and statements published as *Painting Photography Film* (1925), written largely during his time at the Bauhaus, positions photography as an instrument for generating a "new vision," one that must not be hampered by "aesthetic-philosophic concepts" from painting.[55] "Purely optical images" were ones that addressed the material qualities of photographic means, literally as "light-writing": brightness, color, range of gradations of light and dark. In short, formal criteria that were to be turned to social, political ends. These ends are within reach only if photographers give up the notion of an individual image and address the series, which leads to film. The series, and by extension film, Moholy-Nagy argues, makes it "quite unimportant whether photography produces 'art' or not" because this avant-garde "new vision" must seek "not the aesthetic of tradition, but the ideal instrument of expression, the self-sufficient vehicle for education."[56] Operative in Moholy-Nagy's writings is a belief in the "objective": the production of these images and the new experiences they offered were not premised on self-expression or formalism for its own sake; instead, they were aimed at creating new forms of educating people, new forms of social and political organization.

Not surprisingly, Benjamin draws directly on Moholy-Nagy's position, citing him in his "Little History of Photography." In many ways Renger-Patzsch and Moholy-Nagy were two of the most influential photographers in Europe in the 1920s yet each represented diverging directions for photography and art. Benjamin finds more value in Moholy-Nagy's ideas than in Renger-Patzsch's attempt "to capture the magic of material things."[57] But he also posits something different than Moholy-Nagy when he counters the "narrative poverty" of the photograph with a call for combining image and text. Benjamin forwards that the right caption accompanying an image could "rescue it" from "modishness" and even confer on it "a revolutionary use": "What we require of the photographer is the ability to give his picture a caption that wrenches it from modish commerce and gives it revolutionary use value. But we will make this demand most emphatically when

we—the writers—take up photography."[58] This instrumental, at times anti-capitalist, interventionist approach to visual art, particularly photography, has proven to be one of the most salient, and perhaps productive, aspects of critical postmodernism.

The prevalence of image and text in postmodern photographic practice, notably in the juxtapositions of text and black-and-white photographs found in Martha Rosler's *The Bowery in Two Inadequate Descriptive Systems* (1974–5), owes a debt to Benjamin's position here.[59] Bolton acknowledges this debt implicitly when he writes that "critical artists and writers" have argued that "the narrative poverty of the photograph creates an *illusion* of neutrality" that allows for meaning to be "established through interpretative conventions that exist outside of the image—conventions that are socially constructed and serve an ideological function."[60] However, one of the errors of the critical postmodern position is revealed here, one that stems from a narrow reading of Benjamin himself, namely that the socio-political use or function of anything (not only an image) does not equal its meaning. Function is not meaning. A deep understanding of this equation between use/function and meaning is clearly found in Benjamin's work as a whole, most notably in his disagreements with Adorno on interpretative strategy and methodology.[61] In Benjamin's work as a whole, we encounter a critic and historian "who lodged extraordinary hope and wrote with exceptional intensity about the potential radicalism and subversive power of a visual culture shaped by what he famously called 'mechanical reproduction'."[62] (So, far from being someone who foreclosed on the potentiality of visual culture and the *aesthetic* power of the image, Benjamin's theoretical work maintains a potentiality that was not actualized in its translation into postmodernism.)

Currently postmodernism has reached an impasse; in large part because of how it redefines the art image. To be clear, I am not talking about postmodernism as a style or a shoddy form of interpretation, but rather postmodernism as a particular discursive formation, one that has defined a particular intersection of the visible and the sayable. In other words, what is and is not a form of critical art practice is being challenged. In particular critical postmodernism, or the anti-aesthetic position, is being challenged for its overly instrumental conception of a work of art. Whenever a discursive shift occurs it is never a wholesale, clean break, so to speak; rather, it is a slow, often contentious transition. So we must be clear about some of the pros and cons of the critical postmodern position because it has certainly provided several key insights that must be retained even as the discourse of contemporary art, particularly photography, is redefined.

Bolton provides us with astute summations of the positive contributions that critical postmodernism offers the study of photography. He begins by exposing a dire consequence of the formalist position: it gives the "impression that the major questions haunting the medium have been resolved." These questions have still not been resolved. But one question that critical postmodernism did address was how and why the formalist position (in its various guises) represses, if not forecloses on altogether, "the social function of photography and the social

role of the photographic artist."[63] Critical histories of photography have empha-sized the heterogeneity not within the medium of photography but within the field of photographic discourse. In other words, not style, artistic genius, tra-dition, and depoliticized aesthetic experience; but rather "the complex social history of the photographic medium" including its "role in public life," "con-tradictory relationship to material experience" (transparency of photograph and yet its "narrative poverty") and "the contradictory goals of photographic prac-tice" (the multiplicity of its uses).[64] This approach to the history of photography focused not only on the contradictions within traditional art historical (read: formalist) approaches, but on the larger social and political consequences of those contradictions as well.[65] In other words, the "narrowness" of the formalist position must be thought simultaneously with its institutional authority.

There is no doubt that this approach is one lesson learned from reading Roland Barthes's work on photography. More specifically, in an early essay "The Photographic Message" (1961), Barthes lays out what will become the method-ology for critical postmodernism. He insists that in photography there is "never *art* [aesthetic effects, he says] but always *meaning*" and so concludes by writing about how and why the best approach to reading a photograph is to under-stand that "photographic connotation…is an institutional activity."[66] Barthes's semiotic approach to photography demanded an analysis of the cultural codes inscribed within the production and reception of a photograph. He refocused photographic theory as a critique of the social and cultural myths (for example, gender identity) abetted by the denotation of a photograph (its being taken for the thing itself, as a direct analogue of reality), that is, how "the uncultured of a 'mechanical' art" became "the most social of institutions."[67] Hence critical post-modern histories of photography locate its history not within the medium or even within photographs themselves; on the contrary, something called the his-tory of photography is redefined only as a set of trajectories and paths through and along the boundaries of a range of practices. The history of photography becomes a site of interdisciplinary, intersecting lines that scumble and redraw the boundaries of the field as they adapt and address the seemingly endless uses or functions of the photographic image in contemporary society. Thus, in the critical postmodern position only "the collective and multifarious history" of these uses, "institutions and discourses" constitute the "photographic field."[68]

One important element of this position is an argument *against* the "excep-tionalism" of the photograph, that is, a photograph as a unique image. Rejecting this exceptionalism implies that a photograph has no distinct quality as an image, but only serves as a means to an end (that end being a socio-political critique of representation as such).[69] The reduction of the image to something lesser than the idea or linguistic message that it imparts is understood by some as evidence of an anti-aesthetics inherent in criti-cal theory itself, but it is not endemic.[70] The severity and the paradoxical nature of the "iconoclasm" within critical postmodernism is problematic, if only because it is symptomatic of a reaction against modernist formalism, which was deemed conservative. Combining the anti-aesthetic radicalism

of the historical avant-garde, notably a Bauhaus and Russian Constructivist notion of *fotokunst* (art as photographic, not art as photography) championed by Moholy-Nagy and Alexander Rodchenko, and a notion of *critique* inherited primarily from the Frankfurt School of critical theory, postmodernism in art history enacted a permanent critique of conservative formalism that it sought to dismantle and displace.

Here is Hal Foster's explanation of the link between critical postmodernism and anti-aesthetics:

> "Anti-aesthetic" also signals that the very notion of the aesthetic, its network of ideas, is in question here: the idea that aesthetic experience exists apart, without "purpose," all but beyond history, or that art can now effect a world at once (inter)subjective, concrete, and universal—a symbolic totality. Like "postmodernism," then, "anti-aesthetic" marks a cultural position on the present: are categories afforded by the aesthetic still valid?...More locally, "anti-aesthetic" also signals a practice, cross-disciplinary in nature, that is sensitive to cultural forms engaged in a politic (e.g. feminist art) or rooted in a vernacular—that is, to forms that deny the idea of a privileged aesthetic realm...The adventures of the aesthetic make up one of the great narratives of modernity: from the time of its autonomy through art-for-art's sake to its status as a necessary negative category, a critique of the world as it is. It is this last moment (figured brilliantly in the writings of Theodor Adorno) that is hard to relinquish: the notion of the aesthetic as subversive, a critical interstice in an otherwise instrumental world. Now, however, we have to consider that this aesthetic space too is eclipsed—or rather, that its criticality is now largely illusory (and so instrumental).[71]

Photography has been used to "eclipse" any notion of aesthetic space. In lieu of this space, critical postmodernism has engaged the critique of the subject (psychoanalytic criticism) and the critique of institutions (a form of critical theory inherited from Marx's insights on capital).[72] One shortcoming is that this permanent critique of aesthetics never became generative or productive of an approach to the artwork and historiography; with few exceptions, it was unable to shift from critique to any approach to the image that opened a way to writing new histories of art.[73] For what reasons does the concept of the aesthetic, unlike nearly all other cultural constructs, not avail itself to reinscription and redefinition? Must it only be understood as it may have been in the early modernity or as it is presented in the work of Clement Greenberg?[74]

Recent work has shown the shortcomings of critical postmoderism stem from, at times, reductive readings of theoretical positions and a reluctance to confront the *image as an image*, as a singular form of discursive knowledge (even non-knowledge perhaps), which is certainly at play within post-structuralist theory. I would like to examine one of the best examples of critical postmodernism in photography, John Tagg's *The Disciplinary Frame: Photographic Truths and the Capture of Meaning* (2009). In this text, as well as his earlier one

The Burden of Representation: Essays on Photographies and Histories (1988) which played an essential role in the production of a postmodern discourse, Tagg explains that his project is not simply a reductive reading of the photographic image as a reflective instrument of a surrounding cultural and political discourse. On the contrary, the strength of Tagg's work is the manner in which he demonstrates how and why the discursive regime that we name "photography" had "to be constituted" and "multiply defined" from the outset.[75]

Throughout his work Tagg explicates how and why the history of photography limits the multiple meanings any given photograph is capable of generating. The positivistic "evidential force" claimed for the photograph is the crucial concept that Tagg deconstructs via a post-structuralist critical methodology inherited primarily from Michel Foucault. However, what is noteworthy about Tagg's work is how he complicates the idea of a photograph as not merely a reflection of something outside of itself. "A discursive formation," he asserts, is "not a surrounding context. Nor is a frame. Instrumentalization is not a given, but a specific, unstable discursive effect. To ask for a genealogy of the photograph's 'evidential force' is not, therefore…to suggest that 'photography' was the transparent reflection of a power outside itself."[76] Tagg's methodology is inseparable from the overall force of his argument, which focuses our attention "on the contestability of systems of meaning and their effects of power and subjection; on the work of deconstruction across the space of the institution; and on the necessity of political calculation, strategic choices, and a sharpening of the stakes."[77] His work exposes the cultural and socio-political structures that abet what he terms "the violence of meaning" as well as what is at stake in maintaining them: a foreclosure on "the possibility of an event of meaning that evades capture" thereby disrupting "the regimes of normative sense as it does the regimen of art historical explanation."[78]

The entirety of *The Disciplinary Frame* centers on the construction and maintenance of documentary photography as a socio-political rhetoric in the 1930s that inscribes a specific mode of address and complementary structure of subjectification. In the distance covered from his earlier book to this later one we see Tagg trying to occupy a space between representation and politics that reduces neither side of this equation to a transparent reflection of the other. In attempting to do so Tagg forcefully asks us to recollect the full complexity of the critical theoretical positions articulated by Foucault and Derrida. Tagg states that we must continually find ways to work in the shared terrain of Foucault and Derrida: "Inside and outside, event and context, work and setting, the structural and the empirical: These coupled terms—familiar to us as those that fix polarities of an interminable methodological debate in art history—are radically displaced by Foucault's conceptualization of the discursive event and the discursive field."[79] Such an art historical practice would be capable of thinking alongside the visual without rendering the image a mere means for socio-political commentary or, conversely, without remaking the image a fetish; it would necessitate a reassessment of aesthetics as a multiplicity of local, interruptive affects created by

imagery in order to think the image as an event. The question remains as to whether Tagg's text provides a model of a critical practice that allows us to dwell in this space between.

Here is the heart of Tagg's argument, which surveys critical postmodernism as it articulates the parameters of his project:

> Everywhere and nowhere, the status of the photograph remains a sore point, as tempting as it is troublesome to the scratching of the critics, as likely to turn out a source of infection as it is to yield to the cures of the disciplines. Too open to diagnosis and too unresponsive to remedy, it seems to call for a stricter regimen, which is invariably what it receives and what I am bent on avoiding…Photography…is a map of motley differences, identities, jurisdictions, borders, and exclusions that charts a territorial project: the marking out of a yet-to-be-occupied landscape by the closures or power and meaning…It is, then, the mutual imbrication of power and meaning that I have wanted to pursue, not only in relation to those mechanisms of capture that constitute the discursive territory of social discipline and the State, but also…in relation to the discipline of art history itself and its own mechanisms of arrest—its own disciplinary frame.[80]

Tagg claims that he will work to expose how each and every frame renders the field of photography "a map of motley differences," a "territorial project" of power and meaning. However, despite claiming that his entire project is premised on "the possibility of an event of meaning that evades capture" we never get a satisfying, clear articulation of how an image, particularly a photographic image as an image—as a singularity—could ever accomplish this feat.

Conceiving this potentiality of the image is essential because discursive transformation is a creative act. An image is immanent within discourse (a semiotic, a contingent "history" or "medium," a territory) *and* an exceptional exteriority. An image is not simply configured by a discourse as much as it traverses it by opening it to transformations that dismantle its regimes of signs. What we need is an approach to the image as a disjunction, as an "and," that is "neither a union, nor a juxtaposition but…a sort of active and creative line of flight."[81] An image is thus an ensemble: it maps a territory as it constructs a variation or transformational statement.

The analysis of the photographic image as a (semiotic) statement or code leaves one with a desire for the visible; a desire that is not symptomatic of a lack or melancholic, but is rather a productive desire. Statements and visibilities are the basic elements of Foucault's concept of genealogy: one orders the sayable or readable, the other the visible or perceptible. (Visibilities are irreducible to the visual object or the act of perception.) It is crucial to recall what Gilles Deleuze identifies as "one of Foucault's fundamental theses," namely that there is a difference between forms of content (visibilities) and forms of expression (statements), between the visible and the articulatable, "although they continually overlap and spill into one another in order to compose each stratum or form of knowledge."[82] Only by excavating each historical formation are we able to sense the actual as an event. Only by sensing an opening in the thresholds between discourses are we able to

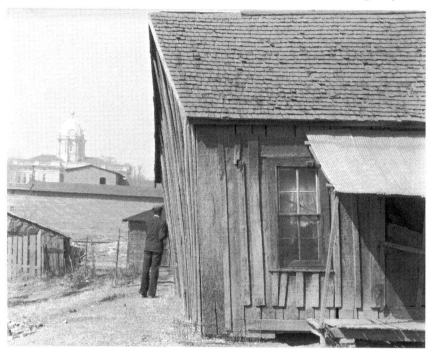

Figure 1.5 Walker Evans, *Man Standing Next to Wooden Shack, Tupelo, Mississippi* (1936)

know how and why each historical formation "sees and reveals all it can within the conditions laid down for visibility, just as it says all it can within the conditions relating to statements."[83]

At the heart of Tagg's book lies a decisive essay on Walker Evans's photography from the 1930s. Here we reach an aesthetic threshold, but Tagg does not venture a step across it. He writes:

> This is the photograph Evans gives us: less than what we want and more than we desire, never adequate to our questions or to our demands, it hands us what we were not seeking and may have preferred to avoid. Inadequate and overwhelming thing, poor compensation, impossible testimony, it offers itself as a ruined monument to the inescapability of an unencounterable real.[84]

Here Tagg locates a threshold between the photograph-as-statement and the photograph-as-visibility, characterizing it as "a certain kind of resistance" to the demands of communication. But then Tagg leads us into a discussion of melancholy as a limit of sense, as a relation with a real that is "the condition of existence and failure of all systems of meaning."[85] But why not remain with the image a bit longer? Is the recourse to the concept of melancholy productive or does it only confuse the issue even more? Is Tagg's statement here not the beginning of a complex, theoretically-informed conception of an

image? The disjunction between the photograph-as-statement and the photograph-as-visibility delineates an aesthetic threshold wherein statements and visibilities, forms of expression, and forms of content, "mobilize knowledge in a direction that is different to that of science, allowing us to offer a definition of a literary text, or a pictorial work, while remaining within the discursive practices to which they belong."[86] Thus the discourse of documentation, for example, is not only bounded by archives, historical strata, and the concept "documentary"; it is also constituted via a relation with a relative outside (aesthetics, ethics, or politics) *and* a "non-relation" with "the space of the Outside" (an aleatory, unforeseen event).[87]

For the study of art (certainly one mode of analyzing the history of forms) visibilities and language constitute discourse, but we must not repress the "and" that binds the two. It is for this reason that Deleuze allows the work of art a formal structure (a distinct discourse, a plane of composition) even as he insists on its productive, informal, relation with a series of forces outside of it. To think a photographic image is to insist that it is more than "melancholy realism" (to resituate Tagg's phrase); it is, rather, a "double capture," as Deleuze insists, that requires us to think and create alongside an image that is at once fortuitous and necessary. Only then will we grasp why art historical and aesthetic thinking "always comes from the outside (that outside which was already engulfed in the interstice or which constituted the common limit)."[88] Only then will we construct a line of flight that encounters images as "unbound points, points of creativity, change and resistance" and perhaps it is with these points that "we ought to begin in order to understand the whole picture."[89]

In conclusion, the debates over photography and its socio-cultural history embodied by the formalist and critical postmodernist positions have each provided insights into the how and why we must study photography; but each also has limitations that must be addressed as we attempt to rethink the photographic image, its history, and its relation to visual art as such. More than either side alone, it is the tension and irreconcilability between the two that proves to be both paradoxical and yet productive. This insight is offered by Geoffrey Batchen.[90] The following is a long quotation but its importance resides in how Batchen succinctly and intelligently lays out the impasse in which we find ourselves by attempting to return us to the potentiality of critical theory itself. He contends that:

> On one side are those who believe that photography has no singular identity because all identity is dependent on context. On the other are those who identify photography by defining and isolating its most essential attributes, whatever they may be. One group sees photography as an entirely cultural phenomenon. The other speaks in terms of photography's inherent nature as a medium...One is primarily interested in social practice and politics, the other in art and aesthetics...Is the difference...quite as marked as it appears?...Why, amid the general postmodern critique

of binary structures, does this division between sameness and difference, nature and culture, substance and appearance, continue to be essential-ized?...Despite appearances to the contrary, both share a presumption that, in the final analysis, photography's identity can be determined as a consequence of *either* nature *or* culture...The point is that postmodernism and formalism, at least in their dominant photographic manifestations, both avoid coming to terms with the historical and ontological complex-ity of the very thing they claim to analyze.[91]

What we must come to terms with is, first, the relation between art (aes-thetics) and politics; and, second, "the historical and ontological complexity" required by the study of photography which demands that we conceive a discourse—that is, a theory of the image coupled with a philosophy of his-tory—capable of addressing the invaluable insights of both formalism and critical postmodernism. Only between the formalist and postmodern posi-tions does one confront an image, that is, an aesthetic production that refutes any simple notion of representation as resembling "the thing itself" by insist-ing on an ensemble between representations and/as the thing itself.

An ensemble does not privilege meaning over "the thing itself" (claiming it as a fiction); instead, it constructs a multiplicity of lines between represen-tations and referents. As Derrida has said, "the thing itself is a sign," but signs have various functions; they cross a multiplicity of thresholds.[92] Thinking a photograph as an ensemble, as a multiplicity, supplements formalism and postmodernism with a history of images comprised of trajectories that draw from impersonal memory and anachronism as much as instrumental meaning and politics.[93] Again photography has a primary role to play in constructing this history of images, or whatever we might call it. In *Memoirs of the Blind*, Derrida called it a *skiagraphia* (a shadow writing), the same term Talbot used in his first attempt to name photography (he referred to "the Photogenic or Sciagraphic process" in a notebook entry dated February 28, 1835).[94] The "origin" of a history of images is already inscribed in the shadows and margins of the event we call the history of photography.

GLOSS ON WALTER BENJAMIN, "LITTLE HISTORY OF PHOTOGRAPHY" (1931)[1]

It has already been made clear that it is impossible to study the discourse of photography without Benjamin's work. Nonetheless, it is also apparent that Benjamin's work has too often been used in ways that foreclose on the nuance and dialectical verve that colors all of his writings. For me, the experience of reading Benjamin far exceeds most interpretations and uses of his philosophy. Perhaps this should always be the case. The experience is somewhat analogous to Benjamin reading Louis Aragon's Surrealist novel, *Paris Peasant*. In a letter Benjamin wrote to Theodor W. Adorno dated May 31, 1935, he confesses that the idea of writing about the arcades, a nineteenth-century architectural and cultural phenomenon that rendered the distinctions between public and private at once porous and definitive—the centerpiece of Benjamin's study of modernity—came to him from reading Aragon's novel, which begins with an image of the arcades "when the pickaxe menaces them."[2] Attempting to explain their appeal Benjamin writes:

> I could never read more than two or three pages in bed at night before my heart started to beat so strongly that I had to lay the book aside. What a warning! What an indication of the many years which had to be spent between myself and such a reading.[3]

Less an encomium for Aragon's prose than an ecstatic revelation, Benjamin's reading of *Paris Peasant* divulges an image of the arcades as "true sanctuaries of a cult of the ephemeral," an image that compels him to invest years of study. As an instance of "profane illumination," Benjamin suggests that the arcades presented themselves to him; *they chose him*.[4] At the moment of reading, with his heart racing, excited and anxious, he was instantaneously consigned to studying and explicating the arcades as the "origin" of commodity capitalism for the next thirteen years of his life. At the "origin" of his study—what he called "the theater of all my struggles and all my ideas"—there is an instance of encounter, passivity.[5] To grasp something that presents itself is to study: an activity that situates one in a threshold between self-possession and captivation. This has been the experience of reading and studying Benjamin for many scholars, myself included.

To study Benjamin is to find ourselves in a situation wherein we have "received a shock and are stupefied by what has struck [us], unable to grasp it and at the same time powerless to leave hold...This *festina lente*, this shuttling between bewilderment and lucidity, discovery and loss, between agent and patient, is the rhythm of study."[6] This "rhythm of study" suggests that any mastery of a subject is in fact necessarily contingent upon time. The moment in which a concept is grasped precedes the moment, so to speak, in which one flails for it.

The reception of Benjamin's philosophy in art history has at times disregarded this "rhythm of study"—the necessity of dwelling over concepts and ideas—in a headlong rush to utilize his work on aura and allegory, two concepts which

nevertheless have proven valuable to modern and contemporary art history. The absence of aura (uniqueness, mythic presence) Benjamin addresses in "The Work of Art in the Age of its Technological Reproducibility" (1936) shifts our focus from the artwork/master circuit to that of the dissemination and reproduction of images. His theory of allegory, developed in *The Origin of German Tragic Drama* (1928) and his essays on the nineteenth-century French poet Charles Baudelaire, focus on allegory as a recurring concern in the visual arts from the Baroque through modernity. Importantly, the insights afforded by Benjamin's concepts of aura and allegory have been greatly bolstered by post-structuralist critical theory and the decisive challenges it posed to the humanities.

The incorporation of Benjamin's work into art history and other disciplines in the late 1970s and 1980s was shaped by the coterminous and outright contentious reception of deconstruction in Anglo-American academia. For example, Paul de Man's *Allegories of Reading: Figural Language in Rousseau, Nietzsche, Rilke, and Proust* (1979) colored the reception of Benjamin's concept of allegory in countless ways, the most salient of which was to enfold his theory of language into deconstructive thought.[7] Along with de Man, Jacques Derrida (undeniably one of Benjamin's most astute and creative readers) has skillfully shown how aspects of Benjamin's philosophy adumbrate the insights of deconstructive criticism. There is no denying the similarities between Benjamin's allegorical logic of language and deconstruction's assertion of the inherent inability of signs to fix meaning; rather, my point is that an influential and very productive theoretical framework ushered Benjamin's work into contemporary aesthetic and cultural discourse, thereby generating a particular set of explications and applications.

For the discipline of art history, perhaps the most important moment in the reception of Benjamin's thought comes in Craig Owens's "The Allegorical Impulse: Toward a Theory of Postmodernism" (1980). This essay identifies allegory as a privileged form of contemporary artistic practice as evidenced by the work of Robert Smithson, Cindy Sherman, Robert Rauschenberg, and others. To explicate this cultural moment, Owens turns to Benjamin's concept of allegory. In an insightful and often brilliant analysis, he explains Benjamin's interest in allegory as a means to "rescue from historical oblivion that which threatens to disappear...a conviction of the remoteness of the past, and a desire to redeem it for the present."[8] Owens's argument is entirely premised on deconstructive practice. This conceptual background is felt throughout the essay, as in this passage: "Allegory is extravagant, an expenditure of surplus value; it is always *in excess*...the allegorical supplement is not only an addition, but also a replacement. It takes the place of an earlier meaning, which is thereby effaced or obscured."[9] The problem with Owens's essay is not its articulation of a critical postmodernism, but its failure to follow through on aspects of Benjamin's work that diverge from deconstruction's purview.[10]

For example, Owens is right to identify one of the primary aims of Benjamin's study of the seventeenth-century German mourning play (*Trauerspiel*) as the attempt to divulge "the theoretical value of the concrete, the disparate, the

discontinuous."[11] However, the full force of Benjamin's philosophy is lessened if his interest in the ruins, the detritus of history, and the outmoded—its very materiality—is understood only as an interest in what Derrida calls the "materiality of language." For better or worse, Benjamin is being quite literal when he claims that the "truth is concrete."[12] Rather than merely privileging the allegorical or celebrating the indeterminacy of meaning, Benjamin's interest in language as such *and* images interrupts the allegorical movement of human language with the "expressionless power" immanent within each and every signifying endeavor.[13] The "expressionless" (*das Ausdruckslose*) is the "truth content" that both originates and impedes representation, what he calls the "material content" (diction, style, imagery, etc.).[14] The task of criticism in Benjamin's philosophy is to recollect what founds the allegorical movement of signification, that is, to present the "expressionless" as "the critical violence which, while unable to separate semblance from essence in art, prevents them from mingling...[and] completes the work, by shattering it into a thing of shards, into a fragment of the true world."[15]

It seems fair to ask if Benjamin's study of photography has even been approached along these lines. If one *studies* his "Little History of Photography" there is a sense not of the end of art, but of its transformation into a "fragment of the true world." Although initially published in *Die Literarische Welt*, an important German newspaper edited by Willy Haas that presented non-partisan views of current events, particularly of art and literature, publishing pieces by Thomas Mann, Jean Cocteau, and several of Benjamin's essays, this "little history" manages to survey many of the key events and turns in what constituted the "history of photography" in the early 1930s. From André Eugène Disderi's invention and marketing of the "carte-de-visite" (calling card photograph) in 1854 to Laszlo Moholy-Nagy's avant-garde comments on photography, Benjamin traverses the discourse.

He begins by stating his motivation for writing this essay: "Attempts at theoretical mastery of the subject have so far been entirely rudimentary. And no matter how extensively it may have been debated in the last century, basically the discussion never got away from...the philistine notion of 'art' [as] a stranger to all technical considerations."[16] Benjamin rejects any such "fetishistic and fundamentally antitechnological concept of art." Photography, he insists, does not need to justify itself as art—as what was understood as art prior to the invention of photography—because its very invention fundamentally redefines art as such. Hence he finds it absurd that some photographers, such as the Pictorialists who emulated painting and painterly techniques in the last decades of the nineteenth century, attempted "to legitimate the photographer before the very tribunal he was in the process of overturning." Instead, Benjamin desires to register the full magnitude of the event of photography, "the real scope of its invention."

For Benjamin, "the real scope" of photography's invention was to transform all aspects of Western culture from astrophysics to archaeology. What remains intriguing is that he turns not to these subjects, but rather to the

human face. In the essay his first sustained engagement with any photograph is David Octavius Hill's *Newhaven Fishwife*, part of a series of portrait photographs that Hill took himself as studies for painting a fresco in the Church of Scotland in 1843. Benjamin notes that these "unpretentious makeshifts meant for internal use" have, ironically, given Hill his "place in history," while his paintings are forgotten.[17]

There are two passages to which I would like to draw our attention. The first begins with Benjamin drawing distinctions between painting and photography. He writes of Hill's work:

> Admittedly a number of his studies lead even deeper into the new technology than his series of portraits—anonymous images, not posed subjects. Such figures had long been the subjects of painting. Where the painting remained in the possession of a particular family, now and then someone would ask about the person portrayed. But after two or three generations this interest fades; the pictures, if they last, do so only as testimony to the art of the painter. With photography, however, we encounter something new and strange: in Hill's Newhaven fishwife, her eyes cast down in such indolent, seductive modesty, there remains something that cannot be silenced, that fills you with an unruly desire to know what her name was, the woman who was alive there, who even now is still real and will never consent to be wholly absorbed in "art."[18]

This is a masterful *ekphrasis*, a written description of an image, and a critical insight. Photography offers a new concept of the portrait, one that "cannot be silenced" because it fills us "with an unruly desire" for "something strange and new." What is "strange and new" opens to us through "art" even as it exceeds ("will never consent to be wholly absorbed in 'art'") it. Hence Benjamin begs us to reject the constraints of historicist ways of narrating the relation between the past and present. With photography, "history" can no longer simply be thought as the "past." As Benjamin writes in *The Arcades Project*, "History decays into images, not into stories."[19]

Instead of continuity, progress, or any teleology, "the real scope of the invention" of photography is a new optics of history. This new *technics* of the visual focuses our attention not on "tradition" but on "the places where tradition breaks off."[20] An image, for Benjamin, is a citation, not from the past (tradition), but from another temporality, an anachronistic, fragmentary, allegorical, even inhuman one. His "hope in the past" is only understandable if one understands its relation to a future, a something radically outside of any human sense of temporality.

This leads to the second passage. Here Benjamin is discussing an early portrait photograph by Karl Dauthendey of his father and his step-mother who latter committed suicide. Benjamin writes:

> Immerse yourself in such a picture long enough and you will realize to what extent opposites touch...the most precise technology can give its products a magical value, such as a painted picture can never have again

for us. No matter how artful the photographer, no matter how carefully posed his subject, the beholder feels an irresistible urge to search such a picture for the tiny spark of contingency, of the here and now, with which reality has (so to speak) seared the subject, to find the inconspicuous spot where in the immediacy of that long-forgotten moment the future nests so eloquently that we, looking back, may rediscover it.[21]

Here it appears as if Benjamin is suggesting that technology does not simply dispel aura, but can, in fact, "give its products a magical value," an aura. The "aura" here is not a fetishistic artistic value, but rather a historical or temporal one. The photography grants us a "space" wherein past and present intersect in such a way that the future "nests so eloquently" there. This "space," he adds, is one "informed by the unconscious" because photographs give us "an optical unconscious" that "reveals" in "material physiognomic aspects, image worlds, which dwell in the smallest things—meaningful yet covert" enough to "make the difference between technology and magic visible."[22] The "inconspicuous spot," which Benjamin searches for in Atget's photographs, is not a magical, immaterial illusion; it is a material reality, a remnant or material trace of time as immanent and disjunctive—open.

Benjamin's attention to photography is inseparable from his attention to the ruins of the arcades.[23] In both, Benjamin hopes to recollect out of the smallest component (the image) the "total event," that is, the very "origin" of modernity inscribed in the "expressive character" of the prefabricated, industrial ephemera of the nineteenth century.[24] As he puts it, there is "hope in the past" because "our image of happiness is indissolubly bound up with the image of redemption."[25] To be attuned, as it were, to the "temporal index" by which the past is "referred to redemption," means to grasp this index: the opening of the time of history into the time of redemption.[26]

In "Walter Benjamin and His Angel," Gershom Scholem explains that for Benjamin redemption has "a wholly new meaning" because it is "based on the conflict between the 'once only' and the 'yet again'...the unique, the 'once only' [and] precisely *not* that which one has lived through...but rather the wholly new and as yet unlived."[27] This (im)possibility of redemption within the profane orients Benjamin's work; it is the ground on which he erects the entirety of his materialist philosophy. For him, to grasp the profane is the "quietest approach" of redemption: the actualization of the as yet unlived, the potentiality of the what-has-been that dislocates the past. For Benjamin, to recollect is to grasp oblivion, the *agrapha* (the unwritten) within the present.

There is a photograph by Gisele Freund of Benjamin from 1938, two years before his death. Freund is major twentieth-century portrait photographer who took several photographs of Benjamin both at work in the Bibliothèque Nationale in Paris working on *The Arcades Project* as well as a couple of classic author back cover portraits. Many of these have been reproduced. There is another photograph, however, one that I have yet to see reproduced. It is this rare photograph of Benjamin that I would like to describe. In it, Benjamin is in

Pontigny, France, home of the famous Pontigny Abbey, a twelfth-century mon-
astery that in the early 1920s was the site of an annual gathering of European
intellectuals such as T. S. Eliot, Jean-Paul Sartre, Thomas Mann, Benjamin,
and others. (Freund photographed many of this gathering's attendees.) She
photographed Benjamin outdoors, beside the river Serein with the abbey in
the background shrouded by a grove of low trees and eight spindly tall ones.
Benjamin is on the far right edge of the frame; his left arm, cut by the edge.
Part of him is out of the frame. He is standing in a three-quarter pose before
a knee-high buttercup bush. In fact, with a careful gesture, he holds a single,
slightly bent buttercup in his left hand. His expression is pensive, no doubt
aware that he is posing yet perhaps somehow lost in thought as well. My eyes
shuttle between the space drawn around him and his face. A distance between
the abbey and its assembly and Benjamin is felt. Face and landscape: a field of
forces. At this point in his life Benjamin was quite literally a "Paris peasant."
The play of the light across the river, a slight breeze, are not enough to render
the image ephemeral; it has a weight, a thingly quality: a slight gesture of the
hands, the two buttons of his jacket, the tightness of his shirt collar, the light
contending with the darkness on Benjamin's margin of the photograph. This
weight is the "different nature that speaks to the camera."

This is no longer a portrait. But what is it? It is an image. A face that must
be studied. As the Italian philosopher Giorgio Agamben writes:

> The face is not a *simulacro*, in the sense of something that dissimulates
> and covers the truth: it is the *simultas* [the fact of being together], the
> being-together of the multiple faces that constitute it without one being
> anymore true than the others. To seize the truth of the face means to
> grasp…the simultaneity of faces, the unquiet potentiality that holds
> them and pools them together.[28]

Hence our intense interest in images, particularly portraits that become images.
It is important to dwell for a moment on the concept of *interest*. This is one
lesson of Benjamin's "little history." Both the German term *das Interesse* and
the Italian *l'interesse* come directly from the Latin root *interesse* meaning "to be
between," "to make a difference," "concern" (*inter*—between, and *esse*—to be).
Implied here is a notion of interest that is not merely self-interest, but a dwell-
ing with something that exposes a threshold between an entity and itself, that
is, a threshold wherein the self becomes other in order to be itself.[29]

We encounter images like things. They give us back our lives as *extimacy*—
as an intimate exteriority—as a life beside itself, an exemplary life.[30] This is
what an image gives us. It is perhaps here that our endless conversing and
writing about images approaches the "truth content" Benjamin sets at the
center of his aesthetic philosophy: his "striking critique" is in large part an
attempt "to force language to become the language of *things*, starting from
things and returning to us changed, *with all the humanity that we have invested
in things*."[31]

2 Frame (matter and metaphor)

> The edges of his film demarcated what he thought most important, but the subject he had shot was something else; it had extended in four directions. If the photographer's frame surrounded two figures, isolating them from the crowd in which they stood, it created a relationship between those two figures that had not existed before.
>
> John Szarkowski

> It can render things with magnificent beauty but also with terrifying truthfulness, and it can also be extraordinarily deceptive.
>
> August Sander[1]

One of the predominant points of contention in photographic discourse is the frame. As such it serves as another of John Szarkowski's sections of *The Photographer's Eye* (1966). But, as with all of his section titles, the frame as a material and metaphorical concept exceeds any formalist usage. It is, in fact, one of the most important figures of thought in critical postmodernism and contemporary philosophy. The frame initially appears as a simple device. It divides the work (of art) from the non-work (the space of the gallery, the general context, etc.). The division functions as a way to focus our attention; it gives our gaze a directionality, a point of view that we come to occupy. So it not only divides, or attempts to separate definitively inside and outside, work and non-work, art and life, but it also functions as a technology itself. As a *technics*, signifying both technology and technique, the frame conditions our viewing habits. It renders us as spectators. A frame, therefore, is not only a transparent device; instead, it is a material structure that organizes perception and separates the work from the non-work. In other words, without the frame, we would not be able to think art, to think alongside it. Without it we would never be able to discern that there is no perception without technics; there is no pure perception.

Inside and outside, perception and technics, the frame itself becomes an undecidable point, one that motivates aesthetic thought from Kant onward.

Is the frame part of the work or just something contiguous to it? In conceptual language that Jacques Derrida uses in his masterful meditation on the frame, *The Truth in Painting* (1978), borrowing Greek terms deployed by Kant in his *Critique of Judgment* (1790): is the frame the work itself (*ergon*) or is it what is beside or adjacent to the work (the *parergon*)? It may not even be possible to make clear distinctions between inside and outside, perception and technics. Aesthetics, defined as critical thinking about our relation to images, may prove to be nothing other than the tracing and retracing—the mapping done by art itself as well as our thinking and creating alongside it— of the boundary between work and non-work, perception and technics, which involves both knowledge and sensation.

For his part, Szarkowski's definition of the frame in the history of photography avoids the difficulties of these possibilities. This is not to say that there is no way to read Szarkowski against himself, that is, to show how his formalist ideas depend upon a radical outside. Evidence of this fact may come in his continual slippage between frame and edge. Here is his all too brief explanation of the frame:

> Since the photographer's picture was not conceived but selected, his subject was never truly discrete, never wholly self-contained...The central act of photography, the act of choosing and eliminating, forces a concentration on the picture edge—the line that separates in from out—and on the shapes that are created in it.[2]

Szarkowski does several things here. He admits that the photograph is never simply a double of a given reality; instead, the camera and its material limitations and idiosyncrasies (its film, shutter speed, etc.) present something that did not exist before ("it created a relationship between those two figures that had not existed before"). However, this act of excision, or of "quotation" as he writes, defines the edge of the photograph and thus its content. Concentrating on the edge or frame, as Szarkowski intends us to do, is a tactic meant to focus our attention on the photograph as a picture, as pictorial.

Turning to a photograph by Lee Friedlander, a photographer close to Szarkowski's thinking on the frame, we can begin to see how the frame can operate. Friedlander emerged in the early 1950s as a freelance photographer of contemporary American culture, particularly portraits of jazz musicians in New York and New Orleans that were often used for album covers and in periodicals such as *Esquire*. Like Robert Frank, Friedlander was awarded Guggenheim Fellowships in 1960 and again in 1962 to undertake more sustained photographic projects. During these fellowship periods he developed an idiosyncratic photographic practice in which the offhanded "snapshot" quality of the work disguises a considerable conceptual sophistication. This conceptual shift is made evident by comparing Friedlander's *Canyon de Chelly, Az* (1983) and Ansel Adams, *Canyon de Chelly, Az* (1942). Adams formal grandeur, the sheer majesty of the photograph is absent from Friedlander's witty, prosaic take on the same

Figure 2.1 Lee Friedlander, *New York City* (1964)

location. Between these two photographs we can see a shift from a high mod-
ernist to an early-postmodernist one. Friedlander's take reveals an ambiguity
about place and photography because Friedlander's shadow may or may not be
reflected on the floor of the canyon Adams majestically photographed. Any rep-
resentation of a place is a representation of the photographer's perspective—his
or her individual relation to a place or site. A representation must address this
subjective aspect as well as the limitations of the medium of photography itself.
For Friedlander, these limitations are most often photography's inability to be
anything other than a self-reflexive image-repertoire and a sustained investiga-
tion of the frame, actually of frames within frames. Consider his *New York City*
(1964). His work reveals the presence of the photographer: the camera's view-
finder doubled in the small view within the white field covering the lower half
of the window. He makes evident his own subject-position, that is, his perspec-
tive as the one who took the pictures, one caught-up in the representations.[5]
 Friedlander's photographs often feature mundane views, but ones that
make us ask the crucial questions, ones we should ask before any photograph:
"What is being photographed here?" Which is never identical to another
question: "what is the subject of this image?" These related questions are
pertinent to his series *Little Screens* (1963). Here the frames within frames
are screens within screens: photography registering the epochal transfor-
mations of another image-system, television. The inescapable creepiness
of these photographs, for example *Galax. Virginia* (1962), void of human
presence, screens projecting light and sound as ambience or as Freudian

screen memories (insignificant memories that keep us from remembering significant events in our life-history). Images within images, screens within screens: the abyss of representation without referent, but not without direction. Walker Evans wrote the preface for Friedlander's *The Little Screens*, brilliantly noting that the

> pictures on these pages are in effect deft, witty, spanking little poems of hate. They are the work of Lee Friedlander, one of the most accomplished and sharp-minded of the younger American photographers. It just happens that the wan, reflected light from home television boxes casts an unearthly pall over the quotidian objects and accouterments we all live with...It is a half-light we never notice, as though we were dumb struck by those very luminous screens we profess to disdain...In this atmosphere of eclipse, let it be said that pictures which are really doing their work don't need words. Friedlander's stinging and though amusing, bitterly funny observations want no line captions, and in this instance they had better be called just One, Two Three...and so on.[4]

As Evans suggests, Friedlander's work represents a dark, multivalent vision that emphasizes the two-dimensional confines of the picture plane as it confronts us with images that challenge photography's formal conventions by making them more apparent, making them the parameters of an even more uncanny artificial paradise.

Problems arise when tactics such as these are understood as part of a larger strategy. This is Szarkowski's approach to work like Friedlander's.[5] He reads the frame as presenting photography and its history as an internal set of formal characteristics and changes ("the shapes that are created in it"). The edge of the photograph is pushed into the foreground not as a genuine location to think photography, but rather as a red herring that encourages us to overlook the frame as precisely what is being added to the photograph by Szarkowski and the Museum of Modern Art. Talking about the edge and concentrating our attention on it displaces our focus from the frame, in this case, as something coming from without, something being added to the photograph to sublimate it as art. Szarkowski claims that the frame is "imaginary," but it is far from being so.

Szarkowski wants to demonstrate that photography has clear, discrete edges. These edges would define it as a distinct medium. He argues that photography is a unique medium, with a discursive practice (e.g. history) and aesthetic criteria. For Szarkowski, then, the frame is a metaphor that nonetheless operates in a very real (material) manner: it separates and divides photography from other visual media thereby creating a formalist history of photography that disavows the sheer multiplicity of uses, techniques, and discourses that are the field of photography.

This institutional formalist position has been severely critiqued by many critics and historians. The underlying premise of the critique is that Szarkowski

and others (Beaumont Newhall and Ansel Adams before him, and several after him as well) construe the medium of photography ontologically, that is, they claim that it has a mode of being distinct from any other art form. Douglas Crimp, one of the foremost critical postmodernists associated with the *October* group, critiques this position clearly in his 1981 essay "The Museum's Old/The Library's New Subject."[6] Crimp counters Szarkowski's claim that for the "artist photographer, much of his sense of reality (where the picture starts) and much of his sense of craft or structure (where the picture is completed) are anonymous and untraceable gifts from photography itself" by arguing that he contrives "a fundamentally modernist position for it, duplicating in nearly every respect theories of modernist autonomy articulated earlier in this century for painting" that is a ploy to create a new economy for photography whose endpoint is the museum itself.[7] Szarkowski and others are accused of ignoring "the plurality of discourses in which photography has participated" in favor of "*photography itself*."[8] What was contingent, technological, undefined, and capable of transforming any and every traditional definition of art was domesticated, rendered merely another medium with its own formal characteristics and criteria.

Beyond an attack on the complicity between formalism, the art market, and the museum, Crimp's essay also wagers that photography is symptomatic of "the end of modernism" itself. "For photography to be understood and reorganized in such a way [as Szarkowski does]," Crimp contends, "entails a drastic revision of the paradigm of modernism, and it can happen only because that paradigm of modernism has indeed become dysfunctional."[9] This dysfunction, the unraveling of a paradigm of modernism best embodied by the critic Clement Greenberg, is the context in which postmodernism begins. "Postmodernism," Crimp concludes, "may be said to be founded in part on this paradox: it is photography's reevaluation as a modernist medium that signals the end of modernism. Postmodernism begins when photography comes to pervert modernism."[10] Two things arise here. First, we must ask ourselves to what extent has photography been asked to hold the art historical narrative of modernism together?[11] Second, as postmodernism itself unravels currently, perhaps its shortcomings stem from its articulation of a critical position only, that is, as a discourse that arose only to "pervert" another?[12]

The paradigm of modernism that critical postmodernism "perverts" is primarily the one developed by Clement Greenberg. One of the most influential art critics of the twentieth century, Greenberg best embodies the canonical formalist position. Throughout his work, but particularly in the essays "Avant-Garde and Kitsch" (1939) and "Modernist Painting" (1960), Greenberg argues that genuine art, avant-garde art, is autonomous (it refers only to itself) and that it deals only in formalist criteria. In a move that will have tremendous negative effects, Greenberg names this interest in formalist criteria, aesthetic. Aesthetic criteria, for him, are "the arrangement and invention of spaces, surfaces, spaces, colors, etc. to the exclusion of" all else. In Greenberg's schema, modernism began in painting

in the 1860s with the work of Manet, whose work breaks with the illusionism of the Renaissance, to present a picture. Greenberg subsequently narrates an evolutionary, autotelic history of modernist painting in which painting itself (as an autonomous structure) moves toward its "essence." This "essence" is what Greenberg called the "fate of painting," that is, the flatness of the picture plane, purity of color, and works that address their material condition (frame, shape of support) but remained purely abstract. In short, Greenberg argues that each medium (painting, sculpture) has specific "unique and irreducible" properties (what painting can present us is unique to painting and cannot and should not be done in another medium, for example). Despite an at times idiosyncratic emphasis on these formal traits as an internal mechanism that motivates the presumed evolution of the medium of painting, Greenberg's theory of modernism has proven determinative. Moreover, his separation of art from daily life (kitsch, popular culture), as well as his separation of aesthetics and ethics (or politics)—in short, his definition of formalism—has "survived remarkably intact and is still used, with some modification" even after the challenge posed to it by contemporary art and critical postmodern art history and theory.[13]

Invaluable work has been done recently by Diarmuid Costello, who has not only challenged Greenberg's position but also the negative reaction against it that we call critical postmodernism or the "anti-aesthetic" position. Simply put, even though "postmodern theory [the anti-aesthetic position] devalues what Greenberg valued, and values what he devalued, it remains—for this reason—part of Greenberg's legacy."[14] In a series of essays, Costello challenges Greenberg's misreading of Kantian aesthetics when it comes to issues of taste and judgment, splitting the aesthetic and ethical into two separate spheres. As Costello explains, "Greenberg's inability to deal with questions of content in art follows directly from his recourse to Kant's formalism. It reflects a failure to distinguish beauty in general (including that from nature) from the historical and cultural complexity of artistic value. Whether this is fair to Kant is highly controversial."[15] Nevertheless, Greenberg's formalist theory of modernism, regardless of the validity of its Kantian premises, has overdetermined our understanding of aesthetics for too long. It is, nearly without exception, the motivating force for the critical postmodern, anti-aesthetic stance that has dominated art history and theory from the late 1970s to the present. This stance presumes two points, as Costello makes evident: first, that modernism had become merely "aesthetic" (invested only in good taste) and no longer ethical and/or political; and, second, that aesthetics is ethically and politically regressive (reactionary) because it blocks critical analysis of art by sustaining the cultural authority of art institutions and the values of the market.[16] It is certainly these two underlying points that we see being articulated in the critical postmodern interest in photography.

One way to clarify these points is to follow Costello's suggestion to read the anti-aesthetic position against itself, as it were, by revealing its narrow yet determining definition of "aesthetics." We will do this here by reading

Rosalind Krauss's work on photography, which includes influential interpretations of photography in Surrealism and Conceptual art. We will add to this close reading an additional turn. I would like to read Krauss's interpretation of photography, as it is given, as the consequence of theoretical readings of Jacques Derrida, Gilles Deleuze, and others. If the "turn to theory" fueled the critical postmodern, anti-aesthetic critique of Greenberg, then we should see how this theory is wielded. Not so as to claim a "correct" reading of the theory involved, but to see if the obsession with devaluing and displacing Greenbergian modernism determined in advance how theory was understood and put into use.

Krauss's approach to art history has proven immensely influential. As one of the founding editors of *October*, Krauss has been at the forefront of advanced art historical writing. This body of work includes serious attention to photography, especially Surrealist photography. In general Krauss's methodology has a "double movement," as Costello has explained. She recuperates avant-garde practices like Surrealism that had been marginalized by Greenberg, for whom they violated the mandate of medium-specificity (he called Surrealism "literary"); this move is coupled by foregrounding contemporary art practices that violate medium-specificity (Minimalism, for example).[17] A synonym for medium-specificity in Krauss's work is the "grid." The "grid" announces, she argues, "modern art's will to silence, its hostility to literature, to narrative, to discourse."[18] The grid is a metonym for Greenberg's theory of modernism. She clarifies her definition of the term here: "the grid functions to declare the modernity of modern art...the grid states the autonomy of the realm of art. Flattened, geometricized, ordered, it is antinatural, antimimetic, antireal. It is what art looks like when it turns its back on nature."[19] Simply put, it "declares the space of art to be at once autonomous and autotelic."[20] Along with these characteristics, Krauss suggests that the grid as a metaphor refuses the real (the "Concrete") in favor of the abstract (the "Universal")—a shift she often terms "aesthetic." The grid is a "myth" because "it makes us think we are dealing with materialism (or sometimes science, or logic) while at the same time it provides us with a release into belief (or illusion, or fiction)."[21] Both the grid and aesthetics are mythic because they present the illusory reconciliation of materialism and spirituality.

To counter the mythic power of the "grid" (or "frame" as Szarkowski later terms it), Krauss deploys a skillful concept, the index. In her two-part essay "Notes on the Index" (1977), she enacts the "double movement" outlined above: she reorients photography to the heart of Surrealist practice, via a reading of Marcel Duchamp, as she explicates Conceptual art and Land art ("sculpture in the expanded field") in the 1970s.[22] Focusing on a particular type of sign called an index allows Krauss to execute this "double movement." She argues that an index is one way to explain the undeniable referential status of photography. "As distinct from symbols, indexes establish their meaning along the axis of a physical relationship to their referents. They are marks or

traces of a particular cause, and that cause is the thing to which they refer, the object they signify," Krauss writes.[23] Examples of an index include footprints, medical symptoms, cast shadows, etc. So an index is a type of sign that stands for its object through a direct relation; it is a one-to-one correspondence, one of cause and effect.[24] Smoke is an index of fire, for instance. A photograph, she concludes, is "thus a type of icon, or visual likeness, which bears an indexical relationship to its object."[25]

Furthermore, she draws on the semiotic work of Roland Barthes and that of the linguist Roman Jakobson to insist that photographs, because they are indexical, are empty signs; they are "shifters" (a term from Jakobson for words like "I" or "this") that "are filled with meaning only when juxtaposed with an external referent, with supplemental discourse."[26] The content of an indexical sign is factual; it is the referent (cause). But, in relation to other signs (iconic and symbolic ones), the index works as "shifter," which enables Krauss to insist that an indexical sign erodes the "certainty of content." The index does not make an ontological claim for photography; it is not medium-specific, she claims. It, and by extension photography as such, gives her a step beyond modernism. The index is a way out of the closed-system of the grid, that is, as a way out of Greenberg's insistence on the autonomy of art.

Krauss uses the index to present contemporary art in the 1970s, with its "pervasiveness of the photograph as a means of representation," as heteronomous, interdisciplinary, and textual. The works she examines all involve "the filling of the 'empty' indexical sign with a particular presence" with the implication being that "there is no convention for meaning independent of or apart from that presence."[27] In language that inverts Greenberg's, she adds that "countermanding the artist's possible formal intervention in creating the work is the overwhelming physical presence of the original object, fixed in this trace."[28] The force of Krauss's entire critical project, which is formidable, is impossible without the photography as index line of argument because the automaticity of photography forecloses on any aesthetic dimensions of photography. Photography is a means to an end, a logic she discovered initially in Surrealism.

For Krauss, Surrealism is privileged not because of its manipulations of the real and the imaginary, but for its straight, unmanipulated photographs such as J. A. Boiffard's *Untitled (Big Toe)* (1929). In a unique reading of Surrealism, Krauss asserts that "it is *this* type that is closest to the movement's heart."[29] These types of photographs present us with a heightened experience of the frame. Index, frame, and spacing are central terms in her reading.

We can take as an example the work of Claude Cahun, on whom Krauss has repeatedly written. Although more well-known for her performative self-portraits where she challenges gender and sexual presumptions, which anticipates much performance art and photography in the 1970s (consider Cindy Sherman as an example), Cahun also made a series of self-portraits on the beach, such as *The Arena* (1926), replete with several indexical signs:

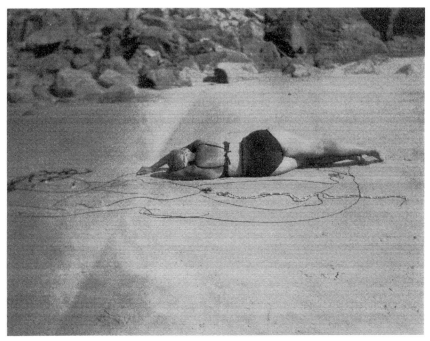

Figure 2.2 Claude Cahun, *Self-portrait Lying on Sand* (1930)

footprints, fingerprints, her arm lying on the sand photographed, the tracery of a rope on the sand. In *Self-portrait Lying on Sand* (1930), we see her lying on her left side with her arms stretched out. Behind her is a rope that she used as a prosthesis of sorts to extend her body, mark the sand, and through which she performed for the camera. Each iteration, each self-portrait is a trace, an index of a multiplicity of identities and potentialities. Cahun uses the relation between photograph and an index to work through the problematics of self-portraiture. She shows that a proper name, even if it is a self-given one, is an index in the sense of a place-holder; a proper name withholds an assemblage of aspects whose traces find their way into each image, but whose entirety remains figurable yet unrepresentable.

As Cahun's photographic work suggests, Surrealist photography "exploits the special connection to reality with which all photography is endowed. For photography is an imprint or transfer of the real; it is a photochemically processed trace causally connected to the thing in the world to which it refers."[30] The indexical nature of photography, Krauss posits, underlies and strengthens the "automaticism" proclaimed by Man Ray and others. Man Ray's variations on early photographic techniques such as Talbot's photogenic drawings, which he called "rayographs," exploit this underlying indexicality.[31] At the same time, the directness of the referent in the photograph supports tactics that focus on the frame and spacing within Surrealist photographs.

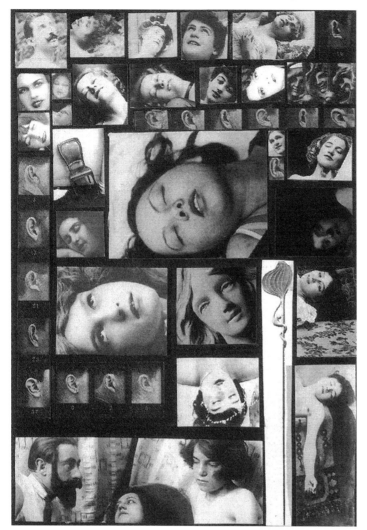

Figure 2.3 Salvador Dali, *The Phenomenon of Ecstasy* (1933)

Salvador's Dali's photomontage *The Phenomenon of Ecstasy* (1933) operates by play-ing on the nineteenth-century pseudoscience of physiognomy, where external traits are taken for internal capabilities, which was abetted by photography's appar-ent objectivity as seen in studies of hysteria. We also recognize the notion of the frame-within-a-frame (a recurring motif in Surrealist practice). Dali's interest in psychological states or experiences (such as ecstasy or paranoia) exceeds the frame/ grid that here signifies objectivity, rationality. There is an ambivalence about the grid/frame in Dali here, an ambivalence that extends to Krauss as well. The frame is required in order for what exceeds or transgresses it to become visible.

Bear in mind both Cahun's and Dali's photographs as we read Krauss:

> Inside the image, spacing can be generated by…the use of found frames
> to interrupt or displace segments of reality. But at the very boundary of
> the image the camera frame which crops or cuts the represented element
> out of reality-at-large can be seen as another example of spacing. Spacing
> is the indication of a break in the simultaneous experience of the real, a
> rupture that then issues into a sequence. Photographic cropping is *always*
> experienced as a rupture in the continuous fabric of reality. But surrealist
> photography puts enormous pressure on that frame to make itself read as
> a sign—an empty sign it is true, but an integer in the calculus of mean-
> ing: a signifier of signification.[32]

Photography depends on the frame to "make itself read as a sign" because the
frame "announces that between the part of reality that was cut away and this
part [the index] there is a difference." What the "frame frames is an example
of nature-as-representation, nature-as-sign," Krauss argues. This is how she
understands André Breton's notion of "convulsive beauty," a later iteration of
the "surreal."[33] Convulsive beauty is nature-as-representation, "presentations
of that very reality as configured, or coded, or written."[34]

Photography presents us with a reality that is already written, that is, con-
figured by cultural and historical associations and points of view. Krauss's
original reading of photography in Surrealism and in subsequent contempo-
rary art practice is dependent not only on her "anxiety of influence" regarding
Greenberg, but also on her readings of critical theory. In "The Photographic
Conditions of Surrealism," Krauss relies on Derrida's concepts of spacing, and
even his take on the frame. But Derrida is cited once, only to acknowledge
his "seminal text" *Of Grammatology* (1967). His work, on which much of the
argument rides, is never addressed in any sustained, developed way. Rather,
it is inferred. She assumes that there is *a* reading of Derrida. There is no such
thing. So just as Krauss presupposes that aesthetics is a discrete, self-evident
discourse—which it has never been—or, at least, that there is *a* reading of
Kant (Greenberg's), she also presupposes that Derrida's concepts of spacing,
trace, framing—his entire critique of representation—results, automatically,
in the anti-aesthetic position she forwards.

In another essay, "A Note on Photography and the Simulacral" (1984),
Krauss more directly addresses how photography grounds the anti-aesthetic
argument. However, to construct this argument she makes no reference to
Derrida, but instead relies on Pierre Bourdieu's *Photography: A Middle-Brow
Art* (1965). Using Bourdieu's sociological reading of photography (he calls
it a "social index"), wherein photography only serves to reinforce social func-
tions such as domesticity and the structure of the modern family thereby
"naturalizing" what is actually a historical and cultural construct, Krauss sec-
onds his position that there is no aesthetics in photography. Photography "can
never be properly aesthetic, that is, can have no aesthetic criteria proper to
itself" because "the most common photographic judgment is not about value

but about identity," a generic judgment.[35] What they mean here is that in front of a photograph, people tend to respond initially by saying what it is, a landscape, a portrait, etc. Bourdieu posits that amateur or vernacular photography—middle-brow art—forecloses on the possibility of art photography because both are read in the same manner, generically, typologically. Krauss explains, and forwards, Bourdieu's position here:

> But the notion that there is really an art photography as opposed to a primitive photography of common usage is, for Bourdieu, merely the extension of the expression of social distinctions. His feeling that art photography's difference is a sociological *effect* rather than an aesthetic reality stems from his conviction that photography has no aesthetic norms proper to itself; that it borrows its cache from the art movements with which various serious photographers associate themselves: that it borrows certain aesthetic notions from the other arts as well—notions like expressiveness, originality, singularity, and so forth.[36]

Substituting uniqueness for multiplicity and the series, as photography seems to do, refuses originality as an aesthetic condition of photography. All art, in Krauss's reading, is redefined by photography. In short, this is the anti-aesthetic position: all art aspires to or, at least, must accept its transformation of the condition of photography, a condition that demands art forego traditional aesthetic criteria like originality, uniqueness, self-expressivity in order to stage a critique of art and its culture. As Krauss writes, contemporary painting and sculpture have "experienced photography's travesty of the ideas of originality, or subjective expressiveness, or formal singularity, not as a failed version of these values, but as a denial of the very system of difference by which these values can be thought at all."[37]

We can examine two instances of contemporary anti-aesthetics that illustrate Krauss's points, one she refers to directly, Cindy Sherman, and another that shares her anti-aesthetic scheme, Victor Burgin.[38] Between 1977 and 1980 Sherman produced one of the most discussed conceptual/performative projects that used photography as a means. Her *Untitled Film Stills* present small-sized black-and-white photographs showing her alone in various settings performing as a series of female "characters."[39] These are not exactly "characters" because they are not taken directly from any specific film, play, artwork, or novel, but they do refer to "characters" that we might recognize from our visual archive of films, advertisements, television shows, etc. They are film stills from films that do not exist. There are a total of eighty-four "film stills" in which Sherman "depicts characters who appear absorbed in thought or feeling; or who look 'offscreen' in a manner that suggest that their attention has been drawn...by something or someone to be found there."[40] The *Untitled Film Stills* are often read as works demonstrating that identity, the fiction of the self, is a construct rather than a given; one's identity is not self-same and autonomous, but rather it comes from without; it is given by and through language, the family,

society, culture. In short, it is performative. Sherman uses photography to show that "the supposed autonomous and unitary self out of which those other 'directors' would create their fictions is itself nothing other than a discontinuous series of representations, copies, and fakes."[41] There is "no real Cindy Sherman in the photographs only the guises she assumes."[42] Her use of photography to document these constructed personas and intertextual settings is read as challenge not only to the relation between art and autobiography, but to authorship as such. This is the point Krauss stresses. Sherman's series "functions as a refusal to understand the artist as a source of originality, a fount of subjective response...the artist as a reserve of consciousness" because it stages "a critical parody of the forms of mass culture," photography included.[43]

Victor Burgin has created a self-reflexive photographic practice that includes the production of photographs and theoretical writing.[44] Burgin's practice shares much with Sherman's. Consider her *Untitled Film Stills* alongside Burgin's *Fiction Film* (1991), a series of silkscreen prints that are presented as remnants of a lost film version of Breton's *Nadja* (1928). The entirety of Burgin's work is central to any discussion of Conceptual art.

For instance, in an early work such as *Photopath* (1967, 1969), which was presented at the Institute of Contemporary Art in London at the exhibition *When Attitude Becomes Form* in 1969, Burgin laid black-and-white photographs of sections of the gallery floor directly over those sections. The photographs as signs and their referents or objects were thus "perfectly congruent" with each other, as he noted. The image overlaid the putative given "reality" that was below it as a perfect enactment of the concept of a simulacrum.[45] As Krauss herself writes, "if the simulacrum resembles anything, it is...nonresemblance. Thus a labyrinth is erected, a hall of mirrors."[46] Burgin's use of photography in *Photopath* traverses many of the most significant developments of postwar contemporary art because it is

> an extension of classic minimalist concerns with site and context, fore-grounding the viewer's apprehension of the object through a decidedly post-minimal embrace of ephemerality and self-effacement...Through its uncanny duplication of the flooring on which it lay, *Photopath* played with conditions of perception, forcing viewers to disentangle representation from reality. Its implicit interrogation of both site and viewer contains elements that Burgin would later explore in works that went "beyond Conceptual art" to incorporate "a systematic attention to the *politics of representation*" including a theory of the subject.[47]

He rejects the idea that photography has an essence and any narrow art historical account of photography and its development. His interest, rather, lies with psychoanalysis and its relation to "the general sphere of cultural production."[48]

For Burgin, the photograph evinces nothing other than desire-itself, desire as a lack or absence that instigates a series of substitutive, imaginary, fetish objects. A fetish, as Freud defined it in the simplest terms, marks the presence of an

absence.[49] In other words, the psychoanalytic structure of desire (and misrecognition) precedes any possibility of photographic meaning. Moreover, it depletes the possibility of any meaning in advance because desire is lack.[50] Therefore, photography is always already beside itself: meaning is always displaced from the *image* to discursive formations, he argues. Burgin calls the "photographic text" a site of "intertextuality," an interleaving of previous texts "taken for granted" at a particular cultural and historical conjuncture…The question of meaning therefore is constantly to be referred to the social and psychic formations of the author/reader."[51] Within this system of desire and semiotics, there is no reason to address the photograph itself because it is only a screen upon which the author/reader projects. Nothing comes from within, but only from without; the subject (author and reader) are both created in a discourse and a visual field outside of themselves. The field of the other is the "extimate" (exterior and yet intimate) terrain of the *photo-graphed* subject.[52]

For Krauss, both Sherman and Burgin, are examples of an anti-aesthetic photographic practice that exposes "the multiplicity, the facticity, the repetition and the stereotype at the heart of *every* aesthetic gesture" because photography "*deconstructs* the possibility of differentiating between the original and the copy, the first idea and its slavish imitators."[53] Geoffrey Batchen has articulated the aporia within Krauss's work on photography:

> Krauss provides photocriticism with a suggestive analogy between the photograph and a kind of *writing*. Nevertheless, in other respects her account retains a traditional notion of photography [in which reality] continues to precede a photography that is "merely" its "faithful trace." Photography is the indexical deposit of a real that it may mimic but of which it is never itself a part.[54]

This analogy posits that both the subject and reality as such are *effects* rather than whole, undifferentiated, givens. They are effects, the reality-effect and the subject-effect, that are both "the product of simulation and signs." When writing on photography Krauss is less invested in the socio-political aspects of these effects; rather, she contends, contra Bourdieu here, that "there *is* a discourse proper to photography." This discourse proper to photography, which is not an ontology of the medium, is the "false copy"—which, it must be noted, implies a reality or a "true copy"—that "served to deconstruct the whole system," that "opened the closed unities of the older aesthetic discourse [read: Greenberg] to the severest possible scrutiny" by putting into "question the whole concept of the uniqueness of the art object."[55] In other words, the discourse proper to photography is never stated as such; it is only certainly "not an aesthetic discourse," for her. Krauss's claim that photography as such is a "project of deconstruction in which art is distanced and separated from itself" is not entirely off mark.

Krauss's position embodies one pole in the debate over how we read the traits of photography, that is, as either characteristics unique to the medium of photography or as possible functions or uses of photography that are not

indicative of meaning (or being, ontology). Recently, various new readings of photography have been given regarding its medium-specificity and its uses. This "return to photography" is less about the putative end of photography (analogue to digital) or even the "turn of photography" that fueled much post-Conceptual art in recent decades. It is more a result of a fundamental undecidability at the heart of the discourse of photography about whether or not it is a distinct medium or not, whether or not it is an art form or an instrument like a graphite pencil. As Alan Trachtenberg wrote in 1980: "There has been little notable effort to address the medium itself, to examine its evolving character…its complex relations with other media…the cause of such neglect lies in the assumption that photography is unitary, a single method of making pictures."[56] It seems safe to say that this is certainly not the case now.

The frame as a metaphor for medium-specificity, what defines photography in itself as unique from other media, is certainly inseparable from a question of matter. Within the collection of essays edited by Robin Kelsey and Blake Stimson, *The Meaning of Photography* (2008), several attempts are made to address the question of medium. Some contributors argue that "photography is over" meaning that digitalization has definitively ended analogue photography but in doing so it offers us "a vantage point" to see "photography as a contained historical moment."[57] Others argue that photography does not simply end with digitalization because it has always been nothing other than "the technical medium of realism," that is, photographs "continue to be visual reflections of reality" because they "are realism mediated by the medium and concentrated in images—even if this reality is a radically constructed one."[58] The former position too readily associates photography with a history of technology, merely one of its many discourses. Has not "photography" already survived no less radical changes in equipment and technology than the shift to digital means? The latter position evinces both the "conservative and iconoclastic tendency" of photography, but refuses digital photography the ability to radically change "our everyday interaction with images."[59]

Medium and indexicality seem to be intertwined, despite the myriad definitions and uses put to each concept. It is not as easy as defining one's terms. The terms change over time and in different contexts. Moreover, the work—the uses or functions—these terms are asked to undertake changes from photographer to photographer, critic to critic, etc. A great example is Krauss herself. Krauss deployed the index as a tool in a particular cultural and historical context. It was a context that sought to displace Greenberg's ideas, but it was also a context in which contemporary art was exploding with a variety of disparate practices. This plurality was not what Krauss imagined would best replace medium-specific practices. It was to challenge medium-specificity but also to critique this pluralism that Krauss turned to the structuralist work of Roland Barthes and the concept of the index. She has made this quite clear:

> As an active critic in the 1960s and 1970s, my irritation with the widespread use of the idea of "pluralism" was intense. The notion it expressed,

that artists have a wide range of options open to them at a given point in history, conflicted with what I saw as Heinrich Wölfflin's correct position that "not everything is possible at any one time." The irritation led to the quest for a "unified field theory," the basis for which turned out to be the indexical sign.[60]

A similar situation has recently confronted Krauss again. The contemporary art world, which is predominantly manifested by hybrid forms such as installation art, is hardly medium-specific. Yet, these new forms of practice are then historicized as media, etc. Plurality is certainly present again, perhaps it never left, in contemporary art practice. For Krauss, this type of work is nihilisitic; it lacks criticality and appears to be indifferent to issues of commodification. For her, these forms and practices have not been able to intervene socially and politically; it is this putative failure that has led her to return to medium specificity, but in a different form.[61]

Her move here follows her "double movement" as she attempts to recuperate elements of critical modernist practice. Evident here is that all of these debates, returns, repudiations, and creative ways of thinking a medium— here, the medium of photography—are not meant to be resolved. There is no meaning of "medium." Rather, these "issues around the concept of medium specificity are only meaningful, that is not narrowly formal, when the larger stakes in such a concept, or in its rejection, are addressed in broader terms."[62] "Broader terms" such as the prevalence of photographic means in contemporary art production today, the advent of digital media, and the unraveling of the critical postmodern position articulated in the late 1970s through the 1990s, are driving these discussions of medium and indexicality.

In her essay "Indexicality and the Concept of Medium Specificity," Mary Ann Doane argues that medium specificity is not an essentialist idea but one that is resolutely historical, capable of changing in a variety of social and cultural contexts. What is specific to the medium becomes apparent as the medium itself changes. Hence, "it is the indexicality associated with the analogical, chemical base of the image that emerges as the primary candidate, in contention with the rise of digital media."[63] Doane notes how a medium is thought to be material or technical means that, although limiting, nonetheless enable possibilities and variations. A medium is "an enabling impediment," she claims. It is an "impediment" because the material (matter) must be acted on and through in order to create a photograph, a sculpture, whatever. "Medium specificity names the crucial recursiveness of that structure that is a medium. Proper to the aesthetic, then, would be a continual reinvention of the medium through a resistance to resistance, a transgression of what are given as material limitations."[64] The materiality of the medium is resisted and transgressed to generate "forms and modes of aesthetic apprehension." This movement is at work in the index.

For Doane, the index needs to be discussed as both physical cause, trace, and as deixis, the gesture of photography. As Charles Sanders Peirce suggested

when he developed his theory of the indexical sign, the trace is countered by the gesture, the pointing finger (index finger). The index directs one's attention towards the frame and perhaps beyond it. Doane posits that the tension between indexicality as trace and as deixis is precisely the tension between analogue and digitial photography. "What is elided," she states, "in the digital (derived from digit or finger) is the finger's pre-eminent status as the organ of touch, of contact, of sensation, of connection with the concrete. It could be said that the unconscious of the digital, that most abstract of logics of representation, is touch."[65] Doane takes the index as a trace of movement, as a gesture of touch. For her, what is unique to photography is the suggestion of the haptic within the image.

It is not clear whether or not alluding to Peirce's notion of the indexical sign clarifies anything about photography or if it simply muddles things to an irreparable point. Throughout discussion of photography and theory there are varying, often contradictory, definitions of Peirce's index. Let alone the uses to which it is put. In his taxonomy of signs, Peirce did distinguish between icon, index, and symbol. An icon being a likeness of an object. An index, minimally, can stand in for its object through an existential link to it. A symbol is a type of sign that stands in for an object by virtue of custom, habit, law, or culture. This, however, is just the opening move of Peirce's system. These three types are further broken down into ten classes of signs. He explains that a sign may be interpreted as a sign of possibility, a sign of fact or a sign of an object (itself a sign) with the "power to determine a specific interpretation by virtue of a habit or a law (argument)."[66] In addition, Peirce spends considerable time discussing how a sign is received and understood by a viewer. Needless to say, Peirce's semiotic system is much more complex than it is often made out to be in photographic discourse. An index, which can be direct or indirect, for Peirce, is not "the *essence* of photography, for the interpretation of a sign is determined both by its semiotic potential as well as by the use that is made of it according to a given epistemic purpose (what it is that we seek to know in using the sign)."[67] The index is not a "zero degree" of signification, nor does it preclude a photograph or a painting from being iconic or symbolic. A photograph can be used as an index; it can be used as a picture (resemblance). For Peirce, a photograph operates as an image-sign, one that has epistemic and aesthetic qualities and affects.

Perhaps the debates around the "end of photography" (digital media) should center on the discourse of photography and on the technical mechanisms within the camera rather than on the recording material (film). Lev Manovich argues that the digital image, with its surplus of information (detail) and mutability, does not simply surpass analogue photography; it is not "a radical rupture."[68] Manovich refrains from "taking an extreme position of either fully accepting or fully denying the idea of digital imaging revolution." Instead, he presents "the logic of the digital image as paradoxical; radically breaking with older modes of visual representation while at the same time reinforcing these

modes…the logic of the digital photograph is one of historical continuity and discontinuity."[69] Rather than relying on distinctions between analogue photography as realism and digital as montage (composite), Manovich views both as intertwined traditions of visual culture. "Digital technology does not subvert 'normal' photography because 'normal' photography never existed," he insists.[70] While admitting that theoretically digital photography presents a unique, new set of problematics and concepts, Manovich emphasizes that in practice there are negligible differences between the two. Thus he can claim that "digital photography does not exist" because there was never a single photography, whether in terms of use or reading.

The absence of any one thing or activity named "photography" does not permanently displace the consideration of medium. Every discourse is a multiplicity. It is never a single, cohesive entity. Photography is a multiplicity that has always been contingent on strategies, materials, readings, uses, and affects that came from outside of it. "Photography" is a name, that is, an assemblage of multiple and often contradictory lines, discourses, motivations, and powers. The proper name designates nothing that is proper to it, but only a set, a unique combination, an assemblage that is open in time.

In recent photographic practice we see less a notion of medium specificity grounded in indexicality than a delimited sense of the medium as an intersection of lines: painterly, cinematic, informatic, temporal. Even a cursory glance at a photograph by Gregory Crewdson supports Manovich's assertion that "cinematic codes find new roles in the digital visual culture."[71] Consider *Untitled (Ophelia)* (2001). To produce an image of this scale, Crewdson needs a crew of around forty people to build sets, dress those sets, rig lighting (sometimes from cranes), run rain and fog machines, act in these scenes, and to be the director of photography. And that is precisely what they are: scenes. Crewdson's work is carefully planned and staged; he is more of a director than what we would traditionally think of as a photographer. For *Ophelia* alone, one gets the sense of Crewdson's "directorial mode," replete with a constructed set (a working-class house) that was then flooded, the details (all the props) had to be careful chosen and edited, the cinematic lighting heightening the isolation of Ophelia's absent gaze. It is unclear if she is alive or dead, as many of the characters in Crewdson's photographs are oddly still, caught in an "in-between moment," as he describes it, in which they are suspended, present yet absent. It is more than being lost in thought. I would argue, however, that it is more than the production requirements—including the fact that Crewdson digitally scans his negatives and then constructs the photography digitally—that associate Crewdson's work with cinema, it is precisely this "in-between moment," the excessive presentation of the "narrative poverty" of photography. (In fact, it is this presentation of the possibilities of its narrative poverty that clearly allows us to discern the relation to Edward Hopper's painting or even Shakespeare, in this particular case. It is the openness of the medium of photography to an exterior (cinema, painting, literature, advertising) that causes it to fold itself anew. When looking at one of his photographs

we are presented with a situation. But the event (the cause) of this destruction or psychological stillness is never given. Even the character's vacant, often exhausted, expression alludes to an out-of-frame or, at least, the existence of something that exceeds what is present (or presentable) within the frame.

The tension between what is within and outside the frame organizes Michael Fried's interest in photography, a book entitled *Why Photography Matters as Art as Never Before* (2008). As someone who has long been associated with Greenbergian formalism, despite his own criticisms of its shortcomings, Fried opposes indexicality. The mere fact that photographs are "the result of reflected light (focused by a lens and captured by a shutter) impacting on a light-sensitive surface" is *not* "a necessary mark of photography" for Fried.[72] Rather, for him, "artistic media are not defined materially, causally, or onto-logically, but in terms of compelling conviction, first in the artist and then in their audience."[73] By examining contemporary works by Jeff Wall, Thomas Struth, and Jean-Marc Bustamante, among others, we witness a shift that began in photography in the late 1970s and continues to the present day: a shift to the use of color, and ultimately digital photography, to present large-scale tableaux images.[74] In observing these tableau photographs Fried sees no value in the index as a useful framework, either to discuss this type of work or the medium of photography.[75] For him, a work in a given medium must relate or construct a relation to past work in that medium; no means or materials can be given in advance to define a medium. A medium has conventions and an idea of "internality" because a medium cannot in advance

> stipulate that for something to count as a photograph it must be made with the mechanical and chemical means of photography. If it means any-thing, the idea of change internal to medium can only mean internal to a structure of intention operating within and against constraints laid down by exemplary past work…[this] theory explicitly rules out, namely, an essentialist conception of an artistic medium…[because] what *counts* as internal to a medium will be a function of the structures of intention underwriting a given practice.[76]

Hence, a medium is not ontologically or historically fixed. It is, instead, the result of a set of conventions, one that allows for media (painting and photography, for example) to be redefined in relation to one another *without* dissolving either as a separate, distinct medium with its own conventionality. Fried's conception of a medium is distinct from Krauss and Greenberg.[77] But what are these "structures of intention" on which Fried's position relies?

Much of Fried's *Why Photography Matters as Art as Never Before* engages the work of Jeff Wall whose large-scale, backlit, digital transparency images extend the mode of address and staging of traditional history painting and modernist art. Wall's work is crucial to Fried's reading of the "structures of intention." Wall's own discussions of his work, which frame it as a continuation of Charles Baudelaire's famous description of modern art as the "painting of modern life," intersects with Fried's desire to read work like Wall's through

the lens of modern painting.[78] Consider Wall's *Morning Cleaning, Mies van der Rohe Foundation, Barcelona* (1999), a 187×351 cm transparency in a lightbox. This is certainly not a photograph that merely documents; instead, its scale, its effects of the light passing through the picture to the viewer, its shapes, forms, colors, and the lines drawn within it, all call out for something called "aesthetic" experience.

Wall himself has narrated the role and transformations of photography through its use in Minimalism and Conceptual art—two artistic strategies that Fried has long disparaged—and as an instrument of the anti-aesthetic position as a whole. Rather than anything like the end of photography, Wall considers "photoconceptualism" the "last moment of the pre-history of photography," a moment whose passing did not foreclose on but rather foregrounds the "Picture" by creating "the conditions for the restoration of that concept as a central category of contemporary art around 1974."[79] By "Picture," Wall means the "experience of depiction," that is, "showing what experience is like," that is, "the experience of experience" as the "significance of depiction."[80]

It is the "Picture" as depiction and experience as well as its relation to past art forms that renders Wall's work compelling for Fried. The work is an *exemplar* because, for Fried, "an artistic medium" is "a structure of intention on the part of artists to elicit a certain conviction in their audience vis-à-vis the standing of their work in relation to the achievements of past art, it follows that if a given artist seeks to rival the achievements of one medium through the means of another their work will count as an example, and if great an exemplar, of the former."[81] Hence Wall's work could be characterized as that of a "'painter', who paints photographically," a valid statement within Fried's theory.[82] Thus the scale of Wall's images—or those of Andreas Gursky or Candida Höfer—coupled with their mode of address toward the viewer are meant to bring "the compositional resources, mode of address, and scale of history painting into dialogue with Baudelaire's call for a painting of modern life to produce a 'painting' of everyday contemporary scenes and events, and hence modern life, *as* historical…worthy of the closest inspection."[83]

Fried has examined this type of work through the lens of absorption and theatricality, terms he developed in his earlier studies of modern painting and in his criticisms of Minimalism in the 1960s.[84] The relation between the out-of-frame and within the frame is key as these works are created to be displayed on the wall so that more than one viewer can experience them at a time. Fried's reading centers entirely on the relationship between the photograph and the viewer. Even in a series such as Sherman's *Untitled Film Stills*, Fried observes that despite their theatricality, the staged aspect of the "stills" that points the viewer to their artifice and interdisciplinarity, there are also characteristics of the absorption.

Absorption is not exactly the opposite of theatricality as much as it is a different mode of address to the viewer. Theatricality is a mode of address wherein the viewer is needed, as it were, to complete the work. These types of works actively solicit viewers as co-performers, even co-authors of the work.

Absorptive works neither require a viewer to complete them nor do they actively solicit them. In fact, absorptive works often present a scene or a set of figures within the frame that are engrossed in whatever activity they are engaged. There is an indifference to the viewer in that what is depicted is "absorbed" in its own actions (thoughts or feelings) or, at minimum, their absorption precludes an awareness or need of a viewing subject. Whereas Sherman's works have been interpreted as theatrical (and thus critical illustrations of the performative, ideological aspects of identity construction), Fried notices that she often "depicts characters who appear absorbed in thought or feeling," who "look 'offscreen' in a manner that suggests their attention has been drawn, fleetingly or otherwise, by something or someone to be found there."[85] It should be noted that in this example, and in nearly all of the examples Fried addresses, there is a relation to cinema, in particular something like the "directorial mode" exemplified in Crewdson's work above.[86] Not having a character look directly into the camera is certainly a convention in cinema, but Fried is more interested in this as an extension of absorption, a trait first appearing in mid-eighteenth-century French painting where the ideal was a work of art that appeared as if the beholder did not exist, or was forgotten. It is this "to-be-seenness" (absorption) that Fried sees in "the most interesting and important photography of recent decades": "the new art photography seeks to come to grips with the issue of beholding in ways that do not succumb to theatricality but...[reserves] an imaginative space for itself" that was not entirely dependent on the viewer.[87] There is a productive tension in these works between absorption and theatricality that traverses the history of modern painting as well as other fields such as cinema. At work in this traversal is the historical, changing "conventions" of a medium, photography. Thinking a medium in this manner that allows us to discuss works by Sherman, Struth, Gursky, and many others as "photography," despite their, at times, vocal claims to have nothing to do with photography proper.[88]

If a medium as a set of changing conventions and "structures of intention," then perhaps there is a way to re-approach the index, however cautiously, not as an ontological trace specific to photography, but as something operative within this tension of absorption and theatricality. In *Cinema 1: The Movement-Image* (1983), the French philosopher Gilles Deleuze examines how images are constructed in film by looking, in part, at different types of framing (relations, movement, sequences) other than the film-still being a synecdoche (a part for the whole). Examining types of framing also requires Deleuze to present his interpretation of Peirce's notion of the index. At stake in any image, Deleuze makes clear, is the visible *and* the legible, statements and visibilities. "The frame teaches us that the image is not just given to be seen. It is legible as well as visible," he writes.[89] The frame only seems to separate out an out-of-field, what is outside the frame. However, "it is none the less true that a system which is closed...only apparently suppresses the out-of-field, and in its own way gives it an even more decisive importance. All framing determines an out-of-field."[90] For Deleuze, the frame determines an out-of-field that refers to a large set of thoughts, actions, texts, etc., that are outside (or contiguous to) what is

within the frame. It is the "art of choosing the parts" that become part of a set. Of course, the out-of-field could then be framed, creating a new out-of-field. "The set of all these sets forms a homogenous continuity, a universe, or a plane of genuinely unlimited content" because it is the "opening of the whole" that passes through each framed image.[91] Hence the out-of-field has two functions: "In one case, the out-of-field designates that which exists elsewhere, to one side or around; in the other case, the out-of-field testifies to a more disturbing presence, one which cannot even be said to exist, but rather to 'insist' or 'subsist', a more radical Elsewhere, outside homogenous space and time."[92]

These two senses of the out-of-field relate to two "sorts or poles" of the index. Remember that Deleuze is analyzing the movement-image, of which the predominant type is the action-image in cinema; he is not discussing photography per se. But, his meditation on how images are constructed, how they function in themselves and in relation to one another, how they mean but also how they function in time, certainly bears on the discourse of these same terms—frame and index—in photography. For instance, the index, as Deleuze understands it, is a sign that refers to its object by a material link, but that is only a condition. What matters is how the index functions. Thus Deleuze differentiaties between an "index of lack" and an "index of equivocity." In the first case, he writes:

> an action (or an equivalent of an action, a simple gesture) discloses a situation which is not given. The situation is deduced from the action, by immediate inference, or by a relatively complex reasoning. Since the situation is not given for itself, the index here is an index of lack; it implies a gap in the narrative [an ellipsis].[93]

In the second case, an index of equivocity, "we are made to hesitate by a whole world of details, another type of indices; not because something is lacking, or which is not given, but by virtue of an equivocity which completely belongs to the index."[94] In the former, there is an ellipsis; in the latter, there is an ellipse, a circuit that the eye travels as it examines and reads these details. In both cases, the index functions to shuttle the viewer's attention toward itself, before diverting this attention to a "world of details." This diversion generates only more distance, an outside of itself, an outside the frame that supplements what the index lacks. In its most complex sense, an index functions in relation to the whole in different ways: ellipses and the possibility of "sudden reversals of the situation" given. Indices link what is presented to the viewer to a situation or history that is not given within the frame. This out-of-field—the whole as the open—is never represented or contained within a single frame or set of frames (because each new framed view produces a new centre and thus a new focal point of an ellipse) yet it enables and passes through each and every frame (still). The movement-image is less the sensory motor link between each frame than it is the movement of the out-of-field as it *deframes* those linkages and inferences. This is a power of art; for Deleuze, art produces (blocs of sensation) which force us to think.

"The frame or the picture's edge is, in the first place," Deleuze writes, "the external envelope of a series of frames or sections that join up by carrying out counterpoints of lines and colors, by determining compounds of sensations."[95] However, art has something else, another power, because "the picture is also traversed by a deframing power that opens it onto ... an infinite field of forces." What is key, for Deleuze, is that these "forces" give the picture the ability to become an image, "the power to leave the canvas," for example, because the action "never stays within the frame; it leaves the frame and does not begin with it."[96] In other words, we can understand the index as something that does not simply ground the photograph in its material conditions, but it also, paradoxically perhaps, enables the photograph to become other, to *deframe* opinions, clichés, and conventions, in order to become an image, an interval in time.

Photography does not just passively record because it is simultaneously active and passive, framing *and* de-framing time. Jacques Derrida discusses this simultaneity—this inseparability—in terms of photography, portraiture, and temporality. A photograph, even as a snapshot, gives us a point of view that we can never take up or occupy. Derrida asks if it is possible to think this point of view, the point of view of the other that is never our own? He proceeds to play on the notion of a *point*, as in point of view, as a form of a stylus, as a *Punkt* as in the German for point that gives us punctuality. The point and time. Between the two, there is an image and its archive. "The experience of what one calls the present would be constituted as self-preserving, certainly, but in such a way that something may be lost, and something kept and preserved, from the same event, from the *point* of the event," he says. The present preserves itself even as it passes into the past and the future. But it preserves itself by losing itself, disallowing itself to be passed or forwarded ahead, and by preserving itself as a point, a moment. This point must be indivisible, or else the line of time would not pass through it.

Derrida begins with a common notion of time, but he complicates this common sense understanding of time and representation by addressing the archive, which gives us a more complex, paradoxical perhaps, notion of uniqueness, oneness. The "unique"—the unrepeatable, the moment—has to "be divisible enough for an archive to separate off from it somehow: an archive would remain; it would survive, whereas that of which it is the archive has disappeared...but in this case the archive would not be simply the copy, the reproduction or the imprint of another present."[97] The present, therefore, is not a point but a duration, a structure that is "divisible even while remaining unique." Before the present is lost, as part of it becomes the past and part becomes the future, it archives itself as present, that is, as divisible and yet non-reproducible. Derrida adds that this "onceness," the moment or point that we commonly believe takes place only once, requires "the indecomposable simplicity, beyond all analysis, of a time of the instant: the moment as the *Augenblick*, the eyeblink...of a shot or of taking (in) a view."

But if the "one single time," if the single, first, and last time of the shot already occupies a heterogeneous time, this supposes a differing/deferring and differentiated duration...As soon as one takes into account the calculability of time, in perception as *prise du vue*, as soon as one considers time not as a series of irreducible and atomic instants but as a differential duration that is more or less calculable, a duration that is correlative to a technics, the question of references becomes complicated, and therefore so does the question of art, of photography as a *technê*.[98]

Of what is a photograph a picture in terms of time? Is it past, present, future? A photograph, even a snapshot, is a photograph of time as a moment, but as such it is nonsense. Nonsensical in the sense that it has a temporal logic of its own, one that is not ours. A photograph is not bound to its referent, as an indexical sign, but it does gives us a structure of time, a structure of reference (as an ellipsis and as an ellipse). A photograph is the blink of an eye suspended in the closing of an eyelid; it is not a moment but a duration, an opening to time as that which endures and differentiates itself. A photograph simultaneously translates something in time and creates a moment, which has no existence outside of the arrow of time. A photograph is the time correlative to a technics called photography; it is the time of photography.

Photography creates a temporality and an image of ourselves that operates by differentiating itself (time and the image) from within. Hence, Derrida's statement that if "technics intervenes from the moment a view or shot is taken, and beginning with the time of the exposure, there is no longer any pure passivity, but this does not simply mean that activity effaces passivity. It is a question of *acti/passivity*."[99] Derrida insists that even though thinking time in this manner may be "unfamiliar" to photographic discourse, it is indispensable because it is one way to see how photography—as an event—"no longer allows us to oppose perception and technics; there is no perception before the possibility of prosthetic iterability," that is, some framing, some technics.[100]

Throughout his work, Derrida has addressed this possibility in art, architecture, and visual culture; however, his thinking on photography is only now coming into clearer focus.[101] Recent publications and translations of his work on photography, such as *Athens, Still Remains: The Photographs of Jean-François Bonhomme* (2010), have refocused critical attention on the relation between Derrida's concepts of translation, trace, archive, and photography.[102] One of the most insightful is a conversation on photography that Derrida had with Michael Wetzel and Hubertus von Amelunxen in 2000, which has been published in English as *Copy, Archive, Signature: A Conversation on Photography* (2010). In all of these iterations, Derrida's "interrogation of photography works to open the medium to its own alterity, to the ways in which photography exposes the non-self-identity and internal self-differentiation that, for him, ultimately condition any act of aesthetic experience and its ethicopolitical futurity."[103] The *technê* (*technics*, technology, structure) of photograph does question the status of the original and the role of the author,

but it also withholds the possibility of another form of temporal experience. This is because, as Derrida states "the logic of the prosthesis and of the supplement as originary contradicts, of course, the common notion of the substitutive prosthesis."[104] In other words, there is no point of view, no shot, no perspective or perception—no reality as such—that is not already a technics, be it an eye or any opening to light, even a camera.

Derrida's philosophy is often referred to as "deconstruction," a term he coined in his early work, *Of Grammatology* (1967). As a concept, it bears within itself two simultaneous actions: building and un-building, construction and deconstruction.[105] Deconstruction, for Derrida, has never been anything merely "negative, destructive, or rejecting" because it has always contained within that gesture its opposite, "something positive, a mode of affirmation and even future-directedness."[106] In other words, deconstruction as a mode of practice, as critical reading and thought, has always involved translation and invention. (As such it is a much different "double movement" than the one motivating Krauss's work.) Derrida attempts to expose an aporia *within* each and every text (be it a novel, an artwork, a discourse) that is that text's "originary trace," its enabling limit. It is no longer a question of cause and effect, original and copy. The only question of interest is how and why does this contingent "supplement" lie at the heart of any idea or text in advance, *within it*. Translation is the key concept for deconstruction because the "substitute does not substitute itself for anything which has somehow existed before it" and the translation "will not retroactively yield, as though it were merely the expression of a kind of Freudian deferred action, the 'original' essence of something that at one point in the past was present to itself, transparently available as a mode of anteriority."[107] The reason being, as Derrida writes in "The Art of Memories," "the disruptive force of deconstruction is always already contained within the architecture of the work, all one would finally have to do to be able to deconstruct…is to do memory work."[108] These are quite interesting terms with which to think photography, that is, as translation, as memory.

This point has ramifications for how an image is thought, particularly as a portrait. In *Memoirs of the Blind: The Self-Portrait and Other* (1990), an exhibition of drawings curated by Derrida for which he wrote an accompanying essay, he retells one of the Greek "origin" stories of art. He relates not the fable of mimesis, deception, and our human desire for what is hidden that Pliny the Elder recounted in his *Natural History* (AD77–9) about two rival painters Zeuxis and Parrhasius. Instead, Derrida recounts that of Dibutade, a fifth-century Corinth girl who traced the silhouette of her lover on the wall before he departed on a long journey.[109] So, if in perception there is already a process of framing and an exposure time, a selection and a development process, then the "psychic apparatus functions also *like*, or *as*, an apparatus of inscription and of the photographic archive."[110] Linking this to the fable of Dibutade, Derrida adds that the shadow and her perception of it on the wall is there before the drawing, that is, there is already a technics involved (thrown

candle light, her lover placed in profile, the play of light and shadow). This technics of perception, which is translated into a drawing, is a form of writing that displaces any original, pure perception. It is a translation of a translation without the sense that one is moving away from or losing the original, which only has an existence as that which is differentiated in and through its representations. The light-writing, or photo-graphy, at work produces the conditions (technics as condition and technique) under which an *invention* (drawing, art, portraiture, memory) can be made.

Here is Derrida's fuller explication of the fable:

> A line *as such* appears when the one who draws—with a sharp point, for example—makes an incision and inscribes a mark, even if he thus follows a natural line. When Dibutade follows a line, she is active; she has an instrument, a technique, but her human activity consists in passively taking as a model a line that is already there. And therefore at the point, at the sharp point or the pointed tip of the pencil, or at the extremity of the metal or wooden point, activity is modeled on a given. It forms itself onto passivity, so to speak; it tracks along a point where it is passive, following something that is given in advance…When Dibutade traces, she begins to retrace. And the *re*marking of the *re*tracing is at once active and passive. But the possibility if this repetition, this iterability, marks in advance the very threshold of perception…This is the movement of the trace: a movement that is a priori photographic.[111]

In a nice touch, Derrida exposes that photography, despite the belatedness of its invention, is the "originary" trace and perceptual structure of art as such. In fact, what is often a disparaging comment about photography—that it is merely the passive taking of a given reality that transfers itself on the photographic film, the logic of the index—is here presented in its full complexity thereby behooving us not only to rethink photography, but art as well. For Derrida's meditation on photography offers us a conception of a photograph as at once a "*re-marking* and the erasure of the line," as with-drawal (Derrida uses the word *le retrait*), as an active/passive operation that grasps something only "to let it be lost, to mark the fact that 'this took place, it is lost'."[112] If there is anything indexical about his concepts of trace and archive, then it is not about reality or the false copy at all. It is about a form of writing that shelters and creates a truly photographic invention: as a discovery or revelation of what is already there, as a simple recording of what was there *and* as that invention (technics) that immediately contaminates that attempt at simple recording by producing, creating, and imagining. These are "the two concepts of invention that lie at the heart of photography," Derrida tells us.[113]

As we can see here, deconstruction is far from a negative or critical (oppositional) activity. On the contrary, it is a kind of close analysis, a diagnosis, that seeks "to understand how an 'ensemble' was constituted."[114] Considering photography, Derrida focuses on the "ensemble" at the heart of "invention." Every

act of perception is conditioned by a technics, a set or ensemble of framing conditions, that records and alters, creates and documents. His meditations on the frame (the Kantian *parergon*) are convincing instances of deconstructive reading, which "does not point out the flaws or weakness or stupidities of an author, but the *necessity* with which what he *does* see is symmetrically related to what he does *not* see."[115] In Derrida's discussions of art there is a different reading of Kant, particularly on the frame, and there is a concerted attempt to explain how and why there is no "false copy" but only always a *technics* that precedes and frames perception. There is still "uniqueness" in Derrida, despite his emphasis on the "originary trace," which is not identical to an indexical sign.

The frame or *parergon* is not an after-thought or merely decorative; it is an enabling condition of the work itself (*ergon*). Although the frame seems to be fixed and solid, separating definitively the work from what is extrinsic to it, the frame *hinges* the interior and the exterior of the work. In Kant's work on aesthetics, the frame, the room in which a work of art is found, or any ornament (for example, drapery) constitute the *parerga*. Derrida's thinking about aesthetics—his writing "around painting" in *The Truth in Painting*— is a retracing of the frame, which functions not as a barrier but as a *hinge*, something that breaks and joins inside and outside, one and the other. Vision and blindness, recording and inventing, work and frame, the conjunction— the *and*—is the spacing, the threshold between that creates. The "truth," the *aletheia* or "disclosure," at work in photography is "memory work" because photography gives us a picture and a frame. Between these blinds—these shelters that conceal—an image appears, one that is impersonal and abstruse, one filched from the real and yet not imaginary. "The photographer left; he told the truth," Derrida concludes.[116]

An image: Jan Dibbet's *Perspective Correction* (1968). Early in his career as a Conceptual artist using photography to create Land art and other forms of practice, Dibbets, a Dutch artist, experimented in his studio and outside in fields with photography and perspective. In his studio, he taped and drew rectangular shapes on his studio floor or wall and then photographed them. In one iteration of these experiments, he taped a trapezoid on the floor of his studio and photographed it. The trapezoid became a square that appears to stand-up vertically. It was the act of photographing the shape that transformed it, changing it into a square that reorients itself in the picture plane. Something similar happens in the field, where the rope that forms the square stands in the field. These photographs are not manipulated. They only demonstrate that the camera abstracts from what is before it. One way it does so is to translate three-dimensional space into a two-dimensional perspectival one. This movement and translation forces us to rethink the series of frames within frames that comprise the photograph itself. The frames are a spiral open at both ends, turning at various speeds: the frames of the eye and the body, the frames of the room itself (its

Figure 2.4 Jan Dibbets, *Perspective Correction* (1968)

play of structure, light, shadow, texture), the frames of the camera (lens, viewfinder), the frames of and within the photograph, and the frames of the print. The further one descends within the photograph, following this calculus of frames, the sooner one reaches an outside. This outside is not reality as such; rather, it is an outside as a threshold between translation and invention. An image is not a transfer off the real. It is what transforms and corrects vision; it is creative, genetic. The image suspends reality by gesturing toward the out-of-frame, which has changed and passed. An image is neither a resemblance nor a picture. It is a possible affect of the camera and our use of it. It is for this reason that all photography is theoretical and inhuman, whether "realistic" or not; it always *abstracts*, that is, separates itself from concrete existence, gestures towards a "placeless place."

GLOSS ON ROLAND BARTHES, "THE RHETORIC OF THE IMAGE" (1964)[1]

In 1964 Roland Barthes, a French semiologist and cultural theorist, published an essay entitled "The Rhetoric of the Image." With this important early essay Barthes not only develops a way of reading a photograph, but he also suggests ideas that are only clarified much later in *Camera Lucida: Reflections on Photography* (1980), a highly subjective, at times maddening, meditation on photography that contrasts with his earlier, more analytical work on the subject. Here is undoubtedly one of the earlier essay's most important, if enigmatic, passages; one we will read closely to produce some of its possible meanings and their consequences for the history of photography:

> In the photograph—at least at the level of the literal message—the relationship of signifieds to signifiers is not one of "transformation" but of "recording," and the absence of a code clearly reinforces the myth of photographic "naturalness": the scene *is there*, captured mechanically, not humanly (the mechanical is here a guarantee of objectivity). Man's interventions in the photograph (framing, distance, lighting, focus, speed) all effectively belong to the plane of connotation; it is as though in the beginning (even if utopian) there were a brute photograph (frontal and clear) on which man would then lay out, with the aid of various techniques, the signs drawn from a cultural code. Only the opposition of the cultural code and the natural non-code can, it seems, account for the specific character of the photograph and allow the assessment of the anthropological revolution it represents in man's history. The type of consciousness the photograph involves is indeed truly unprecedented, since it establishes not a consciousness of the *being-here* of the thing (which any copy could provoke) but an awareness of its *having-been-there*. What we have is a new space-time category: spatial immediacy and temporal anteriority, the photograph being an illogical conjunction between the *here-now* and the *there-then*. It is thus at the level of this denoted message or message without a code that the *real unreality* of the photograph can be fully understood: its unreality is that of the *here-now*, for the photograph is never experienced as illusion, is in no way a *presence* (claims to the magical character of the photographic image must be deflated); its reality is that of the *having-been-there*, for in every photograph there is always a stupefying evidence of *this is how it was*, giving us, by a precious miracle, a reality from which we are sheltered (…) The photograph can in some sense elude history (despite the evolution of techniques and ambitions of the photographic art) and represent a "flat" anthropological fact, at once absolutely new and definitively unsurpassable, humanity encountering for the first time in its history *messages without a code*. Hence the photograph is not the last (improved) term of the great family of images; it corresponds to a decisive mutation of informational economies.[2]

Barthes begins with the linguistic root of the word "image"—*imitari*, which signifies mimesis, an analogue: the thing signified (e.g. a pipe) and the image signifying it (a photograph) are not arbitrary but rather they are continuous, direct, and make no recourse to a code. This analogical nature of a photograph is of great interest to Barthes because it leaves photography outside of structuralist criticism. Structuralist critics, of whom Barthes was one, focus on the systems of signs, codes, and the structures that render them meaningful. Language is the determinative system; it is the underlying structure (system or code) that allows for a multiplicity of different languages (Swedish, Cantonese) as well as for each individual moment of language use (particular utterances or messages whether spoken or written). Linguists and, by extension structuralists, take as their object of study the language-system and not individual or collective utterances or enactments of the underlying system, over which no one individual or group has control. Linguists, Barthes writes, "refuse the status of language to all communication by analogy" such as gestures, the "language of bees," etc.[3] These types of mimetic communication are analogic and not digital; they are not language-systems because they are not combinatory systems wherein signs are "doubly articulated" (read: not direct, continuous, analogic). Thus there is no code, no structure or grammar between the object and its image that orders meaning. Simply put, as Barthes intimates, a structuralist should have no real business studying photography because of its basis in mimesis, its message is not governed by a structure thereby negating it as a proper object of study. Nonetheless, Barthes's desire to study photographic messages is only heightened when he adds that, aside from linguistics, "general opinion" and even "artists themselves" are nonplussed about the signifying nature—what Barthes will call "the structural autonomy"—of a photograph. Both general opinion and artists, he claims, wield "a vague conception of the image as an area of resistance to meaning," that is, the "image's ineffable richness" is irreducible to a single meaning or message. So on one hand, a photograph proves too anemic to convey or produce meaning; on the other, there is a mythic inflation of its poetic ability to transcend prosaic communication.

Despite this paradox Barthes persists. He poses some simple questions, the answers to which have proven quite difficult to answer. Questions such as how do we read a photograph? What do we perceive? What is transmitted within the frame of a photograph? What is the content of the photographic message? How does meaning get into the image? Where does it end? And, if it ends, what is there *beyond*?[4] Here, "beyond" means something like being "at the threshold of" or being "*this-side-of*" language, that is, not quite a language-system but nevertheless having a force of signification that troubles or antagonizes the closed structure the language-system tries to construct in order to insure the meaning of a message. It is for this reason that Barthes famously calls a photograph "a message without a code."

A photograph is "a message without a code" because it is grounded in analogical representation; it is a denoted, non-coded iconic message. In other words, the relationship between the signifier and the signified is not

arbitrary. This makes the photograph exceptional in Barthes's mind: "of all the kinds of image only the photograph is able to transmit the (literal) information without forming it by means of discontinuous signs and rules of information."[5] How does a photograph accomplish this direct or literal transmission of information without deforming it, altering it, or encoding it? It does so because of denotation, the absolutely analogical nature of the photograph, Barthes argues.

Although there are multiple levels to how a photographic message becomes legible, the denotative level is crucial. Barthes asserts that at this level a photograph is "styleless," meaning that it does not demand or require "an apprecenticeship" unlike all other cultural codes, which must be learned. The denoted image within a photograph establishes a "relationship between a nature and a culture" that seems to reaffirm the viewer/reader's faith in the entirety of the photographic message. Even though a photograph represents a choice of object and a distinct point of view, Barthes contends that the denoted aspect of a photograph assures us that it "cannot intervene *within* the object (except by trick effects)."[6] Therefore, denotation is the literal, mimetic presentation of the thing itself, whatever is being photographed is analogically recorded on the negative. However, a photographic message is more complicated, as Barthes explains, because denotation is inseparable from other levels of meaning, both linguistic and connotative.

As an example Barthes gives a reading of an advertising image by Panzani, an Italian foods company. He begins: "Here we have a Panzani advertisement: some packets of pasta, a tin, a sachet, some tomatoes, onions, peppers, a mushroom, all emerging from a half-open string bag, in yellows and greens on a red background. Let us try to 'skim off' the different messages it contains."[7] Barthes begins by leading us through his attempt to "skim off" or separate out the different messages within the photograph because in "the overall structure of the image" the messages therein are "inter-related," the "viewer of the image receives *at one and the same time* the perceptual message and the cultural message."[8] Nevertheless, Barthes wagers that the denoted or literal message of a photograph functions as the "support" of the symbolic or connotative message. For this reason, he proceeds with an explication of the image's messages by separating out three messages: linguistic, connoted, and denoted. It is the interrelationship between these three messages that gives a photograph its "originality": "the number of readings of the same [image] varies according to individuals...The *variation in readings is not, however, anarchic: it depends on different kinds of knowledge—practical, natural, cultural, aesthetic—invested in the image.*"[9] The "rhetoric of the image," its cultural language, is comprised of the signs made and combined by the creator of the image as well as the totality of the signs received, which includes variations in meaning or even outright misreadings.

The advertisement's first message is linguistic; it is comprised of the caption and the labels in French. (The advertisement that Barthes reads was aimed at the French market.) A linguistic message is present within every image. Text (title,

caption, accompanying article) serves as a way to ground or "anchor," as Barthes says, the number of possible readings an image generates. "All images," he writes, "are polysemous; they imply, underlying their signifiers, a 'floating chain' of signifieds, the reader able to choose some and ignore others. Polysemy poses a question of meaning…Hence in every society various techniques are developed intended to *fix* the floating chain of signifieds in such a way as to counter the terror of uncertain signs; the linguistic message is one of these techniques."[10] This act of fixing or disciplining the potential multiplicity of meaning any image can generate is the primary role the linguistic message plays, but in doing so it also allows for dangerous, oversimplified concepts to be produced and transmitted. For example, beyond the French text that appears within the image, Barthes draws our attention to the sign "Panzani" which is an Italian name (signifier) rather than a French one. This signifier *Panzani* is "not simply the name of the firm but also, by its assonance, an additional signified, that of 'Italianicity'." The name signifies Italian-ness, the essence of Italian culture (here cuisine): this is one message of the image, one conveyed through the linguistic means alone but that connects to the second message. So the linguistic message is denotative and connotative because it supplements the second or iconic message, which is cultural and thus coded.

The connoted image is constituted by signs and every set of signs supposes a code. The connoted message, abetted by the linguistic one, attempts to transform the denoted image into a "rhetoric" or a cultural coding through framing, layout, pose, trick effects—all of the representational strategies that are deployed in producing an image. Connotation takes place by "burdening" the image, as Barthes says in another essay, with "culture, a moral, an imagination."[11] Connotation is suggestion, possible but not confirmable meaning; it is perceptual and legible but not empirical knowledge. It is more like myth or ideology. Consider again the notion of "Italianicity." Do all Italians possess an underlying essence that could be expressed by this vague notion of "Italianicity," which suggests that identity is premised on sameness rather than difference? The seductiveness of such essentialist notions are enhanced and amplified by photography because of its "structural paradox," which is how a photograph can be at once objective and tendentious (biased, cultural, mythic). The "paradox" Barthes identifies is that in a photographic image the "connoted (or coded) message develops on the basis of a message *without a code*" because the connoted and the denoted messages are enfolded or imbricated, one within the other. The "analogical plentitude" or objectivity of a photograph, especially when it is being used in a press or advertising context, makes the connoted message "not necessarily immediately graspable" rather it becomes "at once invisible and active, clear and implicit."[12]

The denotative message of a photograph—its analogical, mimetic nature in which there is not delay between object and signifying unit(s)—greatly benefits and enhances the connotative message. This curious interrelationship is one power of photography. As Barthes adds, the connotation "somehow 'emerges' from all these signifying units which are nevertheless 'captured' as though the scene were immediate and spontaneous, that is to say, without

signification."[13] The denotative structure of a photograph, he argues, grounds and purifies the connotative ones (both linguistic and iconic). There is a structural analogy put into play here between natural/mimetic/denotation *and* cultural/codes/connotation. Barthes defines myth, in its simplest terms, as any means by which the cultural comes to appear as natural (or given) rather than constructed, arbitrary, contentious. Photography is one such means for the generation of modern mythology. "The connotation," Barthes explains, is "now experienced only as the natural resonance of the fundamental denotation constituted by the photographic analogy and we are thus confronted with a typical process of naturalization of the cultural." He goes so far as to say that "the connotation of language [as a system of man-made codes] is 'innocented' through the photograph's denotation."[14] The denoted image naturalizes a symbolic message by making it seem as if "nature seems to spontaneously produce the scene represented."[15] The denoted image is therefore the syntax or grammar that allows a set of discontinuous signifying units to be associated; it provides the ground or space for these "scattered traits" to be arranged and to produce meaning(s), a rhetoric.

To be this syntax or arena, denotation has special characteristics: it is both "evictive and sufficient." It is "evictive" because it is a "message without a code." It evicts or deletes the codes (connotation); it is "a message by eviction, constituted by what is left in the image when the signs of connotation are mentally deleted." This absence is in fact productive because this "evictive state" corresponds to "a plentitude of virtualities: it is *an absence of meaning full of all meanings.*"[16] For this reason, it is "sufficient" because as "the letter of the image" it is a "first degree of intelligibility (below which the reader would perceive only lines, forms, and colors)." However, this initial degree of intelligibility is not read but only presupposed: it "remains virtual by reason of its very poverty, for everyone from a real society always disposes of a knowledge superior to the merely anthropological and perceives more than just the letter."[17] This is remarkable. A photographic message—its rhetoric, its discourse—is enunciated by a series of interrelated messages that occurs at both the denotative and connotative levels, with some messages sharing the same substance or material even as it creates different types of statements. At the end of his essay, Barthes arrives at a conclusion that is more a presentiment or an intuition, one that he will only develop further in his last book *Camera Lucida.* He writes that "there is always remaining in the discourse, a certain denotation without which, precisely, the discourse would not be possible."[18] The denoted image is a remainder or originary trace; something in the iconic message that cannot be transformed into a symbol or sign.

What Barthes does as he continues to think about photography from the mid-1960s to 1980 is to reflect on this remainder, the denoted image as an originary trace. He refers to this "remainder" variably as the "third meaning" or the "obtuse meaning," writing that it signifies "the one 'too many', the supplement that my intellection cannot succeed in absorbing, at once persistent and fleeting, smooth and elusive."[19] If the denoted image in the structural economy

of photography naturalizes the symbolic message, then it also harbors within that very message the potential to de-nature, disturb, or render excessive its signifying capability. The structural economy of the photography is always about meaning, never art, Barthes argues in his early work on photography; but in his later (post-structuralist) works he is compelled not by signification but by what happens when this economy, system, or signifying machine fails or breaks. What allows a photograph to be read or studied is, paradoxically, that which "disturbs" and is "indifferent to the story and to the obvious meaning."[20] This "disruptive force" Barthes ultimately names the *punctum*.

The *punctum* is related to what Barthes calls the "pleasure of the text," that is how we read and experience certain photographs in a way that unsettles a viewer's historical, cultural, and even psychological assumptions. Barthes attempts to explain this concept of the *punctum* by writing that "it is what I add to the photograph and what is nonetheless already there."[21] For him, the *punctum* is the essence of a photograph, that is, "a wound: I see, I feel, hence I notice, I observe, and I think."[22] It is what wounds or cuts the viewer psychologically; it is an undialectical point that interrupts a passive, studious reading of a photograph. Whether it is a boy's crooked teeth or a woman's pearl necklace, the *punctum* is a marginal element of a photograph that compels the viewer and problematizes meaning. Hence it "subverts not the content but the whole practice of meaning" and a "new—rare—practice" is "affirmed against a majority practice (that of signification)."[23] Barthes allows us to consider how and why photography becomes a *minority practice*, that is, a how and why it is capable, in certain moments, of accenting language (signification), of making it stutter and mis-function in creative ways.[24] Within all discourse—and not just within a photograph—there is an enabling limit, an originary trace or line, a *punctum* that is "the epitome of a counter-narrative... set to its own temporality...counter-logical and yet 'true'."[25]

Within a photograph there is an ecstatic moment, an "unexpected flash"—an event—that dismantles chronology. The *punctum* is neither the referent of the photograph nor is it what makes photography as such an exceptional form of representation. Rather, it is an opening, something that is and yet remains outside of denotation (the photograph as an analogue) and connotation. Beyond each—just this-side-of-language—Barthes put us on the trail of an experience of temporality that is not simple chronology; instead, as an event, the *punctum* is bound to what Barthes calls the "that-has-been." What makes Barthes last book, *Camera Lucida*, so fascinating is that although it insists that a photographic image is "a message without a code" he changes the significance of this claim: "nothing can prevent the Photograph from being analogical" but "its *noeme* [essence] has nothing to do with analogy... The important thing is that the photograph possess an evidential force, and that its testimony bears not on the object but on time."[26] This shift from the object—how its meaning and rhetoric is produced and functions—to temporality has important consequences for any conception of the photographic image, whether document or artwork.

3 Documentary, or instants of truth

Photography is the purveyor of such knowledge to the world. She is the sworn witness of everything presented to her view. What are her unerring records…but facts which are neither the province of art nor of description, but that of a new form of communication between man and man.

Lady Eastlake

Images *in spite of all*: in spite of our own inability to look at them as they deserve; in spite of our own world, full, almost choked, with imaginary commodities.

Georges Didi-Huberman

To encounter the precariousness of another life, the senses have to be operative, which means that a struggle must be waged against those forces that seek to regulate affect in differential ways.

Judith Butler[1]

Documentary photography is a charged, contentious, and essential aspect of any discussion of photography. It is difficult to arrive at a satisfying definition of "documentary" photography because it is not simply about a visual style, however prosaic and supposedly "objective," nor is it a site of reception (there is no one place that we encounter documentary photography). Instead, "documentary" is a term that implies a certain intersection of knowledge and affect; it is at once intelligible and sensible. It is this relation that is constantly being reformulated, debated, and rethought.

A "documentary" image is at once an aesthetic and ethical. These aspects are inseparable; they form of movement, a circuit. The general premise of documentary photography is that photographs stand in a special relation to vision; however, the "vision" of the camera (its "expanding eye") is meant to be detached from any particular viewer.[2] Hence the notion that a documentary image transcends individual interest and subjective bias. But even within the tradition known as documentary photography, the premise that a photograph is a passive recording

of preexisting sights, that the presence of the photographer and the camera itself does not alter the scenes and the behavior of those before them, has not held for quite some time. On the contrary, documentary photography takes as its enabling limitation a mode of address, a rhetoric, that constructs a relation between photographer and image, photographer and viewer, image and viewer. This mode of address is a series in which the photographs are not "pictures" but only structural elements of the "thing itself," which is never grasped or represented as such, only one part of the relation photographer–subject–imag–viewer–discourse. This mode of address is always already a relation to the conventions and means of the medium of photography itself. As Max Kozloff has written, in documentary work the photograph is a witness, but one with all the possible misunderstanding, partial information, or false testament that a "witness" provides.[3]

In general, documentary photography refers to photographers documenting, reflecting, and intervening in local and global conflicts and issues. This type of work flourished in the 1920s–30s and through the postwar period in publications such as *Life* (first published in 1936) and other illustrated periodicals. It was further promoted by the formation of Magnum Photos (an independent documentary photographers cooperative) by Robert Capa, Henri Cartier-Bresson, David Seymour, George Rodger, and others in 1947.[4] Henry Luce, the founding editor of *Life* magazine, was intent on presenting "photo-essays." To this end, he employed some of the marquee names of twentieth-century photography: W. Eugene Smith, Robert Capa, Margaret Bourke-White, and Alfred Eisenstaedt. The prevalence and power of the photo-essay (photojournalism) relied to a certain degree on the invention of new lightweight, fast, 35 mm photographic equipment such as the Leica camera (developed in 1925) and improved printing processes that enabled the cheap reproduction of images in these periodicals.[5] Of course, all documentary practice owes much to the work done as part of the Farms Security Administration (FSA), part of the New Deal in the United States in the 1930s, and to the photo-essay books that this type of work generated, notably James Agee and Walker Evans's *Let Us Now Praise Famous Men* (1941) and Margaret Bourke-White and Erskine Caldwell's *Have You Seen Their Faces* (1937).

The influence of these types of photographic practices is evident in famous documentary series from W. Eugene and Aileen M. Smith's *Minamata* (1975) to Susan Meiselas's *Nicaragua, June 1978–July 1979* (1981) to Mary Ellen Mark's *Streetwise* (1988). These remarkable projects exposed corporate, political, and societal abuses by presenting us with compelling images, ones that use aesthetic strategies to construct critical and ethical statements. In other words, "documentary" is not an end in itself, if by that we understand it as a singular approach that aims at stylistic restraint. There is no image without some aesthetic (pictorial, sensate) qualities. Within the discourse of photography, it was Beaumont Newhall who put forward the position that "documentary" was an approach, a means rather than an end.[6] In particular, Newhall had Evans's work in mind, particularly his *American Photographs* (1938), when he chose to present documentary in this manner. What this approach puts into

play is a row about stylistic choices (aesthetics) and the supposed integrity of the document. (This will be discussed below in some detail.) What we must come to understand is how and why the "idea that a disengaged aesthetic and dispassionate approach produces pictures that are more truthful, because they pretend to be unmediated by a person, has persisted among many critics and historians, despite the fact that Evans's style is just that—a style."[7] In other words, as Brett Abbott explains in the introduction to *Engaged Observers: Documentary Photography Since the Sixties* (2010), "stylistic choices are made not as meaningless garnishes to enliven the presentation of subjects but as an integral part of the photographer's interpretative program, helping to endow the stories with experiential significance," hence "compositional strategies are a tool, not an end, in that process."[8]

Documentary photography demands addressing not only changing, often contradictory, notions of the relation between the photographic image and reality, but also how and why each and every photograph is simultaneously a document *and* a work of visual art. These are not opposing predicates, nor are they entirely isolatable. Rather this double-bind is a primary way that photography initiates a complete reconsideration of the image as such. It is not enough to consider how photography rethinks art because as a new visual object-sign it presents us with a new thought-image that ushers in altogether, new forms of experience.

This understanding of documentary practice is an inescapable part of its "civil contract," which situates our relation to documentary photographs in larger political discourses about citizenship, human rights, and ethics.[9] When confronted with a documentary image, or any image that transmits knowledge about the world and its happenings to us, what is being asked of us? We are being asked to accept a responsibility as a "spectator" for learning how to read and interpret images. Each and every photograph is "much more than what is printed on photographic paper. The photograph bears the seal of a photographic event, and reconstructing this event requires more than just identifying what is shown."[10] As Ariella Azoulay writes, we all, as "civil spectators" have "a duty," a "responsibility toward photography that obliges [us] to recognize that what is in the photograph actually 'was there' and that what is in the photograph is only part of what 'was there', or sometimes is only a point of departure to arriving at what 'was there'."[11] The image is a fold between visible *and* sayable; it is a form of content *and* a form of expression. It demands of us—as spectators—an engagement more than passive seeing; it "entails dimensions of time and movement that need to be reinscribed in the interpretation of the still photographic image."[12] This "civil contract" is by no means only a contemporary phenomenon; on the contrary, it has been "part of the institutionalization of photography in the first half of the nineteenth century" as such it "lies at the foundation of the practice of photography, even when remaining unspoken or when photography is employed without being aware of its existence."[13] If nothing else, this "contract" requires us to understand that our experience, our being with others in the world, is always a process of translation. It forces us to face the fact of the impossibility of our experience being told in its own unique, appropriate language.

In some ways, all of these issues are at work in Lady Eastlake's opinion, expressed in the epigraph above. Her statement about photography is colored by mid-nineteenth-century assumptions, but it also expresses a finer distinction in that it names the "facts" that a photograph makes evident "neither the province of art nor of description" but rather "a new form of communication." This new form of communication, however, is not so easily severed from any linkages to neither art nor "description," both of which comprise what we could call documentary. For within the discourse of mid-nineteenth-century photography there were no clear distinctions between these contradictory yet linked aspects of photography. The popular belief in the objectivity of photography of the time coexisted with a willingness to entertain contrary aspects like spirit photography.[14] Nevertheless, the concomitant flourishing of an industrial economy with Victorian morality did produce a discourse in which the photograph was put to use as a means to present and expose some of the most egregious faults of modern capitalist society.

This instrumental use of photography, referred to a "social documentary," was an extension of its role in European imperialism and colonialism—the "great age of photographic Orientalism"—into a form of "autoethnography" that mixed Victorian sentiment, voyeurism, and, at times, a sense of genuine social injustice.[15] The concluding decades of the nineteenth century witnessed a spate of social documentary projects such as John Thomson's photographs for *Street Life in London* (1877–8) and Arnold Genthe's photographs made with a concealed camera in San Francisco's Chinatown in the 1890s.[16] This representational economy between voyeuristic colonial violence (including tourism) and a form of expository autoethnography results in a complex set of images that Edward Said called a "great fat archive," one that proves problematic for the concept of documentary photography, caught as it is between reportage and voyeurism.

Several of the most canonical examples of social documentary photography were made by photographers experiencing another culture. It is this sense of displacement, curiosity, and often shame that led the recent American immigrants Jacob Riis and Robert Frank to undertake their transformative photographic projects nearly seventy years apart, the former compiling *How the Other Half Lives* (1890) and the latter *The Americans* (1958–9). Admittedly, between these two projects there is a wide gulf in terms of how a photograph-as-document is understood. Both do, however, evince a shared sense that photography deals with the social or, as Lewis Hine wrote, "the problems and activities of life itself'; a photograph is understood by both Riis and Frank as the best way to narrate a story or point of view in "the most condensed and vital form."[17]

In addressing the issues surrounding documentary work we will focus on the aesthetics and ethics of creating and viewing images of suffering, pain, and death that are often the subject-matter of documentary photography. Photographs of this type confront us throughout the mass media in forms as varied as photojournalism (newspapers have printed photos since the 1880s), advertising (consider the infamous Benetton ads of the 1990s), and art. One line that traverses the history of photography, despite all its

bends and fractures, is what has been called "beautiful suffering," that is, what is at stake when photography is used to capture and transmit the suffering and even death of others to viewers far removed from the given scenes of violence. What is the nature and function of this document if it is more than an act of rendering suffering and pain into an aesthetic, contemplative image to be consumed? Examples of photographs that fall into this category are, in fact, some of the most iconic photographs ever made. Consider just two images from 1936 such as Dorothea Lange's *Migrant Mother* and Robert Capa's *Death of a Loyalist Soldier*. Images like these are certainly not restricted to twentieth-century documentary or photojournalistic work. In no less than one of the first photographs ever produced we are presented with an image of death, or at least staged death. More specifically, we are not presented with a photograph as we are given an unparalleled combination of image and text by Hippolyte Bayard in his *Self-portrait as a Drowned Man* (1840).

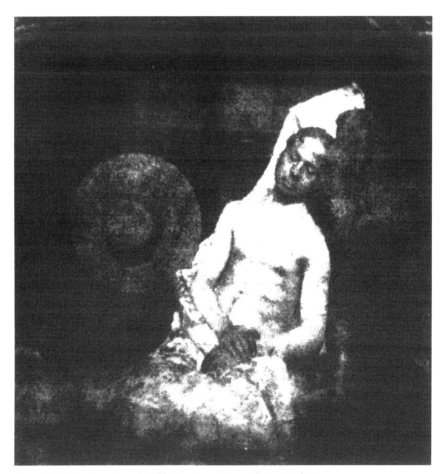

Figure 3.1 Hippolyte Bayard, *Self-portrait as a Drowned Man* (1840)

Bayard's image-text is a postcard whose belated arrival nevertheless had a profound effect. Bayard was one of the most imaginative and brilliant of the first generation of photographers, who thought his achievements fixing images in the camera obscura were overlooked by the French government's formal acknowledgment of Daguerre and Niépce as the "inventors" of record.[18] What he gives us is a remarkable self-portrait, complete with a handwritten explanation or caption on the back of the direct positive print on paper. In the image, Bayard presents himself as a drowned man taken from the Seine that has been curiously propped up in a studio setting replete with props (vase, statuette, well-placed straw hat). The corpse's lower body is draped in a white sheet, whose folds and pleats connote Greco-Roman sculpture. Bayard represents himself as "a thing among other things" (his own words) in keeping with his "association with the Académie des Beaux-Arts, his image overtly refers to classical tradition, specifically to the relief figures seen in sculptural friezes and antique gemstones."[19]

The handwritten statement that completes this strange postcard reads in part:

> The corpse which you see here is that of M. Bayard, inventor of the process you have just seen, or the marvelous results of which you are soon going to see. To my knowledge, this ingenious and indefatigable researcher has been working for about three years to perfect his invention…The government, having given too much to M. Daguerre, said it could do nothing for M. Bayard and the unhappy man drowned himself. Oh! The fickleness of human affairs! Artists, scholars, journalists were occupied with him for a long time, but here he has been at the morgue for several days, and no-one has recognized him or claimed him. Ladies and Gentlemen, you'd better pass along for fear of offending your sense of smell, for as you can observe, the face and hands of the gentleman are beginning to decay.[20]

The subtle wit that Bayard voices with this image-text anticipates an experience that all documentary photographic images desire, that is, the ability to convey a multi-sensory experience. The almost serene beauty of the image itself is countered by the caption, which warns and threatens the viewer that his or her "sense of smell"—which a photograph can in no way transmit—may be "offended." Disparity and experiential confusion rather than clarity of knowledge are fomented by the intersection between image and text. What Bayard puts into play for the discourse of photography, even if his postcard was only belatedly received in the post, is the troubling relation between image and text, photograph and death, presence and absence.

In many ways, the history of photography begins with death. This death not only refers to the claim made by the French painter Paul Delaroche, who purportedly upon seeing a daguerreotype for the first time, claimed that "From today, painting is dead." More importantly, this death, paradoxically, opens a new discourse—photography as "a conceptual economy [with] an identifiable historical and cultural specificity"—that transforms our experience of representation and temporality. Geoffrey Batchen has most thoroughly explicated

what is at stake in Bayard's self-portrait: "a single work that is explicitly all about the practice and implications of photographic representation in general. By undermining the veracity of the photographic image on its reverse, his text seems deliberately to call into doubt the assumed distinction between the literal and the figurative."[21] He continues by adding:

> Here, speaking at photography's origins, speaking *as* photography's origin, Bayard opens a discourse on photography and death, on photography *as* death, that has continued in our own century…[He presents himself] as both subject and object of the photograph, as acting even while acted upon, as a representation that is also real, as self and other, present and absent, dead but also alive, as nature and culture (nature and *nature morte*)—simultaneously both…and for that very reason never simply one or the other…[It] engineers a space of uncertainty, a strategic hesitation, a troubling movement back and forth within the very grain of photography's logic. In this sense, Bayard's ghost haunts not only photography but also the whole of Western metaphysics.[22]

With this last phrase Batchen shifts his reading of Bayard's self-portrait—sent from the first decade of photography—to noting how the work of the French philosopher Jacques Derrida complicates the temporality of any image, any representation. At the "origin" of any representation there is no simple opposition between subject and object, self and other, or representation and "reality." On the contrary, as Bayard's singular self-portrait attests, the photographic image transfigures the real because it refuses any simple distinction between nature and culture, subject and object, self and other, presence and absence. As Batchen explains, photography "embodies precisely the bewildering spatial and temporal play" that Derrida reveals when he deconstructs any form of textual economy, be it political discourse, literary text, or visual text. For Batchen, the uncanny power of Bayard's image-text is its ability to reframe how the history of photography has been conceived (as a linear evolution of cause and effect) as well as how the photograph has been cast as witness and/or evidence.

A photograph wields an uncanny power because it exists in the threshold between artwork and document (evidence, witness). This power results not from a photograph's ability to objectively describe or represent a scene, action, or result (the logic of cause and effect), but rather from its ability to repeat or double the object (whether an individual or scene) before the camera. In fact, even the phrase "before the camera" simplifies things because there is no "before"— as in a temporal sequence or a spatial positioning—rather we are always in the midst of photographs, representations. There is no straight photograph of what is "before the camera" because there is only a constructed image that reveals the "disruptive play" between "nature and culture, real and representation, fixity and transience, observing subject and observed object."[23] Documentary photography is certainly not immune to this "disruptive play." Whether one considers the Victorian shock and dismay over the composite photograph made by Henry Peach Robinson in *Fading Away* (1858) or the digital manipulations of Thomas

Ruff following September 11th, there is no rule by which a photographic image is read as either a document or as an artwork.

Even the use to which the image is put does not serve as a guarantor of intention or meaning. Robert Capa's images, for example, initially appeared in illustrated magazines and newspapers, today they are found in art museums. It is not simply that context matters because it frames how we perceive and read an image. Context does matter. However, what is more significant is that the same photograph can move between these contexts and many more. The photograph is always already both document and artwork; it is forwarded ahead, carrying within itself a anachronistic non-place that we receive time and again in varying presents.

We can take Brassaï's *Sleeping Tramp in Marseille* (1935) as an example. Brassaï is most well-known for his book *Paris at Night* (1932), a series of photographs he made of the demimonde of Paris in the 1920s, and his involvement with the Surrealists (he published several photographs in the journal *Minotaure*). Despite

Figure 3.2 Brassaï, *Sleeping Tramp in Marseilles* (1935)

the success of *Paris at Night*, Brassaï is not considered a documentary photographer because his concerns, stemming from his involvement with the Surrealists, are deemed to be aesthetic, that is, he is read as someone more keen on creating striking or perplexing visual imagery than documenting Montmartre in any serious, anthropological manner. These types of readymade distinctions make it difficult, if not impossible, to read an image such as this one. Here Brassaï frames together an advertisement for salad dressing (or mayonnaise), which occupies the upper two-thirds of the print, with a homeless man sleeping on the sidewalk beneath the advertisement. It is the juxtaposition between the image of the meal and the imagined hunger of the emaciated, homeless man sleeping on a thin outspread of newspaper that serves as both the visual and moral interest of the photograph. The disparity between the advertisement and the "tramp" is too much to reconcile. On one hand, readings of this image tend to focus on the juxtaposition, at times referring to it as "unbearable," but do not call it a social document. On the other hand, they assert that it is not about photography "in the service of a social cause," but rather the work of a "bohemian" photographer.[24] Does this image function as plea for our sympathy? Is this an example of sympathetic social documentary or a Surrealist interest in "objective chance"? Is it meant to make us ashamed, shock us into action, or merely tantalize us with an image that scumbles the line between real and imaginary?

In addition, let us consider another photograph taken two years later: Margaret Bourke-White's *At the Time of the Louisville Flood* (1937), which

Figure 3.3 Margaret Bourke-White, *At the Time of the Louisville Flood* (1937)

was printed in *Life* magazine. There is a similar use of juxtaposition here. In the aftermath of a devastating flood that occurred while the United States attempted to recover from the Great Depression, Bourke-White made this photograph depicting a line of African-Americans waiting for relief goods and support. The brutal contrast between the billboard depiction of a white American family smiling contentedly as they drive through an idyllic countryside under a banner with the boast "World's Highest Standard of Living" and the line of African-Americans, whose direction renders the slogan ("There is no way like the American way") on the far right of the billboard either parody or horrible irony. The line of weary yet patient men, women, and children in the foreground encourages one's eye to move left to right, from the paired faces of the white terrier with his head out of the car window in the billboard and the African-American boy with the aviator hat and blank stare to what awaits them, that is, the "American way." The benefits of this "American way" are left suspended by Bourke-White.[25] Will the hungry and displaced people waiting in line be helped or abandoned? (Bourke-White's photograph eerily foreshadows some of the most dejecting images taken in the aftermath of Hurricane Katrina in New Orleans in 2005.)

Which photograph is documentary and which art? How would one define and articulate the difference? Is it in how the images are constructed or how they are read? It does not appear to be dependent on the subject matter. How far are we to push the biographical information we know about each photographer? Does the fact that Bourke-White made this photograph when commissioned by *Life* magazine decide the issue? As John Tagg explains in the 1930s and 1940s Bourke-White's photographs "arrived like postcards home from the airplane-hopping career of the woman *U.S. Camera* called 'the most famous on-the-spot reporter the world over'."[26] He adds that the context in which the photograph was presented is also of note because when it appeared in *Life* in 1937 it was "anonymous."[27] Tagg elaborates that the "viewpoint" of the photograph is neither "a subjective, located space" nor does it insert the viewer "into a rhetorical immediacy."[28] In his reading of Bourke-White's photograph, Tagg ultimately decides that it is "not a 'documentary image'" because, for him, documentary, particularly New Deal documentary in the USA in the 1930s, always involved a "point of capture" in which the viewer was exposed to and inscribed within "the rhetoric of recruitment." Bourke-White's photograph here is not documentary because "it does not demand the enactment of the viewpoint as a psychic space, a point of identification at which the viewer is interpellated into the dramaturgy of the image and compelled to 'the place of decent seeing'."[29] So one marker of a documentary photograph may be that it demands the viewer take up a certain, acute and engaged, point of view: a point of identification or psychic relation with the subject(s) depicted in the document.

Tagg's definition of documentary is astute, but it does, as he himself has addressed, run into difficulties with certain photographs, such as those created by Walker Evans in the 1930s.[30] Evans is one of the most perplexing cases when it comes to discerning the distinctions not only between art and documentary, but perhaps between different documentary practices as well. Between 1935–7 Evans worked for the Historical Section of the FSA, but his photographs for this assignment never achieved the stature that ones such as Dorothea Lange's *Migrant Mother* did. The reason being that Evans's work is often of the commonplace and the ephemeral rather than iconic. His images of commercial signs, posters, and vernacular architecture simply do not lend themselves to the types of viewers or readings that the FSA desired for their documentary work. In other words, it did not participate fully and successfully in the "rhetoric of recruitment" Tagg explicates. Photographs such as *Allie Mae Burroughs (Alabama Tenant Farmer's Wife)* (1936) are quite uncommon in Evans's oeuvre. More frequently one encounters more deftly constructed images that require complex readings such as *Graveyard, Houses, and Steel Mill, Bethelem, PA* (1935). Although it proved a difficult fit for the agenda of the FSA, Evans's work presented a practice that rejected fine art photography (he and Berenice Abbott despised Pictorialism and Alfred Stieglitz's Photo-Secession as "arty" and pretentious) even as it problematized the notion of documentary as "the dramatic presentation of fact," to borrow Beaumont Newhall's definition.

Evans neither desires nor presumes to achieve the idealism of art; rather, he utilizes documentary work as a means to present images that are indiscernible as either art or documentary much like we find in the work of Eugène Atget. This is why Evans's work has remained so reticent and so prescient. It stems from his intense interest in Atget as much as his dislike of Edward Steichen and any photography that is consciously trying to be art. As Evans himself said, "That thing I'm always talking about (documentary style) shows a purity, a rigor, a simplicity, an immediacy, a clarity which are arrived at through the absence of pretension to art."[31]

In his early essay "The Reappearance of Photography" (1931) it is evident that Evans arrives at this position—documentary as a means—via a thorough understanding of photography both historically and in his own context. Unlike, for instance, the highly subjective, formal experiments by Moholy-Nagy, who emphasized rejecting the past in order to arrive at a "new vision," Evans does not reject earlier photographic work, even that not deemed art such as Lewis Hine's social documentary work. Instead, he works to trace a new line through the field, one that positions Atget's work as a key node or turning point. Furthermore, by rejecting Steichen's "technical impressiveness and spiritual non-existence" and Albert Renger-Patzsch's "photo method" as shallow and disappointing, Evans heightens the importance of Atget and, by extension, August Sander, "one of the futures of photography foretold by Atget."[32] What Evans learns from Atget is a lyrical understanding of the street, how to observe it without intervening in it, how to capture the façade of a building or storefront as a bloc of sensations, and how to develop an eye

for detail that renders the image "a document of the *now*."[33] Through an artistic apprenticeship with Atget, Paul Strand, and others, Evans constructs a modern practice in which documentary is a style or means rather than an end in itself.

With documentary as a starting point, Evans comes to occupy a primary place in the history of photography: he presents us with a signature style that reads as anonymous or subject-less. As Gilles Mora writes, Evans continually confronted "the question of anonymity" by rigorously attempting to free photography from "the aesthetic of a subject."[34] Therefore, Evans forwards "straight" photography as not only highly detailed images in sharp focus, but as a "more impersonal kind of affirmation, a noble reticence, a lucid understatement."[35] "Neither in the impersonal architectural still lifes of American facades," as Susan Sontag writes about his work, "nor in the exacting portraits of Southern sharecroppers he took in the late 1930s" was Evans "trying to express himself."[36] This impersonal process is evident in the experiments Evans made by hiding a Contax camera under his coat and taking snapshots of people on the New York City subway between 1938–41 as well as in his now canonical achievements such as *American Photographs*.

The collection of images that comprise one of the most important photography exhibitions and books, *American Photographs* (1938), reflect Evans's impersonal, indeterminate practice. If the *American Photographs* exhibition at MoMA is one of the most significant twentieth-century achievements of photography as art, then it is so not because this type of practice was immediately recognized as valuable. Rather, it is due to a determined effort on the part of Evans and others who championed his work to alter the discourse of documentary in the 1930s. In "A Genealogy of Orthodox Documentary" John Stomberg convincingly shows how the exhibition was the end result of an ad campaign and published essays that sought "to define the dominant mode of late 1930s photographic practice so that it more clearly supported the idiosyncrasies of Evans's particular style."[37] Quite consciously downplaying other documentary work from the time, most notably and vehemently the work and the success of Bourke-White, Evans and others "presented their aesthetic preferences as ethical principles, arguing that some formal approaches to photography were inherently morally superior."[38] Those "formal approaches," not surprisingly just happened to be those deployed by Evans and the genealogy of photography he constructed.

However, if we consider a photograph exhibited at MoMA in this exhibition such as *Torn Movie Poster* (1930) (see page 94), what can we say about Evans's aesthetic choices? Is this work more like the Bourke-White image above, despite Evans's antagonism towards her, or is it more in line with Brassaï's, who is closer perhaps to Evans's ideal, Atget? Does Evans's photograph function differently? Does one ever reach a meaning? Perhaps Tagg's summation is helpful here: "For Bourke-White, meaning must be delivered and the viewer must take receipt. In Evans's image, meaning is held back, seemingly less by the photographer than by the objects themselves, from which the viewer is cut

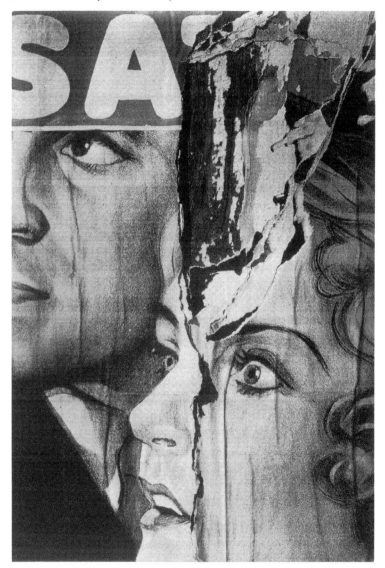

Figure 3.4 Walker Evans, *Torn Movie Poster* (1931)

off by an uncertain distance that reintroduces the presence of the lens between the eye and the scene."[39] At minimum, what we must discern in an image like this one is precisely what makes Evans so pivotal in the history of photography. He grasped some disparate lines of photography that came before him, notably Atget and Hine, and in doing so he created a new photographic line that anticipated the "snapshot aesthetic" of the 1960s and 1970s, in particular the work of Robert Frank, Lee Friedlander, Garry Winogrand, and others.

It is uncanny to view a collection of Evans's work because it refracts Strand and Frank (see *New York*, 1929–30), Sander and the Bechers (see *Wooden Churches, Southeast* (1936)), Atget and Friedlander (*Gas Station, Reedsville, West Virginia* (1936)). What links these disparate practices is Evans's photography, which presents the intelligible world as "a world of representation, and the proliferation of representation open on the abyss of the real" because the camera is "a portal to a world that has no message, that is addressed to no one."[40] It is thus not coincidental that Evans's project with James Agee, *Let Us Now Praise Famous Men* (1941) was reprinted in 1960, thereby allowing it to re-enter another context in which debates about photography and documentary practice were reanimated and heated.[41] As much as Beamont Newhall played a role in exhibiting *American Photographs* at MoMA, John Szarkowski played an equally important one in foregrounding Evans's work as he curated shows such as *New Documents* at MoMA in 1967, which included Friedlander, Winogrand, and Arbus. As Winogrand understood it, Evans's photographs are "about what is photographed, and how what is photographed is changed by being photographed, and how things exist in photographs."[42]

It is not surprising, then, to find Evans at the center of the discourse surrounding the *New Documents* exhibition. In addition to the indeterminacy of meaning and even the melancholy that Evans's work possesses, Szarkowski noted how Evans's work is "rooted in the photography of the earlier past and constitutes a reaffirmation of what has been photography's central sense of purpose: the precise and lucid description of significant fact."[43] But what we have seen is that Evans's work, contrary to Szarkowski's statement, is reticent and patently unclear about the "fact" it is representing or describing. Nonetheless, this same reticence and self-reflexivity is found throughout the work Szarkowski included under the banner of "new documents."

The connections and differences between Evans's practice and the generation of postwar American photographers are best presented by Sontag when she positions the figure of Walt Whitman, the nineteenth-century American poet, as a pivotal figure in the genealogical line from Stieglitz to Evans to Arbus. Giving attention to Whitman is a brilliant move, not only because it reveals how the discourse of photography is dispersive rather than reducing itself toward some essence. Sontag notes that Evans chose an epigraph from Whitman to open his *American Photographs*: "I do not doubt the majesty & beauty of the world are latent in any iota of the world…I do not doubt there is far more in trivialities, insects, vulgar persons, slaves, dwarfs, weeds, rejected refuse, than I have supposed."[44] What Sontag identifies by turning her attention to the Whitman epigraph is the anti-Platonic movement of the "new documents" generation in the 1960s. Rather than striving to attain an ideal form of beauty or spirituality that transcends life (the everyday, the commonplace), Whitman fractures the ideal and finds it within the smallest piece of life as such. Whitman's poetry requires an affirmation of life as such, in all forms, in an unending process of becoming. However, Sontag argues that although "new documents" photographers such as Frank, Friedlander, Winogrand, and

others, were motivated by the idea that no moment is more important than any other, no person is more interesting than an other, they present us with a "parody of Whitman" because they are no longer creating images that "as they emit themselves facts are showered with light" (Whitman). Instead, these photographers demystify the world about them: "among American photographers who have matured since the Second World War, the Whitmanesque mandate to record in its entirety the extravagant candors of actual American experience has gone sour. In photographing dwarfs, you don't get majesty & beauty. You get dwarfs," Sontag asserts.[45] While she positions Evans as the last photographer to work in light of Whitman's "euphoric humanism," Sontag identifies Stieglitz and Photo-Secession as the turn that moved American photography "from affirmation to erosion, to finally, a parody of Whitman's program."

The work that Stieglitz produced and promoted through his journal *Camera Work* (published 1903–17) and his galleries (291 and An American Place) certainly had a basis in Whitman's work. Not in terms of the emphasis on photography as a medium that was distinct from painting, but in terms of Stieglitz's belief in the transformative effects of photography. Photography, he insisted, could redeem the lowly and commonplace by transfiguring it as art, that is, the photographer-as-artist could transfigure both commonplace, material objects and the medium of photography itself (a mechanical, modern means) by reference to spirituality. As Sontag tells us, "Steiglitz, pledged to redeem the world with his camera, was still shocked by modern material civilization."[46] For example, in Steiglitz's *The Flatiron Building* (1903) the modern architecture is transformed into a weightless, immaterial, evanescent figure by the natural world (the fragility of the bare trees and the shimmers of a light snow fall). Sontag posits that here we have stepped away from Whitman's affirmation of change; his belief in oneness in diversity. I agree with Sontag because one only has to recall Stieglitz's later photographs of New York City, almost always taken from vertical (elevated) vantage points looking down or across the cityscape where the buildings become nothing more than a series of formal relations: the vitality and chaos of the city transcended into a Platonic *hyperouranion topon*, a place beyond the heavens, a heavenly world of forms.[47] "The Whitmanesque appetites," Sontag rightly claims, "have turned pious: the photographer now patronizes reality."[48]

The aim of Sontag's critique, however, is not Stieglitz, "the man who believed that a spiritual America existed somewhere, that America was not the grave of the Occident," but those who she believes do consider it "the grave of the Occident." Sontag aims at photographers whose work in the 1960s and 1970s is imbued with an inescapable "melancholy." Those who "without Whitman's delirious powers of synthesis," document only "discontinuity, detritus, loneliness, greed, sterility." She is direct in her critique when she says that "the implicit intent of Frank and Arbus, and many of their contemporaries…is to show that America *is* the grave of the Occident."[49] Here Sontag overreaches. Her argument perhaps applies best to Arbus, whose work Sontag discusses in detail, but when it comes to Frank it is just as easy to read

the melancholy and disconnectedness that pervades the America he witnesses and constructs as it is to read an intense empathy and "democratic vista," as we find in Whitman. Nonetheless, it is interesting to remain with Sontag and Arbus because Arbus's project, which creatively problematizes the category of documentary, has proven undeniably influential. Without Arbus, it is hard to imagine Nan Goldin's *The Ballad of Sexual Dependency* (1986) or Larry Clark's photographs of Tulsa "speed freaks," for example.

Arbus is one of the pioneers of the "new" documentary style that emerged in the late 1960s and 1970s. Her work focuses on "freaks" (her term), be they circus performers, prematurely adult teenagers, mixed-race couples, the mentally challenged, transvestites, nudists, twins, etc.[50] Her photographs drew immediate attention from the artistic community. Notably, she was awarded Guggenheim Fellowships in 1963 and 1966 to continue her work. However, in July 1971 Arbus took her own life in Greenwich Village. The following year she became the first American photographer to have work exhibited at the Venice Biennale. In the same year a major retrospective at MoMA traveled throughout the USA and Canada and was viewed by over 7.25 million people. Although her work was often compared with that of Sander, whose work *Men Without Masks: Faces of Germany 1910–1938* expressed similar concerns but in a perhaps less ruthless manner, and that of Weegee, particularly his shocking and raw *Naked City* (1945), which is singular in its exposed voyeurism, Arbus's photographs "suggest a naiveté which is both coy and sinister, for it is based on distance, on privilege, on a feeling that what the viewer is asked to look at is really *other*."[51] The rub is that Arbus effaces this exposure of otherness, the giddy shame of this work, by creating photographs (a frontal, almost oppositional pose of her subjects, a way of lighting them) that makes her subjects complicit, seemingly offering themselves up to the gaze of the viewer. Even though most of the subjects return the gaze of the photographer and, by extension, the viewer, the complexities of voyeurism persist.

As Arbus herself said of her pictures:

> What I am trying to describe is that it's impossible to get out of your skin and into somebody else's. And that's what all this is a little bit about. That somebody else's tragedy is not the same as your own…Freaks was a thing I photographed a lot. It was one of the first things I photographed and it had a terrific excitement for me. I just used to adore them. I still do adore some of them. I don't mean they're my best friends but they made me feel a mixture of shame and awe. There's a quality of legend about freaks. Like a person in a fairy tale who stops you and demands that you answer a riddle. Most people go through life dreading they'll have a traumatic experience. Freaks were born with their trauma. They've already passed their test in life. They're aristocrats.[52]

Reading this statement one is left with many questions. Is voyeurism an inescapable aspect of any documentary photographic project? If Arbus is bringing an "other" culture (or subculture) into the view of mainstream, why? For what

reasons? Curiosity? Do these images transgress socio-cultural norms? Do they puncture the conceits of politeness? To what extent does Arbus identify with her subjects? Is photography capable of making connections between people? Do viewers identify with her subjects?

Within Arbus's project the photographer is conceived as a figure of privilege. She has access to these subcultures. Simply put, Arbus is not documenting people on the street; rather, she frequently gains access (through friends, introductions) to their private, intimate spaces. The most pressing question remains whether or not Arbus's images are able to convey to the viewer whether she is looking for sameness, homogeneity, or difference, an insurmountable difference that underlies every identity? How Sontag answers this question is clear. She is adamant that all Arbus's subjects "are equivalent" and therefore "making equivalences between freaks, mad people, suburban couples, and nudists is a very powerful judgment... Instead of showing identity between things which are different (Whitman's democratic vista), everybody is shown to look the same."[53] Even more exacting is how Sontag summarily exposes so many of the discursive lines (tourism, anthropology, urban ennui, archival practice) that course through Arbus's project and, by extension, this entire notion of "new documents."

> The camera is a kind of passport (for Arbus) that annihilates moral boundaries and social inhibitions, freeing the photographer from any responsibility toward the people photographed. The whole point of photographing people is that you are not intervening in their lives, only visiting them. The photographer is supertourist, an extension of the anthropologist, visiting natives and bringing back news of their exotic doings...The photographer is always trying to colonize new experiences or find new ways to look at familiar subjects—to fight against boredom.[54]

What is intriguing is how Sontag's criticism here has shared points of reference with other critiques of documentary. One important critique of the notion of documentary, one that shares a serious skepticism about the category "new documents," but one whose ultimate aim is quite different from Sontag's, is Martha Rosler's "In, Around, and Afterthoughts (On Documentary Photography)" (1989).

Rosler focuses on the Bowery in New York City, a skidrow that has often been the subject of documentary photography. As she rightly says, "the site of victim photography in which victims, insofar as they are now victims of the camera—that is, of the photographer."[55] By retracing the discourse of documentary photography from Jacob Riis to New Deal liberalism to Arbus, Rosler asks: "How can we deal with documentary photography itself as a photographic practice? What remains of it? We must begin with it as a historical phenomenon, a practice with a past."[56] She highlights, for example, the ineffective, Eurocentric voyeurism of Edward Curtis's "documentary" photographs of the North American Indian, that is, of a "vanishing race," which were in fact not documents at all, but rather staged, propped, and performed—a "sentimental Pictorialism" Rosler calls it. In her essay she arrives

at two interrelated "moments" in the discourse of documentary photography. One being instrumental: an image is caught or created from the present and then presented a testimony (as a document or evidence) arguing for or against a social practice and its ideological supports. This includes "the 'artless' control motives of police record keeping and surveillance."[57] The second "moment" is the "conventional 'aesthetic-historical' moment, less definable in its boundaries, in which the viewer's argumentativeness cedes to the organismic pleasure afforded by the aesthetic 'rightness' or well-formedness (not necessarily formal) of the image."[58]

It is this second moment that reveals Rosler's own anti-aesthetic position and her ultimate call for a "radical documentary" practice. A call made in part through a critique of the "new documents" photographers. Rosler's position is that this type of work, a "line that documentary has taken under the tutelage of John Szarkowski," is "dangerous" because (1) it is an appreciation of images rather than an interrogation of the "dialectical relation" between political and formal meaning; (2) the "aesthetic aspect" of this work is "enhanced by the loss of specific reference."[59] In making her points Rosler cites Szarkowski's introduction to the *New Documents* exhibition:

> Most of those who were called documentary photographers a generation ago…made their pictures in the service of a social cause…to show what was wrong with the world, and to persuade their fellows to take action and make it right…A new generation of photographers has directed the documentary approach toward more personal ends. Their aim has not been to reform life, but to know it…*What they hold in common is the belief that the commonplace is really worth looking at, and the courage to look at it with a minimum of theorizing.*[60]

The source of Rosler's invective is found here. For her, it is not "courage" at all that these photographers exhibit; instead, it is cowardice or, at minimum, a naiveté (as Sontag suggested). For Rosler, this "minimum of theorizing" is precisely what renders this type of documentary practice fragile and ineffective. Moreover, it makes this work complicit with the demands of the market (the "gallery–museum–art–market nexus" she terms it). The critique levied at Winogrand, Frank, Arbus, Bruce Davidson, and others whose images have "more personal ends" is that their work is part of "a general movement of legitimated photography discourse to the right—a trajectory that involves the aestheticization (consequently, formalization) of meaning and the denial of content, the denial of the existence of the political dimension."[61]

Again the opprobrium works through a propping up and tearing down of "aestheticization" in which the aesthetic and formalism are putatively synonymous. This false equivalence between the aesthetic (or aesthetic strategies, effects) and formalism is a key move in the anti-aesthetic position. A position which attempted to refute the simple commodification of photography as art in the 1980s, but in doing so went too far. Even if this false equivalence works for a photographer like Winogrand, who claimed that images can mean anything as

long as all meaning takes place within the frame of the photograph, it is much more difficult to read Frank or Davidson or Susan Meiselas in this manner. Yet Rosler has criticized Meiselas's use of color film in her Nicaragua project. In a review of Meiselas's project, Rosler warned of "the dangers of conflating art and journalism" and she viewed the use of color as "incompatible with depictions of atrocity and as catering to sensation, exoticism, and commercial interests."[62] Rosler's focus on the use of color film precludes trying to comprehend Meiselas's decision to use it. She chose color film "not simply to make the images electrifying, but because she felt it better captured and conveyed the spirit of the revolution as she experienced it."[63]

This notion of the aesthetic as the formal or, to be fair to Rosler's phrase "well-formedness," is at work in Sontag's position as well.[64] Both she and Rosler agree on the genealogy they present for Arbus and others, one that emphasizes the role of Henri Cartier-Bresson and Brassaï—whom Rosler terms a "bohemian photographer"—rather than socially-engaged precursors. Sontag discusses Cartier-Bresson's version of Surrealism by reiterating his warning that "the thing to be feared most is the artificially contrived."[65] This is part of the equation of aesthetization that Rosler forwards. The "artificially contrived" is indissolubly paired with a reactionary, politically impotent, "pious...respect for things as they are."[66] For Rosler, the remedy for this situation is a "radical documentary" that neither presents generalized, supposed universal statements on the "human condition" nor creates images that are easily commodified by the gallery-museum system. On the contrary, she posits a practice in which documentary is "incorporated into an explicit analysis of society and at least the beginning of a program for changing it."[67] Remarkably, she writes that the "germ" of this radical or other documentary coexists with and perhaps within the shortcomings of the form of documentary we currently have: "The documentary of the present...coexists with the germ of another documentary—a financially unloved but growing body of documentary works committed to the exposure of specific abuses...by racism, sexism, class oppression, works about militancy, about self-organization, or works meant to support them."[68]

Figure 3.5a Martha Rosler, *The Bowery in Two Inadequate Descriptive Systems* (1974–5)

Figure 3.5b Martha Rosler, *The Bowery in Two Inadequate Descriptive Systems* (1974–5)

An example of Rosler's own practice that works toward these goals is her *The Bowery in Two Inadequate Descriptive Systems* (1974–5). Its presentation strategy extends the Conceptual art practice black-and-white photographic document juxtaposed with typed text (here a list of slang words for being drunk). The disjunction between image and text is key because the photographs never depict people (the homeless or alcoholics who sleep on the streets of the Bowery). Instead, the images show empty bottles, traces in effect of what occurred or of who was there. Here the photograph as document is challenged because it documents not what is before the camera, but what is absent. It is a trace of a trace, evidence of evidence. The text provides a series of captions for the photograph, thus framing and characterizing the evidence. Both representational systems are limited and ultimately fail to provide an account of anything meaningful: the context, the location or site (the Bowery), or the people who left these traces. It is an "act of criticism," Rosler explains, that did not aim to evoke concern or pathos in the viewer (as traditional documentary practice did); rather, it was meant to redress the necessary limitations of any representation as translation, as tendentious.

Let us note the difference between Rosler's approach and Sherrie Levine's *Untitled (After Walker Evans)* (1979). Levine selected twenty-two images by Evans that he made while working for the FSA between 1935–8. She then re-photographed the images as they were presented in a catalogue of Evans's work. These appropriated, new images were then presented at Levine's solo exhibition at the Metro Pictures gallery in New York City in 1981. These images were received with "a mixture of excitement and outrage."[69] Levine's practice, as evidenced by this example, is commonly referred to as appropriation art. This term refers to re-photographing and re-presenting a real object or a pre-existing work of art into a new context. This practice has precedents in Synthetic Cubism, Duchamp's readymade strategy, and Surrealist found objects. In the late 1950s appropriated images and objects appear

extensively in the work of Jasper Johns and Robert Rauschenberg, Pop art, as well as in Assemblage art practices. However, with the advent of postmodernism, appropriation practices became a primary means to challenge the ideas and myths of modernism. The aim of this form of practice being to create a new situation, and therefore a new meaning or set of meanings, for a familiar image. Appropriation art raises questions of originality, authenticity, and authorship. It is one tactic of the anti-aesthetic because artists forego art as self-expressive, original, and unique in order to salvage its ability to present a political critique.

The ways in which Levine's images stage this critique are more indirect and theoretical even, than Rosler's Bowery series or her equally well-known *Bringing the War Home* (1967–72), a series of photomontages in which brutal images of death and violence from the Vietnam War were inserted into interior design photographs of ideal American suburban homes. She reiterated the series nearly forty years later to address the Iraq War in *Gladiators* (2005). Both of these series operate through a Brechtian alienation effect because the jarring juxtapositions demand awareness: they strike against complacency, indifference, and habit. As Rosler has said of herself and her peers who undertook similar work called "new social documentary," "we wanted to be documentarians in a way that documentarians hadn't been. As readers of Brecht, we wanted to use obviously theatrical or dramatized sequences or performance elements together with more traditional documentary strategies, to use text, irony, absurdity, missed forms of all types."[70] This faith in intercutting imagery and text is part of the legacy of the modern avant-garde, in this case particularly John Heartfield's Berlin Dada photomontages that spoke out against the rise of Nazism in the mid-1930s such as *Hurrah, the Butter's Finished* (1935).

It is telling that when discussing one of Rosler's strongest works, *Bringing the War Home*, and its shared assumptions with avant-garde practice from the 1920s and 1930s, we are confronted by the inescapable aspect of *an image as an image*, one that has visual effects. This aspect is irreducible to any questions of formalism. These questions have returned to the forefront of the discourse recently because of a plethora of new photographic and photographic-based works that address the problematic of our relation to images of suffering and death, violence and dehumanization. Any conversation about these issues is not at all new; rather, it is a conversation dispersed throughout the discourse of photography from its inception. Consider the heated debates around some of the earliest images of war, whether Roger Fenton's *The Valley of the Shadow of Death* from the Crimean War in 1855 or the photographs made by Matthew Brady and members of his staff of the American Civil War.

From the beginning "official" war photography involved staging scenes, moving dead bodies; in short, creating images with certain ideological and/or sentimental ends in mind. This is certainly the case for Fenton and Brady's studio.[71] This desire to see the violence—the impossible "reality" of war—was also expressed on the part of the consumer. In a statement from 1859 that is disconcerting in its excited anticipation, Oliver Wendell Holmes hoped that the "next European war will send us stereographs of battles. It is asserted that a bursting

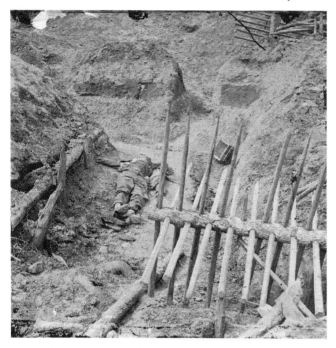

Figure 3.6 Matthew Brady (or staff), *Petersburg, Va. Dead Confederate soldier, in trench beyond a section of chevaux-de-frise* (1865)

shell can be photographed. The time is perhaps at hand when…[we] shall preserve the very instant of the shock of contact of the mighty armies that are even now gathering."[72] The psychological reasons for this desire to see death and destruction are complex, but those reasons are not at the center of the most recent return to these issues. Rather, the debates in the 1970s and 1980s about documentary and aesthetics have been reanimated as photographers have created images of suffering that have been criticized for "aestheticizing" the pain of others.

It is wise to measure the distance here from early documentary images, even before addressing the "return of aesthetics." The debilitating power of an image like George Rodger's photograph of the Bergen-Belsen concentration camp in April 1945, an image that beggars description and whose solicitations to us, as human beings endowed with memory, may fail. This is an image whose power comes from the *unimaginable* arrangement of facts: the idyllic forest setting cut by the rows and rows of bodies lining the road cut by the boy walking that road, straining not to look to his left. My description here is as much a representation as the photograph itself. Yet Rodger's photograph possesses something *in* the image itself that we will never encounter in a verbal description. It is an inquiry into what this something *in* the image is that has instigated a rethinking of the anti-aesthetic position. Therefore, we must ask after what lies between a photograph such as Rodger's and Sebastião Salgado's *Serra Pelada, Brazil* (1990)?

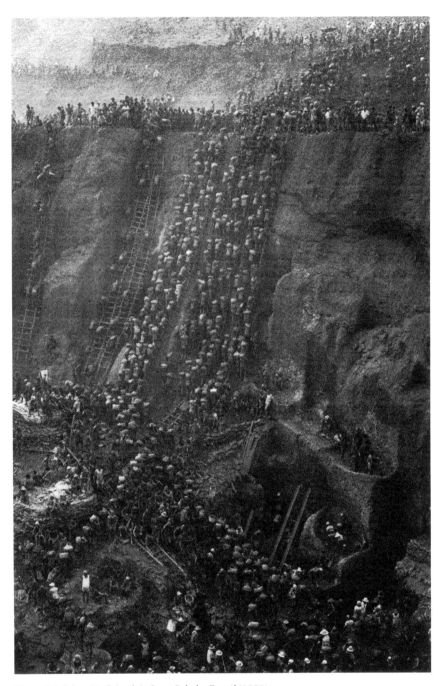

Figure 3.7 Sebastião Salgado's *Serra Pelada. Brazil* (1990)

Salgado's color photographs from the Serra Pelada goldmine in Brazil are examples of recent documentary work, work that has been criticized for being "aesthetic" and thus irresponsible, even "dangerous" in Rosler's terms. But why? Is Rodger's photograph capable of conveying context whereas Salgado's is not? Are the two photographs different in kind or different in degree? Does slandering the Salgado as "aesthetic" enhance or detract from our engagement with the subject matter with which he is concerned?

These questions were raised in a remarkable exhibition entitled *Beautiful Suffering: Photography and the Traffic in Pain* (2007). In a catalogue essay, "Picturing Violence: Aesthetics and the Anxiety of Critique," Mark Reinhardt sets out to challenge the oversimplified notion of "aestheticization" that has been voiced by Abigail Solomon-Godeau, Allan Sekula, back through the Frankfurt School, including Benjamin's "The Author as Producer" (1934). This position, as we have seen, claims that "aestheticizing suffering is inherently both artistically and politically reactionary, a way of mistreating the subject and inviting passive consumption, narcissistic appropriation, condescension, or even sadism on the part of viewers."[73] Reinhardt stages this challenge as he examines work such as Thomas Ruff's appropriation of Patrick Sison's Associated Press photographs of the World Trade Center on September 11th and Alfredo Jaar's *The Eyes of Gutete Emerita* from *The Rwanda Project* (1996). In trying to work with these images Reinhardt admits:

> I have come to doubt that "aestheticization" is an entirely satisfactory—or even altogether coherent—concept for addressing what might be problematical in photographs of suffering…I explore the conceptual limits of the idea of aestheticization and the anxieties that underwrite it—anxieties that, I contend, ultimately prove to be about the very nature of photographic representation itself…[Aestheticization is] an overly blunt tool for getting at what is most troubling about certain photographs of suffering people…The consistent charge is that the aesthetic satisfaction of the images is a source of the pictures' failures to provide genuine understanding of the situations and suffering of those pictured: the aesthetic qualities are often cited as causes of the pictures' tendency to misdirect the viewer's attention, to place the emphasis of the glance on the quality of the image or, at least, to leave us with not much more than a sense of how striking the sufferers look in their moments of affliction.[74]

What Reinhardt challenges here are the presuppositions operative in the anti-aesthetic position, notably the putative ironclad distinction between the purely visual/aesthetic and the critical as well as the oversimplified separation of aesthetics and ethics. In a persuasive essay that reconnects with theoretical work by Barthes, Jacques Rancière, and others, Reinhardt refuses to debase and weaken the visual for the sake of the textual or discursive; instead, he wants to ask how and why an image—the visual—can do the work of critique, be it ethical or political.

For example, he provides a detailed reading of Allan Sekula's influential essay "Dismantling Modernism, Reinventing Documentary (Notes on the Politics of Representation)" (1976). Sekula dissects the rhetoric of "objective" reportage that simplifies social dimensions and seems to "naturalize the eye of the observer." A consequence being that when "documentary is officially recognized as art" all questions of reference are displaced by expressionism and the attention of the viewer "is directed toward mannerism, toward sensibility."[75] Here the shared terrain of Sekula and Rosler is evident. In fact, Sekula's example of engaged documentary practice is Rosler. Hence he calls for a more epistemologically complex, politically subversive approach to both the making and the exhibiting of photographs: "Documentary photography has amassed mountains of evidence. And yet…the genre has simultaneously contributed much to spectacle, to retinal excitation, to voyeurism, to terror, envy and nostalgia, and only a little to the critical understanding of the social world."[76] What Sekula, drawing on Benjamin's and Brecht's call for an image-text that "wrenches it [the photograph] from modish commerce and gives it a revolutionary use value" (Benjamin), desires for artists is to "openly bracket their photographs with language" thereby going "beyond the meaning offered by the images themselves."[77]

Reinhardt's take on Sekula is to question the efficacy of denigrating the visual. He focuses on Sekula's use of the phrase "retinal excitation" and sees in it an echo of Duchamp's critique of "retinal flutter" and retinal pleasure. For Reinhardt, visual pleasure "names…a recurrent anxiety in those who write about photography and suffering, an anxiety about the relationship among vision, aesthetics, and understanding."[78] Reinhardt gives Sekula his full due, explaining that the insight offered by the critical postmodern position that an image's possible meanings are produced within a "broader economy of statements and discourses (which, surely, include other images as well as written texts)" is invaluable.[79] Nonetheless, the manner in which the visual is narrowly theorized and presented as resolutely divorced from any critical or ethical potentiality remains problematic. "Much of Sekula's argument," Reinhardt explains, "appears to rest on a distinction between the purely visual or aesthetic and the critical or metacritical, and to worry about the capacity of the former to produce the latter. Even when explaining how an image *can* do the work of critique, challenging both prevailing social relations and the perceptual codes that sustain them, Sekula turned to text."[80] The key question he poses: "Is there not something in images that resists or eludes every effort to fix meaning through language?" In asking this question Reinhardt neither reasserts a formalist position nor does he contend that the insights offered by the anti-aesthetic position were irrelevant. Far from it. Thus it is only to the threshold between the aesthetic and ethical that Reinhardt returns in order to rethink the concept of the aesthetic.

For example, Alfredo Jaar's *The Eyes of Gutete Emerita* (1996). Jaar visited Rwanda in the immediate aftermath of the 1994 genocide, interviewing and photographing many people he encountered. This research culminates in *The Rwanda Project*, a series of works presented over seven years (1994–2000). *The Eyes of Gutete Emerita* is an installation with a temporal structure. The viewer

enters a room with bare black walls illuminated only by the glow of the twin light boxes placed side by side. As Reinhardt describes it, the text offers brief accounts of Rwandan genocide, of her experience (she watched her husband and sons murdered in front of her), and of Jaar's encounter with her. This text comes in three installments, each one shorter than the one before—ten lines per box, then five, then one. Jaar keeps each message on screen for far more time than is needed to read it (45 seconds, then 30, then 15). After the final lines, "I remember her eyes. They eyes of Gutete Emerita" the text gives way: Emerita's eyes flash on screen for the briefest of instances...then they are gone, and immediately the piece begins again.

Jaar explains the pace of the work as an attempt to alter the viewers' habits who move from work to work, image to image far too quickly. The slowness of the text is deliberately frustrating and viewers grow impatient. It is an aesthetic experience Jaar constructs, one that is about temporality, memory, attentiveness, an ethical encounter of apprehension. He does *not* show or reconstruct any acts of violence or suffering; he only shows us the eyes that witnessed what we will never experience or understand, that is, precisely what we must learn to construct a relation to. Neither is Jaar's own subjective position as an interviewer, as a researcher, or as an artist outside of the parameters of the installation. We are presented with Jaar's visual memory. He makes evident his relation to the subject neither by appropriating her story or experience nor by resorting to some notion of the sublime or inexpressible. Rather, Jaar marks the limit of representation in a pragmatic way, one that does not foreclose on the visual as a political, ethical, and cognitive contested ground. It is through aesthetic strategies that Jaar presents the "language of events": time, memory, representation, affect. In short, Jaar reminds us that the visual is always more than the visible.

Reinhardt values Jaar's project because he reads the work as an indictment capable of confronting "genocide in a manner at once pointed and elliptical; his work is about seeing and the failure to see and about how *both* implicate his audience in the situations to which the work responds."[81] Moreover, Jaar's work is a contemporary example that does not shy away from aesthetic strategies and effects. Rather, its resistance to resist simple formalist readings and even accusations of commodification are a direct result of the singularity of its expression. It is not coincidental that Jaar's project rides on the indeterminate status of the photograph. For it is to the photograph that Reinhardt returns when he presents his concluding remarks: "It is precisely *through* aesthetic strategies, however, that [photography] invites both critical engagement and a kind of metacritical reflection on the mass-mediated character of the disaster...It is not as if a photograph of human suffering could simply be without aesthetic properties, thus *avoiding* the employment of a visual rhetoric or the generation of thought and feeling through the interaction between—for want of better terms—form and content."[82]

The strong point Reinhardt makes here extends work done by the theorist Jacques Rancière that severely challenges the conception and deployment of the image in critical postmodernist practice. Moreover, Rancière gives us a

definition of an image that displaces the anti-aesthetic premise. An image is not a simple representation (whether mimetic or metonymic, the effect for the cause or the part for the whole). It is a particular intersection of visible and sayable, sensible and intelligible. An image thus *never* stands alone. As Rancière insists:

> The image is not the duplicate of a thing. It is a complex set of relations between the visible and the invisible, the visible and speech, the said and the unsaid. It is not a mere reproduction of what is out there in front of the photographer or the filmmaker…It is a question of constructing an image—that is to say, a certain connection between the verbal and the visual. The power of the image is that it disturbs the ordinary regime of that connection.[83]

Rancière challenges how the image has been defined and wielded in contemporary discourse, that is, he questions why concepts such as the sublime and the intolerable image remain so prevalent. He encourages us to challenge any use of the image that associates it with multiplicity, passivity, or as a hindrance to critical knowledge.

Rancière gives brilliant readings of works that press the anti-aesthetic position. He reads Rosler and Jaar in contending ways. Regarding Rosler's *Bringing the War Home*, Rancière explains the underlying critical postmodernist usage of montage: "The image of the dead child was supposed to tear apart the image of the artificial happiness of American existence; it was supposed to open the eyes of those whose enjoy this happiness to the intolerability of that reality and to their own complicity."[84] The supposed shock of the juxtaposition, however, is questionable. Does it achieve the result it sought? Rancière is doubtful. He argues that "there is no particular reason why it should make those who see it conscious of the reality of imperialism and desirous of opposing it. The stock reaction to such images is to close one's eyes or avert one's gaze."[85] In the simple opposition of reality versus appearance, where one image plays the role of reality (in the Rosler image, the dead Vietnamese child) and the role of mirage or illusion (the idyllic American suburban space), there is no exit, so to speak. The moral and political efficacy of the image is compromised in advance because an image is shown to be capable of representing either position (reality or appearance). Furthermore, it is symptomatic of the same discourse to counterpose words (speech) to images. Rancière's aim is to resist the system or apparatus by which we drown "in a flood of images in general, and images of horror in particular, thereby rendering us insensitive" to these horrors.[86] His critique of Rosler's project—but it is not limited to it— it extends in fact to the anti-aesthetic position as a whole—is that images, the images of art "do not supply weapons for battles." Rather, they "help sketch new configurations of what can be seen, what can be said and what can be thought and, consequently, a new landscape of the possible. *But they do so on condition that their meaning or effect is not anticipated.*"[87]

The image is open to a radical outside; it must create a new distribution or arrangement of the sensible. An image is fortuitous, anarchic, disturbing, but only if we conceive of how and why it constructs "different spatiotemporal

systems, different communities of words and things, forms and meanings."[88] Rancière offers Jaar's work as an example. He reads Jaar's *The Eyes of Gutete Emerita* as constructing different relationships between visible and sayable, that is, an example that demonstrates how an image "never stands alone" but "belongs to a system of visibility that governs the status of the bodies represented and the kind of attention they merit."[89] The photographic image of her eyes "do not tell us what Gutete Emerita thinks and feels" because it is an image. This is why Rancière adds that before seeing her eyes Jaar has us read "text that shares the same context and recounts the history of those eyes—the history of this woman and her family." Thus Rancière claims that it is not an ethical question as to whether or not to create or view such images of suffering and death. The critical stance is one capable of discerning the theatre or apparatus—the "sensible system within which it is done."[90] An image is a complex representation that binds and unbinds the visible and the sayable. It is only through images that things become visible, which is a condition and a system rather than a simple act of perception. Images do not "counter-pose reality to its appearance," which is a closed-system, one without an outside; instead, they "construct different realities, different forms of common sense."[91]

It becomes apparent that recent photography and post-conceptual projects with photographic elements do not become visible within the framework of critical postmodern, anti-aesthetic discourse. Recent practice presents critics, historians, and philosophers with a new problematic. Rancière's response is meant to reconfigure new relations between visible and sayable so as to rethink the relation between aesthetics and ethics. He does so by not asking too much or too little of an image. Art, he concludes, does not work "*in order to* make contemporaries responsible with regard to the past, or *in order to* construct better relations between different communities. It is an exercise of such responsibility or of such construction, insofar as it takes in its own equality the different kinds of art that produce objects and images, of resistance and of memory. It does not disintegrate into social relations...The solitude of the artwork is always the construction of a sensitive community that is prolonged beyond itself by creating wider forms of community."[92]

Rancière's reading of these works, however, does not preclude others, which may deal with the same types of images—images that do not forsake aesthetic effects and criteria—in ways entirely at odds with his. Contrary readings of this type of photographic work are not problematic as much as they are exciting. What Rancière's work helps us grasp is that no image is anticipated, but it is transmitted, sent ahead.

"Sent further." In *Images in Spite of All*, the art historian Georges Didi-Huberman discusses four images "snatched from the hell of Auschwitz" in August 1944. These images were taken by a Greek Jew named Alex (he has still not been identified further) who was a member of the *Sonderkommando* (German for "special squad"), one of those chosen by the Nazi SS guards to operate the mass exterminations, most notably they worked in the crematoria. It is in the fold between these two possibilities—the imminent obliteration

of the witness, the certain unrepresentability of the testimony—that the photographic image suddenly appeared.

> One summer day in 1944, the members of the *Sonderkommando* felt the perilous need to snatch some photographs from their infernal work that would bear witness to the specific horror and extent of the massacre. The need to snatch some photographs from the *real*. Moreover, since an image is made to be looked at by others, to snatch from human thought in general, thought from "outside," something *imaginable* that no one until then had even conceived as possible—and this is already saying a lot, since the whole thing was planned even before being put into practice.[95]

The "whole thing was planned" by members of the *Sonderkommando* and the leaders of the Polish Resistance in 1944, who helped smuggle in a camera that contained only one small piece of blank film. The members of the *Sonderkommando* organized a plan, involving lookouts on the damaged roof of crematorium V that was being repaired at the time. David Szmulewski watched from the roof, observing his own overseers, as Alex remained on the ground level, before five open, inflamed, incineration pits behind the crematorium that were being used to alleviate the massive deportations of Jews and gypsies from Hungary that summer. Simply put, the crematoria were insufficient for the desired scale of the exterminations that summer.

The "terrible paradox" that faced Alex as he tried to steal these four "unimaginable" images was that "in order to remove the camera from the bucket [it was smuggled in with], adjust the viewfinder, bring it close to his face, and take a first sequence of images, the photographer had to hide in the gas chamber, itself

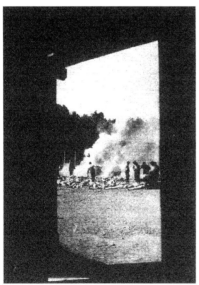

Figure 3.8 Alex _____, *Cremation of gassed bodies in the open-air incineration pits in front of the gas chamber of crematorium V of Auschwitz* (August 1944)

barely emptied—perhaps incompletely—of victims."[94] He took two images from this location, and another two after leaving the crematorium, out in the open. Four images. Four images in spite of all, as Didi-Huberman writes.

The first two images show the incineration pits, gassed bodies being dragged into the smoke and flames. The image reproduced here, the second view, Didi-Huberman describes as "a little more frontal and slightly closer. So it is more hazardous...sharper. It is as though fear had disappeared for an instant in the face of necessity."[95] As he advanced "in the open air toward the birch trees" Alex captured two more images: a "convoy" of women, undressed, ostensibly being led to their deaths; the final image is blurred and washed out by sunlight. Here is Didi-Huberman's description:

> One of the two images—visibly deprived of orthogonality, or "correct" orientation—we can see in the far left corner a whole group of women who seem to be walking or awaiting their turn. Nearer, three other women are headed in the opposite direction. The image is very blurred. We can see, however, a member of the *Sonderkommando* in profile, recognizable by his cap. At the very bottom, to the right, we can make out the chimney of the crematorium. The other image is practically abstract: we can just make out the top of the birch trees. Facing south, the photographer has the light in his eyes. The image is dazzled by the sun.[96]

These images are quickly returned to Szmulewski, who gets them into the hands of Helena Dantón, an employee in the SS canteen. She smuggles the film out of the camp. In early September it reached the Polish Resistance in Krakow from where they were "sent further."

Didi-Huberman initially wrote about these four images in a catalogue essay for an exhibition entitled *Mémoire des camps: Photographies des camps de concentration et d'extermination Nazis (1933–99)*. The force of his writing about them stems from his refusal to invoke the concept of the sublime or the unimaginable; he refuses to "close our eyes before the image."[97] Rather, he insists that the image bears within it an opening to the past, and as such it demands an ethics. "In order to know, we must *imagine* for ourselves. We must attempt to imagine the hell that Auschwitz was in the summer of 1944. Let us not invoke the unimaginable...We are *obliged* to that oppressive imaginable."[98] This ethical obligation requires us not to condemn these images to failure in advance (they are unable to tell the whole story) or to ask too much of them (they cannot be definitive historical proof). What Didi-Huberman asks us to face is the image, nothing more or less, in a manner that carries with it—that act of looking, that act of imagining—"a difficult ethics of the image." He writes:

> Unbearable and impossible, yes...*To imagine in spite of all*, which calls for a difficult ethics of the image: neither the invisible par excellence (the laziness of the aesthete), nor the icon of horror (the laziness of the believer), nor the mere document (the laziness of the learned). A simple image: inadequate but necessary, inexact but true. True of a paradoxical

truth, of course. I would say that here the image is the *eye of history*: its tenacious function of making visible. But also that it is *in the eye of history*: in a very local zone, in a moment of visual suspense."[99]

Didi-Huberman's insistence on the image as an opening in history, as our opening to the past as such, is made against the recropping and touching-up of these four images in order to "make" them better historical documents, to "make" their information clearer. He claims that in doing so the "event" of these images is emptied because

> to erase a "zone of shadow" (the visual mass) for the sake of some lucid "information" (the visible testimonial) is, moreover, to act as though Alex were able to take the photographs safely out in the open...This black mass is nothing other than the mark of the ultimate status by which these images should be understood: their status as a visual event.[100]

Here Didi-Huberman is arguing something that we have also seen in Rancière and others, that is, a refusal to accept the indexicality of the photograph as transparent, as a mere means to an end. A photograph is an image, a phenomenology, a singularity that presents its own mode of address, its own ability to construct a historical relation. "To speak here," Didi-Huberman adds, "of the interplay of shadow and light is not the fantasy of a 'formalist' art historian: it is to name the very *structure* of these images...It offers the equivalent of the way a witness might speak: the pauses, the silences, and the heaviness of the tone."[101]

Didi-Huberman's position elicited two particularly intense responses. One argued that these images were unimaginable because they were too real; they refused viewers any critical distance. Another put forth an argument for the sublime. These four images did not—and could never—represent the totality of the Shoah because "at the heart of the event of the Shoah there is something unrepresentable—something that cannot be structurally fixed in the image."[102] It is clear that these four images make no such claim, let alone is this Didi-Huberman's position. Rather, at work in both responses is a privileging of speech (narrative, testimony) over the image; it is as if the image poses a real threat to the uniqueness of the event (or worse, the image has the potential to erase or negate the event itself).

To these points both Didi-Huberman and Rancière offer a more complex idea of an image, one not based on it being a simple representation of a pre-existing given. Both encourage us to rethink an image, to relearn how to be attentive to it. As Didi-Huberman adds:

> The discourse of the unimaginable has two different and rigorously symmetrical modes. The one proceeds from an *aestheticism* that often fails to recognize history in its concrete singularities. The other proceeds from a *historicism* that often fails to recognize the image in its formal specificities...
>
> We must do with the image what we already do more easily (Foucault has helped us here) with language. For in each testimonial production,

Figure 3.9 Alan Cohen, *Auschwitz* (1994), from *On European Ground* (2001)

in each act of memory, language and image are absolutely bound to one another, never ceasing to exchange their reciprocal lacunae. An image often appears where a word seems to fail; a word often appears where the imagination seems to fail. The "truth" of Auschwitz, if this expression has any meaning, is neither more or less *unimaginable* than it is unsayable.[103]

Doing so requires us to work through the discourse of the sublime, of the unrepresentable, the unknowable, in order to arrive at a new conception of the image, one premised not on its mimetic veracity or its instrumentality (whether historical, critical) but rather on its ability to form a "complex montage of time" as though "the deferred action" of the image were "contemporaneous of the action."[104] The image survives, but it comes from and with another temporality.

In the midst of any documentary image, ask yourself: what is being documented here? What is being transmitted to me? What is being asked of me as a spectator?

Above is an image: Alan Cohen's *Auschwitz* (1994) from his book *On European Ground* (2001).[105]

Here is a text. In 1961, writing about the trial of Adolf Eichmann, an SS lieutenant colonel who has been referred to as one of the architects of the Holocaust, Hannah Arendt gives us this passage: "Lacking the truth, [we] will however find *instants of truth*, and those instants are in fact all we have available to us to give some order to this chaos of horror. These instants arise spontaneously, like oases in the desert. They are anecdotes and they reveal in their brevity what it is all about."

GLOSS ON SUSAN SONTAG, *REGARDING THE PAIN OF OTHERS* (2002)[1]

Between 1973 and 1977 Susan Sontag published a series of essays in the *New York Review of Books* on the subject of photography. The essays range from historical inquiries to then contemporary photographic practice (e.g. Diane Arbus and photojournalism). Her interest in the subject resulted from an experience that is irredeemably biographical (personal) and intellectual (ethical). The traumatic effects of the Second World War are one cause of the various positions, some remarkably astute, some hyperbolic, that Sontag gives us throughout these essays, which were published together in a volume entitled *On Photography* (1977). Her quintessential postmodern meditation on photography as a cultural event, as a transformative artistic practice, as a basic element of contemporary visual culture—in short, her presentation of photography as a "new visual code" that re-marks the lines and parameters of visual culture—is bound to "an ethics of seeing." As Sontag herself admitted in a prefatory note to *On Photography*: "It all started with one essay—about some of the problems, aesthetic and moral, posed by the omnipresence of photographed images."

In that first essay, "In Plato's Cave," Sontag explains that her interest in the "aesthetic and moral" aspects of photography stems from a "negative epiphany" she had when she was twelve years old. It was her first encounter ("revelation" she terms it) with "the photographic inventory of ultimate horror."

> For me, it was photographs of Bergen-Belsen and Dachau which I came across by chance in a bookstore in Santa Monica in July 1945. Nothing I have seen—in photographs or in real life—ever cut me as sharply, deeply, instantaneously. Indeed, it seems plausible to me to divide my life into two parts, before I saw those photographs (I was twelve) and after, though it was several years before I understood fully what they were about. What good was served by seeing them? They were only photographs—of an event I had scarcely heard of and could do nothing to affect, of suffering I could hardly imagine and could do nothing to relieve. When I looked at those photographs, something broke...I felt irrevocably grieved, wounded, but a part of my feelings started to tighten; something went dead; something is still crying.[2]

What one finds throughout *On Photography* is Sontag's attempt to work through this traumatic experience. Despite her contention that she had finally "understood fully what they were about" it is clear that this working-through took much longer. It may have perhaps been unfinished even at the time of her death in 2004. For what we read in *On Photography* is by and large Sontag's attempt to grapple with these images by addressing their aesthetic existence, that is, the existence of these images as images, as imaginary in some sense, severed from experience. While her attention is largely on the image world it has created, it comes at a cost as Sontag empties the photographic image of its moral, political, and ethical agency in this initial text. The cost of this wager is precisely what Sontag reconsiders, not easily it must be noted, but necessarily, in her later work *Regarding the Pain of Others*.

I would like to present two contending statements made by Sontag, one from *On Photography*, the other from *Regarding the Pain of Others*. The discourse stitched through and between these two statements is nothing less than the predicament of modern and contemporary art, especially the creation and current dismantling of the anti-aesthetic, critical postmodern position that has framed art history, aesthetics, and photography since the late 1970s. It was Sontag's work, among others, that established anti-aesthetic discourse by turning to photography as a means to challenge the autonomy of art and its functions within culture.[3] After all, it was Sontag who initially extended Walter Benjamin's work from the 1930s to conclude that "all art aspires to the condition of photography" and yet photography is "not an art"—a statement made in the essay "The Image World" towards the end of *On Photography* that still accurately describes much contemporary art practice today.

The first passage I would like to present is found immediately after Sontag confesses her "negative epiphany." The following passage does not present a definitive statement, but rather it is an anxious, even conflicted one:

> To suffer is one thing; another thing is living with the photographed images of suffering, which does not necessarily strengthen conscience and the ability to be compassionate. It can also corrupt them…after repeated exposure to images it [an event] also becomes less real…At the time of the first photographs of the Nazi camps, there was nothing banal about these images. After thirty years, a saturation point may have been reached. In these last decades, "concerned" photography has done at least as much to deaden conscience as to arouse it. The ethical content of photographs is fragile. With the possible exception of photographs of those horrors, like the Nazi camps, that have gained the status of ethical reference points, most photographs do not keep their emotional charge…Aesthetic distance seems built into the very experience of looking at photographs, if not right away, then certainly with the passage of time. Time eventually positions most photographs, even the most amateurish, at the level of art.[4]

In some ways what Sontag writes here is a standard line about imagery, media, and technology. The sheer repetition of an image (e.g. footage of the September 11th attacks) certainly plays a role in distancing the viewer from the event as a singularity; it is said that as it is repeated it becomes a weakened, anaesthetized experience. This is what Andy Warhol's "death and disaster" series foregrounds, precisely by putting a readymade image (from a newspaper) into play. So there is a question of repetition, trauma, experience, and affect. However, this complex question does not deserve or result in a simple answer such as images have a "fragile" ethical content or that all images are ultimately positioned as art. What is this "aesthetic distance" Sontag speaks of and, moreover, why is it necessarily, in advance, couched as a negative, that is, something that lessens the ethical affect of an image? Furthermore, Sontag precedes from the passage cited above to explicating how the fragmentary nature of a photograph negates it "realistic" (read: documentary) value. What she avoids in *On Photography* is venturing any possible explanation of how and why images of an event (such as the

Shoah), not the event itself, are capable of becoming "ethical reference points." How does the relation of aesthetic image and the passage of time generate an ethics? Could it? This does not simply happen. So we must consider what labor on the part of the photographer and on the part of the viewer is required for an image to possess ethical efficacy.

Sontag's initial position was that images of pain and death merely aestheticize suffering, which means to invite a passive, narcissistic, and perhaps indifferent consumption of them. She calls it "aesthetic consumerism." At the time of *On Photography*, written against the end of the Vietnam War among other events, Sontag is strident in her claim that a photograph, "while it can goad good conscience, it can never be ethical or political knowledge." Why? The answer lies in large part with her presumption that it is an image that we ultimately consume as art. Despite it not being an art, as Sontag contends, our relation to a photographic image, coupled with the passage of time, produces an aesthetic contemplation of even the most inhuman suffering and pain. She insists that a photograph offers only "knowledge at bargain prices," that is, "sentimentalism, whether cynical or humanist." However, Sontag offers no prolonged, convincing explanation of why we view images of suffering as aesthetic. Nor does she explain that the repetition of images does not necessarily result in a blunted ethical responsibility. Repeated viewing may lead one to no longer wish to see, but that does not necessarily mean the viewer has become indifferent to the suffering seen or to the memory of the injustice witnessed through the photograph.

It is this larger historical and ethical scope that Sontag has in *Regarding the Pain of Others* where she more or less reverses her earlier position on the ethical efficacy of images. I would like to emphasize that this reversal is not as unforeseen as it may appear.[5] Within the passages from *On Photography* above, the tone, although usually quite confident and clear, is at times equivocal. For example, Sontag ends the discussion of "aesthetic consumerism" of images of suffering and death by writing that the "omnipresence of photographs has an incalculable effect on our ethical sensibility."[6] Despite the effect being "incalculable" Sontag offers just that, a calculated, summary of these effects, that is, how the ethical content of photographs such as these is fragile, if not altogether nonexistent. In her more recent book, however, Sontag returns to these effects as "incalculable," as effects whose power and actualization are often delayed. Whereas her former position was wagered on the ephemeral, feverish, unreliability of memory, her latter one rides on a more complex, ethical understanding of memory, both its limits and its power.

Here is a passage from *Regarding the Pain of Others* where Sontag is at her most poignant and sober. In the penultimate chapter of the book, with no trace of irony, she writes:

> Still, it seems a good in itself to acknowledge, to have enlarged, one's sense of how much suffering caused by human wickedness there is in the world we share with others. Someone who is perennially surprised that depravity exists, who continues to feel disillusioned (even incredulous) when confronted with evidence of what humans are capable of inflicting in the way

of gruesome, hands-on cruelties upon other humans, has not reached moral or psychological adulthood. No one after a certain age has the right to this kind of innocence, of superficiality, to this degree of ignorance, or amnesia…Even if they [images] are only tokens, and cannot possibly encompass most of the reality to which they refer, they still perform a vital function. The images say: This is what human beings are capable of doing—may volunteer to do, enthusiastically, self-righteously. Don't forget.[7]

An extraordinary passage. Here Sontag changes her answer to the question she asked herself, and by extension all of us, after recounting her experience in the bookstore: "What good was served by seeing them?" Her initial response is a negative one. A form of shock and trauma that makes one indifferent to suffering and death observed; it is a kind of defense mechanism, a psychological response that evidences Sontag dismissal of the ethical efficacy of photographs. The response given here is quite the contrary. It is "a good in itself" to have seen them. Sontag posits that we have an ethical responsibility "to acknowledge, to have enlarged, one's sense of how much suffering caused by human wickedness there is in the world we share with others." Throughout *On Photography* Sontag presents photography as a means to an end; here she suggests that one lesson, one experience, offered by photography is an end in itself. An ethical one at that. Still it is not with the photograph itself that Sontag remains; instead, it is with the ethical act that it facilitates, enables, and coexists: memory.

As much as her first readings of photography are colored by her biographical experience as a young woman, the emphasis on memory and survival in Sontag's latter work was colored by her experiences in Sarajevo during the Balkan wars in the 1990s.[8] Her idea of memory given in *Regarding the Pain of Others* is neither sentimental nor trite. It is a complex position, informed by writers such as Samuel Beckett and W.G. Sebald, but also philosophers such as Benjamin. It is less dependent on a means-end relation than on what Benjamin called "pure means" in his thoughts on recollection. For Sontag is adamant that "Don't forget" is different in kind (ethically and politically) from "Never forget." Understanding this difference in kind is an ethical responsibility.

> Don't forget. This is not quite the same as asking people to remember a particularly monstrous bout of evil. ("Never forget.") Perhaps too much value is assigned to memory, not enough to thinking. Remembering is an ethical act, has ethical value in and of itself…Heartlessness and amnesia seem to go together. But history gives contradictory signals about the value of remembering in the much longer span of a collective history. There is simply too much injustice in the world. And too much remembering (of ancient grievances: Serbs, Irish) embitters. To make peace is to forget. To reconcile, it is necessary that memory be faulty and limited.[9]

Remembering, in Sontag's mind, involves both an act of memory and forgetting. This relation forms the ethical value of remembering. But after the changes in her position regarding images of suffering, pain, injustice,

and death, what image (if there could be one) does she offer as an example of this type of remembering? It is precisely one in which the paucity of the real, its distance from documentary, inversely measures its ethical efficacy, its aesthetic power.

It is with a steady tone that Sontag admits that "the view proposed in *On Photography*—that our capacity to respond to our experiences with emotional freshness and ethical pertinence is being sapped by the relentless diffusion of vulgar and appalling images—might be called the conservative critique of the diffusion of such images."[10] This does not allow us to apathetically consume images of other people's suffering. On the contrary, Sontag encourages us to engage, read, and interpret, for example, even the injurious, callous use of the photographs made of torture at Abu Ghraib prison in 2004 by the photographer Steven Meisel. Meisel's spread for the September 2006 issue of *Italian Vogue* reenacted some of the images from Abu Ghraib only two years earlier, complete with raven-haired models on their knees before guards with batons and snarling dogs.[11] As revolting as this may be, it is part of contemporary culture, wherein any signifier can be repositioned, reused, and thus given a new set of signifieds. However, this does not allow us to simply resign ourselves meaninglessness; instead, as Sontag demonstrates, it requires us to develop a critical apparatus that can engage photographs as representations, but in a manner that does not negate the transformative power of photography (or art as such).

Sontag is clear on this point when she writes:

> Photographs tend to transform, whatever their subject; and as an image something may be beautiful—or terrifying, or unbearable, or quite bearable—as it is not in real life. Transforming is what art does, but photography that bears witness to the calamitous and the reprehensible is much criticized if it seems "aesthetic"; that is, too much like art. The dual powers of photography—to generate documents and to create works of visual art—have produced some remarkable exaggerations about what photographers ought or ought not to do.[12]

Here she is referring to her own earlier position. The difference is clear: all photographs "transform" their subjects; they all simultaneously create documents and works of visual art. There is no zero degree of photographic representation, no exit from artifice.

It may be for this reason that Sontag ends her book with a brief discussion of Jeff Wall's *Dead Troops Talk (A Vision After an Ambush of a Red Army Patrol near Moqor. Afghanistan. Winter 1986)* (1992). The title of this large-scale, digital color Cibachrome transparency mounted on a light box, measuring over seven and a half feet high and over thirteen feet wide would have perturbed Sontag in 1977, let alone the aesthetic decisions of the photographer. Wall produced this image by building an enormous studio set and hiring actors to perform as if the "dead troops" awoke and began to interact (often grotesquely) and carry on a dialogue. The final image is a composite: Wall shot the actors alone or in pairs, scanned these negatives, and

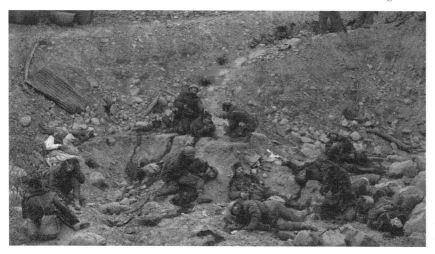

Figure G.1 Jeff Wall, *Dead Troops Talk (A Vision After an Ambush of a Red Army Patrol near Moqor, Afghanistan, Winter 1986)* (1992)

then montaged the digital files into "perfect illusionism." Nevertheless, Sontag finds this image by a Canadian photographer, who has never been to Afghanistan and who has called his own work "near documentary," who has astutely explained his own work as working with the "truth-claim" of photography, to be "exemplary in its thoughtfulness and power."[13] It is after all a "vision," an imagining of the horrors of war; it is an aesthetic, performative statement that consciously draws from an archive of art historical and cultural references such as history painting, Goya's *Disasters of War* (1810–20) prints, and nineteenth-century dioramas.

This image confronts Sontag. As a "visionary photo-work" she does not engage the various, contending interpretations of Wall's practice because over the course of nearly twenty years the lesson she has learned is that "the strong emotion will become a transient one. Eventually all the specificity of the photograph's accusations will fade; the denunciation of a particular conflict and attribution of specific crimes will become a denunciation of human cruelty, human savagery as such. The photographer's intentions are irrelevant to this larger process."[14] So in lieu of addressing Wall's intentions or the anti-aesthetic criticism of his practice, Sontag gives an extended *ekphrasis* (a detailed verbal description) of the work before her. In doing so she performs a simple fact: that one never sees what ones says, and vice versa. In the gap between seeing and saying, remembering takes place. Not once and for all but as an ethical act wherein the dead troops do not speak, but they are present.

It appears as if both Wall and Sontag return us to documentary, the archive, and time, that is, what we see and say, what we become. As she rightly concludes, "There now exists a vast repository of images that make it harder to maintain this kind of moral defectiveness. Let the atrocious images haunt us."

4 The archive as producer

Just as 70 years later Utrillo painted his fascinating views of Paris not from life but from picture postcards, so did the highly regarded English portrait painter David Octavius Hill base his fresco of the first general synod of the Church of Scotland in 1843 on a long series of portrait photographs.

Walter Benjamin

This general impulse is hardly new: it was variously active in the pre-war period when the repertoire of sources was extended both politically and technologically (e.g. in the photofiles of Aleksandr Rodchenko and the photomontages of John Heartfield), and it was even more variously active in the post-war period, especially as appropriated images and serial formats became common idioms (e.g. in the pin-board aesthetic of the Independent Group, remediated representations of Robert Rauschenberg through Richard Prince, and the informational structures of Conceptual art, institutional critique and feminist art). Yet an archival impulse with a distinctive character of its own is again pervasive—enough to be considered a tendency in its own right, and that much alone is welcome.

Hal Foster[1]

Recently any discussion of photography often quickly becomes a debate about the status of an archive. In a sense the invention and dissemination of photography across a variety of uses and discourses—travel, science, art, history, anthropology, etc.—increased the number and heightened the stature of archives. As a depository of statements and images of past events, the stature of the archive goes hand-in-hand with the creation of modern historiography. This includes the discourse of art history, which is dependent on reproductions of artworks. As the epigraph above from Hal Foster's essay "An Archival Impulse" states, the archive, variously defined as a "repertoire of sources" or raw material for the production of artworks extends from Dada photomontage to the most recent contemporary work. This is coupled with the role mass-produced imagery played in the 1920s and 1930s when photographers such as Albert Renger-Patzsch and avant-garde artists such as Rodchenko and Moholy-Nagy generated a discursive event that transformed both traditional

art discourse as well as more instrumental ones such as photojournalism. That event is the "photographic," a concept that raised the status of the photograph to new heights in the first decades of the twentieth century by investing the photographic image with unprecedented socio-political, ethical, propagandistic, and aesthetic value.[2]

"One of the defining characteristics of the modern era," writes Charles Merewether in his introduction to *The Archive*, "has been the increasing significance given to the archive as the means by which historical knowledge and forms of remembrance are accumulated, stored, and recovered. Created as much by state organizations and institutions as by individuals and groups, the archive, as distinct from a collection or library, constitutes a repository or ordered system of documents and records, both verbal and visual, that is the foundation from which history is written."[3] However, when the role of the photograph within archives is closely examined it becomes evident that an archive is no static, passive "foundation" on which present activities, lives, and histories are erected. Instead, the ways in which artists and theorists have addressed the concept of the archive emphasize the complexities of how the present—what is taken as given, what can be said and done, what is visible to us as individuals, as a culture—is indissolubly caught up with archives of many kinds.

Hence an archive as theorized by Foucault, Jacques Derrida, Giorgio Agamben, and others is not simply a repository of things said or done; rather, it is more like a threshold wherein said and unsaid interpenetrate, wherein they are contingent upon one another. Thus the "archive fever" that we see in many contemporary photographic projects stems from a sense of disordering the archive, challenging its authority with fictions and counter-memory. Archival practice—both the production of archives and the manipulation of pre-existing ones—is related to, but is not the "same as forms of remembrance, or as history" because it has the ability "to fragment and destabilize either remembrance as recorded, or history as written."[4]

Contemporary projects that address issues of memory and the archive extend and differ from the photography archives created in the nineteenth century. This uncanny repetition is the logic of the archive, which is both productive and melancholic, mnemonic and creative: "For the logic of the archive is the logic of loss and control; the history of archival projects parallels and depends upon the history of the use of photography."[5] Thus, several nineteenth-century canonical projects began when something was on the verge of disappearing, for example, Baron von Haussmann's *Paris* led Charles Marville to record areas of the city set to be destroyed in the 1850s. It is important to understand that contemporary projects termed "archival" do not usually approach the archive as evidence of the past, as that which has passed and is finished; instead, they frequently attempt to use archival material and/or means to present the coexistence of the past in the present, that is, to focus our attention on its continued psychological, political, and socio-cultural affects.

One such project is Shimon Attie's *The Writing on the Wall* project, in particular his *Steinstrasse 22 (Berlin)* (1992–3). Attie's work is part photography,

part site-specific installation, part performance, but all of these aspects stem from his archival research in Berlin. Instead of "memory-acts that collapse the distinction between themselves and the past" Attie proposes "acts of remembrance that expose the gulf between what happened in the past and how it now gets remembered."[6] In 1991 Attie began work at archives in Berlin, ultimately gathering many photographs of the Scheunviertel district in Berlin, one of the city's pre-war Jewish quarters. He then projected slides of these images at the addresses where they had originally been in the 1920s–30s because, as he says, "I wanted to give this invisible past a voice, to bring it to light, if only for some brief moments."[7] For a year (1992–3), Attie displayed an image for a night or two, and then moved onto the next site. As Mark Reinhardt admirably writes:

> block by block, the specters of a vanished population reappeared—uninvited and unexpected—confronting the city's contemporary residents…On multiple occasions they provoked denial, anger, or outright denunciation from current residents. Yet the projections that provoked these (and of course diverse other) responses created scenes of great beauty…in bringing the past briefly back into the present, the photograph does more to mark history's fissures and disjunctures than to fill them in. The picture invites reflection on place and displacement, loss and erasure, and photography's role in the making of collective memory, in sustaining the presence of the past. The beauty of the work shapes and intensifies the invitation.[8]

Rather than recapturing or re-presenting the past as it truly was, which is an impossibility belonging more to the psychological structure of desire than to historiography, Attie creates a visual event wherein the past is not represented; rather, it transmits not the past (meaning what we have represented, the small part of what has occurred that we claim to know) but the sheer mass of all that which falls outside the parameters of what we call the "past." Attie's archival project traces the limits of the past. It transmits an opening in and to the past.

These issues traverse the entirety of photographic discourse as it encounters and works through the concept of the archive. I would like to engage this discourse by turning our attention to a canonical photographic project, one that will serve as an opening to one of the most extended, critical positions on photography, particularly in its complicity with archives. So let's turn to Eadweard Muybridge and then to Allan Sekula's work, notably his widely influential essays "The Traffic in Photographs" (1981) and "The Body and the Archive" (1986).

Muybridge is most well-known for his photographic studies of movement, collected in *Animal Locomotion* (1887). He experimented and devised a process of stop-motion photography that allowed him to record a horse (named Occident) at full gallop with an exposure time of less than 1/1000 of a second. In 1877, Muybridge made images of Occident in full canter, that is, he photographed the horse's gait to reveal that there are moments when all four of the horse's legs are off the ground at once, dramatically exposing the

scientific "eye" of the camera. His cameras revealed a truth that would never have been exposed to the naked human eye. Hence Muybridge represents a major moment in the epochal transformation of vision and knowledge in the second half of the nineteenth century, that is, in modernity as such. One that earned him a patent for the methods and equipment he developed as well as a lecture tour of Europe and the publication of two more volumes, *Animals in Motion* (1899) and *The Human Figure in Motion* (1901).

What has been downplayed, however, is Muybridge's role in photographing the American West. He was a director of official photographic surveys by the US government. Muybridge was initially a landscape photographer in the American West. His images of the American frontier in the years following the American Civil War are notable for their ingenious vantage points (Muybridge would climb to dangerously high points with his glass plates and full format camera). How are we to approach and read these photographs made under the aegis of the US government? Must their origin as geographic documents and war documents (Muybridge documented the white settlers' war against the Native American Modoc tribe in northern California in 1873) indelibly color how we encounter them as images? Do they belong to the discourse of art, science, geography, documentary?

The inability of the discourse of photography to settle questions such as these is at the center of Sekula's critical Marxist project. One inescapable premise of which is that photography is "haunted by two chattering ghosts: that of bourgeois science and that of bourgeois art."[9] Hence Sekula asserts, "from 1839 onward, affirmative commentaries on photography have engaged in a comic, shuffling dance between technological determinism and auteurism, between faith in the objective powers of the machine and a belief in the subjective, imaginative capabilities of the artist."[10] This assertion illustrates precisely the bind of photographic discourse when it comes to difficult sets of images like Muybridge's archives breaking down movement into its constitutive parts. Sekula's attention to "the traffic in photographs" is in large part an approach to the discourse of photography wherein the entire discourse, in its contradictions and in its various ideological positions, is engaged as an archive. Sekula refuses to examine this archive through an art historical lens, preferring a materialist cultural history that he believes is capable of answering the most pressing questions facing the study of photography: How does photography serve to legitimate and normalize existing power relationships? How does photography help us understand the relationship between culture and economic life? What resistances to the culture of late capitalism are encouraged and strengthened? Does photography support these resistances or does it abet the existing structures and systems of power? Sekula continually asks how historical and social memory is preserved, transformed, restricted, and obliterated by photographs. In short, his position is one in which "archival ambitions and procedures [broadly defined] are intrinsic to photographic practice," which includes historical research and criticism; archives are the very "territory of images."[11]

Sekula critiques any use of the archive as a positivist, representation image of the past, as if the elements in an archive present the past as it really was, as if there is a simple linear progression from past to present, as if any archive is free from the need for interpretation and reading. On the contrary, photographic archives, whether in the form of pictorial histories, school textbooks, or mass-media entertainment, "by their very structure maintain a hidden connection between knowledge and power."[12] Sekula insists that archives are organized and controlled by bureaucratic means; they are one apparatus by which the cultural and historical are naturalized. In a passage with consequences for several of the archival projects we will examine in this chapter, Sekula argues that:

> In an archive, the possibility of meaning is "liberated" from the actual contingencies of use. But this liberation is also a loss, an abstraction from the complexity and richness of use, a loss of context. Thus the specificity of "original" uses and meanings can be avoided and made invisible, when photographs are selected from an archive and reproduced in a book... Clearly archives are not neutral: they embody the power inherent in accumulation, collection, and hoarding...Within bourgeois culture, the photographic project itself has been identified from the very beginning not only with the dream of a universal language, but also with the establishment of global archives.[13]

For Sekula, then, the archive constitutes the framework from which photographic statements are constructed. These statements reflect changes in the status of any given archive. For example, an archive from a magazine publisher accrues historical value once its usefulness as illustrative fodder for the magazine has passed. Photographic statements include those made by John Szarkowski in an exhibition such as *The Photographer's Eye*, which included Muybridge. Sekula argues that this inclusion is exemplary of "the new art history of photography" which "rummages through archives of every sort in search of masterpieces to celebrate and sell."[14] The repeated refrain throughout his criticism is that genuine historical experience and critical evaluations are transfigured by photographic archives and the histories authored through their selection and rearrangement as "aestheticism."

The aesthetic, for Sekula, is what abets the viewing of photographic archives as an "imaginary temporal and geographical mobility" because the experience is no longer historical or even cultural in any broad sense. It simply becomes self-referential to the viewer. Or worse, for Sekula, this type of viewing transfigures these images as art. The "aesthetically informed viewer" engages these images only with a "covert elitism" that is nothing other than a "patronizing, touristic, and mock-critical attitude toward 'kitsch'."[15] Granted, Sekula admits, in a curiously anachronistic phrase, that it is possible to "respect the craft work of the photographer," even a photograph's place "within a set of formal conventions" without indulging in "romantic hyperbole," that is, dealing with photographic images as art. The hyperbole at work here, however, is Sekula's, who refuses

to examine how and why aesthetic strategies are capable of generating critical evaluations. In other words, aesthetic criteria are irreducible to the dandyism explicit in Sekula's charge. Is it not possible to read an archive from "below," as he insists, without categorically rejecting any aesthetic strategies, effects, let alone gestures toward the viewer's critical capacities?

One archival project that does some of what Sekula calls for—reading an archive "from a position of solidarity with those displaced, deformed, silenced or made invisible"—is by Walid Ra'ad and The Atlas Group. Although the manner in which it reads or creates an archive otherwise may not be exactly what Sekula has in mind because The Atlas Group mixes documentary and fiction to create aesthetic and epistemic effects. *The Atlas Project* (1999, ongoing) uses the concept of the archive to address the Lebanese Civil War (1975–91). The Atlas Group creates and presents archival material center-ing on the life and work of Dr Fadi Fakhouri, the foremost historian of the war. The project attempts to answer a question The Atlas Group posed in an interview: "How do we represent traumatic events of collective historical

Figure 4.1 The Atlas Group/Walid Ra'ad, *Civilizationally We Do Not Dig Holes to Bury Ourselves* *(Arc de Triomphe)* (1958–9)

dimensions when the very notion of experience is itself in question?"[16] Ra'ad's work with The Atlas Group, presented as slides, notebooks, video footage, and photographs, problematizes the documentary status of the archive. It is not readily "apparent whether it is genuine archival material or…a fake" and as such its aesthetic labor examines "how the idiosyncrasies of archive material can trigger partial and emotive understandings of social unrest and history."[17] As The Atlas Group itself has said, "we urge you to approach these documents we present as we do, as 'hysterical symptoms' based not on any one person's actual memories but on cultural fantasies erected from the material of collective memories."[18] In other words, an archive is understood here not as the past as such, not as factual evidence; rather, it comprises a set of symptoms indicative of our partial, hyper-mediated, anemic relation to past events and to ourselves. The project exposes the blind spots within the Western historical purview in order to trace what has been lost and forgotten more than to recollect emblematic facts and experiences.

If Ra'ad's Atlas Group archival projects possess avowedly, inescapable, aesthetic aspects to help the work stage and transmit critical and ethical statements, then Sekula's begins to appear too narrow. This is not to say that it does not offer some invaluable insights. Whereas Ra'ad's archival project is predicated on localized histories as they intersect with larger geopolitical narratives, an exhibition of the conceit and scale such as *The Family of Man* held initially at the Museum of Modern Art (MoMA) in 1955 undeniably bears the problematic elements of photographic discourse that Sekula rightly critiques. Beginning with his underlying premise that photography is not an autonomous or independent system because its statements (its very language) "depends on larger discursive conditions." The photograph, he argues, is "invariably accompanied by, and situated within, an overt or covert text."[19] Text here means a larger ideological discourse that could be political or scientific, etc. It does not narrowly mean a written caption or narrative supplement. As such Sekula's reading of *The Family of Man* begins with the text that accompanies it, namely "American multinational capital and government" that is for him "the epitome of American cold war liberalism."[20]

The Family of Man was one of the first international blockbuster exhibitions comprised entirely of photographs, curated by no other than Edward Steichen with an innovative exhibition design by Paul Rudolph. The initial and most ambitious presentation of the exhibition took place at MoMA. It was funded through its international program, which was supported in large part by the United States Information Agency (USIA), a cultural agency linked to the Central Intelligence Agency. It traveled to thirty-eight countries, ultimately being seen by over nine million people from 1955 to 1962. These international presentations were co-sponsored by the USIA and Coca-Cola. The catalogue of the exhibition—inexpensively made for mass publication—remains the best-selling photography book of all time. Carl Sandburg, the American poet and Steichen's brother-in-law, selected the texts that accompanied the images as well as wrote the prologue for

the catalogue. *The Family of Man* is an event within twentieth-century photographic discourse, one that goes beyond the exhibition and even the catalogue. It is undeniably a momentous yet anomalous event.

It was momentous because even its "creators" (Steichen, Rudolph, MoMA, and the various governmental interests involved) proclaimed it "the greatest photography exhibition of all time." So this claim has been part of the exhibition's discourse since its inception. However, the exhibition is an anomaly; it is one of the most debated subjects in the history of photography. This debate focuses on one of several interrelated topics: Steichen's conscious de-aestheticizing of the photographs; the exhibition design and its use of art photography as mere elements in a three-dimensional photomontage; and the manner in which politics was aestheticized through this intersection of photography and installation design. All of these problematic aspects are grounded in the enabling conception of the exhibition itself, that is, the enabling limit of photography as such: photography as a putative universal language. In an essay "Photography: Witness and Recorder of Humanity," Steichen "stages photography as the completely transparent medium of the communication of 'or common being' that speaks for and to the global community." He says that photography is "the only universal language we have, the only one requiring no translation."[21] As Sekula adds: "*The Family of Man*, more than any other single photographic project, was a massive and ostentatious bureaucratic attempt to universalize photographic discourse."[22]

This attempt to universalize photographic discourse begins with Steichen's role as curator. He chose from an archive of photographs numbering over 2.5 million. This archive was generated by soliciting submissions from around the world and through Steichen's own curatorial work. In the end he chose 503 photographs (from 68 different countries), but he only chose works by professional photographers using sophisticated equipment. To reinforce the universalism of photography, Steichen homogenized the look of the photographs. They were cropped and exhibited without their original titles. In addition, they were processed in a commercial lab that harmonized all the tonal values of the black-and-white photographs and enlarged many of them to poster-sized images. Steichen thought that this would make all the photographs equal. In short, national boundaries were downplayed in order to construct a fictional, ideological utopian statement about the so-called "family of man," a universal family.[23] But this utopic gesture masks a clear voice of power and authority—this nuclear family has a father. This must be understood in light of both the context of the immediate postwar period and the exhibition design itself.

The exhibition design was dictated by the logic of the narrative. Themes of work, love, death, marriage, etc., were presented as universals. To reinforce this narrative the black-and-white photos (all except one, we will get to this in a moment) were free of labels identifying the photographer's name, the title, or the year made. The photographs were stripped of their authorship and thereby presented as archival in the sense of being empirical evidence of these

so-called universal themes. Interspersed with the images were texts from biblical sources, "primitive" sources (Native American thought, for example), Western literature, etc. Collectively these textual supplements were meant to represent "wisdom" highlighting the commonality of humanity. In short, the exhibition was a picture story to support a concept. Viewers were choreographed through the exhibition.

This choreography took place in and through a scenography: in essence a three-dimensional photomontage. Rudolph's design techniques reveal how Soviet and German avant-garde art from the 1920s and 1930s was appropriated and deployed in ways that unconsciously, perhaps, contradict, or at least problematize, the exhibition's intent. The exhibition did not follow conventional display organization. It was not a traditional exhibition of photography based on either the nineteenth-century model or the formalist model championed by Beaumont Newhall at MoMA in exhibitions of F.64 members in the pre-war years. Instead, the display techniques borrowed directly from Russian and German artists working between the wars. The photographs were floating in space, hanging from strings and other structures without frames (no glass, no mattes). Each photograph was dematerialized so to speak; it was presented as replaceable, interchangeable. No priority was given to any print as an image in its own right. On the contrary, its significance was subsumed under the weight of the exhibition as a whole.

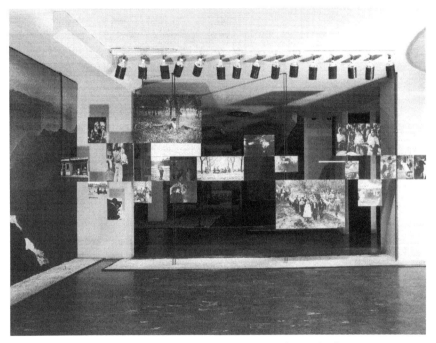

Figure 4.2 Rolf Petersen, Installation view of the exhibition *The Family of Man* (1955)

These display techniques stem from avant-garde experiments with photography that emerged from a critique of abstract painting and its claims to be a universal language. Avant-garde artists turned to photography as a way to engage iconic images by manipulating them into a new framework: photomontage. Photomontage continues the utopian ideals of abstraction but without returning to traditional, realistic image making. It was meant to engage the audience directly by drawing on a surplus of readymade images and rearranging them to create new images that exposed and/or undermined the very capitalist culture that generated this surplus in the first place. The audience were not conceived as passive consumers of the image, but rather the viewers were meant to become agitated, politicized participants. However, in the history of the avant-garde's use of photomontage changes occur.

As Benjamin Buchloh's unparalleled work on the topic makes clear, the emphasis on "discontinuity and fragmentation in the initial phase of Dada-derived photomontage" was meant to refract the "'shock' experience of daily existence in advanced industrial culture."[24] This strategy was meant to "dismantle the myths of unity and totality that advertising and ideology consistently inscribe" on modern consumers and political subjects. But this position was deemed ineffective, thus calling for another conception of photomontage.

> Already in the second moment of Dada collage (at the time of Hannah Höch's *Meine Hausspruche* (1922)) for example, the heterogeneity of random order and the arbitrary juxtapositions of found objects and images, and the sense of a fundamental cognitive and perceptual anomie, were challenged as either apolitical and anti-communicative, or as esoteric and aestheticist. The very avant-garde artists who initiated photomontage (e.g. Heartfield and Höch, Klutsis, Lissitzky, Rodchenko) now diagnosed this anomic character of the Dada collage/montage technique as bourgeois avant-gardism, mounting a critique that called, paradoxically, for a reintroduction of the dimensions of narrative, communicative action and instrumentalized logic within the structural organization of montage aesthetics.[25]

Hence the move toward more minimal, controlled, in a sense "readable" photomontages by Moholy-Nagy, for instance his *Leda and the Swan* (1925), are symptomatic of a change in how photomontage was understood at the time. The shock-value of random juxtapositions and surprising syncretic constructions proved ineffective to achieving a socialist revolution. Narrative, communication, and instrumentalized logic were forwarded because the viewers of early Dada photomontage were not adequately politicized; their experience remained within learned, conventional aesthetic frameworks. For both photomontage and subsequent experiments in exhibition and spatial design by artists and architects the goal was collective experience rather than individual experience: individual viewers were to be transformed into active, collective subjects. To do so, art aimed at simultaneous collective expression rather than individual aesthetic contemplation.

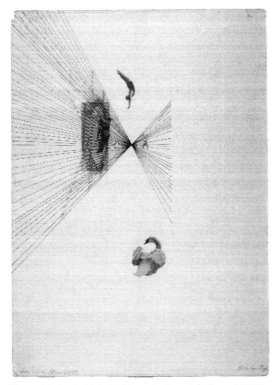

Figure 4.3 Lazlo Moholy-Nagy, *Leda and the Swan* (1925)

An example of how these ideas were translated into exhibition design is El Lissitzky's *Cabinet of Abstract Art* (Hanover, 1926). He hung paintings on panels that moved, some on which were low to the floor or above the normative height for presenting a work of art. The audience was invited to reorganize the exhibition (to a certain degree), that is, to activate the surfaces of the room by moving the panels and thus the works themselves. The premise here is that the work(s) themselves are not fixed in an idealized gallery/museum space, but rather they exist in real space and time. Lissitzky designed it so that the viewer had to move through the space (inter)actively. One had to create scenes as you moved. The motivation is filmic and theatrical: the signs themselves are in motion. Reality is fragmented, juxtaposed, erratic. But an order is discernible and thus alterable if one engages that reality. In short, if reality becomes discernible as a social construct, then it can be reconstructed, remade.

It is the shift to narrative and communication that opens these techniques, which start on the left, to appropriation by positions on the right. Infamous examples being the appropriation and reinscription of montage in film as fascist propaganda in Leni Riefenstahl's *Triumph of the Will* (1934) and in Italian Fascist photomontage posters. We can trace this arc by following

certain individuals. For example, Herbert Bayer worked in the Bauhaus but also made designs for Nazi events such as the 1936 Olympics in Berlin, before some of his works were included in the Degenerate Art exhibition in Munich in 1937. Bayer ends up at MoMA after the war.[26] There he argued that exhibition design should invade the space of the viewer with means similar to the psychology of advertising and social engineering. Bayer designed one of the immediate precedents for *The Family of Man*, an exhibition that used blown-up documentary military photographs in a similar manner, *The Road to Victory* (MoMA, 1942).

The Family of Man deployed the sleeker, more instrumental aesthetic of later avant-garde photomontage. So one can characterize the exhibition design as analogous to walking around in a three-dimensional photomontage but only if one recognizes how and why the randomness of photomontage (as it is commonly understood) is neutralized under the overarching theme of universalism. The exhibition was far from random or open-ended. It was deliberate, unrelenting, pointed. The viewer is conceived and activated in ways that invert the goals of the inter-war period avant-garde. The viewer is passive, not active; he or she must submit to the logic of the narrative. The narrative involved the instrumental use of photography as a means through which the tensions and uncertainties of the Cold War could be seen in a wider context of human values.

There is a clear emphasis on common humanity against the destructive effects of polarization. Photography is wielded to express a faith in humanity after the Second World War, the revelation of the concentration camps, Hiroshima and Nagasaki, and in the face of the threat of global nuclear war. Hence, in the midst of Cold War debates, this exhibition was initially conceived as a show that could give a stark picture of American as opposed to Soviet life, but it ultimately shifted towards a more universal agenda. As part of this reformulation, Steichen discarded any images that demonstrated strong political and cultural differences (a lynching scene in the USA, for example). Nevertheless, what Sekula and others foreground is how this original intention is still operative in the revamped exhibition. In other words, Steichen moves away from explicit American propaganda to larger questions of humanism and the dignity of "Man" but in doing so he only renders the propaganda more subtle and effective by couching it in universal themes.[27]

The emphasis on universalism was not unique to this exhibition. The United Nations (UN) was founded in 1945. In 1948 the UN wrote the *Universal Declaration of Human Rights*, which comprises thirty articles such as "all human beings are born free and equal in dignity and rights."[28] What is unique to this exhibition, however, is that it used photography to make a supposedly universal statement. This had been done with photography on smaller scales as in "People are People the World Over," a series of monthly photo-essays showing common activities in rural families around the world—laundry, shopping, cooking—published in *Ladies' Home Journal*

in the 1950s. Steichen's intention was to present a liberal alternative to McCarthyism, as such he wanted the exhibition to function as a means to promote dialogue. Nonetheless, this sympathetic humanism relied on unexamined assumptions about universality and the new concept of the global or globalization (American multinational corporations (Coca-Cola) and government). As Sekula was the first to note, *The Family of Man* is one of the first instances of globalization, one that comes in the guise of a photography exhibition![29] The larger point is that within this cultural and historical context, Steichen's intention (sympathetic humanism) is undermined. The exhibition's claim to universal brotherhood is bankrupted by an American ideological agenda: America as law, power, father.

This paternalistic, authoritative assertion of power—what Steichen at the time saw only as "visual literacy"—is clearly evident in the exhibition's final rooms and the images presented. (This ending was best presented in its ideal version at MoMA.) Here is how the exhibition ended. Photographs of pairs, couples, were displayed. Next to them was placed a stark warning by the British philosopher Bertrand Russell about the capacity of the hydrogen bomb to destroy all human life. Just beyond this admonition was a panel showing a dead soldier on the Bikini Atoll (a photograph by Raphael Platnick) coupled with a question posed by Sophocles: "Who is the slayer, who the victim? Speak." Lastly, the viewer had to pass under an overhead light and into a darkened room where a 6×8 ft back-lit color transparency revealed a red–orange image of a 1954 US hydrogen bomb test on the Bikini Atoll in the Pacific. The glaring, color photo—coming after hundreds of black-and white-images—startled viewers. It remains the *punctum* that motivates the entire discourse of the exhibition and the cultural context.[30] Immediately viewers were then directed to a massive photo of the UN General Assembly, before exiting through some final, schmaltzy images of children.

As one can imagine critiques of the exhibition are in no short order. In general they range from calling attention to Steichen's role as curator/author (the exhibition is more his achievement than an exhibition of photographs), to considerations of how this exhibition plays a role in subsequent changes in photographic practice (i.e. street photography), to serious explications of how and why the viewer surrenders to the story/narrative of the exhibition (the viewer is rendered passive viewer).[31] The color photo at the end is certainly manipulative and serves only to heighten the impotence of the shoddy, sentimental universalism it advocates. An oft-cited critique is the one given by Roland Barthes entitled "The Great Family of Man," an essay in his 1957 text *Mythologies*. At this stage in his intellectual life, Barthes understood semiotics—the study and interpretation of signs; a systematic analysis of cultural representation and behavior that incorporates linguistics and psychoanalysis to address how meaning and its effects are produced—as a way to strip the visible world of its spectacle and its guilty pleasures, that

is, to reveal as "a great web of symptoms and a seedy exchange of signs."[32] For him, *The Family of Man* is precisely such a spectacle—a myth—whereby a single society or an authority legitimates itself by naturalizing and masking itself as self-evident, "universal." Barthes tried to demonstrate that the image was "in fact a vehicle for a silent discourse," which he endeavored to make audible, apparent. The most salient part of Barthes critique lies in his juxtaposition of "classic humanism" (clearly the perspective of Steichen) and "progressive humanism." Admittedly, this conceptual pair is also wanting, but Barthes position comes across. Here is the key passage:

> This myth of the human "condition" rests on a very old mystification, which always consists in placing Nature at the bottom of History. Any classic humanism postulates that in scratching the history of men a little, the relativity of their institutions or the superficial diversity of their skins (but why not ask the parents of Emmet Till, the young Negro assassinated by Whites, what they think of The Great Family of Man?), one very quickly reaches the solid rock of a universal human nature. Progressive humanism, on the contrary, must always remember to reverse the terms [Nature and History] of this very old imposture, constantly to scour nature, its "laws" and its "limits" in order to discover History there, and at last to establish Nature itself as historical.[33]

I have always thought that the parenthetical statement Barthes gives here about the parents of Emmet Till, the fourteen-year-old African–American boy from Chicago murdered in Mississippi in 1955, is one of the most biting critiques of "classic humanism." The event propelled the Civil Rights Movement, but the suspects were acquitted. (The FBI later reopened the case in 2004 and the surviving suspects admitted their guilt.) Till's mother insisted on a public funeral and an open casket to show what they had done. This sort of explicit, unchecked violence is reflected in the exhibition's ending. It also forces one to reconsider Steichen's decision not to include an image of a lynching in the exhibition.

So let us reconsider Steichen's statement about photography as a universal language: "It is the only universal language we have, the only one requiring no translation." What he proposes is an exhibition of "naked images" that serve to bolster this claim of universality. This concept of the "naked image" lies at the heart of the most current discussions of contemporary art and aesthetics. It is a central aspect of the work of the French philosopher Jacques Rancière, particularly his *The Future of the Image* (2007). He claims that the "naked image" is not art because it excludes the "prestige of dissemblance [for him, the essential power of art]" as well as the "rhetoric of exegesis." (An example of this type of image would be a photograph of a concentration camp such as those discussed in Chapter 3.) In these images only the act of witnessing "the trace of history, of testimony to a reality" is primary. Rancière argues that we are witnessing a plethora of contemporary

exhibitions that present this type of image—naked images—just as Steichen did in 1955. Rancière wants us to ask whether or not these "naked images" do in fact preclude the "rhetoric of exegesis"? This follows what Barthes argued, that is, we must interpret and read images to understand how they could be used to make the cultural, historical, or political appear as if it were natural (Barthes's definition of myth). "Naked images" are not self-evident; they call out for exegesis, a reading, an explication. Hence, as many of the critiques of the "naked image" at work in the exhibition foreground, there is no such thing as a "naked image." All images—whether or not they are works of art, and perhaps especially then—require exegesis, interpretation, discourse, that is, language as a necessary supplement of the visual. There is a politics of aesthetics and an aesthetics of politics, however they do not coincide. It is the image—the photographic image in all its contingency and mutability—that may very well be the "common measure" between them that we must come to understand anew if we are to rethink a "progressive humanism."

It is important to note that the presumption at work in *The Family of Man* extends from a nineteenth-century discourse that not only assumed the photography was a transparent, objective means for scientific observation, but that troublingly enacted this assumption in the fields of modern anthropology. It is within these discourses that photography—as a metaphor of transparency and automaticity—is coupled with an exhibition value supported by race theory, justifications of European colonialism, and, collectively, the creation of the modern nation-state in the mid-nineteenth century. What photography, and its exhibition in various contexts, too often presents is analogous to the "imagined community" presented in *The Family of Man*.[34]

There is thus a direct connection between the discourse of photography and larger geopolitical issues in the nineteenth century. For example, Daguerre and Talbot frequently turn their early camera lens towards collections of objects. While this extends the genre of the still life, it also alters its significance. This intimate relation need not have been evident to Talbot or his audience in 1844. Studying culture involves making connections through time as much as trying to understand the complexities of a single historical context. The more one studies history and culture the more one is confronted with often unexpected connections that appear between a moment of the past and a moment of the present. These link up, at times without the intervention of the cultural historian, presenting themselves in ways that illuminate each moment as well as redefine our image of the past through this new historical relation. We see an incidence of this in the "dialectical image" (Walter Benjamin's phrase) constructed between Talbot's *Articles of China* (Plate 3 from *The Pencil of Nature*) and the contemporary Chinese-born artist Ni Haifeng's *Self-Portrait as a Part of Porcelain Export History (no. 1)* (1999–2001).

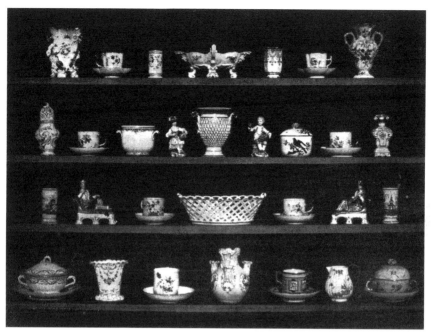

Figure 4.4 William Henry Fox Talbot, *Plate 3. Articles of China* from *The Pencil of Nature* (1844)

Figure 4.5 Ni Haifeng, *Self-Portrait as a Part of Porcelain Export History (no. 1)* (1999–2001)

Haifeng, who has been based in Amsterdam since 1994, works with archives of colonial history in order to re-present them in new cultural and historical contexts. He literally inscribes the discourse—image and text—of the colonial history between the Netherlands, particularly the role of the Dutch East India Trading Company, and China in the seventeenth and eighteenth centuries when the demand and craze for porcelain was at its height, on his body. Haifeng's "self-portrait" project involves a performance, photography, and a ceramics exhibition. By working with the archive of documents, statements, and images of the trade between West and East—by inscribing this archive in the form of language and images directly on his body—Haifeng strives to make apparent the ways in which history and individual identity are inextricably bound. His individual identity is marked by this history of global trade and colonialism. Even though this trade produced fictional images of each culture. The archival impulse involves both acts of discipline (Haifeng's work reminds me of Franz Kafka's story "In the Penal Colony" in which a criminal's charge is tattooed directly onto his body) and the exposure of a "no man's land" between individual and collective identities as well as cultures.[35] This "no man's land" is the authoritarian and liberatory potential of the archive.

European and American photographers in the nineteenth century created archives of images of foreign lands and peoples. The examples are too numerous to recount. They include the legions of "zealous and famous scholars and artists attached to the army of the Orient," who accompanied French troops into Egypt, such as Maxime Du Camp. Consider someone like Felice Beato whose Orientalist photography gave us not only shocking images of the colonial Opium War orchestrated by the English and French in China in 1860 but also an archival record of Eastern architectural styles and peoples.[36] Beato photographed the Dutch and American colonial troops at leisure in Japan on Queen Victoria's birthday. Juxtaposed with an image such as this are his photographs of "native types," images of the colonized from lowly shop keepers to Sumo wrestlers. Hence his *Photographic Views of Japan* (1868) is not an innocent photo-documentation of a foreign land and peoples; instead, it is an archive of colonial power and Euro-American desires of evidence to bolster the pseudo-science of physiognomy.

Physiognomy has a long history within Euro-American cultural discourse. Its first coherent appearance is in the Enlightenment text by Johann Kaspar Lavater, *Essays on Physiognomy (4 vols)* (1789–98). Lavater claimed that the human face indicates moral character. Thus facial beauty indicates virtue whereas ugliness, vice. "The moral life of a man...reveals itself in the lines, marks, and transitions of countenance," he insisted. Physiognomy, for him, meant the act of judging temperament and inner character from outward appearances; reading the outside for the inside: the "original language of Nature, written on the face of man," Lavater believed. In the nineteenth century physiognomy is folded into the discourse of positivism (simply the idea that one cause equals one effect).

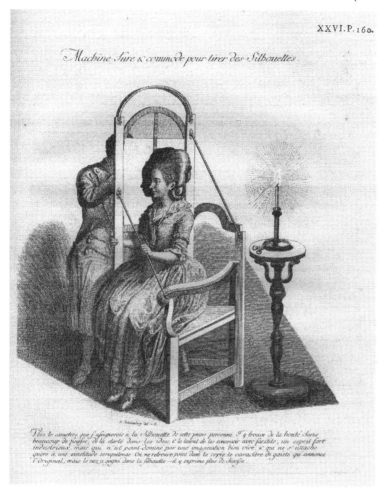

XXVI. P. 160.

Machine Sure & commode pour tirer des Silhouettes.

Voici le caractère que j'assignerois à la Silhouette de cette jeune personne. J'y trouve de la bonté sans beaucoup de finesse, de la clarté dans les idées, & le talent de les concevoir avec facilité, un esprit fort industrieux, mais qui n'est point dominé par une imagination bien vive, & qui ne s'attache guère à une exactitude scrupuleuse. On ne retrouve point dans la copie le caractère de gaieté qui annonce l'original, mais le nez a gagné dans la silhouette — & y exprime plus de finesse.

Figure 4.6 Johann Kaspar Lavater, *Silhouette Machine* (1780)

Physiognomy predates and partially anticipates positivism (the sociology or "social physics" promulgated by Auguste Comte). A number of social scientific disciplines absorbed physiognomic method as a means of implementing positivist theory during the nineteenth century…The historical trajectories of physiognomy and of related practices of phrenology and anthropometrics, are extremely complicated and are consistently interwoven with the history of photographic portraiture.[37]

The cultural obsession in the late eighteenth and throughout the nineteenth century with recording a face and reading one's character, intellect, social standing, etc., put photography to work generating examples because photography was deemed a more "scientific" medium to investigate physiognomy.[38]

One instance of the complicated "historical trajectories" of Lavater's ideas would be their presence in the work of Duchenne de Boulogne. Duchenne, a physician at the Paris hospital La Salpêtrière, published his *Mécanisme de la physiognomie humaine* in 1862. It was accompanied by eighty-four photographs showing the faces of his human subjects, whom he submitted to an electric current. The electric current involuntarily activated the muscles of a subject's face, distorting it into strange, often disconcerting expressions, which he then photographed. Most of his photographs are of mentally challenged people. Forty-five of the eight-four are of a single man. Duchenne's motivation for this experiment was based in physiognomy: he wanted to see the full range of human expression. Despite the obvious unnatural, involuntary conditions causing these effects, Duchenne read them as emotions, universal expressions. Moreover, he published these photographs next to photographs of expressions on neo-classical sculptures. His photograph of a woman reveals the perversity of Duchenne's project: she is dressed in a white gown that is pulled off her shoulders to expose her shoulders and décolletage. He has hold of her arms across her midsection, with her left hand cupping her breast, in a gesture at once provocative and probably necessary (her dress may very well fall if she does not catch it there). Her half-closed eyes gaze back at us as her sad face is involuntarily transformed by electric current into a slight smile. A smile that Duchenne willfully reads as indicative of his subject's "coquetry."[39]

Duchenne's work is not an isolated event.[40] Similar ideas are at work in the anonymous photographs that accompany the French physician Jean-Martin Charcot's *Iconographic Photography From Salpêtrière* (1876), based on his studies of hysteria which he attempted to treat with hypnosis at Salpêtrière. The most troubling extension of this pseudo-science is its entry into modern systems of population control, including criminology. Carl Durheim, a photographer and lithographer, made 220 photographic portraits of itinerant people from 1852–3 as part of a large-scale Swiss government operation to document stateless, itinerant people. The images were distributed to the police as a way to identify and arrest these people, mostly tradesmen and craftworkers. They were rounded up and then held in open confinement in the city of Bern and forced to settle. Police photos did not become routine until the late 1850s to 1860s; this is one of the earliest instances of a now familiar practice.

In the 1880s police photos were standardized due in large part to Alphonse Bertillon, who developed a verbal and visual system to describe criminals. His main intent was to identify recidivists (repeat offenders) so Bertillon invented the mugshot. But the physiognomic premise of this invention makes clear its difference from what we are used to. While he did take photographs of a person's face frontally and in profile, he also made images of a person's ears, mouth, chin, forehead, and eyes. Together with measurements and this typology of different body parts, a mugshot supposedly gave a unique record of an individual. By standardizing the process (consistent focal length, lighting, distance from subject), Bertillon broke down one's physical appearance into small, standardized units which allowed unskilled clerks to file and retrieve criminal photos at a police station. This led to the creation of large archives that strengthened governmental control over the

Figure 4.7 Alphonse Bertillon, *Instructions Signalétiques* (1893)

Fig. 29. — La **forme** du pli inférieur est décelée sur ces figures par la direction
de la petite bande d'ombre projeté par la *tige directrice* :
N° 1 — la tige est contiguë à l'ombre projetée sur le bord de l'oreille et en est séparée
par un millimètre de blanc sur le pli interne (ombre et pli à forme *cave*).
N° 2 — l'ombre est projetée en droite ligne sur les deux parties parallèlement et tout
contre la tige directrice (ombre et pli à forme *intermédiaire*).
N° 3 — la tige touche l'ombre sur le pli interne et s'en sépare brusquement sur la
bordure externe (ombre et pli à forme *convexe*).

Figure 4.8 Alphonse Bertillon, *Measuring the ear of a criminal* (1893)

populace. However, the idea of physiognomy undergoes a change here. Criminality becomes to be seen less as an innate character flaw visible on one's face, in fact throughout one's physical characteristics, than as evidence of how innate tendencies in the individual could be brought out by the pressures of modern society.[41] This more nuanced reading of criminality is at work across a series of nineteenth-century photographic projects, including Jacob Riis's *How the Other Half Lives* (1890).

What we see taking place here is the dichotomy of photographic discourse: its visual traces are capable of being read both repressively and progressively. We see this dichotomy at work in the tension between Steichen's "progressive humanism" and the underlying authority of the USA in *The Family of Man* exhibition. The progressive uses of photography never fully escape repressive or reactionary ones such as the desire to use photographic means to investigate whether or not "criminals form a variety of the human family quite distinct from law-abiding men" (a statement made by Eugene S. Talbot, an American medical doctor, in his 1901 text *Degeneracy: Its Causes, Signs, and Results*). As Sekula and others contend, photography has always been "a convenient conduit that enables more or less powerless subjects to be represented by the forces of modern oppression as objects of knowledge, analysis, and control" because for them photography is always already in service of modern bourgeois ideology.[42]

This ideology includes physiognomic justifications for Euro-American colonialism and imperialism. There are complex ways in which anthropology is tied to physiognomy. Some of these points of intersection are made visible by photography's role in compiling an archive of images to fuel the Euro-American cultural imaginary. For instance, J.A. Moulin's *Etudes: Seduction* (1849–50), an example of "academies" (photographs of nude and semi-nude women). These "academies" were postcard-sized images, replete with suggestive poses between interracial pairs (but not always), suggestive drapery, and staged "exotic" settings. Most were made for professional use by artists, but many became the face of an emerging erotica and pornography trade that was fueled by a titillating tie between sex and otherness. As Malek Alloula explains in his remarkable book *The Colonial Harem* (1986), cheap images such as these proliferated throughout Europe during the modern age of Orientalism (beginning around 1870); they quite literally were sent and received by the entirety of European culture, existing as a major part of "a very fat archive," as Edward Said called it. In examining this archive of stereotypes and phantasms, Alloula suggests that we not only study them as a theme or a pressing question but, echoing Barthes, as a wound inflicted by the gaze, by the archives that comprise our visual culture as such.

One of the originary wounds of Euro-American modernity, one that traverses and unites these various intersections between photography, anthropology, colonialism, and a faux universalism is undoubtedly *The Great Exhibition* in 1851. *The Great Exhibition of the Works of Industry of all Nations* or *The Great Exhibition*, sometimes referred to as the *Crystal Palace* exhibition in reference to the temporary structure in which it was held, took place in Hyde Park, London, from May 1 to October 15, 1851. Shuttling back and forth along the line from *The Great Exhibition* to *The Family of Man*, through

a century that has just passed, one encounters the discourse of photography in all its guises. Although open for only six months, the exhibition was visited by nearly six million people from throughout the world. It was the first world fair, an exhibition, a museum, that touted the modern technocratic mantra of technological progress and material prosperity. As another "historical trajectory" of physiognomic thought and archival practice, the exhibition presented commodities and artworks, over 800 examples from six different countries despite the "all Nations" of its title, and attempted to inscribe or impose cultural identities, and a hierarchy of those identities and capabilities, through those objects. With Queen Victoria herself opening the exhibition and attending nearly every day, it should come as no surprise that the ultimate statement of the exhibition was the dominance of Britain as the leader in industrial and artistic production, which was supposedly to lead to the social betterment of all classes, and, more shrewdly, justified the phrase "the sun never sets on the British empire."

Built of glass and iron, new building materials for architecture at the time, Jospeh Paxton designed a crystal palace. J.J. Mayall photographed the glass and iron construction, showing its open vistas, tall interior spaces, and its luminous transparency, which was both a material fact and a metaphor for the exhibition as a whole. It was in essence a glasshouse. This linked it to photography because photographers at the time, most notably Talbot, often worked in small glass structures that resemble the Crystal Palace, except with opaque windowpanes. The larger implication is that modern architecture and photography are associated with social advancement. Also photography had a conspicuous presence at the exhibition. Cameras were on display as well as photographic equipment; commercial portraits and landscapes were shown. Daguerreotypes (French) and calotypes (English) equally represented. Anything falling under the title of "art photography" was on display in the Fine Arts Court.[43]

So what is going on in the *Crystal Palace* exhibition? In some ways it is an act of autoethnography, Europe turned the physiognomic, anthropological premise back on itself. We have the first instance of what becomes a convention for world fairs to follow: representations of modern nation-state in the form of national pavilions. Simply put, you are your stuff, your representations. Of course, all of this takes on a darker countenance when this logic is applied to the colonies, the people subjugated by Europe and America. But the underlying logic and its consequences are vast. As Donald Preziosi writes:

> This most radically translucent—and simultaneously stubbornly opaque— of nineteenth-century constructions may well have been our modernity's most unsurpassable artifact. It was the lucent embodiment and semiological summa of the principle of the modern order itself: infinitely expandable, scaleless, anonymous; transparently and stylelessly abstract…The very diagram of the modern symbolic order…Its exhibitionary order was the ideal horizon and the blueprint of patriarchal colonialism…the laboratory table on which all things and people could be objectively and poignantly compared and contrasted in a uniform and perfect light.[44]

Preziosi understands the Crystal Palace as "the ideal horizon and the blueprint of…colonialism" because it embodies "the modern order itself." In the justification of colonialism and imperialism we see the extension of the classificatory, encyclopedic mania that marks the nineteenth century. The Crystal Palace anticipates and refracts the logic of *The Family of Man* as both attempt to construct an order of things, a photographic "universal language," with white European Christians sitting at the top of this hierarchy. Photography aids in this codifying activity, which has drastic and long-lasting geopolitical effects.

Photography abets the construction of race as a pseudoscientific category. It allows for the exhibition, the documentation, and presentation of connotative differences, that is, social constructed idea, as denotative fact. The myth of reading the outside for the inside is captured, reified, and materialized in photography. This is the mythology at work in the too prevalent conception and use of photography as "instrumental realism" (Sekula's phrase). Consider, as an example of a much larger practice, an image by John Lamprey, *Front and Profile Views of a Malayan Man* (c. 1868–9) where the grid background, signifying science, order, objectivity, rationality, maps and overwrites the body of the colonial, non-white, non-European subject.

Here we see how Barthes's discussion of denotation and connotation takes on an ethical importance. In the nineteenth century we see a myth of racial difference being constructed, one that uses photography as evidence. What we see is the connotative meanings of otherness, foreignness, xenophobia, blackness, etc.—meanings that rely on a specific cultural and historical context as well as a viewer's lived, felt knowledge (social and personal significance)—substituting themselves for denotative ones. Barthes defines myth as cultural values and beliefs that are expressed at this level of connotation. For him, myth is the hidden set of rules and conventions through which meanings, which are in reality specific to certain groups, are made to seem universal and given for a whole of society. Myth thus allows the connotative meaning of a particular thing or image to appear to be denotative, hence literal or natural, when in fact they are historically and culturally specific.

In the early 1990s, the contemporary photographer Carrie Mae Weems created a series by re-reading the photography archive at The J. Paul Getty Museum in Los Angeles; her images draw on, extend, and reinscribe the relation between anthropology, race, and photography.[45] Weems selected nineteenth- and early-twentieth-century daguerreotypes of slaves made to purportedly validate racial theories. Weems's work from this series, like *From Here I Saw What Happened and I Cried* (1995), is the result of her re-photographing, coloring (here in red tint), and re-framing the chosen image. She also provides a text or caption for it: "You Became A Scientific Profile." Weems's effort to read the historical record and create a new relation to it is part of her *Diana Portraits* (1992) as well. Mary Warner Marien has shown that Weems directly connects works in these projects to the photographs by J. T. Zealy that were commissioned by the Swiss-born, American anthropologist Louis Agassiz to provide visual evidence for his theory of racial development. In two of his

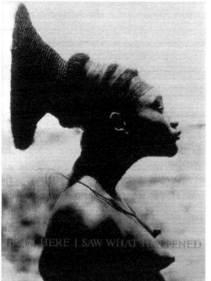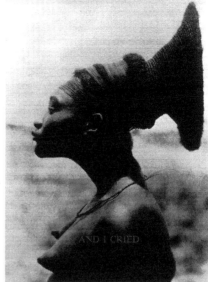

Figure 4.9 Carrie Mae Weems, *From Here I Saw What Happened/And I Cried* (1995–6)

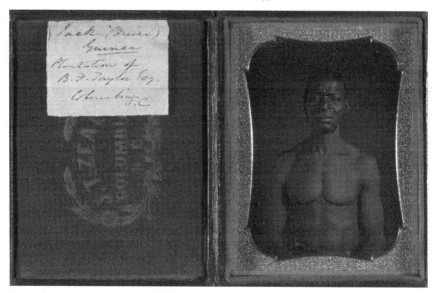

Figure 4.10 Joseph T. Zealy, *Jack. frontal. Guinea Plantation of B. F. Taylor. Esq.* (1850)

fifteen commissioned images we see a slave called Jack. As Marien writes, "the key assumption of middle-class portraiture—that personal character was expressed through physical appearance—vies with the desire to record objectively a generic physical type." She continues by describing how in the first picture Jack is "romantically lit, emphasizing facial features that make him appear noble, pensive, and unassenting" whereas in the second one these traits

are downplayed as the same lighting technique is used to "intensify anatomical features that would substantiate Agassiz's thesis" on racial difference.[46]

Issues pertinent to photography and identity (individual, cultural, and historical)—which underlie the entirety of portrait photography as such—are also at work in Rineke Dijkstra's and Catherine Opie's work. Dijkstra came to prominence in the 1990s by creating portraits in which the subject was photographed right when he or she relaxed or lost the pose. In these photographs the subjects often look uncomfortable or, at least, put out. But this absence of a pose, a projected public image of oneself, also allowed for the presentation of a beauty of sorts. An archival impulse runs throughout Dijkstra's practice. One example being the photographs she made over an eleven-year period (one photograph a year) of Almerisa, a Bosnian girl whose family had relocated to Amsterdam. Here Dijkstra's work creates an archive documenting a child of refugees from the war in the former Yugoslavia (1992–5). Dijkstra first photographed Almerisa in 1994 and continued to do so until a final image in which Almerisa is holding a child of her own. Like other of her projects, Dijkstra's images of Almerisa maintain a consistent compositional format, showing an isolated figure seated on different chairs in distinct yet nearly entirely cropped out interiors. The pictures serve to archive not only Almerisa's life but also to document her cultural and geographic displacement.

Opie's work constructs an archive of difference that draws on cultural codes and stereotypes of gender, sexual identity, and ethnicity. Stereotypes are elements of a larger cultural discourse whose truth is less important, especially as stereotypes are gross misreadings, than their effects. In her self-portraits and other images from the early 1990s, Opie challenges the assumption that one's identity is simply written on and through one's appearance: identity is performative, but not if one takes this to mean that there are simple scripts and costumes. Identity is performative only to the degree that one's image of oneself engages a pre-given cultural discourse and creates a variation on it. Hence a (self-)portrait brings something else into being through itself; it makes something visible that was obscured: life as a narrative event.

Oddly enough it is only now, after these contemporary works, that we can turn our attention to August Sander's unfinished archival project *People of the 20th Century* (planned fourty-five folios with twelve images in each).[47] There are also significant differences, of course, between the mid-nineteenth-century context wherein physiognomy and photography combined to fuel conceptions of race, cultural superiority, and exercises in the policing of populations, and a mid-twentieth-century German one. As Sekula explains, "In a very different historical context—that of the last crisis-ridden years of Weimar Germany—August Sander...delivered a radio talk in 1931 entitled 'Photography as a Universal Language'. The talk...stresses that a liberal, enlightened, and even socially critical pedagogy might be achieved by the proper use of photographic means."[48] Hence Sander undertook an epic project to photograph the "entire social arc" of German society between the First and Second World Wars. His

aim was an archive of social and generational portraits of the German people. Photography, for him, was capable of being a transparent means of representation, one capable of an unrivalled "power of expression": physiognomy. For Sander, "every person's story is written plainly on his face."

Sander worked over a period of decades on his attempt to archive German social and cultural types, but only one volume of his project ever appeared, the tellingly titled *The Face of Our Time* (*Antlitz der Zeit*) in 1929. He was a commercial portrait photographer, which he advertised as "exact photography." As George Baker explains, Sander rejected most avant-garde formal manipulations of photography; he also saw Pictorialism in the early 1920s as kitsch, as symptomatic of the decline of photography because it denied the photographic.[49] Sander's approach to his subjects (his types) was consistent: blank, expressionless faces and a felt distance between him (as photographer) and his subjects because Sander does not register any emotional character (hidden sense of self).[50] So these are not likenesses but photographs of faces. "The photographer with his camera," he said, "can grasp the physiognomic image of his time."[51] This belief associates Sander with European New Objectivity (*Neue Sachlichkeit*), a predominate approach to the photographic prevalent in the 1930s and into the immediate postwar period.[52] In *The Face of Our Time*, each figure is thus always referred to a larger frame of social identity. For Sander, the people he photographs are types, that is, social beings defined by their profession(s) and/or place (location). The implication is that one's identity comes from without rather than within: we are types (one's profession, for example).

In the preface to Sander's volume of photographs, Alfred Döblin noted the distance between his notion of physiognomy and earlier versions. He writes:

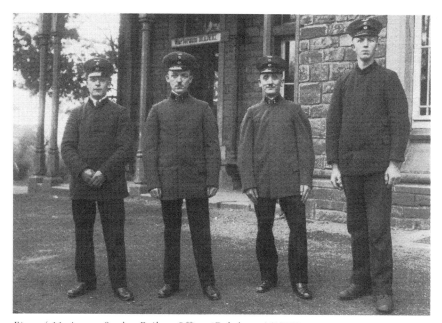

Figure 4.11 August Sander, *Railway Officers (Bahnbeamte)* (1910)

You have in front of you a kind of cultural history, better, sociology of the last thirty years. How to write a sociology without writing, but presenting photographs instead, photographs of faces and not national costumes, this is what the photographer accomplished with his eyes, his mind, his observations, his knowledge, and last but not least his considerable photographic ability.[53]

It is clear that Sander's "physiognomy" lies at some distance temporally and, more importantly, conceptually from Lavater's understanding. Sander does not imply that each contour and spacing of his subjects's faces needs to be examined and read for as an archive of signs indicative of underlying, intrinsic characteristics. Rather, Sander "wanted to envelop his project in the legitimating aura of science without violating the aesthetic coherence and semantic ambiguity of the traditional portrait form."[54] (This may be the most legitimate claim to associating Sander with New Objectivity as a whole.) It is crucial to understand how physiognomy is understood by Sander in this project, for without this understanding it is impossible to understand the difference between Sander's idea and Nazi race theory.

When the National Socialist Party, or Nazis, came to power in Germany in 1933 they objected to Sander's project because the "face" of the German people he archived was not Aryan enough. Sander included unemployed, disabled, and supposedly sexually deviant people. Sander's printing plates were destroyed along with the remaining copies of *The Face of Our Time*.[55]

Sekula's reading is again insightful here. He argues that Sander "organized his portraiture in terms of a social, rather than a racial, typology," a key difference between him and Nazi race "theorists" such as Hans F.K. Günther "who deployed physiognomic readings of photographic portraits to establish both the biological superiority of the Nordic 'race' and the categorical otherness of the Jews."[56] Sekula reads Sander's project as "an indirect and somewhat naïve attempt to respond to the racial particularism of the Nazis, which 'scientifically' legitimated genocide and imperialism." It suggests, he writes, "a neatly arranged chessboard that was about to be dashed to the floor," one that nevertheless remains an inadequate reading of German social history.[57] On a stronger note Sekula hints that what makes Sander's archive of Weimar-period types so compelling for contemporary viewers is the "kind of false stasis, the appearance of a tense structural equilibrium of social forces."

The relation between stasis and narrativity is precisely what Baker asserts is "one of the most interesting formal aspects" of Sander's work, that is, its imbrication of the narrative sequence within the practices of traditional still photography.[58] He contends that it is this relation, even more than the melancholy (depictions of a world that has disappeared) that is retroactively read into the project. Photographic meaning, Baker argues, is "necessarily torn between the forces of narrativity and those of stasis."[59] Narrativity here signifies readable discourse, duration, movement, a certain sense of plurality; whereas stasis signifies refusal of duration, an anti-historical presence.[60] Sander's social typology was "an attempt to map a complex web of social sites, an attempt to firmly articulate a narrative of social placement," that is, the "decay of social rootedness and fixed placement."[61]

"Depicting a narrative of social decay, Sander's work," Baker argues,

> disavows the realities of the historical changes in which German society was then involved, and the logic of this disavowal indeed results in that most characteristic of Neue Sachlichkeit practices, fetishization. This fetishization encompasses many telling things: that of the human subject, of course, but perhaps more tellingly, that of the signified…The political potential of his photography thus comes only from emptying out his intentions, and from seeing in his work something that he never actually achieved—but which exists behind his disavowals—and through the effects of the history to which his work inevitably attests..[62]

In Sander's typology, Baker identifies a clear narrative, a cyclical, organic model of society, growth to degeneration to rebirth. Sander may have intended his still images to be read as a narrative rather than as a series of singular, still portraits (stasis). There is a shared logic between Sander's narrative and the one *The Family of Man* exhibition articulated because Sander's "narrative cycle moves, it is true, but it moves only to return to its origin."[63] Sander constructs his narrative by moving from images of individuals to portraits of couples and from there to group portraits of families or clubs.

The complexities of the Weimar period are only intensified by Sander's use of physiognomy, typology, and his weaving the images into a narrative motivated by "rootlessness." All of these concepts veer dangerously close to rightist discourse in 1930s Germany. Several commentators share Baker's contention that Sander's project is "an ambiguous, contradictory condition for a photographic project that was supposedly of a leftist, socially critical bent."[64] However, readings of Sander's project that do not address the full complexities of its historical and cultural context (Weimar Germany in the 1920s and 1930s) abound. The risks run by doing so are evident in the formalist position, which after the war attempted to salvage Sander as a modernist (formalist) photographer. Making a strong point, Baker starkly clarifies that

> such a construct, however, emphasizing stasis through a claim for the easy accessibility and ultimate validity of an originary cultural "rootedness," reiterates reactionary trends in Weimar philosophy and corresponds to their eventual adoption by Nazi theorists, and in this light it is troubling that modernist photographic criticism of Sander's work has embraced just this aspect of his photography as its most remarkable characteristic. John Szarkowski, in one of the earliest critical essays in America to treat Sander's work, claimed Sander as the progenitor of a photographic practice that could provide a welcome antidote to the 1960s American photographic context, with its concentration on the "ephemeral" and the "moment." Sander had achieved, in Szarkowski's words, the "expressive meaning of the prototype, of a sense of permanence, of stability"… Comprehending one crucial aspect of Sander's work, Szarkowski completely overlooks any intersections such a practice had with the social and historical field that made up Weimar Germany.[65]

To avoid the glaring missteps of a reading like Szarkowski's, Baker attempts to counter stasis with narrativity (a characteristic of the archive when best understood). In many ways, Baker's work here is not to critique the formalist position with an equally determinative contextualist one; instead, he addresses the context while leaving some space for the aesthetic effects of the image's themselves. It is a dialectical relation between narrativity and stasis that Baker desires.

Nonetheless, Baker is intent on providing Sander's project with a political reading, even if only in how it has been received by contemporary photography, for instance by Bernd and Hilla Becher. "Inasmuch as photographers have realized the unconscious and social crisis posed by Sander's photographic portraiture and typological practice, they may manage to achieve a truly political function for photography—to an extent, this legacy has been realized by Bernd and Hilla Becher, and Thomas Struth, among others," Baker concludes.[66] Whether or not the Bechers and their students (Struth, Andreas Gursky, and others) have achieved

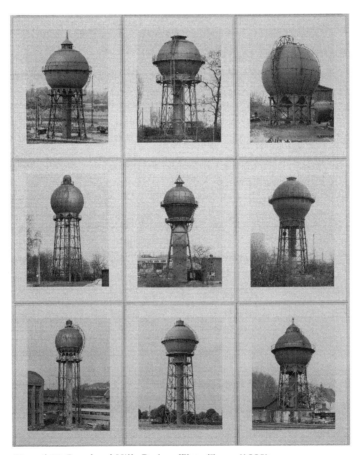

Figure 4.12 Bernd and Hilla Becher, *Water Towers* (1980)

anything like "a truly political function for photography" is far from clear or evident.[67] What is the "truly political function for photography" forwarded by the Bechers? How do the Bechers engage either critique of institutions or raise serious questions about the constitution of the subject? These are the two poles of the Octoberist (critical postmodern) position. How are Sander's project and the Bechers's postwar typologies of industrial structures related, taking into account that the former is always given as a precursor of the latter?

Bernd and Hilla Becher began photographing industrial structures in 1966, traveling throughout Europe and the USA. Their project has become one of the most influential in postwar art and architectural history.[68] The relation of their work to Minimalism and Conceptual art as well as their distinctive mode of presentation has made the work central to any discussion of contemporary art and photography. Their photographs, made with a large-format camera, are sharply focused and are taken from slightly elevated viewpoint, and first appeared with the publication of *Anonymous Sculptures: A Typology of Technological Structures* in 1970. Subsequent publications includes *Water Towers and Industrial Landscapes*. In these series they photograph lime kilns, blast furnaces, water towers, grain elevators, and gasometers. Although the Bechers's have used a few different phrases to name their work—"anonymous sculptures," "basic forms," and "nomadic architecture"—it is most productive to consider the concept of a typology; these are typological studies of industrial forms done in a documentary photographic style in which several individual images are presented together in the form of grid-tableaus.[69]

In making the photographs the Bechers's use an affectless, documentary style like that found in nineteenth-century documentary photography and New Objectivity in the 1920s and 1930s. For example, consider Renger-Patzsch's *Industrial Forms and Smokestacks* (1927), one of many images that clearly tie to the Bechers's photographic practice. As Hilla Becher has stated, "I was interested in a straightforward 19th-century way of photographing an object. To photograph things frontally creates the strongest presence and you can eliminate the possibilities of being too obviously subjective."[70] There is very little variation from a procedure that was first presented in the *Anonymous Sculptures* book. The "procedural rules" being the use of black-and-white film, standardized format and ratio of figure to ground, uniform, full-frontal view, flat lighting conditions or the approximation of such conditions in the processing of the print, lack of human presence, uniformity in print quality, sizing, framing, and presentation.[71]

Coupled with this consistent photographic style is an equally recurring presentation technique wherein the photographs are presented in systematic grid-tableaux. The Bechers select a small number of photographs of a particular type of structure and arrange them in three to five rows, with photographs directly above one another in a grid formation. It is the mode of presentation that the Bechers deploy that is more noteworthy than the photographs themselves. Simply put, they arrange them into various numbers (three, six) so that each image is an independent unit and yet entirely dependent on the set as a whole. The question arises as to whether in arranging pictures in grids of

different numbers, which negates the isolation and autonomy of an individual image, is there movement (or narrativity) from image to image? How are the images connected? Is it a network, a series, a set, a sequence—an archive?

Is the Bechers's project, therefore, an attempt at archival, documentary work? Is the reason for their consistent photographic procedure and exhibition style to preserve these disappearing structures? On this question concerning to what degree preservation served as a motivating factor, the pair gives us different emphases. Hilla Becher refers to the preservation aspect as a "side effect" not a motivation; Bernd Becher has repeatedly said that it is "an important point." Some commentators often ground their readings of the Bechers in this archival, documentary framework. Several posit that it is a form of "historical documentation" because the Bechers "invite the recognition of 'anonymous sculptures' in these constructions because their technical function is in the process of disappearing and, with mine shafts, for example, closing one after the other, they survive in the form of the vestiges which are documented in these series of uniformly monochrome photographs."[72] In my opinion, these readings place extraordinary emphasis on the scant captions that the Bechers's give under the images, which is limited to type of structure, location, and year built.

Other readings of the project do not share this emphasis on the archival, documentary nature of it. For example, Michael Fried does not read the Bechers's "surrogate objects" (their phrase) as documenting a changing industrial landscape. Instead he emphasizes the presentation of the images as the aspect that "reveals the depth of its originality." "The point of such an arrangement is above all comparative: the viewer is thereby invited to intuit from the nine, twelve, fifteen, sixteen or more individual instances the latent 'presence' or operation of a single type, and at the same time to enjoy a heightened apprehension of the individuality or uniqueness of the particular instances relative both to one another and to the latent or implied type."[73] Fried reads the Bechers's work against the commonplace yet rarely satisfying association of it with Minimalism.

Fried's opposition to Minimalism is longstanding and trenchant, as is clearly evident in his essay "Art and Objecthood" (1967) where he critiques the theatricality at work in Minimalism. As developed by Robert Morris, Carl Andre, and others, Minimalist practice sought the greatest formal reduction in order to create embodied perceptual encounters or situations in which the viewer of the work negotiates the art (a mirrored cube or line of firebricks placed one after the other) object, the site or context itself (environmental cues), and the limits of his/her own perceptions to create an open-ended perceptual experience. Minimalist work is "theatrical" in Fried's terms because the work is absolutely contingent upon the viewer to perform and thus complete the work, that is, the creation of a perceptual, bodily encounter. Fried turns to the Bechers because they taught many of the contemporary photographers that instigated him to examine photography in his *Why Photography Matters as Art as Never Before* (2008). The Bechers have been teaching photography at the art academy in Düsseldorf since 1976 and several of their students, Struth, Gursky, Thomas Ruff, Candida Höfer, have become the leading photographers of their generation. It was these students of the Bechers

that led Fried to photography, so it is interesting to note how he reads their work, specifically how he distances it from Minimalism.

Fried cites an interview with the Bechers in which Bernd Becher addresses the relation between their work and Minimalism. He begins by acknowledging the role played in introducing their work to an English-speaking audience by Carl Andre's text published in *Artforum* in December 1972. Bernd Becher adds that Andre was "interested in the idea that the object was not created by composition but was defined by the situation. It's about the concept of 'found objects', of prefabricated parts, like bricks or iron."[74] Without simply stating a historical, documentary impulse, he notes a distance from Andre's Minimalist practice and their own when he says: "I would say that we want to complete the world of things." Fried argues convincingly that the relation to Minimalism is tenuous, especially when one presses the Bechers's decision to eliminate the context of the structures which, in effect, suggests an indifference to the idea of site and context at the center of Minimalism. Moreover, Fried gives a reading of the seriality at work in the Bechers's practice that bears no relation to the serialism (as in the process is the content of the work) prevalent in Minimalism.

Fried interprets Bernd Becher's statement about desiring "to complete the world of things" in a manner that results in viewing the work as neither a historical archive or nor as a simple iteration of Minimalism, or even Conceptual art practice. He concludes:

> I take this ["we want to complete the world of things"] to mean not that the world at large or the more limited realm of industrial structures as it exists outside the Bechers's photographs is to be "completed" by making a photographic inventory of the whole of its contents (nothing could be further from their project); nor even that there is still much to be learned about a distinctively modern form of life from studying relatively short-lived industrial structures that would otherwise never be paid the close and sympathetic attention they deserve...rather that what is missing from the "world of things" as it stands—what is to be supplied by the Bechers' typological "tableaus"—is precisely a "showing" of the grounds of its intelligibility, which is also to say of its capacity for individuation, as a world. Or, as a world, one bearing the stamp of a particular stage in history, to go part of the way toward Bernd Becher's expressed concerns.[75]

Fried's reading of the Bechers's project is at once ontological (it is about a mode of being in the world, the complex relation of each thing to the whole) and epistemological (the typologies and the grid, tableau structures render visible the very conditions and conventions, perhaps, of intelligibility). The multiple presented through the grid-tableaux are less archival in this reading than it is a framing condition in and through which the type (the idea, or form) may be evoked, made present and appear intelligible.

Another intriguing reading of the Bechers's project also centers on the concept of the "world" even as it parts company with Fried's skepticism as to

whether "there is still much to be learned about a distinctively modern form of life from studying relatively short-lived industrial structures" is given by Blake Stimson in his *The Pivot of the World* (2006). Stimson reads the Bechers's near-total elimination of context, which again counters readings that simply characterize their work as preservationist, and the "seemingly objective and scientific character of their project" as an aesthetic strategy that must be understood in relation to the historical precedents of the work. These precedents are not artists associated with Minimalism (Stimson does not follow this line at all). Instead, he reads the Bechers's project as "in part a polemical return to the 'straight' aesthetics and social themes of the 1920s and 1930s in response to the post-political and post-industrial subjectivist photographic aesthetics that arose in the early postwar period."[76] Stimson is referring here to the New Objectivity and New Vision photography of the 1920s and 1930s as well as the postwar photography embodied in projects as varied as *The Family of Man* exhibition in 1955 and Robert Frank's *The Americans*, for example. He traces the faults lines between the Bechers's and Otto Steinart's "subjective photography" (1952) and the "syrupy universalism" (Robert Frank's brilliant phrase about Steichen's *The Family of Man* exhibition).

Even as it draws on the photographic as constructed in New Objectivity and New Vision, the Bechers's project does not share the underlying premise that the photographic can "monumentalize" a building, for instance, in order to advance a political view, "a fresh view of the world, a new man, a new beginning" (their words).[77] Stimson acknowledges the turn to aesthetics at work in the Bechers's project, which certainly distances it from the anti-aesthetic stance of Minimalism and Conceptual art. However, he works to militate against severing it entirely from the "world":

> Theirs was one of measured, calculated relations with the world around them, not of merging into it or fleeing from it, and so the affective and aesthetic charge of their work is always tempered, nuanced, qualified, and guarded. The tension that drives their work is a matter of simultaneously holding onto a commitment and indulging in a visual delight without allowing either the ethical impulse or the desire to get the upper hand.[78]

Stimson sees in the Bechers's project a "vision of photography as a medium of sociality, as a modeling agent for social form." This is a wager that rides on the metaphoricity of the seriality in the project itself. The persuasiveness of Stimson's conclusion rests on how far one is willing to stretch that metaphoricity.[79]

Stimson's take on the Bechers's project is illuminating because he gives it a socio-historical significance without foreclosing on its aesthetic aspects. In short, he does not denigrate or even apologize for the aesthetic strategies at work in the Bechers's typologies. Rather, he works through the fact that "the use of rhythm and repetition endows the buildings they photograph with the 'anonymity' or abstract form they seek (by divorcing meaning from original purpose and everyday social function) rather than with scientific specificity and, in turn, allows us to read them ahistorically and extrasocially

and appreciate them as autonomous aesthetic objects or 'sculpture'."[80] He concludes by pressing these "autonomous aesthetic objects" even further. "The delight offered by their art," he adds, "is therefore realized only against the revolutionary promise of the modern industry it depicts. It is a view of industrial history as if it were nature."[81] Where Stimson's reading needs to be challenged is when he describes the Bechers's project as an archive "exactly in the manner that Foucault would describe." We must turn to how Foucault's concept of the archive is wielded in the discourse of photography so as to demonstrate that it does not signify a simple depository of documents or photographs of presupposed historical value. (I will undertake this task more fully below.)

In many ways the Bechers's work is undeniably canonical yet it remains uncertain as to what they are precisely doing with this repeated procedure and format. On one hand, it has been received and read through the parameters of the anti-aesthetic position. The Bechers's project forfeits originality, uniqueness, and self-expression, but this is not done in the service of any immediately discernible political critique. Nonetheless, Baker and even Stimson try to provide one. On the other hand, Fried's reading, which ignores any elements of the anti-aesthetic position is equally unconvincing. If the Bechers's project does not construct a simple historical, documentary archive, then what is it? How does the project function? What are its aims? One function is an experiment in reading difference within repetition. How do we discern difference, variation, from repetition? It is important to note that the Bechers's never present identical water towers or lime kilns; rather, as noted above, each image depicts a unique, individual structure. However, it is the presentation strategy that encourages an initial slippage on the viewer's part to first seeing them as identical (repeating an ideal form) before she begins the aesthetic and epistemic labor of discerning differences. Hilla Becher says as much, stating that "you can very well perceive things that differ little from each other as individual elements, if you assemble them in groups."[82] Perhaps the Bechers's project is not an archive but an atlas, that is, a visual map or geography of contemporary culture? A training manual?[83] An atlas that only art can create.

The concept of an atlas, of course, is linked to many fields (astronomy, botany, etc.) but most notably to geography. Geographical expeditions quickly adopted photography as a means to survey new, unknown territories. These photographs were initially dictated by the conventions of landscape painting, but by the mid-1860s landscape photographers who accompanied these expeditions began to devise conventions that varied from those inherited from painting. As Joel Snyder explains, a large and distinct market for landscape photography began in the mid- to late 1850s (publishing houses, tourism, stereographs) and by the mid-1860s photography had fully entered popular culture. Thus landscape photographers had to both adopt and reformulate landscape conventions. They were "caught in a double bind: they had to devise an approach to the production of landscape pictures that appeared to escape

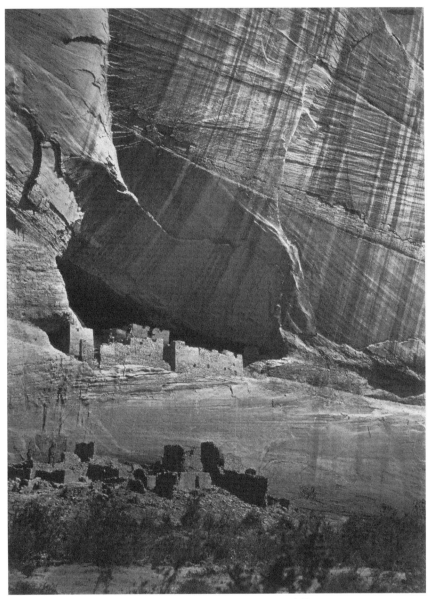

Figure 4.13 Timothy O'Sullivan, *Ancient Ruins in the Canon de Chelle, New Mexico* (1873)

the generally sanctioned motifs and formulae of landscape depiction, while emphasizing, at the same time, those qualities that were increasingly taken by their audience to be indices of photography—qualities that convey aspects of singularity, factuality, and materiality."[84] What we see in this moment is a conflict between inherited pictorial conventions and the public's desire to define

photography as fact, objective, as a passive record of pre-existing sights. Hence photographers such as Carleton Watkins and Timothy O'Sullivan made photographs of the Western USA for geographical expeditions (both private and government-funded), but in ways that adumbrate the photographic as defined much later in the 1920s and 1930s.

Focusing on landscape photography not only allows us to complicate the relation between archival work and photography, but it also allows for another pass through the formalist/postmodernist one. Images such as O'Sullivan's *Ancient Ruins in the Canon de Chelle, New Mexico* (1873) were made for geographical expeditions yet they were recuperated into the formalist canon in the 1930s.[85] Robin Kelsey admirably presents the context of this recuperation and the subsequent readings of O'Sullivan, for example, by postmodern critics. His "Viewing the Archive: Timothy O'Sullivan's Photographs for the Wheeler Survey, 1871–74" opens with Ansel Adams urging Beaumont Newhall to include survey photography in MoMA: Adams argued that Watkins and O'Sullivan's work was "a harbinger of modernism."[86] O'Sullivan's work was done primarily on two surveys led by the Army Corps of Engineers, one led by Clarence King and one by Lt. George Wheeler, with the now iconic photographs being made in 1873 and 1874 with the Wheeler expedition. As Kelsey writes:

> Even a glance at *Ancient Ruins in the Canon de Chelle, NM*, a photograph included in the Museum of Modern Art's landmark exhibition of photography in 1937, helps to explain Newhall's enthusiasm: the picture features stark geometric relations, radical value contrasts, instances of insistent planarity and graphic reduction, and other qualities in keeping with a modernist sensibility.[87]

Yet, as Kelsey notes, postmodern criticism of this inclusion is intense. Scholars dismissive of formal experimentation and vehemently opposed to the construction of a distinct medium named photography with an institutionalized canon have zeroed in on O'Sullivan (and other nineteenth-century photographers such as Atget) in order to draw our attention to context, "the actual circumstances of production and reception" as Kelsey notes.

Kelsey traces a line between the formalist and postmodern (contextualist) positions. If the formalist (modernist) position represses context ("the governing circumstances of O'Sullivan's practice"), then the postmodern position suppresses "his puzzling pictorial choices," in short, aesthetics. By examining O'Sullivan's wet-plate photographs and his stereopscopic views from these expeditions, Kelsey argues that

> weaving together the emphases of both camps may yield a more compelling understanding not only of how O'Sullivan approached his work but also of how his work performed its instrumental and ideological functions…[I will consider] the possibility that O'Sullivan fashioned his unusual images by inflecting pictorial conventions with values and

strategies drawn from the survey visual culture in which his practice was embedded...In particular, his photographs conveyed assurances that the survey was translating the West into legible graphic materials that could facilitate resource extraction, military control, and scientific understanding. O'Sullivan, however, did not always abide strictly by the demands of this representational program. At times, he struck a skeptical note, making pictures that called into question the capacity of photography to deliver epistemological gain.[88]

Through close readings of O'Sullivan's images and their contextual requirements, Kelsey proves that the photographer created images that varied the conventions of the genre. O'Sullivan's variations on the conventions are neither liabilities (postmodern position) nor are they choices made *ex nihilo* in a vacuum by artistic "genius" (formalist position). Rather, his images present a "gentle recession into space, a penetrating line of sight" and "starkly geometric planes" that draw directly from the graphic visual techniques of topographers and geologists, Kelsey demonstrates. Thus O'Sullivan meant to counter the imprecision and excessive "visual noise" of photography which, at the time, was no longer considered a reliable means for quantitative translations of territory. What we see in O'Sullivan's images does not simply adumbrate modernist values of flatness or sharp contrast. As Kelsey concludes, the "paradigmatic surface" reflected in these images was "not the spare wall of the modernist gallery but the distilled informational display of the report or atlas page."

Kelsey arrived at this new interpretation of O'Sullivan's photographs because he refused to foreclose on the qualities of the image as an image, that is, on its aesthetic dimensions. As he shows, the aesthetic dimension is only one aspect of an image, although a significant one. Postmodern criticism of O'Sullivan's inclusion in MoMA, for instance, has not only refused to see the images, but it also wields the concept of an archive to argue for strict discursive boundaries. O'Sullivan's images, in this reading, must belong either to science (the "view") or art (landscape). An extended reading of O'Sullivan is given by Rosalind Krauss in her "Photography's Discursive Spaces," an essay taken as a "starting point" of the postmodern critique of photography.[89]

She argues that the photographs by O'Sullivan have been "legitimated" by formalist/modernist critics.[90] Asking "within what discursive space does the original O'Sullivan...function?" Krauss says that we must answer: "that of the aesthetic discourse."[91] "And if we ask what is it a representation of, the answer must be that within this space [aesthetic discourse as she presents it] it is constituted as a representation of the plane of exhibition, the surface of the museum, the capacity of the gallery to constitute the objects it selects for inclusion as Art."[92] Krauss does not remain here, however, as her real objective is not to place O'Sullivan's work within aesthetic discourse, but to reveal the gross missteps of the formalist critics who were doing just that.

Krauss not only goes to lengths to dismiss the inclusion of O'Sullivan within a modernist (aesthetic) canon but also works to give a reading of

O'Sullivan's work as "views" (primarily stereographs) so as to negate any reading that construes him as the artist/author of his images. She begins with more questions, although they all end up being rhetorical:

> But did O'Sullivan in his own day, the 1860s and 1870s, construct his work for the aesthetic discourse and the space of the exhibition? Or did he create it for the scientific/topographical discourse that it more or less efficiently serves? Is the interpretation of O'Sullivan's work as a representation of aesthetic values—flatness, graphic design, ambiguity, and behind these, certain intentions toward aesthetic significations: sublimity, transcendence—not a retrospective construction designed to secure it as art? And is this projection not illegitimate, the composition of a false history?[93]

As we have already seen, Kelsey answers these questions in ways that are more subtle and persuasive than Krauss. I will not address her argument that they are "views" in full, a reading intent on foreclosing their "art" or "aesthetic" aspects by insisting on the automaticity of photography. Simply put, Krauss holds that photography is automatic, thus positivist, passive, nonartistic (not expressive of an individual subject). She uses photography to move beyond traditional notions of an artist/author as well as traditional notions of a medium. In many ways, she "simply reversed the established terms of scholarly conversation, generating an almost equally constraining, problematic, and, ultimately, conservative dialogue as put forward by Peter Galassi, Szarkowski and, others."[94] Instead, I would like to foreground Krauss's use of Foucault's work to stage this critique. Krauss wields Foucault in a way that circumscribes the richness of his work. In other words, let us examine how she uses Foucault—how she constructs her "Foucault"—in order to inaugurate the postmodern critique of photography.

In his fine essay "Krauss's Foucault and the Foundations of Postmodern History of Photography" Andrew E. Herschberger provides a close reading of Krauss's usage of Foucault's work, which he named "archaeology." (As we have seen Foucault's work undergirds the entirety of the postmodern position.) He begins by demonstrating how and why even Krauss's use of "discursive spaces"—making a distinction between art and science, for instance—may be at odds with Foucault's definition of it as that which contains "concepts that differ in structure and in the rules governing their use, which ignore or exclude each other...which cannot enter the unity of a logical architecture."[95]

Much of his attention is given to Krauss's use of Foucault's concept of the archive, which does not simply refer to photographic archives found in various institutions. It is not a repository or a set of images. Here is Krauss's assertion: "Everywhere at present there is an attempt to dismantle the photographic archive...and to reassemble it within the categories previously constituted by art and its history."[96] Herschberger argues that Krauss takes the archive to be a particular set of historical relationships; the term "set" that Krauss uses being at odds with Foucault's "system." An archive being "the general system of the formation and transformation of statements."[97] It seems more as

if Krauss slips between the standard notion of an archive as a set of distinct, coherent documents, and one more aligned with Foucault's. Nonetheless, I agree with Herschberger's contention that Krauss fails to see the lengths to which Foucault goes to make distinctions between his archaeology and structuralism in general. It is here that his emphasis on the dispersion, incoherence, and fragmentary nature of the archive is unavoidable. Thus, Herschberger concludes that the verbs "dismantle," "reassemble," and "maintain" not only imply that "we know, from the start, what sort of a thing early photography's 'archive' ought to be, but also what sort of a thing it actually was. But how can we 'dismantle', 'reassemble', or much less 'maintain' something that Foucault claimed was beyond our grasp, something 'never completed' or 'never wholly achieved' in the first place"?[98] He finishes by adding that Krauss's "insistence on the coherence of her 'discursive spaces' (e.g. art separate from science), unfortunately eliminates elements of non-coherence, incoherence and/or discontinuity from within an 'archive'."[99]

Beyond even Herschberger's critique of Krauss we must acknowledge the degree to which Foucault's concept of the archive both correctly fuels the postmodern attack on traditional notions of authorship and art historical categories such as oeuvre and medium. Krauss's work is certainly singular on these fronts. It is not enough to say that she misreads Foucault's work because all readings of theoretical texts—to a certain degree—are misreadings, that is, interpretations that put different aspects of the work to use. In this instance, what needs to be redressed is the use of theory to support overarching, reductive notion of "aesthetics" as formalism *tout court*. The task remains to return to these theoretical positions and read them otherwise, give them new uses and functions—some of which may well help us gain a fuller understanding of context and aesthetics. Despite being lumped together into a single set of thinkers labeled "postmodern" or "post-structuralist" we must discern the differences between Foucault and Barthes and Derrida et al. If we do so, then we may very well come to understand that art theory—the discourse itself—is a "dispersion that can never be reduced to a single system of differences."[100] These theoretical texts are our archive, that is, precisely what we cannot see or say, hope for or anticipate. It is our element.

As Derrida told us in *Archive Fever*:

> And the word and the notion of the archive seem at first, admittedly, to point toward the past…to recall faithfulness to tradition. If we have attempted to underline the past…it is also to indicate the direction of another problematic. As much as and more than a thing of the past, before such a thing, the archive should call into question the coming of the future…The archive: if we want to know what that will have meant, we will only know in times to come.[101]

The archive opens time.

GLOSS ON MICHEL FOUCAULT, *THE ARCHAEOLOGY OF KNOWLEDGE* (1969)[1]

After the publication of his landmark text *The Order of Things* (*Les Mots et les Choses*) in 1966, which was accompanied by both laurels and misunderstanding, Foucault sought to clarify his methodology, which he called "archaeology" or "genealogy." The result being *The Archaeology of Knowledge*. This book is related as well to a series of remarkable essays that he wrote around the same time, namely "What is an Author?" (1969), "Nietzsche, Genealogy, History" (1971), and "Theatrum Philosophicum" (1970) an essay-review of Gilles Deleuze's *Difference and Repetition* (1968) and *The Logic of Sense* (1969).

Foucault was dismayed that his position in *The Order of Things* was not more understood as being distinct from structuralism. In *The Order of Things*, Foucault analyzes various human attempts to foist the categories of language and conceptualization onto an indifferent world. He saw structuralism as "the last attempt at representing the things of the world to consciousness," that is, "as if the world were made to be read by man."[2] Nonetheless, the failure of even this most recent attempt exposed other histories that transgress the order putatively underlying and linking historical events. Rather than structure or systematicity, Foucault discerned a discontinuous, incoherent disorder that became evident on the level of things said: discourse.

Archaeology is a methodology that Foucault developed to orient us toward this discontinuity and dispersion as opposed to the supposed legibility and order of the past. This methodology neither implies the search for a beginning (an origin) or law, nor is it related to geological excavation. Instead, it is a new (post-structuralist) methodology, one that is neither philosophy (a return to an origin, a Platonic anamnesis or recollection) nor history conceived as "giving life to half-effaced faces." Archaeology "describes discourses as practices specified in the element of the archive."[3]

For Foucault, discourse is not a chronology of events, ideas, or even individual speech-acts. On the contrary, discourse is comprised of groups and descriptions of statements about events. It is for this reason that Foucault writes that "every discourse appears against a background where every event vanishes."[4] It is groups of statements that historians deal with when writing history, not events. Statements are the basic element of discourse: they have already been said or spoken. These statements—what is said about an event, what "truth" they produce—are governed by the archive: what is *unsaid* within discourse. The archive is the system of rules that governs the appearance of statements; it acts on these statements but not with the weight of tradition or oblivion. The archive is the force of the unsaid. It exists in a threshold between tradition and oblivion. It delimits the threshold of historical consciousness itself. Thus discourse and archive form a relation that accounts for what can and cannot be said (or analyzed) in a given historical period.

Here is a key passage from *The Archaeology of Knowledge* where Foucault explains the archive in terms somewhat familiar to us. It comes in the chapter "The Historical *a priori* and the Archive." He begins his closing remarks of that chapter by stating:

> Between the *language* (*langue*) that defines the system of constructing possible sentences, and the *corpus* that passively collects the words that are spoken, the *archive* defines a particular level: that of a practice that causes a multiplicity of statements to emerge as so many regular events, as so many things to be dealt with and manipulated. It does not have the weight of tradition; and it does not constitute the library of all libraries, outside time and place…between tradition and oblivion, it reveals the rules of a practice that enables statements both to survive and to undergo regular modification. It is *the general system of the formation and transformation of statements*. It is obvious that the archive of a society, a culture, or a civilization cannot be described exhaustively; or even, no doubt, the archive of a whole period. On the other hand, it is not possible for us to describe our own archive, since it is from within these rules that we speak.[5]

The archive is not *a priori* truth or even experience. It is also not ahistorical or atemporal. Foucault is clear that the archive is not tradition or history as lived experience; on the contrary, the archive disperses statements in time. It enables the survival of statements *and* the potentiality of changing a discourse. As he repeatedly explained of his methodology, "I have not denied—far from it—the possibility of changing discourse: I have deprived the sovereignty of the subject of the exclusive and instantaneous right to it."[6]

Understanding Foucault's methodology, precisely how it offers the "potentiality of changing a discourse" without resorting to the "unity" and "sovereignty" of the human subject, requires being able to differentiate discourse and archive. If his aim is to describe the relations of coexistence among statements, then he does not rely on traditional, presumed "unities" such as humanity, the work of an author, the cohesion of an age or epoch, the myth of progress, or the supposed transparency (neutrality) of language.[7] Even the idea of "human consciousness" is not continuous for Foucault; it is not a valid ground on which to base historiography.[8] Accepting any of these "unities" in advance, presupposing any of them as a ground or guarantor of one's study of history, makes it more difficult to discern ruptures and discontinuities because each insures continuity and tradition, a necessary symmetry between an event and its narrative.

Foucault "means to indicate his utter unconcern for the staple of conventional history of ideas: continuities, traditions, causes, comparisons, typologies, and so on. He is interested, he tells us, only in the 'ruptures', 'discontinuities', and 'disjunctions' in the history of consciousness, rather than the similarities."[9] Therefore, his archeology or genealogy aims

> not to trace causal influence among events, nor to follow the evolution of the "Spirit of History"; it does not adhere to strict historical laws, nor

does it believe in the power of subjects, great or small, to act "originally," that is, to "change history." Rather it [genealogy] describes events as transformations of other events which, from the vantage point of the present and its needs, seem to be related by a family resemblance. It shows how these transformations have no causal or historical necessity; they are not "natural." It shows how the adjacency of events, that is, their simultaneity within ostensibly different fields, can transform entire domains of knowledge production.[10]

It is for these reasons that Foucault has little interest in so-called historical "truth." Discourses are the statements we have made about historical events, regardless of being true or not. His focus is on the statements made about events, not their truthfulness. What is more interesting to him is that these statements and frames of reference precede any given event. They actually domesticate each and every event by linking it to other events. Therefore, an event is never told, described, understood in language that is unique to it. Instead, discourse makes it reliant upon and understood in relation to other statements. As Foucault explains, "when it comes to determining the system of discourse on the basis of which we still live, as soon as we are obliged to question the words that still resonate in our ears, that are mingled with those we are still trying to speak, then archaeology…is forced to work with hammer blows."[11]

This image of working "with hammer blows" reveals Foucault's debt to Nietzsche, but it also suggests that his interest in describing discursive acts (knowledge and power) is motivated by a desire to fracture the semblance of continuity and tradition. To determine the discourse that determines how we live is difficult work because statements (things said, not the expressions of a speaking subject) are "rare." Foucault notes "the fact that few things, in all, can be said." Statements are "not, like the air we breathe" but are "things that are transmitted and preserved, that have value, and which one tries to appropriate; that are repeated, reproduced, and transformed."[12] Moreover, because discourse produces knowledge it is inextricably bound to power (institutions, governments, etc.) that have the authority to produce statements (again often with disregard of the "truth").

Discourse is "an obscure set of anonymous rules" ("a body of anonymous, historical rules, always determined in the time and space that have defined a given period") that reveals the linkages between knowledge and power. Power, Foucault explains, constructs truth-producing systems; power is productive because it produces statements. It is creative. Foucault helps us understand the seductiveness of power: it is not merely repressive or negative as in the common understanding of power; rather, power is creative because it "makes possible" new frames of reference. "Truth," in Foucault's terms, is an effect of these frames (truth-producing systems). The more a discourse coheres, the more "truthful" it appears. However, when Foucault turns his attention to statements he discerns how the unsaid (archive) plays a crucial role in producing the said (statements). An archive, then, is a "special place"

in which it is possible to analyze the mutual coexistence and dependence of said and unsaid, knowledge and power, even if it only emerges in fragments that become clearer as they are removed from us in time.

Foucault is adamant that by using this term "archive" he does not mean "the sum of all texts that a culture has kept upon its person as documents attesting to its own past, or as evidence of a continuing identity." Nor does he refer it to "the institutions, which, in a given society, make it possible to record and preserve those discourses that one wishes to remember and keep in circulation."[13] The archive is "the law of what can be said, the system that governs the appearance of statements as unique events." It insures that statements are "grouped together in distinct figures, composed together in accordance with multiple relations, maintained or blurred in accordance with specific regularities."[14] This means "releasing them from all groupings that present themselves as natural, immediate, and universal unities" so as "to constitute discursive ensembles that would not be new but would, however, have remained invisible."[15]

Foucault adds:

> But these invisible relations would in no way constitute a kind of secret discourse animating the manifest discourses from within it; it is not there- fore an interpretation that could make them come to light but, rather, the analysis of their coexistence, of their succession, of their mutual depend- ence, of their reciprocal determination, of their independent or correlative transformation. All together (though they can never be analyzed exhaus- tively) they form what might be called, by a kind of play on words—for consciousness is never present in such a description—the "unconscious," not of the speaking subject, but of the thing said.[16]

An archive simultaneously creates a discourse and differentiates it into a num- ber of correlative spaces. This is why discourse has a multiple existence, with distinct and varying durations, specified by the element of the archive. We can only read, find, and retrieve pieces and aspects of the archive through the effects of discourse. The archive is inexhaustible, fragmentary, and indescrib- able in its entirety. However, the greater the temporal distance from us, the "greater sharpness" of the archive and its functions.

An archive is a threshold in which Foucault searches for the historical con- sciousness itself.[17] His aim being "to enter into the interior of any given mode of discourse in order to determine the point at which it consigns a certain area of experience to the limbo of things about which one cannot speak."[18] For instance, consider Foucault's studies of madness as a discursive construct, that is, who can be said to be insane as opposed to sane. It is for this reason that he repeatedly denies his concept any historicist or even melancholic meaning: "I shall call an *archive*, not the totality of the texts that have been preserved by a civilization or the set of traces that could be salvaged from its downfall, but the series of rules which determine in a culture the appearance and disappear- ance of statements, their retention and destruction, their paradoxical existence

as *events and things*."[19] Foucault demands not thinking of the elements of the archive as documents, but rather as "*monuments*," that is, a "monument" as an ongoing, enduring event *and* a thing. The unsaid (the general element of the archive) is a monument, a counter-memory that renders discourse by coexisting with it. Thus it is "from within [the archive] that we speak, since it is that which gives to what we can say…its modes of appearance, its forms of existence and coexistence."[20]

This is why the statements (forms of expression) and visibilities ("modes of appearance," forms of content) of discourse are the exteriority in which we are "caught up." It is for this reason, among others, that Foucault rejects the "sovereignty of the subject" to change discourse. We are "caught up" within it. We are its dispersion. Foucault's archaeology does not rely on the speaking subject; rather, it is situated at the level of the "it is said" (the statement). By this he means the "the totality of things said, the relations, the regularities, and the transformations that may be observed in them."[21] But to this must be added another dimension of historical strata (strata being the levels that comprise the present).

For Foucault, the "historical" is comprised of stratified formations that are empirical. Strata are made up of words and things, speaking and seeing, the sayable and the visible. Thus, to our discussion of statements we must add what Foucault terms "visibilities." Visibilities are distinct from the "visible" understood as that which is available to perception. They are

> not to be confused with visual elements, whether qualities, things, objects, or amalgams of action and reaction. In this respect, Foucault constructs a function which is no less original than his "utterance" (statement). Units of visibility are not the forms of objects, nor even those forms which would be revealed in the contact between light and things. Instead, they are forms of the luminous, luminous forms, created by light itself, allowing things only to subsist only as flashes, reflections, or sparkles.[22]

This accounts for Foucault's intense interest in *ekphrasis*, the description of the visual (at times, works of art). Consider his brilliant descriptions at the opening of *The Order of Things* of Velazquez's *Las Meninas* or his interest in Manet.[23] The stratification of the present has two elements: the forms of content (visibilities) and the forms of expression or discursive formations (statements). The task Foucault sets himself is to extract statements from words, speech-acts, phrases, and language *and* to extract visibilities from things and vision. "In this sense," Gilles Deleuze explains in his reading of Foucault, that which is stratified

> constitutes Knowledge…and is subject to archaeology. Archaeology does not necessarily refer to the past, but to strata, such that our present has an archaeology of its own. Present or past, the visible is like the utterable [the sayable, the statement]: it is the object not of phenomenology, but of epistemology.[24]

The archive is what exists between statements and visibilities. Between "the visible and its luminous condition, utterances slip in; between the utterable and its language condition, the visible works its way in."[25] This threshold *between* is an opening in time; it has no content, but is only an articulation of forces. Moreover, the archive, the history of forms, is doubled by an evolution of forces, the diagram.

Scholars that use Foucault's work, particularly to address photography, have only dealt with half of what comprises his methodology. The half that has been suppressed is the diagram. The archive, the history of forms, is dependent on an "informal" dimension, the diagram. Thus the diagram is "no longer an auditory or visual archive but a map, a cartography that is coextensive with the whole social field. It is an abstract machine…It is a machine that is almost blind and mute, even though it makes others see and speak."[26] Deleuze adds that every diagram is

> intersocial and constantly evolving. It never functions in order to represent a persisting world but produces a new kind of reality, a new model of truth. It is neither the subject of history, nor does it survey history. It makes history by unmaking preceding realities and significations, constituting hundreds of points of emergence or creativity, unexpected conjunctions or improbable continuums.[27]

Diagrams are drawn by the "Outside," but the latter is never identical to or merges with any one diagram. Diagrams are forces of chance and newness, but they are also dependent upon an Outside, a non-place, a non-relation. For Foucault, to think is to undertake historical research to reach an Outside. The Outside, which he also brilliantly calls the "actual," is an opening to another temporality.

Archaeology is "untimely" because it asks us to "think the past against the present…not in favour of a return [nostalgia, etc.]" but in favour of a time to come, as Nietzsche hoped. For Foucault, to study the historical is to render the "past active and present to the outside so that something new will finally come about."[28] Thought must pass through strata (statements and visibilities) in order to think itself otherwise. Thinking is never a question of resemblance.

Lastly, thinking photography means to pass through the archive (the history of forms) to reach the diagram, the map, or atlas that traces the contours of a fortuitous, unexpected, unimagined Outside, that is the actual. For Foucault, the actual is "not what we are but, rather, what we become, what we are in the process of becoming—that is to say, the Other, our becoming-other."[29] Most importantly, we must distinguish the actual: not an archival life, but life as a becoming-archival.

5 Time-images

Suddenly there is a difference between a quaint evocation of the past and an open window looking straight down a stack of decades.

Walker Evans

The aesthetic discussion of photography is dominated by the concept of time. Photographs appear as devices for stopping time and preserving fragments of the past, like flies in amber…The lover of photography is fascinated both by the instant and by the past. The moment captured in the image is of near-zero duration and located in an ever-receding then. At the same time, the spectator's "now," the moment of looking at the image, has no fixed duration.

Peter Wollen[1]

An image is an envoy, a messenger. It confronts us. We are encountered by this envoy—sent anonymously, forwarded ahead, redirected—time and again because it appears, whether or not it is sought after. The envoy—the image—is sent ahead both to clear and to block our way. We are thus always in the midst of images. As such we are put under a constraint, momentarily imprisoned, that is, offered a moment to think. Only by responding to this encounter do we truly conceive and receive an image. Only then do we become spectators, what the ancient Greeks called *theoreson*: a spectator or special envoy (*theoros*) sent by his home city to another place, to experience and transmit an event. A spectator is an aesthetic *and* political figure, one capable of recognizing how and why a contingent, aleatory encounter (e.g. the event and time of the image) becomes necessary and essential. Is it possible for us to recollect how to become spectators rather than consumers of images? Too often, for us, consumption and forgetfulness go hand-in-hand. What are the pleasures and politics of spectatorship reconceived in this manner? Is there an ethics (a responsibility to the image) at work in this encounter? The answers to these questions, however difficult, suggest why we still must learn how to become spectators of images; we must learn how to recollect an "image of thought" in response to this confrontation, this virtual simultaneity (being in another time as well as another place).

Let us begin by considering how a photograph is always simultaneously here and there, now and then. It is best not to begin with a question such as "What is a photograph?" but to ask how it functions? For instance, how, why, and what does a photograph transmit? Avoiding the question of a photograph's essence or ontology is, for the moment, necessary because we are never free to think the ontology of the photograph. Simply put, our ability to think what a photograph is does not precede our encounter with it. A photograph forces us to think, which means that we create alongside it: we bear witness, we remember, we act differently, we perceive anew, we learn, we become something different. To think with a photograph means "to interpret—to explicate, to develop, to decipher, to translate a sign."[2] What would it mean to think and to create (whether as an artist, a historian, a theorist, or a curator, etc.) alongside a photograph, which may very well be an "impossible object"?[3] Only then can we ask after the ontology of photography. Are there alternatives, new possibilities for conceiving the ontology of a photograph as an image, one with transformative material functions?

So as not to avert our eyes, let us face two photographs. The first is a haunting paper print from a calotype negative dating from 1853–4. Gradations of gray, from the salt gray of the Egyptian sky to the dappled darks within whites, bisected by an oasis before a mountain range whose indications are nearly indecipherable from the water in the bottom half of the picture. John Beasley Greene made this minimal, evocative, nearly abstract photograph as part of an expedition to document the landscape and monuments along the Nile in Egypt.

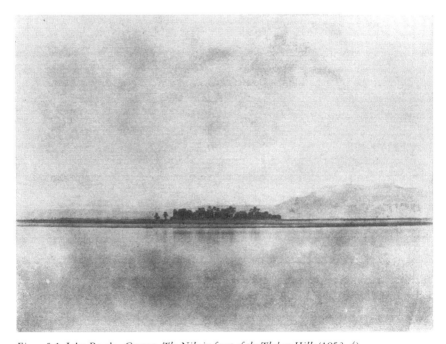

Figure 5.1 John Beasley Greene, *The Nile in front of the Theban Hills* (1853–4)

A selection of these photographs were published in 1854 under the title *Le Nil: Monuments. Paysages. Explorations photographiques*. Greene gives us something different from the descriptive, prosaic, often archaeological, photographs that accompanied colonial enterprises in Egypt and throughout the ancient world. Distinct from what we see in photographs made by Maxime Du Camp in Egypt or Henri Le Secq, who was the official photographer to the Historical Monuments Commission of the French Ministry and documented the interior of France in the mid-nineteenth century, Greene transmits a psychological, emotional response to the Nile.

Rather than a descriptive photograph he gives us an experience of dislocation in space and time; a temporal sensation traverses space. It is true that the graphic forms Greene presents adumbrate modernist photography (one reason for his inclusion in Newhall's famous photography text), but it is *not* a case of forms referring to other forms (empty formalism). On the contrary, Greene deploys these forms; they function. Their function is not to represent the Nile or Egypt through resemblance or expectation (showing a Sphinx, for example); instead, he creates an aesthetic experience, an image capable of being an opening in time rather than a representation of the past. There is an enigmatic form of life within this image that is simultaneously a play of forms and a play of forces (temporality as a force).[4]

There is something analogous at work in Carleton Watkins's *Cape Horn near Celilo. Oregon* (1867). Notice the left side of the photograph in particular. Watkins couples the signifiers of modern American expansion (the telegraph poles and the train track disappearing into one-point perspective) to another representational strategy, one less invested in the rhetorical space of Western perspectival painting. This other strategy hints at the open: not the territory (property) but the terrain (the landscape, geography). Watkins presents us with an image whose aim is neither simply geographic (political) nor is it an aesthetic or personal expression only; rather, it attempts not to picture but to create an image.

Creating an image means to actualize the inhuman vision of the camera, presenting us with an image of time that confronts us with a perception we have never and could never have. The point—the one-point perspective, the point of the camera lens, the pointing of the photograph itself—is not a memory but a becoming in time, that is, "a zone of proximity and indiscernibility, a no-man's land, a nonlocalizable relation sweeping up two distant or contiguous points" (be they past and present, man and nature, subject and object) and "carrying one into the proximity of the other."[5] An image is a line of time. One that "emerges when sensation can detach itself and gain an autonomy from its creator and its perceiver, when something of the chaos from which it is drawn can breathe and have a life of its own."[6] A "life" that is not natural, pure, or autotelic; but only unnatural and impure, hence cultural and untimely. This "life" or line of time affords returns and repetitions that are not doublings. This is why photography bears a privileged relation to the image. A photograph, a writing with light, is always too late to record anything as it is. It always gives us something as it was, never as it is.

On the horizon mapped by Greene and Watkins, Sze Tsung Leong appears. With an 8×10 view camera Leong has been creating panoramic photographs of major cities, rural landscapes, and iconic locations such as Venice and Cairo. In these panoramas the position of the horizon line, falling about a third of the way up the picture plane, is consistent. So the photographs of Venice can be read alongside those of Amman, for instance. This horizon line is material as much as it is metaphorical. "In terms of looking, the horizon is the farthest we can see yet in terms of knowledge, it reflects the limit of experience," Leong has said.[7] Leong's practice requires him to travel to places he has usually never been, but does know about, like Venice. His photograph *Canale della Giudecca* (2007) was taken at dusk from the mainland, looking eastward toward the Giudecca. The winter sky and the canal bear the same even tonality, with the colors of the tightly arranged buildings thickening the horizon line. It is at once a picture of Venice and not. There are no people, no *vaporetti*, as no movement has survived the one-minute exposure time. Even the Adriatic's ebb and flow, the currents of the canal, are paused, transformed into a blank sheet, just like the sky. Leong acknowledges the nineteenth-century work by Felice Beato and others, although he does not directly cite Greene. But he also links his practice to Thomas Struth. (I will discuss Struth in more detail below.) In explaining his relation to Struth's empty city blocks and apartment buildings, Leong indirectly tells us what his images are after: "You're not only looking at what is depicted on the picture plane, but at a kind of emotional context he is trying to describe. There's a heaviness, the weight of history and the weight of the light."[8]

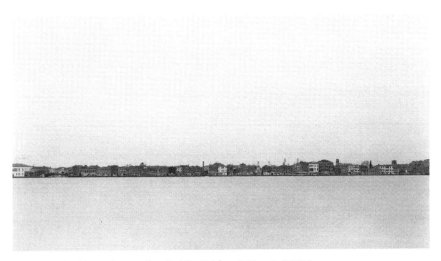

Figure 5.2 Sze Tsung Leong, *Canale della Guidecca I, Venezia* (2007)

A photograph becomes an image when it gives us—not represents for us—a line of time, a life that passes through our own like a foreign territory. An image presents us with a bloc of sensations that has little to do with meaning or knowledge of what has happened; instead, it *decreates* the world by giving us a "monument" that does "not commemorate or celebrate something that has happened but confides to the ear of the future the persistent sensations that embody the event."[9] These sensations are not the image itself; the image is the field that transmits sensations—the sense of an image is not its meaning or positionality, it is an encounter with a time-image that has nothing to do with moments or eternities. Images move and as such they move us.

An image is never contemporary, *with* or *of* time; yet it is not altogether outside of time either. Perhaps if we consider a photograph—one privileged type of image—we can extract from its temporal modes a difference in kind between it and an image. A photograph is still. This, of course, is one of its basic differences from film, which is movement. Nevertheless, photographs can be used as the elements of a narrative. One can narrate a series or sequence of photographs. Some argue that photographs, however, cannot be taken as narratives in themselves. If it is meant by this that no single, still image is ever completely free from language, then fine. But if it means that a photograph cannot condense or dilate time—which is the beginning of any narrative— then perhaps we should reconsider. As Peter Wollen writes, the "time of photographs is one of stasis. They endure."[10] Wollen understands that this relation between stasis and duration (in time) impels narration. But how? What is the relation between stasis and narrativity within a photograph?

Wollen argues that there are different types of still photographs, by which he means still photographs are put to different uses (they enter different discourses). These different types "correspond to different types of narrative element."[11] Simply put, he ventures, we pose different questions to a documentary photograph as opposed to an art photograph. In a photograph, Wollen adds, there is a "fit between the photographic image which signifies a state and its own signified." But this "fit" is quite complicated. A photograph signifies a state (a duration, temporality) and a signified (its object, or referent), but how do they "fit" together? Wollen posits that "aspect" is one way to understand the "fit" between stasis and narrativity.

Aspect is "a dimension of the semantics of time" that is "used to place the spectator, within or without a narrative."[12] Aspect allows for an approach to photography that admits the complexity of the relation between and image and time, a relation that is traversed by memory, new uses, and narration (even fiction). A photograph, although it "lacks any structure of tense" can "order and demarcate time." An example that Wollen gives is Robert Capa's famous photograph of a solider in the Spanish Civil War taken at the moment of his death. (It will be become evident that discussing the relation between photography and time is often negotiated by a meditation on death.) Capa's photograph is more than a

moment in time or a moment snatched from the flow of time; it is a duration rather than a snapshot (point in time). In addition to its referent (the fate of a republican soldier during the Spanish Civil War) and even its symbolism at the time, Capa's photograph also carries within itself "the condensed implication of a whole action, starting, happening, and finishing in one virtual point in time."[13] That "virtual point" is the image which, far from representing the whole as a totality, as a closed system, indexes a multiplicity of narratives and temporalities outside of itself. The image as a "virtual point" is a fragment, an aspect, that gives us time as an open whole rather than as a linear, temporal sequence of moments.

Capa's image is the nexus of a series of discourses that came before and after its being taken. Like all photographs, it has a "currency"—it is "trafficked" as Allan Sekula argues—because it circulates, thereby entering new contexts (both discursive and temporal). "Far more is involved," Wollen writes, "than the simple doubling of the encounter of the photographer with the object and spectator with the image."[14] Part of what is involved beyond the photographer–object–image–spectator chain is the role of memory.

> The photograph can be an aid to memory, but it can also become an obstacle that blocks access to the understanding of the past. It can paralyse the personal and political ability to think beyond the image. Proper knowledge depends not just on the photograph itself but on the place it is afforded in the always fraught project of remembrance. However, in the popular culture of mass media, the frozen image is often used as a simple signifier of the memorable, as if there were a straightforward connection between the functions of memory and the "freezing" capabilities of the still camera.[15]

A photograph, therefore, does not give a simple image of time as a tense. It gives us an aspect of time as duration, as a contraction or a dilation in time. What we must arrive at is not an oversimplified notion of either memory or an image; but rather, "proper knowledge" of each. In other words, an image is a not a point but an opening between art and epistemology (a way to arrive at knowledge).

There is a distinction to be made here between two, but there are certainly more, conceptions of photography and time. (These two conceptions should return us to the difficulties inherent in the discussion of Greene, Watkins, and Leong above.) On one hand, William Henry Fox Talbot insisted that one immediate, undeniable application of photography (née "the pencil of nature") was palliative, that is, it could heal the "injuries of time."[16] It was capable of such therapeutic acts because it could record architecture, monuments, and other traces of the past that would inevitably succumb to the ravages of time. Photography, therefore, could purportedly salvage and rescue the past by taking something out-of-time with "impartiality," as Talbot posited. On the other hand, an earlier text, written before Talbot's invention, refuses this assertion of excision and fact. Gotthold Ephraim Lessing, the German writer, penned an essay on the Hellenisitic sculpture *Laocoon* in 1766. In it he set out to explain the difference between poetry and painting (visual art).

Whereas visual art (sculpture but also paintings of the subject) only froze Laocoon's screams in time, poetry could tell the story thereby restoring movement and energy. For Lessing, visual art simply is not capable of incorporating time (understood as movement). As a result, the spectator (viewer) had to reconstruct the event in his or her imagination, that is, supplement the still image with temporality. Lessing doesn't present the differences between poetry and visual art in terms of a deficiency or lack in the latter. Rather, he attempts to provide a guide by which a visual artist could be evaluated as a success or a failure. An artist must choose his or her subject matter carefully because success depends on the selection of a "pregnant moment." This "pregnant moment" is a point in the narrative, a point in time, but one that has the potentiality to encourage and allow the spectator to re-temporalize the event by unfolding the "pregnant moment" into a temporal sequence (a narrative). It is not, of course, able to do this in reality; instead, this is a potentiality of art. This type of experience is something art provides us. "This crucial instant, totally concrete and totally abstract, is what Lessing calls (in the *Laocoon*) the *pregnant moment,*" Roland Barthes writes.[17] Whether or not a work of visual art encouraged this activity in the viewer, whether or not the work itself was transformed through the activity (as opposed to instigating it while it remained unchanged outside of this activity), was a test for a work's success or failure.

Without wanting to place too much emphasis on the differences between Talbot's "injuries of time" and Lessing's "pregnant moment," especially not if it requires veering off into a discussion of artistic judgment, I would like simply to use these contrasting positions on visual art and time, albeit written at different times and with different conceptions of the visual in mind, to suggest that they assist in introducing, and perhaps clarifying, the difference between a snapshot and a time exposure. Knowing full well that the two are inextricably bound within any photographic image. A snapshot here is less a quick, semi-automatic picture taken with fast film and a lightweight camera, as is commonly understood. Rather a snapshot indicates one relation to time: the excision of a moment out of time, let's say. A time exposure, which to a degree all photographs are regardless of how briefly the shutter is open, implies a different relation to time, one capable of extracting from the moment (the lived) the *as yet unlived*. Both the snapshot and the time exposure coexist in every photograph, but it is our relation to a photograph that allows us to imagine their autonomy and distinctness.

Snapshot and time exposure are folded within each other just as subject and object are. This folding creates a temporal aspect that lies not within the photograph but within the relation between the photograph and its spectators, displaced as they are from it in space and time. Perhaps this is the true significance of Henri Cartier-Bresson's grossly misunderstood notion of the "decisive moment."[18] This notion stems from a poor translation of Cartier-Bresson's French phrase *"images à la sauvette"* that accompanied his 1952 solo exhibition at the Museum of Modern Art. The French phrase means something like "salvaged images" or "photographs taken without being seen."[19]

Figure 5.3 Henri Cartier-Bresson, *Callejon of the Valencia Arena* (1933)

Here is a passage from Cartier-Bresson that suggests the dialogical relation between snapshot and time exposure, self and world:

> To me, photography is the simultaneous recognition, in a fraction of a second, of the significance of an event as well as of a precise organization of forms which give that event its proper expression. I believe that, through the act of living, the discovery of oneself is made concurrently with the discovery of the world around us, which can mould us, but which can also be affected by us. A balance must be established between these two worlds—the one inside us and the one outside us.[20]

In a way, the "decisive moment" is nothing like a "moment" at all. The "simultaneity" of the snapshot with that which it doubles (the external world) is by no means the "event" of which Cartier-Bresson speaks. The "event" is the act of figuring the image as a fold between inner and outer, subject and object, individual (human) time and the temporality of the world. The image is this threshold between the world affecting an individual and vice versa; it is the threshold that reveals one's subjectivity as this fold. Only an image can establish a "balance" between worlds, "the one inside us and the one outside us."

In a fine essay, Thierry de Duve summarizes the snapshot and the time exposure, but concludes that "photography doesn't allow an intermediate position" between them.[21] Why? Isn't it our task to think this "intermediate position," alongside Cartier-Bresson and others. De Duve reads "the didactic opposition" between the snapshot and the time exposure as a "manic-depressive

functioning," with the snapshot being a "manic defense reaction" and the time exposure expressing melancholy and loss. Before explaining de Duve's reading more clearly, it is important to note that he poses these two models as "didactic" because there is "no such thing as an empirical definition of snapshot and time exposure. One cannot decide on a shutter speed that will operate as a borderline between them…they were used [only] to unravel one of the paradoxes of photography."[22] Hence these two "attitudes" to time (snapshot and time exposure) are "coextensive" yet "they do not mingle." We have to ask why these two "do not mingle"? What keeps them apart and what are we to make of de Duve's psychological reading of these two presymbolic "moods" as manic-depressive?

De Duve begins by laying out these two didactic models: snapshot and time exposure. "Photography is generally taken," he writes,

> in either of two ways: as an event, but then as an odd looking one, a frozen gestalt that conveys very little, if anything at all, of the fluency of things happening in real life; or it is taken as a picture, as an autonomous representation that can indeed be framed and hung, but which then curiously ceases to refer to the particular event from which it was drawn.[23]

Here de Duve is reiterating a basic premise which oversimplifies things. On one hand, a photograph is taken as evidence, an event in itself; on the other hand, it is aesthetic or "picture-like" in de Duve's terms. Both models make reference to external reality, but in different ways. He gives this example:

> the funerary portrait would exemplify the "picture." It protracts onstage a life that has stopped offstage. The press photograph, on the other hand, would exemplify the "event." It freezes onstage the course of life that goes on outside. Once generalized, these examples suggest that the time exposure is typical of a way of perceiving the photograph as "picture-like," whereas the instantaneous photograph is typical of a way of perceiving it as "event-like."[24]

It is not evident that these examples are typical of an approach to a photograph or that they are even unique or, at least, characteristic of photography. The ways in which an "event" is related to life are complex. Moreover, other forms of representation can also protract "a life that has stopped offstage," consider biography or theatre. Also, what of this freezing "onstage the course of life that goes on outside"? It neither continues on in the same manner nor does the photograph provide *a priori* evidence that what it depicts is indicative of what "goes on outside." Consider a photograph that exists at the intersection of these two models such as the Capa photograph discussed above.

These questions are not aimed at de Duve's reading which, as we will see, is more complicated; they are, rather, aimed at these assumptions or those that hold these basic premises when it comes to a photograph and its relations with time. De Duve uses these examples only as a starting point to attempt "a theoretical description of the photograph."[25] What he wagers is that the "semiotic structure" of a photograph is "located at the juncture of two series": a superficial series and a referential one. The "superficial series" is

"image-producing" because it "generates the photograph as a semiotic object, abstracted from reality; this is the "picture-like" and aesthetic dimension.[26] The other series, the "referential," is not image-producing but rather "reality-produced" (note a certain passivity here that is an extension of indexicality) as it "generates the photograph as a physical sign, linked with the world through optical causality."[27] Each series implies a relation and an image of time. In the referential series (the snapshot) the photograph presents a singular event, a unique moment. In the superficial series the photograph extracts itself from and abstracts an event into a picture; it attempts to flee its dependence on reality as such as it is "reality-producing." The problem with the snapshot is that time is not a series of discrete events; it is the "continuous happening of things." The time exposure, the superficial series, "petrifies the time of the referent and denotes it as departed." "Whereas the snapshot refers to the fluency of time without conveying it," de Duve adds, the time exposure "liberates an autonomous and recurrent temporality" because it "offers itself as the possibility of staging that life again and again in memory."[28]

To understand de Duve's reading of our psychological reception of a photograph, that is, "how we live through the experience of this unresolved alternative" between snapshot and time exposure, is it essential to challenge his use of the indexicality of photography, which grounds both of his intersecting series, and to address how memory functions. The paradoxical nature of the photograph, for de Duve, derives from "the indexical nature of the photographic sign."[29] An index is a sign causally related to its object; it signifies cause and effect (smoke is an indexical sign of fire) as well as indicating a relation of presence and absence.[30] There is no one way to handle how a photograph is indexical so here is de Duve's summary. He states that although "the photograph appears to be an icon (through resemblance) and though it is to some extent a symbol (principally through the use of the camera as a codifying device), its proper sign type, which it shares with no other visual representation (except the cast and, of course, cinema), is the index."[31] What underlies the two models de Duve has forwarded is their shared origin as indexical signs. There is a "direct causal link between reality and the image" which is the automatic impression of light, reflecting off the object in front of the camera's lens, as it is left after the "physical action upon silver bromide," he insists. As a result of its indexical nature, "the referent may not be excluded from the system of signs considered."[32] Therefore, when dealing with photography the referent, as it is recorded and traced through the light and chemical process itself, cannot be entirely excluded. This is not to say, however, that one aspect of the photograph (as an index) must necessarily be privileged over its others. A sign can simultaneously embody and present different types. But privileging the index— raising it to an ontological status by saying it is the "nature" of a photograph—is accompanied by a subsequent series of curious explanations about how this index works. De Duve claims that "the photograph is the result of an indexical transfer, a graft off of natural space," which operates "to indicate that it is this one, *here*, that we mean."[33] What exactly is grafted off of space? A photograph is something that requires an indexical condition, but that condition does not preclude it becoming

iconic or symbolic. There is nothing natural or passive about a photograph; in fact, it is quite inhuman as its presentation of stillness has no equivalent in human vision, let alone memory.

Arguments that over-invest in the indexical "nature" of photography often suggest that reading a photograph is difficult, if not impossible. The semiotic definition of an index as a direct causal relation between sign and object trumps the complexities of signification (relation of signifier to signified). Hence de Duve's assertion that for

> an image to be read requires that language be applied to the image. And this in turn demands that the perceived space be receptive to an unfolding into some sort of narrative. Now, a *point* is not subject to any description, nor is it able to generate a narration. Language fails to operate in front of the pin-pointed space of the photographer.[34]

How is the "perceived space" of a photograph, even a snapshot, not conducive to language, even if it problematizes language by making it stutter? What are the boundaries of this "perceived space"? Is it only the material ones of the photograph itself? The "aphasia" de Duve insists we experience in front of a photograph is only traumatic if the stasis in the picture is denotative, that is, if it is taken *as* the object photographed. A photograph is not metonymic. Simply put, a footprint is not the bird itself, despite it being a trace of the bird's presence. De Duve argues that a photograph is "traumatic" not because of its content, but "because of immanent features of its particular time and space."[35]

The trauma a photograph causes is tied to conceptions of memory because it either presents only an "abstract pastness" or it forecloses on time entirely (giving only a point, a moment). Susan Sontag represents both of these options when she assumes that "photography implies instant access to the real. But the results of this practice of instant access are another way of creating distance."[36] Photography teases us with knowing the past, possessing it metonymically, as a fragment containing the entirety of the past. No photograph can possess the past, let alone time. Nevertheless, Sontag insists that "a photograph is only a fragment, and with the passage of time its moorings come unstuck. It drifts away into a soft abstract pastness, open to any kind of reading (or matching to other photographs)."[37] Is there an alternative to a photograph signifying an "abstract pastness"? Perhaps this "unmooring" is an opening in time rather than a relation to a particular past?

In fact, despite repeated references to the most well-worn pages of his work, Walter Benjamin offers us a passage here. Even though Sontag uses Benjamin to support her claims—going so far as to suggest that a photograph may be a quotation—his work is one of the most concerted efforts to move beyond this notion of "abstract pastness" and toward a direct relation with "what-has-been" which would create a new historical relation between past and present. While Sontag alludes to Benjamin's practice of keeping notebooks of quotations and his penchant for using quotations throughout his work, she takes the notion of a quotation literally. Benjamin, on the contrary, developed his interest into a concept: *citation*.

For Benjamin, citation denotes both an act of quoting and a juridical, even theological, summons. It refers both to an action by the historian and to the fragments of the past that remain (that which is cited). The ultimate aim of citation in Benjamin's work is to open a threshold (*eine Schwelle*) between the what-has-been and the now, that is, the proper "sphere of history."[38] Opposed to any historicist notion of a linear conception of temporality in which the past simply precedes the present, Benjamin's proper "sphere of history" is a threshold between the "what-has-been" (*das Gewesene*, what falls to the side of experience, what is beyond or absent from what we commonly call the "past") and the "now." Within this threshold—the "sphere of history"—there is a kind of "total neutrality in regard to the concepts of both subject and object...a unity of experience that can by no means be understood as a sum of experiences."[39] Benjamin creates the concept of citation in order to imagine a new relation between past and future wherein there is a logic of immanence at play in the temporality of modernity, that is, not one epoch superseding the next, not a relation of *archē* (origin) and *telos* (end, aim), but instead an immanent temporal structure laced with singularity and repetition, alterity and movement.[40] In contrast to traditional ways of conceiving of history, Benjamin imagined that citation destroys the illusion of any discrete temporal context with the uncanny presence of the what-has-been, which is immanent within any and every instantiation of a present. The goal of citation is "not to preserve, but to purify, to tear from context, to destroy." A citation robs the past of any pretense of completion—of any claim to posit itself—by rendering it incapable of fulfilling itself in the present; it does not transmit the past as much as force it to take place as irretrievable.

Quite unlike any "abstract pastness" Benjamin seeks a temporality outside of the past–present–future chain. Citation *renders* (creates as it destroys, rends) the past irretrievable as it opens a passage to the what-has-been. In the late 1930s he composed his childhood memories of Berlin into a text entitled "Berlin Childhood around 1900." Written from the perspective of exile and with an acute awareness of the passage of time, it is over "the threshold of a century" that he writes:

> I deliberately called to mind those images, which, in exile, are most apt to waken homesickness: images of childhood. My assumption was that the feeling of longing would no more gain mastery over my spirit than a vaccine does over a healthy body. I sought to limit its effect through insight into the irretrievability—not the contingent biographical but the *necessary social irretrievability of the past.*[41]

It is this radical idea that marks Benjamin's work: *irretrievability*. In this way the text casts doubt on the possibility of simple representation, autobiography, or any narration of life. Is the translation of life possible? Certainly not through a photograph, right? This question begs a supplementary one: how is one to translate "experience"—as radically redefined in the wake of modernity—faithfully? It is here, of course, that photography enters.

I would argue that Benjamin leaves us the possibility of thinking photography, not as an "embarrassed praxis," but as a means "to accomplish the renewal of existence."[42] "To renew the old world," as Benjamin writes.[43] This phrase is essential because it is the one Sontag quotes to justify her claim that "the old world cannot be renewed—certainly not by quotations, and this is the rueful, quixotic aspect of the photographic enterprise."[44] But for Benjamin, "renewal" does not signify a representation nor a recuperation of the past, but rather an ascetic transfiguration within human temporality; it signifies a narrative withholding, an openness that is not stasis or sublime (aphasia). Rather, citation and "renewal" embody a peculiar historiographic praxis capable of reading "what was never written," that is, the *agrapha* (unwritten) of the what-has-been (*das Gewesene*). One cannot conjure or evoke the what-has-been no matter how hard one tries. Hence, the act of recollection is not about what actually occurred, but about what remains "as yet unlived" in the past, that is, open to the future.

Is it possible to read a photograph not as a document, or even as an index, of what has actually occurred, but rather as a "citation," of a temporality outside of human history? Is it possible to understand an image as "the contour, the configuration, the constellation of an event to come" which "does not refer to the lived, by way of compensation, but consists, through its own creation, in setting up an event that surveys the whole of the lived"?[45]

This may very well be what Benjamin sensed in Eugène Atget's photographs. Benjamin considered Atget not merely a "forerunner" of modern photography but a "virtuoso." Atget's work was taken up by Man Ray, Berenice Abbott, and others, but Atget insisted, when he was alive, that he was not an art photographer but that he "simply made 'documents' for artists."[46] This is consistent with the unraveling of these signifiers "art," "documentary," and "photography" at the turn of the century and throughout modernism. What was Atget, impoverished and unknown during his lifetime, selling his pictures to artists in Paris for a pittance, creating then in these "documents for artists"? This is the question that fascinated Benjamin. In a nice touch, Benjamin imagines that "Atget was an actor who became disgusted with the profession, wiped off the mask and then set about removing the makeup from reality as well."[47] For Benjamin, Atget cleansed photography of its reliance on tricks, gimmicks, props—"arty" effects—that dominated in the mid-nineteenth century, only to be replaced with retouching and other pictorial effects in the last decades of it.

Observe an Atget image and then read Benjamin's description—one cannot do both at once—and trace what Benjamin is claiming:

> He cleanses this atmosphere—indeed, he dispels it altogether: he initiates the emancipation of the object from aura...He looked for what was forgotten, cast adrift. And thus such pictures, too, work against exotic, romantically sonorous names of the cities...Atget almost always passed by the "great sights and the so-called landmarks." What he did not pass

Figure 5.4 Eugène Atget, *Bibliothèque Nationale* (1920–3)

> by was a long row of boot lasts; or the Paris courtyards, where from night
> to morning handcarts stand in serried ranks; or by the tables after people
> have finished eating and left, the dishes not yet cleared away…almost all
> of these pictures are empty…empty are the triumphal steps, empty are
> the courtyards, empty, as it should be, is the Place du Tertre.[48]

Atget's work is usually empty (few people ever found their way into his photo-
graphs) but not "lonely," only without "mood," Benjamin adds.[49] The camera is
not being used to represent anything, but only to present "a healthy alienation
between environment and man," that is, nothing other than capitalist moder-
nity. This is not to say that Benjamin simply gives a politicized reading of Atget.
If he does hint at one, it is only indirectly through the Surrealists champion-
ing of Atget. His reading is meant to expose only what Atget's work gestures
toward, that is, how it links what is depicted to something not given as if it was
an ellipsis.[50]

More importantly, Benjamin reads Atget's work as inhuman and thus refrac-
tive of our predicament because "another nature"—another life—"speaks to the
camera rather than to the eyes: 'other' above all in the sense that a space informed

by human consciousness gives way to a space informed by the unconscious."[51] With Atget's photographs we inherit not pictures (which didn't sell even when he made them), but images wherein appearance and time are bound. In the image there is the potentiality to grasp neither resemblance nor the intentionality of the photographer's perception, but only a "tiny spark of accident"—of the here and now. This "tiny spark of accident"—chance, a fortuitous encounter—is no moment but a duration in time, that is, "the inconspicuous spot where in the immediacy of that long-forgotten moment the future nests so eloquently that we, looking back, may rediscover it."[52] This returns us to Benjamin's distinction between the past and the what-has-been. An image is a citation that opens the past to an outside, the what-has-been. In doing so an image is untimely because it opens the past to a "tiny spark of accident"—it is contingent, not self-dependent, not closed. This opening is a threshold between past and present. In presenting his "Little History of Photography," Benjamin writes that within an "interval of ninety years that separate us from the age of the daguerreotype," a interval or threshold "discharges its historical tension." "It is in the illumination of these sparks that the first photographs emerge, beautiful and unapproachable, from the darkness of our grandfathers' days."[53] Or, as he noted in his unfinished *The Arcades Project*, "In the fields with which we are concerned, knowledge comes only in lightning flashes. The text is the long roll of thunder that follows."[54]

Benjamin's uniqueness lies in his ability to discern within modernity and its ruptures (social, economic, historical)—in short, our existing in the aftermath of collective experience—a chance to enact an event of memory, to grasp what is exposed by these "tiny sparks of accident" (a throw of the dice), which he calls the "turn of recollection."[55] This concept of recollection is an indispensable part of Benjamin's longstanding concerns regarding epistemology and historiography. His investigation of "the turn of recollection" in *The Arcades Project* foregrounds how Benjamin's interest in images underlies his ethical critique of nineteenth-century historicism. The "turn of recollection" takes place precisely where the faculty of memory is no longer capable of maintaining something like tradition, that is, where and when there is an absence of collective experience. An image does not lie between the past and future; rather, it scumbles the tenses because it is transmittable. It transmits the disquiet of the past to the future. This disquiet of the past (to play on Hegel's "the quiet of the past")—its haunting, repetitive aspect—is a clamor that causes anxiety and dread as much as it does excitement and possibility. An image deframes the past by opening a radical outside within it. Here the what-has-been, what falls outside of the frame of what we call the "past," folds itself into an aleatory, unforeseen future. These temporal aspects are immanent, but only an image can give us what Marcel Proust called "a strange sectioning of time," a phrase Benjamin frequently cites.

There is an affinity between Benjamin's ideas about history and the photography of Thomas Struth, particularly his brilliant black-and-white images of empty streets in Europe, notably those of Rome and Naples. If we take an image such as *Via Medina, Naples* (1988), then hopefully this affinity—passing

as it does through Benjamin's interest in Atget and Proust—becomes evident. Here, after noticing several different building styles almost collaged together, one begins to trace one's eye over the surface of the image, searching for openings, passages, doorways, windows. In short, clues to what is going on here. It is a stage set, or as Benjamin said of Atget's work, a "scene of a crime," before which the action has not ceased even though the actors have left the stage. For Struth, whether in his famous museum photographs or even his portraits of families, the real subject is history itself, that is, the immanent relation between individual and collective experience. This relation is traversed by time. However, it is for this reason that Struth photographs a city like Naples when it is completely empty of people. For in Naples the past coexists with the present through a collection of seemingly random architectures and chaotic ways of living amongst those same public and private spaces. Frequently Struth has commented that his empty black-and-white images of streets are "abstractions," images in which the emptiness of space is noticed but the presence or weight of time (whether an experience of anticipation or belatedness or dilation even) is felt. Struth wants to capture a historical resonance or vibration; or, perhaps what Benjamin himself said of Naples, a spatial and temporal "porosity." An image for Struth and Benjamin, then, is about what is visible as much as what is invisible.

In 1929 Benjamin published an essay entitled "On the Image of Proust." Proust's seven-volume work *In Search of Lost Time* (1913–27) fuels Benjamin's thinking about memory, representation, time, and images. Benjamin's interest in photography is matched, in many ways, by Proust's own discussions of it throughout the novel.[56] Benjamin's singularity as a critic is confirmed in the essay on Proust, which refuses to collapse the author's life into the work. The narrator of the novel is and is not Proust. Proust's "lifework"—the work of his life—arises only if one recognizes the incommensurability between art and life. Art is not life. Only between the asymmetry of art and life does an image arise. Benjamin builds on Proust's own notion of the image as an "invisibility."

> All prior assumptions—about autobiography, about the image of the writer in the writer's own work, about continuity between life and work, character and author—are suspended…[the] notion of the image…is deprived of its visual imaginary consistency (so eloquently analyzed by [Jacques] Lacan.) It can no longer be considered the representation of an organic, visible whole, insofar as the "*Lebenswerk*" (lifework) can no longer be read as a faithful replica of the author's life. The *Bild* (image in Benjamin's work), both visual and scriptural, enters the terrain of Proustian *invisibilia*: it reveals not a life, but the impossibility of revealing that life…Proust's description of time as the invisible form qualifies that invisibility as the most paradoxical image of all.[57]

Time is invisible, yet it is possible for an image—a sensation—of it to appear, as a flash, as a vertiginous opening. This time-image causes vertigo because its appearance is the result of a "discharge," a shock, a flash of illumination that

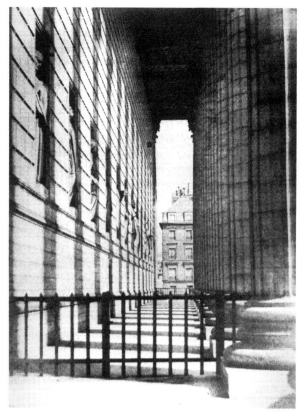

Figure 5.5 Hippolyte Bayard, *The Madeleine. Paris* (c. 1845)

exposes a terrain that is not the past, not even the past as lost time; rather, it gives us the what-has-been, or time regained as it has not been lived.

Relations are constructed through an image, not only through the language that accompanies and passes through it. Recall the discussion of Struth above and consider Hippolyte Bayard's *The Madeleine. Paris* (c. 1845). One is never in front of this image as much as one is always in the middle of it. The photograph does not give us a "useful" picture of the La Madeleine, a neo-classical church based on a Roman temple (Maison Carrée in Nimes) built after the French Revolution. We can only see down the length of one side, between the Corinthian columns and its exterior façade with sculptures set in niches. The play of striations, structural details and shadow—this play of forms—is countered by a play of forces that traverse it. What Bayard gives us is a passage, an aspect of the object open in time. (Of course, Bayard's image of the Madeleine folds into Proust's work, which opens with a madeleine cake dipped in tea.) Bayard's image, as well as Proust's, positions us between a sign and an object.

In his remarkable text *Proust and Signs*, Gilles Deleuze is clear that there are images and signs, but images are irreducible to signs. They are not the same. Images are sensations; they are dispersive; they are ellipses.[58] Signs convey meaning (as in linguistics). This type of meaning only abolishes the image.

Nonetheless, there are always images and signs at once. Signs subsist in images, and vice versa. But an image relinquishes any referent; it does not refer to an object, a discrete situation, or something that has already been lived.

There is a disjunction between signs and objects. A sign is not merely a stand-in for an object; signs operate within their own system, one independent from the object (referent). For instance, a photograph is a sign that functions as more than a metonym for an object. If a sign is only tethered to an object, then its only function is recognition (mimesis). Deleuze suggests that a sign has two parts. "Each sign," he writes, "has two halves: it *designates* an object, it *signifies* something different. The objective side is the side of pleasure, of immediate delight, and of practice. Taken this way, we have already sacrificed the 'truth' side. We recognize things, but we never know them."[59] We find pleasure and comfort in creating subjective associations between signs and objects. But in doing so we miss an opening to knowledge, that is, an opening to something essential yet fortuitous: "we miss our finest encounters, we avoid the imperatives that emanate from them [signs]." By substituting encounters for recognition (reminiscence rather than discovery), we forfeit an experience of the image.

Of course, there are a many types of signs. Deleuze encourages us to pass through meaning (significance) to arrive at the function of signs. Rather than analyzing the intricacies of different types of signs, including the indexical condition of photography, Deleuze refuses to persist in the illusion ("objectivist illusions") that the meaning of any sign is *in* or *with* the object that emits or bears them. He asks why we "continue to believe that we should be able to listen, look, describe, address ourselves to the object, to decompose and analyze it in order to extract the truth from it."[60] Deleuze turns from signs as meaning to how images (what Proust calls the signs of art) function. He gives an image a precise function: to be "untimely," that is, to give us an image of another temporality at the heart of human time (time lost). Art offers us an image, which is immanent to and yet distinct from a sign. An image that *complicates* our sense of time beyond memory.

An image is enveloped within the sign. It does not simply transcend the sign; rather, it is immanent to the signs that compose it. An image *embodies* something different. It is neither an object in the world (referent) nor merely other signs in a system (language as such). An image is immanent with its signs; it does not transcend them as much as it is different in kind from them. Whereas signs are read, images *encounter* us. No matter how savvy we are at interpreting signs we will never, through that activity alone, arrive at an image because an image comes from without, comes toward us, and forces us to think. "Our apprenticeship would never find its realization in art if it did not pass through these signs that give us a foretaste of time regained, and prepare us for the fulfillment of aesthetic ideas. But they do nothing more than prepare us: a mere beginning."[61] What an image forces us to think is time regained rather than the past.[62]

As much as an image emerges from a set of clichés (exceeding stock notions and commonplaces), it also diverges from subjective chains of association: memories, the past as it has already been recalled, codified, represented.[63] In extracting the

concepts and functions Proust created in his *In Search of Lost Time*, Deleuze posits that voluntary memory "does not apprehend the past directly; it recomposes it with different *presents*."[64] Moreover, voluntary memory proceeds by "snapshots," "as boring to me as an exhibition of photographs," Proust wrote. For Proust and Deleuze, voluntary memory, can never address the past as past because it always recomposes the past in relation to different presents. A snapshot is the sign of a given object (the past as understood, represented); it is a reminiscence, a voluntary memory. For all of their partiality, snapshots are instants, moments, rather than durations in time. They function as an extraction of one moment from the succession of moments that we call time. Nevertheless, they set us "on the path of art."[65]

The synedochal, mimetic illusions of voluntary memory are not even dissipated by Proust's well-known concept of "involuntary memory." Involuntary memory is a memory triggered by the senses, as is clear in the opening of Proust's novel where the narrator's reminiscence of his childhood town (Combray) is instigated by a sensation, dipping a madeleine in his tea (touch, smell, vision).

> So long as we remain on the level of voluntary memory, Combray remains external to the madeleine, as the separable context of the past sensation. But this is the characteristic of involuntary memory: it internalizes the context, it makes the past context inseparable from the present sensation...*The essential thing in involuntary memory is not resemblance, nor even identity, which are merely conditions, but the internalized difference, which becomes immanent.*[66]

It is this "internalized difference" that is "immanent" to both types of memory. The sensation common to the past (the narrator's childhood in Combray) and the present (his smelling and tasting the madeleine as an adult) allows Combray to "rise up in a form that is absolutely new." "This is no longer the Combray of perception nor of voluntary memory. Combray appears as it could not be experienced: not in reality, but in its truth; not in its external and contingent relations, but in its internalized difference, in its essence. Combray rises up in a pure past, coexisting with the two presents, but out of their reach," Deleuze writes.[67] Involuntary memory recaptures lost time—Deleuze is clear that a sensuous sign is closer to art than other types of signs—by generating internalized differences, that is, differences between the past as it is actualized in present moments (or sensation) and the past as such, the pure delimited past. However, the "reminiscences in involuntary memory are still of life" and not of art. Only art, Deleuze insists, "in its essence, the art superior to life, is not based upon involuntary memory. It is not even based upon imagination and unconscious figures. The signs of art are explained by pure thought as a faculty of the essences."[68] Art is not based on involuntary memory, imagination, or unconscious figures; instead, it sets us on the path to time regained, that is, "a bit of time in a pure state" (one of Deleuze's most cited phrases from Henri Bergson).

The "essence" that art creates is not a totality of all time; rather, it gives us an image of time as coexistence, as multiplicity, as more than could ever be experienced from a single person's point of view. Proust's novel is comprised of many episodes, conversations, reminiscences, all of which take place in a variety of times and spaces. But "the essential point," Deleuze explains, is "that the parts of the Search remain partitioned, fragmented, *without anything lacking*" because the "search" for lost time itself becomes something other.[69] It becomes a time-image, a multiplicity "swept on by time without forming a whole or presupposing one, without lacking anything in this quartering, and denouncing in advance every organic unity we might seek to introduce into it." Proust's "search" does not have an object external to it. Instead, it functions only as a means to create internal differences within itself. Those differences do not add up to a whole because it only proffers time as the dimension of the narrator. The image Proust gives us is a time-image wherein time "is not a whole, for the simple reason that it is itself the instance that prevents the whole."[70] Time is not an individual, discrete experience; it is that which individuates (breaks, multiplies, endures). The whole—time as such—cannot be given because it is open; hence, it is "invisible" Proust says. Any sense of a series of viewpoints comprising a temporal sequence (before and after, now and then)—a sequence of autonomous moments or actions—is displaced with a sensation of duration. Duration is neither time as a series of actions nor is it a narrative; it is an essence.

For Proust, essence is not "the seen ideality that unites the world into a whole" but it is "an irreducible viewpoint that signifies at once the birth of the world and the original character of the world."[71] This "character" is that the world does not exist for us; there is no image of the world as such; the world is not the *gestalt* (formed whole) of innumerable viewpoints. Essences open only through art, thereby revealing "an original time, which surmounts its series and dimensions. This is a time 'complicated' within essence itself…Hence, when we speak of 'time regained' in the work of art, we are concerned with that primordial time that is in opposition to time deployed and developed—to the successive, 'passing' time."[72] In other words, what the artwork (here Proust's novel) grasps is "the singular essence, the Viewpoint superior to the two moments [past and present]" that breaks any "associative chain that links them."[73] Thus the image of Combray in its essence, "as it was never experienced; Combray as Viewpoint, as it was never viewed." This is not possible in reality, but only as an affect produced by art (here literature). The Viewpoint afforded by art complicates time by presenting its durations, that is, the coexistence of asymmetric, immanent, non-communicating parts.[74] The whole is neither given nor describable, but it is discoverable as an image.

Deleuze asserts that "art is a machine for producing…certain effects" because "the readers or spectators will begin to discover, in themselves and outside of themselves, effects analogous to those that the work of art has been able to produce."[75] What art produces are "resonances." At the end of Proust's text, "we see what art is capable of adding to nature [life]: it produces resonances…between any two objects and from them extracts a 'precious image'."[76] This "precious image" is never a totality; it is never complete or whole. The image is a fragment.

A world can never be organized hierarchically or objectively, and even the subjective chains of association that give it a minimum of consistency or order break down…Even when the past is given back to us in essences, the pairing of the present moment and the past one is more like a struggle than an agreement, and what is given us is neither a totality nor an eternity, but "a bit of time in a pure state," that is, a fragment.[77]

The "precious image" is a fragment. These fragments will never reconstitute the whole, but this should not be met with melancholy. The whole was never whole; it was never one but was always, in advance, a multiplicity. It is not a failure of an image if it cannot give the whole from which it was extracted. This was never its charge nor within its scope. An image is a fragment not of a fractured, broken world rather it is a messenger or envoi: "the messenger is itself an incongruous part that does not correspond to its message nor to the recipient of that message."[78] We *encounter* images because we are in the midst of images. Images are our element. There is no simple "coming before" or "coming after" but only varying coexistent temporal durations; there is no organic totality but only a crystallization that we call, at times, an image, at other times, an individual. A lifework—life as a work of art, an aesthetic life—only "detours in order to gather up the ultimate fragments," it sweeps "along at different speeds all the pieces, each one of which refers to a different whole, to no whole at all, or to no whole other than that of style."[79]

In the encounter with an image what seems to be contingent becomes, in fact, necessary. The image forces us to think ourselves otherwise, anew; it makes inescapable demands on us. For this reason art presents us with thought-images, images of thought, that are "worth more than a philosophical work," Deleuze, one of the greatest philosophers of the twentieth century, writes. "For what is enveloped in the sign," he continues, is "more profound than all the explicit significations. What does violence to us is richer than all the fruits of our goodwill or of our conscious work, and more important than thought is 'what is food for thought'."[80] Proust's work competes with philosophy because he "sets up an image of thought."[81] It is not a case of an image or an aesthetics that must forego itself and thereby be actualized or translated into pure thought by philosophy. An image does not culminate in philosophy. Philosophy articulates itself through the friend and love (*philia*) whereas art presents quite another image of thought: not the friend but the criminal, the thief. This reminds me of Benjamin, who wrote that "Quotations in my work are like wayside robbers who leap out, armed, and rob the idle stroller of his conviction."[82] Art is "untimely" because it robs us of our conviction, it sets us on another path, it forces one to think.

Thought is nothing without something that forces and does violence to it…The *Leitmotif* of Time regained is the word *force*: impressions that force us to look, encounters that force us to interpret, expressions that force us to think…What forces us to think is the sign. The sign is the

> object of an encounter, but it is precisely the contingency of the encounter that guarantees the necessity of what it leads us to think…We seek the truth only within time, constrained and forced.[83]

Unlike a picture (resemblance), an image forces us to think, that is, to create alongside it, in time and yet out of order. Time "forces every present into forgetting, but preserves the whole of the past within memory: forgetting is the impossibility of return, and memory is the necessity of renewal."[84] *To renew the past…*

I would like to end by discussing one of the most well-known and yet elusive texts on photography, Roland Barthes's *Camera Lucida*, which twists the discussion of temporality in ways that extend and diverge from what we have heard above.[85] "Now, one November evening shortly after my mother's death," Barthes begins the second part of his book, "I was going through some of her photographs. I had no hope of 'finding' her, I expected nothing from these 'photographs of a being before which one recalls less of that being than by merely thinking of him or her' (Proust)."[86] Barthes discovers a photograph of his recently deceased mother—one that he does not reproduce in the book—but his encounter with it, the manner in which it compels him, is different from what he understands Proust to be after. Voicing his reading of Proust, Barthes adds that this photograph that has chosen him "does not call up the past (nothing Proustian in a photograph)" because the "effect it produces upon me is not to restore what has been abolished (by time, by distance) but to attest that what I see has indeed existed."[87] Of this photograph of his mother, he writes:

> Here again is the Winter Garden photograph. I am alone with it, in front of it. The circle is closed, there is no escape…no culture will help me utter this suffering which I experience entirely on the level of the image's finitude (this is why, despite its codes, I cannot *read* a photograph)… And if dialectic is that thought that masters the corruptible and converts the negation of death into the power to work, then the photograph is undialectical…I cannot place it in a ritual (on a desk, in an album) unless, somehow, I avoid looking at it (or avoid its looking at me).[88]

For Barthes, this photograph of his mother is the *punctum* (a concept he creates in this meditation on photography) of the entire text; it is the "undialectical point," a wound, a prick, chance, an irrational focal point that never allows a photograph to be a memory because a *punctum* delays memory, becoming a "counter-memory." The *punctum* that encounters Barthes in some of the photographs he looks at is not limited to him. It is an experience that we all may and can have, whether the *punctum* be a detail of a photograph or the entirety of it in some cases. "The Photograph is violent: not because it shows violent things, but because on each occasion *it fills the sight by force*, and because in it nothing can be refused or transformed."[89] In Barthes's mind, we are always before photographs; they are *there* as a stubborn, unrelenting presence.

This stubborn presence, ironically an "enigmatic point of inactuality," grants a photograph its ability to fill sight by force: this is *what a photograph is*, for Barthes. Throughout his remarkable text, he posits an ontology of photography: "I was overcome by an 'ontological' desire: I wanted to learn at all costs what Photography was 'in itself', by what essential feature it was to the distinguished from the community of images...I wasn't sure that Photography existed, that it had a 'genius' of its own."[90] Barthes ontology of photography is premised on its indexical nature. For him, a photograph is never distinguished from its referent (from what it represents), "at least it is not *immediately* or *generally* distinguished from its referent."[91] A photographic picture is a tautology because, following Barthes's indexical logic, a pipe is always intractably a pipe. (Yes and no, it is an image of a pipe; it is similitude not resemblance or reproduction.)[92] The referent "adheres" in the photograph because "whatever it grants to vision and whatever its manner, a photograph is always invisible: it is not it that we see."[93] This is because we supposedly see through it—Barthes called a photograph a "transparent envelope"—to the referent itself. Barthes admits as much early in the book: "Myself, I saw only the referent, the desired object, the beloved body."[94]

Nevertheless, Barthes is not after a semiology of photography in *Camera Lucida*. His interest in the ontology of a photograph is not motivated by a search for meaning or interpretation; it is motivated, instead, by an attempt to construct a relation to time. Time is the true *punctum* of photography, he writes. Difficulties arise because the author of *Camera Lucida* is seemingly far removed from the earlier Barthes of *Mythologies* and *Image-Music-Text*. In his last text, Barthes is not interested in sociological commentary, discourse, or cultural codes. His interests and thinking has changed over time as anyone's would, but there are elements in his earlier work that hints at these later perspectives.[95] In *Camera Lucida* Barthes is clear: "I wanted to be a primitive, without culture."[96]

Hence his disinterest in what he calls the *studium*, the counterpart to a *punctum*. Recuperating another Latin word, Barthes explains that *studium* does not "mean, at least immediately, 'study', but application to a thing, taste for someone, a kind of general, enthusiastic commitment." The *studium* is cultural (coded); it allows for civil, polite knowledge. For instance, reading the style of the clothes evident in a photograph. "It is by *studium*," he continues, "that I am interested in so many photographs, whether I receive them as political testimony or enjoy them as good historical scenes: for it is culturally (this connotation is present in *studium*) that I participate in the figures, the faces, the gestures, the settings, the actions."[97] Conversely, the *punctum* does much more than provoke general or cultural interest. A *punctum*, unlike the *studium*, is defined as "sting, speck, cut, little hole—and also a cast of the dice."[98] It is chance, openness, encounter, accident, "a tiny shock," but not trauma. A *punctum* is a point, a punctuation, a pause, a detail that "overwhelms" Barthes's reading of a photograph thereby transforming "an intense mutation of my interest" because "everything is given, without provoking the desire for or even the possibility of a rhetorical expansion."[99] In other words, a

punctum reveals the ontology of photography, for Barthes. The indexical refer-ent that he discussed is not the same as the referent in linguistics or semiology (to which the *studium* belongs). What he calls the "photographic referent" is not "the *optionally* real thing to which an image or a sign refers but the *neces-sarily* real thing which has been placed before the lens, without which there would be no photograph."[100] The being of photography is not historical but temporal: a photograph gives "*the thing that has been there*," the "that has been."

If we consider Barthes's attraction to the Winter Garden photograph—the image of his mother that we, as readers, never see because all we would see is the *studium* of it—then it becomes clear that a photograph's "inimi-table feature" is the "that has been," its tracing and marking a moment in time. It is "not memory, an imagination, a reconstitution, a piece of Maya, such as art lavishes upon us, but reality in a past state: at once the past and the real," Barthes insists. This is what Barthes's desired from photography when he says that "I wanted to explore it not as a question (a theme) but as a wound: I see, I feel, hence I notice, I observe, and I think."[101] He desired to "give a name to Photography's essence and then to sketch an eidetic science of the Photograph" without denying the "intractable feeling" he had that "Photography is essentially (a contradiction in terms) only contingency, sin-gularity, risk."[102] A *punctum* is the point at which the contradiction reconciles itself: the essence and uniqueness of photography is its contingency, not only its dependence on time but its existence away from time as something both "past and real." Its essence is its "real unreality," as Barthes writes.

In a brilliant touch, Barthes admits that however "lightning-like" the *punctum* may be it has a bodily and perceptive affect (love, compassion, grief, enthusiasm, desire) on the spectator. It not only has the power to expand (dilate) and to contract time, but the photograph has the ability to think—free of the spectator. This may be its true power. A photograph is "subversive not when it frightens, repels, or even stigmatizes, but when it is *pensive*, when it thinks," Barthes writes. What a photograph thinks is not what it says, even if its most powerful statement is about what has been, a "certificate of presence."[103] Photography's true madness, its delirium, is this disjunctive temporal presence. Its "force is nonetheless superior to everything the human mind can or can have conceived to assure us of reality—but this reality is never anything more but a contingency."[104]

This line of argument continues as Barthes concludes, and almost recapitu-lates, his text:

> At the time (at the beginning of this book: already far away) when I was inquiring into my attachment to certain photographs, I thought I could distinguish a field of cultural interest (the *studium*) from that unexpected flash which sometimes crosses this field and which I called the *punctum*. I now know that there exists another *punctum*...than the "detail." This new *punctum*, which is no longer of form but of intensity, is Time, the lacerat-ing emphasis of the..."*that-has-been*"...its pure representation.[105]

Thus the photograph as epiphany and ellipsis, as two different relations to time at once, which fractures and deframes time rendering it an opening. Most photographs are "merely analogical" Barthes adds, stating that they only provoked his mother's identity. But the Winter Garden photograph as *punctum*, as time as such—a simple question whose complex answers he terms a "true metaphysics"—"achieved...*the impossible science of the unique being*."[106]

Nothing can prevent a photograph from being analogical, Barthes concludes, but its essence, its very being, has nothing to do with analogy, only with its "evidential force" that "bears not on the object but on time."[107] Surveying his work over the preceding thirty some odd years, Barthes resolves that the "realists, of whom I am one and of whom I was already one when I asserted that the Photograph was an image without a code—even if, obviously, certain codes do inflect our reading of it—the realists do not take the photograph for a 'copy' of reality, but for an emanation of *past reality*: a *magic*, not an art...the power of authentication exceeds the power of representation."[108] Barthes's shift from semiotics, his belief in critique, to his saying that "I gave myself up to the image" is a starting point for W. J. T. Mitchell's extraordinary work on the "living image," on the "magical relation" between an image and what it represents.

For those who "scoff at the idea," Mitchell asks whether we would "take a photograph of [our] mother and cut out the eyes."[109] Some, undoubtedly would. But the vast majority would hesitate, if not cringe at the very idea. Mitchell is confident in his initial position: "I believe that magical attitudes toward images are just as powerful in the modern world as they were in so-called ages of faith."[110] He argues that we have a "double consciousness"—a simultaneous belief and disavowal—of images in the modern world that is "a deep and abiding feature of human responses to representation." He adds:

> At the same time, I would not want to suggest that attitudes toward images never change, or that there are no significant differences between cultures or historical or developmental stages. The specific expressions of this paradoxical double consciousness of images are amazingly various... [including] the ineluctable tendency of criticism itself to pose as an iconoclastic practice, a labor of demystification and pedagogical exposure of false images. Critique-as-iconoclasm is, in my view, just as much a symptom of the life of images as its obverse, the naïve faith in the inner life of works of art. My hope...is to explore a third way...a mode of criticism that did not dream of getting beyond images, beyond representation... [rather] a delicate critical practice with just enough force to make them resonate, but not so much as to smash them.[111]

Like Barthes in *Camera Lucida*, Mitchell begins by posing questions of desire and life rather than signification and power. What do images want? In addition to their meanings, what are we to make of their silence and their "nonsensical obduracy"? Thus, we need a "delicate critical practice"—a relation *to* and *alongside* images—that can "grasp *both* sides of the paradox of the image: that

it is alive—but also dead; powerful—but also weak; meaningful—but also meaningless."[112] The question facing anyone who studies images is "not just what they mean or do but what they *want*—what claim they make upon us, and how are we to respond" which requires us to ask, in turn, what is it that we want from them?[113]

The life of images does not simply mean reconciling art and life. Nor does it mean repudiating one or the other. Instead, a living image is one that is not human life because it partakes of something more general. "It is not one term [art or life, or subject or object] which becomes the other, but each *encounters* the other, a single becoming which is not common to the two, since they have nothing to do with one another, but which is between the two, which has its own direction."[114] These lines are from Deleuze. The becoming he refers to is "time as primary matter, immense and terrifying, like universal becoming"[115] Becoming-photographic, as we all have, is not to be subjected and policed; rather, it is "becoming caught in a matter of expression." This, Deleuze adds, is one lesson of Proust, who gave us an "art-monument" wherein the virtual—the coexistence of lines of time, distinct yet indiscernible forces—is not actualized (made present) but is embodied: the art-monument, the living image, "gives it a body, a life, a universe," a "life higher than the 'lived'" that is "neither virtual nor actual" but "possible, the possible as aesthetic category."[116]

The last image: Daguerre's *View of the Boulevard du Temple* (c. 1838).[117]

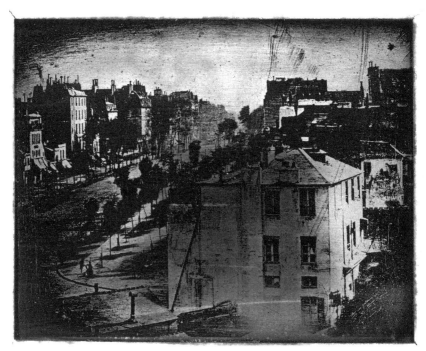

Figure 5.6 Louis Daguerre, *View of the Boulevard du Temple* (c. 1838)

GLOSS ON VILÉM FLUSSER, *TOWARDS A PHILOSOPHY OF PHOTOGRAPHY* (1983)[1]

Vilém Flusser was an émigré intellectual whose reputation as a philosopher and cultural historian has continued to grow since his death in 1991. Increasingly his name appears in discussions of post-industrial image-saturated society alongside Jean Baudrillard, Marshall McLuhan, and Paul Virilio, among others.[2] Flusser's interest in photography is inextricably linked to his thoughts on history (or our post-historical existence) and his nomadic life, which was set into motion by the catastrophic events of the Second World War. Flusser came from a family of Jewish intellectuals who lived in Prague; his parents and his sister perished in Nazi concentration camps. As Hubertus von Amelunxen has written, "Flusser's writing is 'nomadological'; it reflects the fate of being an émigré in the twentieth century, the 'rootlessness', the 'groundlessness' and the basic insecurity of human destiny."[3] This type of existence fuels Flusser's commentary on photography. He emphasizes photography's ability to translate, displace, and emit information without any ground. For him, photographic images themselves are nomadic. This may account for Flusser's text, which presents us with no photographic images, no descriptions of photographs, or even any substantive references to other thinkers. Flusser, instead, spends his time analyzing the discourse of photography: its automaticity, the apparatus and program of the camera (technology) in confrontation with a human agent trying to work within and even against that technology.

Flusser's text is "a work of doubt and concern, a work of indecision characteristic of the photographic universe in which one still has to come to terms with a history steeped in photographs and the 'collective memory' going endlessly around in circles'."[4] What he desires is a critical thinking about photography—its creation, functions, and reception which comprise the "photographic universe"—an education in photography that would be capable of reversing the gross "illiteracy" and willful ignorance of it. This "illiteracy" comes at quite a cost. As he writes:

> images come between the world and human beings. They are supposed to be maps but they turn into screens…Human beings cease to decode the images and instead project them, still encoded, into the world "out there," which meanwhile itself becomes like an image…Human beings forget they created images in order to orientate themselves in the world. Since they are no longer able to decode them, their lives become a function of their own images: Imagination has turned into hallucination.[5]

One consequence of this "illiteracy," then, is the re-enchantment of the photographic image. All photographic images, for Flusser, are "surfaces that translate everything into states of things" and therefore, like all images, "they have a magical effect."[6] This "magical effect" is an enticement, a mirage, in which we dupe ourselves: "the function of technical images is to liberate their receivers by magic [the magic is a ritualization of 'programs'] from the necessity of thinking conceptually, at the same time replacing historical consciousness."[7] In some ways,

Flusser's narrative of our collective ("human beings" as a whole) act of being duped by images is far from original. The notion of an image as deceptive, hallucinatory artifice has been reiterated since Plato. Moreover, Flusser's emphasis on the automaticity of photography, the instantaneous recording of reality by optical, chemical, and mechanical devices (the entire apparatus of photography) is a common refrain. Nevertheless, the demands he makes on criticism stemming from his reading of the photographic apparatus is quite nuanced; it helps us orient ourselves in a "photographic universe" that is undoubtedly becoming more automatized, free of human agents, and so ubiquitous as to be nearly invisible.

The products of this automaticity he terms "technical images." The invention of photography is a historical event that gave us the first technical image. Flusser contrasts these with "traditional images," that is, prehistoric as opposed to post-historic (post-Industrial Revolution), signifying phenomena as opposed to concepts. In short, traditional images, for Flusser, are symbolic in character because "human beings (for example, painters) place themselves between the images and their significance."[8] This mediation by human agents is what is increasingly absent in our relations with photography. Of note is Flusser's argument that technical images are indexical, although he never uses this term. "To all appearances," he writes, "[technical images] do not have to be decoded since their significance is automatically reflected on their surface—just like fingerprints, where the significance (the finger) is the cause and the image (the copy) is the consequence."[9] It is this indexicality that Flusser insists obscures the role technical images play in post-industrial, post-historical society. The "lack of criticism" of the technical image leads to a new form of "magic" in our dealings with these images. As much as any other type of image, technical images are coded: they are not instances of pure denotation, despite Flusser's emphasis on indexicality. However, Flusser posits that they are not encoded by culture (connotation), but by the photographic apparatus itself: the "inner workings" and operative program of the "black-box" (the camera) itself.

His "philosophy of photography" is primarily an attempt "at an elucidation of its inner workings" because "as long as there is no way of engaging in such criticism" we shall "remain illiterate."[10] Two points are pertinent here. First, Flusser implies that only amidst a proliferating "universe of technical images" does the event of photography—historically and ontologically—become apparent. So only now, in our contemporary moment, does the epochal event of photography in the mid-nineteenth century become readable. Second, Flusser does not resort to a Frankfurt School, Marxist critical theory position to dispel this "new magic" that escorts our reception of technical images. There is nothing "behind" these types of images. As he writes, "The cultural criticism of the Frankfurt School is an example of a second-order paganism: Behind the images it uncovers secret, superhuman powers at work (e.g. capitalism) that have maliciously created all these programs."[11] Contrary to this "paganism," Flusser insists that "the programming proceed in a mindless automatic fashion" that we must admit and then attempt to work through in order to figure out how to struggle against this automatic, anonymous programming.

Here is a key passage that summarizes much of Flusser's argument as a whole. It is here that we see him addressing the antinomy between the apparatus and human agency, which includes his crucial notion of "decoding" a technical image:

> Every single photograph is the result, at one and the same time, of co-operation and of conflict between camera and photographer. Consequently, a photograph can be considered decoded when one has succeeded in establishing how co-operation and conflict act on one another within it. The question put to photographs by critics of photography can therefore be formulated as: "How far have photographers succeeded in subordinating the camera's program to their own intentions, and by what means?" And, vice versa, "How far has the camera succeeded in redirecting photographers' intentions back to the interests of the camera's program, and by what means?" On the basis of these criteria, the "best" photographs are those in which photographers win out against the camera's program in the sense of their human intentions, i.e. they subordinate the camera to human intention...But in the photographic universe as a whole, one can see how programs are succeeding more and more in redirecting human intentions in the interests of camera functions.[12]

Let us pause here and comment on this portion of the passage. Flusser reiterates the idea that photography is one of the first instances where we witness the encounter between humanity and technology. Benjamin argues something similar in his "Little History of Photography." This encounter does not presume a dialectic; there will be no synthesis of human and technology. Rather, the constant struggle to "subordinate the camera's program" to human intentions and vice versa is open-ended, ongoing. This gives us a criterion of judgment for photography that does not suppress the technology at work in and against the photographer. It should also remind us of Martin Heidegger's comment that technology is an act without an image.[13] This encounter is an attempt to rend—to pilfer and snatch—an image of ourselves as part of "the photographic universe."

Flusser continues the passage above by declaring the "task of photography criticism" as being

> to identify the way in which human beings are attempting to get a hold over the camera and, on the other hand, the way in which cameras absorb the intentions of human beings within themselves...If photographic criticism succeeds in unraveling these two intentions of photographs, then the photographic messages will be decoded. If photography critics do not succeed in this task, photographs remain undecoded and appear to be representations of states of things in the world out there, just as if they reflected "themselves" onto a surface. Looked at uncritically like this, they accomplish their task perfectly: programming society to act as though under a magic spell for the benefit of cameras.[14]

To look critically at photographs is to decipher the tense encounter of human intentions and camera program in them. Evidence of this encounter is translated onto the surface of the image itself; it is a crucial part of the information a

photograph imparts, Flusser argues. But what is encoded is not only this struggle, but the struggle between the photographer and the "distribution apparatus" of the image (mass media, publishing, television, advertising), which is just as unwieldy and powerful as the camera apparatus itself, as well.

Flusser also provides a distinction between "redundant images" (snapshots, vernacular, or amateur photography) and art-photography. Snapshots, he argues, evince that the ones taking them are not in charge of the camera but only using it as a "plaything." This is a condition of the fact that although a camera is a complex set of scientific and technological principles it is simple to use. "The camera," he adds, "is structurally complex, but functionally simple, a plaything." He then contrasts it with chess, our metaphor of photographic discourse. "In this respect, it is the opposite of chess which is a structurally simple, and functionally complex game: Its rules are easy, but it is difficult to play chess well."[15] In other words, it is simple enough to take a picture, but it is quite another to understand how photography functions as discourse. In his terms, how to decode a photograph. He expands on this comparison by claiming that snapshooters, unlike photographers (those who struggle against the camera's program and technological limitations) and chess-players, "do not look for 'new moves', for information, for the improbable, but wish to make their functioning simpler and simpler by means of more and more perfect automation."[16] This desire for "more and more perfect automation" results in cameras and programs being produced that attempt to satisfy it. Flusser contends that taking snaps, not art-photography as such, fuels the photographic industry (camera models, printing processes, etc.). The sheer volume of snapshots in the photographic universe exhibit a redundancy. "Photo-mania" leads to the "eternal recurrence of the same," Flusser contends, using language borrowed from Nietzsche. The snaps are redundant images, more and more images of the same objects, the same states of things, because we (snapshooters) "can only see the world through the camera and in photographic categories...[we] have become an extension of the button of their camera [as our] actions are automatic camera functions."[17]

These redundant images are indicative of a "form of camera memory," one that Don Delillo masterfully characterized in his postmodern novel *White Noise* (1985).[18] Two characters are standing in front of "THE MOST PHOTOGRAPHED BARN IN AMERICA." In a "makeshift" parking lot there are "forty cars and a tour bus." "All the people had cameras; some had tripods, telephoto lenses, filter kits," the narrator, Jack Gladney, explains. The narrator's colleague Murray Jay Siskind has taken them to this site. It is his comments that give us a sense of Flusser's concept of the photographic universe and the role played by snapshots in constructing and maintaining it. Murray says that "We're not here to capture an image, we're here to maintain one. Every photograph reinforces the aura. Can you feel it, Jack? An accumulation of nameless energies...They are taking pictures of taking pictures." Within this universe—taking pictures of taking pictures—there is loss; there is no exit. "What was the barn like before," Murray goes on, "before it was photographed? What did it look like, how was it different from the other

barns, how was it similar to the other barns? We can't answer these questions because we've read the signs, seen the people snapping the pictures. We can't get outside the aura. We're part of the aura. We're here, we're now."

Flusser is not content to accept this fate. His attempt to write a "philosophy of photography" offers a couple of possible ways out. First, he would agree that "people taking snaps are unable to decode them" because "they think that photographs are an automatic reflection of the world," which "leads to the paradoxical result that the more people take snaps, the more difficult it becomes to decode photographs."[19] But the force of his project is to learn how to decode them, that is, precisely not to accept this ignorance neither as innocuous nor as a given. If this is "democracy in post-industrial society," then Flusser wants nothing to do with it. By extension, if photographs form "a magic circle around us" (an aura that we are part of as Delillo writes) in the shape of the photographic universe, then Flusser demands that we try to "break this circle." But how? With what means? This leads to the second point. To "break this circle" Flusser suggests that we learn how to "be in the photographic universe," that is, how to engage with "informative images" made by (experimental) photographers in order to learn how to resist the automatization of human life. This only comes if we learn how "to experience, to know, and to evaluate the world as a function of photographs."[20]

Experimental photography, for Flusser, takes as its premise that "there is no such thing as a naïve, non-conceptual photography."[21] Each and every photograph is an image of concepts. Hence photographers, as opposed to snapshooters, "wish to produce states of things that have never existed before" and they try to accomplish this by pursuing "possibilities that are still unexplored in the camera's program."[22] This pursuit results in informative images. Flusser wagers a tremendous amount on these types of images. "Our thoughts, feelings, desires, and actions are being robotized; 'life' is coming to mean feeding apparatuses and being fed by them. In short: Everything is becoming absurd. So where is there room for human freedom?" he asks.[23]

We have arrived at the heart of Flusser's argument. If "the world is a function of photographs," then "freedom is playing against the camera." This is precisely what photographers—experimental ones who create informative images—do. He insists that photographers'

> acts are programmed by the camera; they play with symbols; they are… interested in information; they create things without value. In spite of this they consider their activity to be anything but absurd and think that they are acting freely. The task of the philosophy of photography is to question photographers about freedom, to probe their practice in the pursuit of freedom [because]…they are conscious that *image, apparatus, program* and *information* are the basic problems that they have to come to terms with. They are in fact consciously attempting to create unpredictable information, i.e. to release themselves from the camera, and to place within the image something that is not in its program. They know they are playing against the camera.[24]

What they are not conscious of are the implications of this "playing against," which is what a "philosophy of photography would provide," Flusser claims. This is not accurate. Instead, it forwards the longstanding conceit that artists (here photographers) are ignorant of the consequence of their actions (aesthetic strategies, etc.) and only philosophy can articulate them. With that said, Flusser's larger point is intriguing: that within a world saturated with ever more automated photographic images, it behooves us to study the work of photographers who acknowledge and test the enabling limits of the apparatus itself. In this way we may learn how to "create a space for human intention in a world dominated by apparatuses" even as "the apparatuses themselves automatically assimilate these attempts at liberation and enrich their programs with them." It is the "task of a philosophy of photography to expose this struggle between human being and apparatus in the field of photography and to reflect on a possible solution to the conflict."[25]

In the end, Flusser's text is more of a provocation than a prescription. Hence his concluding statements are certainly not eschatological. Flusser's hope is redolent of Benjamin's unnerving essay "Experience and Poverty" (1933) where he writes that we have become impoverished because we "have 'devoured' everything, both 'culture and people', and [we] have had such a surfeit that it has exhausted us…We have become impoverished."[26]

Flusser's metaphor of "blindness" shares much with Benjamin's "poverty." Extending the etymological sense of "snapshot" (a term derived from the discourse of hunting), Flusser arrives at the hunting blind in which someone is lying in wait for something. This sense of someone or something preparing is at work in the term apparatus. Remaining passive and thereby hunted by the apparatus results in visual blindness. We feel as if we "have gone blind."[27] However, if we struggle with the apparatus, try to render informative images, and force ourselves to think possible solutions to our predicament in the photographic universe, then we may be able to truly engage "the current and future existence of human beings."[28] This is a lot to ask of photography. But in not doing so we run the risk of becoming a figure whose presence punctuates the history of photography: the blind. From the vantage point of the contemporary this blindness is becoming more and more visible.

The gesture of photography is thus a privation and a strength.[29] It gives us an image that forces us to accept what has become irretrievable (the thing itself, history, the past) and yet continues to transmit itself otherwise. As Benjamin wrote: "It is likely that no one ever masters anything in which he has not known impotence; and if you agree, you will also see that this impotence comes not at the beginning of or before the struggle with the subject, but at the heart of it."[30]

Glossary

Note

The names included in this glossary were ones that, although mentioned in the preceding chapters, I thought should be referred to here for reference and to convey their importance to the history and theory of photography.

Appropriation art A term referring to re-presenting a pre-existing work of art, image, or object into another artwork. This practice has precedents in Synthetic Cubism, Duchamp's readymade strategy, and Surrealist found objects. In the late 1950s appropriated images and objects appear extensively in the work of Jasper Johns and Robert Rauschenberg, Pop art as well as in Assemblage art practices. However, with the advent of postmodernism, appropriation practices became a primary means to challenge the ideas and myths of modernism. Consider the work of Sherrie Levine, Jeff Koons, and others. The aim of this practice being to create a new situation, and therefore a new meaning or set of meanings, for a familiar image. Appropriation art raises questions about the value of originality, authenticity, and authorship in art.

Automaticity The idea that a photograph is generated automatically by the camera (machine) with little to no role played by the photographer. The human agent (subjectivity, desire, bias) is thus removed. It is claimed to be as simple as pressing the button to open the shutter. For those who argue from this position, which includes many important thinkers of photography, a snapshot is the summation of photography as such. It also plays an important role in the discourse of documentary photography. Automaticity is tied to the concept of an indexical sign.

Avant-garde Originally a French military term meaning "forward or advance guard." Within art and literature, the term refers to groups of writers and artists whose work is formally (stylistically) innovative (defies convention). This formal experimentation is usually combined with socio-political goals/ideas, that is, an attempt to unite "art" and "life," to gesture toward the construction of a more just world, or even to negate the notion of artistic autonomy. Thus the term is often associated with revolutionary social/political tendencies and a challenge to the institutional

status of art. A key element of this definition must acknowledge how the term is a Eurocentric and gendered concept within Western art history.

Baudelaire, Charles (1821–67) Modern French poet who published a landmark volume of poetry entitled *The Flowers of Evil* (1857). His work is associated with Romanticism and Symbolism; it addresses themes of sex, death, and melancholy. He also wrote some of the most definitive art criticism in pieces reviewing the salons of 1845 and 1846 as well as the famous essays "The Modern Public and Photography" (1859) and "The Painter of Modern Life" (1863). Baudelaire was a prominent figure in the cultural scene of mid-nineteenth-century Paris. He is depicted in paintings by Edouard Manet (*Music in the Tuileries*, 1862) and Courbet (*The Studio of the Painter*, 1854–5); in addition, he is the subject of a few early photographs by Nadar and others.

Bauhaus Famous art school that opened in Weimar, Germany in 1919, which championed modern art, design, and architecture. Initially had a leftist, socialist orientation, yet its designs and ideas have become part of mainstream capitalist society. The instructors at the Bauhaus from 1919–24, who were called "Masters of Form," included Johannes Itten, Gunta Stozl, Lyonel Feininger, Oskar Schlemmer, Paul Klee, Wassily Kandinsky, Laszlo Moholy-Nagy, and Walter Gropius. The school moved to Dessau, Germany in 1925, where Gropius built its distinctive headquarters. In 1932 it moved to Berlin, but only for a few months as it was disbanded by the Nazis in 1933. An important document about the school's organization is Walter Gropius's "The Theory and Organization of the Bauhaus" (1923). A key feature of which was the dissolution of boundaries between painting, sculpture, etc.; there was to be no hierarchy of medium, thus their commitment to handicrafts. Six-month introductory course (*Vorkurs*) for all students aimed to release their creativity, then three years mastering different materials and related theoretical studies. The target or aim being: "building" or "design" (*Bau*) (which did not simply mean "architecture"). The Bauhaus concept of *Bau* was utopic; it sought to change the world through a combination of idealism, rationalism, experimentation, and functionality. In short, designing a new, modern world. One aspect of their position was that the formation of objects (machinist, design principles) that would usher in the revolutionary formation of society (socialism). Architecture played a central role in the Bauhaus in Dessau, especially in its last years under the direction of Mies van der Rohe.

Brecht, Bertolt (1898–1956) German Marxist poet and playwright who was a prominent intellectual and artistic figure in the Weimar Republic (Germany between 1919 and 1933). His major work *The Threepenny Opera* (1928) established him as a major avant-garde figure. Brecht created what he called "epic theatre," that is, a form of theatre that had a clearly defined political agenda and that self-consciously drew the audience's attention to itself through "alienation effects" (breaking the illusion of

the play as a self-contained internal universe). As Walter Benjamin wrote, epic theatre "does not reproduce conditions, but, rather, reveals them." Hence it aimed to expose the cultural conditions of capitalism. Brecht's "alienation effect" is tied to certain ideas from Russian Formalism, notably Viktor Shklovsky's "defamiliarization," that is, a function of art and literature to estrange everyday events and objects so that they appear in a new light; art removes objects and relations from the automatism of perception, estranging them, so that they can be rethought or reimagined.

Camera obscura Literally, means a "dark room," a pre-modern invention that directly led to the invention of photography. The first clear description and scientifically accurate account was given by Alhazen, an eleventh-century Islamic scientist. An essential element in the pre-history of photography, it was used as an aid for artists because it offered an inverted image of the external world which could be traced. Initially a camera obscura was a room-sized, completely darkened chamber in which a tiny opening in one wall acted as a lens, casting an upside-down image of the outside view on the opposite wall. They were later made smaller, replete with focusable lenses and a glass surface on which to place paper for sketching or tracing the image.

Camera lucida Literally, a "light room," although it is neither a "light" nor a "room." Invented and patented by the British scientist William Hyde Wollaston in 1806, a camera lucida was more transportable and lightweight (useful for travel) than a camera obscura. It consisted of a rod to which a glass prism having two silvered sides was attached, this prism superimposed the reflected scene and the drawing paper.

Cartes-de-visite A "card photograph" patented in 1854 by French photographer André Disdèri. Small portrait photo (albumen print) pasted on a regular visiting/calling card (2.5×3.5 in). A multiple-lens camera took up to eight different images of the sitter. They were cheap to produce. Disdèri set up conventions for this type of portraiture: painted backdrops (stage setting for creation of a public image), props, full even lighting, etc. They were formulaic: individual shown as a class type. Although it was a short lived practice (ten years), it coincides with the rise and reign of the middle-class in France (the Second Empire (1852–70) of Napoleon III).

Collodion A wet-plate process invented by Frederick Scott Archer in 1851 that replaced both the daguerreotype and the calotype (a dry process) by the 1860s. It was a dominant technique until the 1880s. The popularity of the collodion process stemmed from it being free of all patent restrictions, unlike Talbot's calotype, and because it afforded smooth, sharper photographic prints. The prints were made on albumen paper, a printing paper coated with egg white and salt, before it was sensitized with a silver nitrate solution. The demand for egg whites for this process created an industry; a factory in Dresden is said to have had young women working to crack 60,000 eggs in a day around 1851. Plus, the paper prints made from the glass-plate negative were much cheaper than daguerreotypes.

However, it required an ether solution, glass plates, and strong sunlight. It remains a finicky, labor-intensive process. The contemporary photographer Sally Mann continues to work with this process. For example, see the photographs in her *Deep South* project (2005).

Composite photograph/composite printing Technique that used a series of negatives to construct a photographic image. They usually had a noticeable false appearance and depicted allegorical scenes that had a dramatic, theatrical quality. At the height of its practice in the mid-nineteenth century composition ideas were borrowed from history painting and there was an emphasis on morality. Composite photography presents an early example of photography as a manipulatable process, not as a mere reflection of the objective world. Note Oscar Rejlander's *The Two Ways of Life* (1857) and Henry Peach Robinson's *Fading Away* (1858).

Conceptual art An international phenomenon in the art world, height of its practice was 1965–72. A gesture of self-reflexivity and criticality organize this type of work. It is not about forms or materials, but about ideas and meanings. This type of practice is indebted to the work of Marcel Duchamp. The artist works with meaning, not shapes, colors, forms, or materials; instead, it undertakes a critique of art and its values. Conceptual art arose in a time of crisis—a crisis of authority—in the mid- to late 1960s (Civil Rights Movement, student protests against Vietnam War, the events of May 1968, etc.). However, much of the canonical Conceptual art from this period rarely addresses these events directly. Conceptual art, in general, abandons the aesthetic process altogether because art itself was contaminated by the art world. In doing so it works to dismantle the idea of a transcendental viewing experience, which is central to Modernism, to expose art's means of distribution and its position in society as a commodity (ephemeral materials, aesthetics of administration). Therefore it marks the emergence of the theoretical question about the nature of art (what it is, who decides). The term "Conceptual Art" was first used in Sol LeWitt's essay "Paragraphs on Conceptual Art" in 1967 (published in *Artforum*). Recurring forms of Conceptual art include the readymade, interventions, affectless documentation, and the use of language. The genre of straightforward, explanatory prose coupled with a black-and-white documentary photograph—presentation not representation—that predominates in much Conceptual art practice in the 1960s and 1970s is a key notion in the anti-aesthetic position.

Critical theory An interdisciplinary approach to cultural analysis that draws on philosophy, literary criticism, gender studies, sociology, history, aesthetics, and economics. From Marxism onwards, critical theory has sought to engage the complex social, political, and ethical interdependence at work in any form of cultural production. Critical theory intervenes in a wide range of debates. The Frankfurt School is a key version of cultural criticism in Western Marxist tradition that included major figures such as Theodor W. Adorno, Max Horkheimer, Herbert Marcuse,

Jürgen Habermas, and Walter Benjamin. It was Adorno and Horkheimer who first used the term "critical theory" for their methodology; see their *Dialectic of the Enlightenment* (1947). In general, their work challenged orthodox Marxist thought by staging new, often more subtle and innovative critiques of Western capitalist culture by engaging, rather than dismissing, high modernist literature, visual art, and music. However, the term "critical theory" is no longer limited to the Frankfurt School. It now covers a wide range of methodological approaches: psychoanalysis, post-structuralism, queer studies, critical race theory, semiotics, etc. Critical theory remains linked to articulating a range of political positions. It has also changed the very idea of being a critic or historian in that one no longer studies literature or art, for example, without also becoming familiar with a variety of theoretical perspectives on those subjects.

Crystal Palace The venue built to house, and alternative name for, *The Great Exhibition of the Works of Industry of all Nations.* This exhibition was hosted by Queen Victoria and Prince Albert in London in 1851. It ran for six months. It was the first in a series of international exhibitions: the prototype of world fairs, contemporary museums, and malls. The building was made of modern materials (glass and iron) and was designed by Joseph Paxton. Its construction was officially photographed. The exhibition included national pavilions where certain nations displayed their art and technology as a way to express their national identity. The Crystal Palace is modernity's most unsurpassable artifact: the most clear embodiment of modernity itself. Issues of representation, the myth of photographic truth, and anthropology/ethnography are all relevant in discussions of this cultural event.

Dada During the First World War (WWI) (1914–18), Switzerland was neutral so many young artists fled to Zurich. Dada was an international group of artists such as Jean Arp, Hans Richter, and Sophie Taeuber as well as writers such as Hugo Ball and Tristan Tzara who gathered at Ball's Cabaret Voltaire. Dada was born of the disillusion and hysteria of European civilization as it collapsed into WWI. Even the name Dada was supposedly chosen at random by Richard Huelsenbeck and Hugo Ball by flipping through a French–German dictionary and stopping at random (dada means hobby-horse in French, yes-yes in Russian, and there-there in German—it is a meaningless term for the group). Their works and performances expressed their reactions to the nationalistic madness that led to WWI and the emergence of a mass media culture. Their works were negative, anarchic, often destructive, and satirical, but also at times quite amusing. After the war there were distinct Dada groups in Berlin (Raoul Hausmann, Hannah Höch, and Richard Huelsenbeck), Hannover (Kurt Schwitters), and New York (Francis Picabia, Man Ray, and Marcel Duchamp). As a whole, and in various ways, Dada critiqued the concept of art because (1) it was implicated in the cultural ideas (nationalism, etc.) that led to the war; (2) they would not allow art to look away from

life, that is, to be an end in itself (art for art's sake); and (3) they rejected illusionistic art that conveys imaginary worlds (as in Symbolism). The strategies deployed were: chance as a compositional method, interest in performative and ephemeral construction, photomontage, and a desire to challenge the conventional means of exhibition, distribution, and commodification of art. The ideal axis of Dada strategy, particularly with the Berlin group, focused on politics, mass media, and the audience.

Daguerre, Louis-Jacques-Mande (1787–1851) One of the most well-known of the inventors of photography because of a certain amount of showmanship (he named the image a "daguerreotype") and because the French government disseminated his invention to the world. Before the daguerreotype, he was best-known as a scenographer for operas (he was a master of lighting effects) and for his dioramas, a picture show with changing light effects and very large, immersive painted scenes. Dioramas are a part of the early nineteenth-century culture of modern spectacle. To construct these dioramas, Daguerre required the aid of a camera obscura. At the beginning of January 1829, he had agreed to a partnership with Nicéphore Niépce but it was cut short by Niépce's death in 1833. In 1835 he arrived at a breakthrough when he discovered that a latent image could be developed through the use of chemicals. In 1837, he fixed an image made in the camera obscura. On August 10, 1839, his invention—the daguerrotype—was presented by Francois Arago, a French politician, on August 19, 1839 to the French Academies of Science and Fine Arts in Paris. A daguerreotype is a copper or brass plate onto which the image is fixed through an amalgam of the silver iodide coating the plate and the mercury vapors used in the developing process Daguerre devised. Key attributes were its clarity (its mirror-like surface) and capacity to record detail. However, each daguerreotype is a unique, easily effaced image/object that must be held at an angle in order to view it. It was a direct positive process (there is no negative) and thus was not reproducible.

Documentary photography A broad category in the history of photography that came into usage primarily in the 1930s. In its largest sense, it refers to all non-fictional representation, that is, photographs that record or document reality: straightforward images of people, places, and things. These images aim at educating the public about experiences of hardship, injustice, suffering, etc. So there are two key aspects of documentary photography: representing an event (for example, a war) and eliciting the viewer's empathy. While the category of documentary photography could be stretched to include work from Jacob Riis to Thomas Struth, we must recognize some differences. In the 1930s, documentary photography arose as a combination of modernist style and realistic subject matter that strove to create a bond between the viewer and the subject of the photograph. A primary example would be the WPA photographs by Dorothea Lange, Walker Evans, Gordon Parks, and others. However, we also see an acknowledgement that the realist premise of documentary is

challenged in later work by Diane Arbus, Martin Parr, and other contemporary photographers. The idea is that the photographer's presence must be accounted for because it alters the situation; therefore, all documentary photography is a depiction of what the photographer saw, not merely an objective presentation of it. Key moments: WPA photographs, Walker Evans, Magnum Photos (Robert Capa, Henri Cartier-Bresson, and others), and the shift to contemporary (postmodern) photography following the exhibition entitled *New Documents*, curated by John Szarkowski at the Museum of Modern Art in 1967, which showed Lee Friedlander, Diane Arbus, and Garry Winogrand together. These moments in the history of documentary photography help us understand contemporary photography from William Eggleston's *Guide* (1976), to Nan Goldin's *The Ballad of Sexual Dependency* (1986), to Sebastião Salgado's *Workers: An Archeology of the Industrial Age* (1993).

Düsseldorf School of Photography Refers to contemporary photographers who studied at the Kunstakademie Düsseldorf under Bernd and Hilla Becher. Bernd Becher was appointed to a professorship at the Kunstakademie in 1976. It was then that he began his legendary photography program. Between 1976 and 1987 their students included what were to become some of the most prominent and important contemporary photographers today, including Thomas Struth, Candida Höfer, Axel Hütte, Thomas Ruff, Andreas Gursky, Simone Nieweg, and others.

F.64 A group of high modernist American photographers that formed in northern California in 1932. On the tail of a successful Edward Weston exhibition at the M. H. de Young Memorial Museum in San Francisco, Williard Van Dyke and Ansel Adams petitioned the curator for an exhibition of work by photographers in their group, who included Imogen Cunningham, John Paul Edwards, and later Brett Weston and others. The first exhibition of the F.64 group took place in 1932 at the M. H. de Young Memorial Museum. It presented eighty photographs, Weston participated, and had a manifesto that, in part, read: "The members of Group f/64 believe that photography, as an art form, must develop along lines defined by the actualities and limitations of the photographic medium, and must always remain independent of ideological conventions of art and aesthetics that are reminiscent of a period and culture antedating the growth of the medium itself." The group's name (F.64) is a technical term that refers to the opening of the lens; the smaller the camera's aperture the greater the depth of field, that is, the more space that one can have in focus in the photograph. F.64 indicates the greatest depth of field. The group wanted photography to be a unique art, one that required a mastery of all of the equipment and procedures of photographic equipment, including both the camera and the full printing process. The group forwarded a set of qualities that were essential to their conception of a photograph as art: large format cameras, sharp focus, clear definitions from edge to edge, slow film (long exposure time), final print

on smooth glossy paper, and no retouching or retrimming (full negative printed, an 8×10 contact print). Printing is an essential part of the photographer's art. They also worked against the inherent reproducibility of photography by creating limited editions and series.

Faktura An important term in the history of Modernism that is associated with Russian Constructivism, the artistic and cultural response and collaboration in the immediate aftermath of the Russian Revolution in 1917. As part of this larger cultural revolution (new spaces, objects, transparency, social idealism) *faktura* is referred to by the Russian critic Viktor Shklovsky's claim that "The aim of art is to awaken our sensitivity to things to really see them and not merely to recognize them" (*Art as Technique*, 1917). *Faktura*: focus on materials, textures, (tactile sense) *and* a mode of construction, that is, discovering a mode of production wherein the material (the medium itself) determined the process; thus, it was an attempt to erase or counter individual artistic will. *Faktura* also required incorporating the technical means of construction into the work itself, which included serious consideration about the placement of the constructivist object and its interaction (functionality) with the spectator. Note: *faktura* is part of the avant-garde's interest in constructed images such as photomontage.

Family of Man, The One of the most ambitious and contentious exhibitions of photography that took place at the Museum of Modern Art (MoMA) in New York City in 1955. Curated by Edward Steichen (then the head of MoMA's Photography Department) with an exhibition design by Paul Rudolph, the exhibition traveled to thirty-eight different countries (through funding provided in part by the United States Information Agency) and was seen by over nine million people from 1955 to 1962. It is arguably the first international blockbuster art exhibition as it was co-sponsored by Coca-Cola. Its creators called it "the greatest photography exhibition of all time" and yet Steichen deaestheticized the photographs by cropping them, exhibiting them without their titles, having them all processed in a commercial lab to unify tonal variation, and enlarging some of the photographs to poster-size. The presentation of the photograph was at Steichen's discretion, much to the chagrin of many of the photographers whose work was chosen. In addition, the photographs were not viewed or presented as art; rather, they were subsumed under the logic of the exhibition's narrative and its powerful exhibition design, which was essentially a three-dimensional photomontage. The importance of this exhibition and the controversy surrounding it must be understood in historical and cultural context: the creation of the United Nations in 1945, the beginnings of the Cold War, the Nuclear Age, and the ways in which culture (art, photography, film) was utilized politically.

Frank, Robert (b. 1924) A Swiss-born photographer who emigrated to America during the Second World War (WWII). His photographic mentor was Walker Evans. Frank is the face of contemporary street

photography, the snapshot aesthetic. He received a one-year Guggenheim Fellowship in 1955, which allowed him to undertake his famous series *The Americans*. The book was initially published in France in 1958, but ultimately it appeared in the USA in 1959. Frank used several approaches to his subject matter—American culture immediately after the war—that have become very influential: photographer-as-anthropologist, photographer-as-voyeur, and what has been called the snapshot aesthetic, that is, his use of fast film (35 mm film) to capture quick, spontaneous reactions to what was happening around him. This results in grainy prints that run counter to the dictates of the F.64 group as well as the idea of the heroic documentary photographer forwarded by the WPA and Magnum photographers. Frank's individualistic vision captured a certain sadness and alienation in American society, especially as he focused on young people, subcultures, the poor, African-Americans, etc., in 1950s America. The Beat writer Jack Kerouac wrote the introduction to Frank's *The Americans*.

Freud, Sigmund (1856–1939) A Viennese physician who developed psychoanalysis after working in hospitals studying hysteria and other nervous disorders. Freud's great construction is the concept of the "unconscious," the non-conscious, unrepresentable part of the mind that effects conscious thought and behavior. Psychoanalysis focuses on discovering and reading the traces of unconscious events through the interpretation of dreams, paying attention to slips of the tongue (Freudian slips), forgetting proper names, etc. At the heart of Freudian psychoanalysis there is a single wager, that is, whatever has been repressed by the conscious mind will be kept within the unconscious and return—the return of the repressed. His system is based on the return of the repressed, that is, what one represses returns in some manner (distorted, masked, hidden) until it is dealt with. Concept of the "uncanny" is directly related to the return of the repressed. Key texts include *The Interpretation of Dreams* (1900) and *Civilization and its Discontents* (1930).

Goldin, Nan (b. 1953) An American photographer whose raw, intimate, transgressive color photographs from the late 1970s and 1980s have become a touchstone for much contemporary art photography grounded in documentary practice. In 1979 Goldin began presenting slideshows of her photographs accompanied by music in nightclubs in New York City. These color images, which extend the snapshot aesthetic as well as the work of Diane Arbus, depicted gay and transgender subjects, explicit images of heroin-use and its effects, and the toll taken on human lives, including Goldin's own, by drug-use, intense personal relationships, and the AIDS crisis. These images came to comprise her book *The Ballad of Sexual Dependency* (1986), which was the title of her slideshow projections. The title is taken from a line in a song from Bertolt Brecht's *The Threepenny Opera* (1928). It is important to note that one of the elements that sets Goldin's practice apart from someone like Arbus is the inclusion

of herself in several of the photographs, an act that counters the fraught issues of voyeurism and exploitation. The cover of *The Ballad of Sexual Dependency* shows Goldin herself lying on the bed. She had a retrospective at the Whitney Museum of American Art in 1996, and another at the Centre Pompidou in Paris and the Whitechapel Gallery in London in 2001. In 2010, she exhibited *Scopophilia* at the Louvre.

Index One of three kinds of signs defined by the American philosopher C. S. Peirce. In semiotics (the science of signs), an index is a type of sign in which the relation between the signifier and the referent is determined by contiguity or co-presence, that is, based on factual or existential contiguity: cause and effect. For example, smoke is an index of fire; a footprint in wet sand is another example. An index is a sign that stands in for an object by virtue of a real (existential) connection to it. Marks or traces of a particular (not arbitrary) cause and that cause is the thing to which they refer.

Kitsch A term used to describe objects and images that became ubiquitous with the Industrial Revolution in the nineteenth century. Kitsch appeals to a common (often referred to disparagingly as "low") cultural sensibility in that mass-produced objects and images repackage and resell culture by emptying it of any critical dimension. So there is a symbiotic relation between kitsch and art. In his essay "Avant-Garde and Kitsch" (1939), Clement Greenberg named kitsch the natural enemy of avant-garde art. Kitsch, he argued, is thus the witless embrace of cliché as a defense against the weight of human estrangement in late capitalist, consumerist society.

Leica The name for the first lightweight 35 mm camera developed by Oskar Barnack for the German company Leitz; it was made available for the public in 1925. Lighter and more portable, it was capable of taking quick shots but resulted in grainy photos: qualities that became synonymous with photojournalism in the 1940s. Alfred Eisenstadt, Robert Capa, Henri Cartier-Bresson, and David Seymour all used Leica cameras to create the modern field of photojournalism. Cartier-Bresson used a Leica exclusively for his entire career. The use of a Leica by this generation of photographers influenced the "snapshot aesthetic" of the 1950s and 1960s in the United States. Robert Frank's iconic images comprising *The Americans* were shot with a Leica.

Nadar, Félix (1820–1910) French caricaturist turned photographer, specialized in heroic portraits of cultural celebrities. Capitalized on the burgeoning middle-class taste for images of creative people (writers, actors, artists). Marketed his own public persona as an artist (not as a photographic operator). He also posed his sitters, but differently from the conventions of the *cartes-de-visite*, using dramatic chiaroscuro, no props, curious poses, etc. He wanted to capture the sitter's "character." He also experimented with artificial light, photographing the sewers of Paris, and with aerial photography, making photographs from a hot air balloon above Paris.

Niépce, Nicéphore (1765–1833) Created the first fixed, "permanent" photographic image in 1826 by using a plate of polished pewter coated with bitumen. It is called *View from the Window at Gras*. It is an image

made from his attic window that required eight hours of exposure time. His invention is called a *heliograph* ("sun-writing"), which was a direct positive image, that is, a one-off process, no copies, not reproducible. Unfortunately, Niépce died before being able to fully explore his invention with Daguerre, with whom he had formed a partnership in 1829.

Orientalism The attitude of racial superiority adopted by many white Europeans and Americans toward Middle-Eastern, North African, and Asian peoples. Nineteenth-century Europe is marked by a near mania for Orientalist representations, at first paintings and later photographs as well. These representations were frequently overtly racist, emphasizing the supposed unchecked violence or exoticism of the Orient. Collectively they functioned to produce a mythic, discursive "Orient" that nonetheless colored Euro-American ideas and attitudes toward these cultures. In 1978 Edward Said published *Orientalism*, a groundbreaking text that focuses on how Western (Occidental) European culture is defined against its supposed antithesis: the Orient. In short, European culture is created through a dialectic (a dialogue between contending or opposing forces that tries to reach a resolution or synthesis) with its non-European others.

Photo-Secession The name of a group of photographers formed by Alfred Stieglitz in February 1902. They "seceded" from the Camera Club of New York, which had become too commercial and conventional. This separation was based on the Viennese Secessionists and other European groups that broke with the established art academies, which were deemed too conservative and stifling to artistic experimentation. The group used its photographs and its quarterly journal *Camera Work* (published 1903–17) to argue that photography is a unique medium (versus Pictorialism) and that it was a medium in which an individual (or artist) could express himself or herself (particularly in the development process) without resorting to painterly tactics. Straight photography was at the center of their discussion. Straight photography meaning purity and formalism: images that were not manipulated to give them non-photographic effects in the development process. However, by 1910 there were divisions in the group over this point, with some arguing for the straight position and others insisting that some manipulation should be acceptable. Photographers associated with Photo-Secession included Edward Steichen, Gertrude Käsebier, Clarence H. White, Alvin Langdon Coburn, Paul Strand, and others.

Physiognomy A pseudo-science popular in the late eighteenth and throughout the nineteenth century. Physiognomy has a long history within Euro-American cultural discourse. Its first coherent appearance is in the Enlightenment text by Johann Kaspar Lavater, *Essays on Physiognomy* (4 vols.) (1789–98), in which he claimed that human face indicates moral character. Thus facial beauty indicates virtue whereas ugliness, vice. Physiognomy, for him, meant the act of judging temperament and inner character from outward appearances; reading the outside for the inside: the "original language of Nature, written on the face of

man," Lavater believed. In the nineteenth century physiognomy is folded into the discourse of positivism (simply the idea that one cause equals one effect). By serving as a supposedly "scientific" aid, photography undoubtedly abetted this dubious practice. A practice that is inextricably tied to myths of race and criminality. Note the role of photography in generating a typology of difference based on facial expressions and body parts, that is, an archive of signs read as indicative of moral defects, predilection for crime, sexual deviancy, etc.

Pictorialism International photographic movement from the 1850s to the 1920s, with a peak in the late nineteenth century. Photographers associated with Pictorialism shared a disgust with industrialization and mass-produced goods coupled with a belief that photography was first a fully modern art form. Yet new processes, such as gum-bichromate printing, allowed these photographers to paint the surface of the photograph, adding color and other painterly effects. The logic of Pictorialism is that photography allows for the artistic expression of the photographer, but it does so, in part, by mimicking painting. Simply put, a photographer does what a painter does, just with different tools. There is an emphasis on mood, atmosphere, light, and soft focus in many Pictorialist photographs. Qualities one clearly sees in the work of Julia Margaret Cameron, whom the Pictorialist championed. Hence there is also a tonal complexity (gray tones versus stark black and white) that worked against commercial photography.

Picturesque Literally means "like a picture." A broad aesthetic category throughout nineteenth-century European and American art. It began in the eighteenth century with the publication of Uvedale Price's book *An Essay on the Picturesque, as Compared with the Sublime and the Beautiful* in 1794. In general, it meant a natural scene composed in such a way that it stirred feelings or thoughts in the viewer. In photography, we see photographers choosing topics and scenes reminiscent of paintings as a way to validate their practice. The picturesque as a strategy and a genre was particularly dominant in England, where photographers such as Roger Fenton and others chose ideal vantage points from which to view and represent the landscape as a timeless Arcadia, that is, a unified (mythic) vision of social life that denies actual lived experience of land and political realities.

Postmodernism An attempt to address the relation between postwar society and representation. It arose after the conceits and failures of Modernism, including a certain conception of history and identity, had been exposed as untenable after the Second World War. Within the study of art history, postmodern thought contests any formalist approach to art, particularly photography. It argues that ideas and concepts (including one's own identity) are not given (defined completely and in advance), but are social and cultural constructs, that is, contingent on other ideas, people, contexts, representational systems, etc. General characteristics

of postmodernism include an attention/commitment to multicultural-ism; attention to the particular (not universalism); a focus on simulacra; engagements with how identity is constituted through language; and demonstating that meaning is not fixed, but is indeterminate, in flux. These lines of thought are inherently political because if things are not simply given (there is not simply a way things are), then change is possi-ble. The links between representation and knowledge are directly related to power and ideology. Thus representation and power are mutually dependent, which problematizes any notion like "art for art's sake" or a belief in the autonomy of an artwork.

A key text in defining postmodernism is Jean-Francois Lyotard's *The Postmodern Condition* (1984). He argues that postmodernity is the next, critical phase of Modernism; it critiques the claims of Modernism. Postmodernism challenges Modernist ideals of originality, progress, essence, and rationality. He posits the disintegration of "metanarra-tives" (grand, rationales about the human condition improving, even perfecting itself, through progress, science, technology, history (destiny), etc.). These "metanarratives," which defined Modernism, he argues, are replaced not by unifying ideas, but rather by a complex of "little stories" or minor points of view that never add up to the whole.

In contemporary art, postmodernism is also linked to an anti-aesthetic position, which argues for the substitution of originality and unique universal expression for the possibility of a political cri-tique. Much postmodern art poses a political critique by rejecting the ideals of beauty, uniqueness, etc. For photographic discourse, critical postmodernism shifted attention to photography's institutional spaces and away from formalist considerations. Philosophers, cultural critics, art historians, artists, etc., who took up this position, critiqued the formalist approach from a variety of theoretical vantage points, including Marxism, feminism, psychoanalysis, and semiotics. This "turn to theory" in the late 1970s and 1980s occurred, in art in particular, because of the discourse around Conceptual art. With Conceptual art the general theoretical ques-tion about the nature of art ("what is it?," etc.) emerged: art became self-reflexive; concepts (especially language) became the starting point of art, not formal concerns, experiments, etc. However, if the question is about the nature of art then what fuels the discussion is not limited to art anymore: linguistics, gender studies, critical theory are necessary to understand this open-ended investigation of how images make meaning.

Realism A phase of nineteenth-century art and literature. Rejecting the metaphysical, spiritual, and highly subjective tendencies of Romanticism, leading mid-century European artists such as Gustave Courbet concentrated on producing what was immediately accessible to them, in terms of both social and sensory experience. They emphasized detailed, accurate, sober representation, in part as a response to the new invention of photography (1839). However, Realism is not simply

naturalism; rather, it was a set of aesthetic strategies and signifiers that were used to create (not mimic or reproduce) images. Hence attention to low, humble, commonplace subjects and images from popular culture was a way of going against conventional, academic (official realism) art: there is a cultural and political aspect to Realism that is grounded in French politics from 1848–74, especially the Second Republic (1848–51) and its end with the reign of the emperor Louis-Napoleon (Second Empire 1852–70).

Riis, Jacob (1849–1914) A Danish immigrant to the USA, Riis became a journalist in New York City and began to write about the appalling conditions of the Lower East Side, a densely populated area, in an attempt to alter housing conditions and improve the conditions of recent immigrants and the poor in the city. He then began to use photography as a means of social reform. His famous book *How the Other Half Lives* (1892), includes fifteen photographs. He gave magic-lantern lectures to the middle-class to expose them to the realities of urban life. Questions remain about how to think about Riis's relation to his subjects. Nonetheless, he believed individuals were formed by their environment. Thus crowded and unsanitary conditions were more accurate variables in the rate of crime and moral decay in the city than were the deductions based in physiognomy.

Romanticism In the visual arts, as in literature and music, Romanticism can be defined as a revolt against the formality, containment, and intellectual discipline of Neoclassicism. It was a dominant, although loosely defined phenomenon in Western art from 1798–1846. It expressed a commitment to feeling and the individual's right to self-expression (imagination, psychological states, emotions). In a narrow sense, Romanticism ended with the arrival of Realism in 1846, but in a broader one it is still with us, since it was the insistence on the rights of the imagination that led eventually to modern art. The key characteristics of Romanticism are: emphasis on self-expression and self-revelation (insistence on the authentic voice of the individual artist—*the artist's vision*—which is meant to lead to direct, truthful experience free from academic training and all aesthetic, economic, and cultural restraints); the artist as rebel, marginalized and suffering; a new mythology of the artist (individual against society) that foregrounded disillusionment with the contemporary world expressed through nostalgia and irony as well as fascination with the exotic and the irrational; in visual art, there is an emphasis on color rather than line (drawing, as in Neoclassicism) because color is thought to appeal to our emotions and senses directly (a painting should grow organically from the artist's mind and brush rather than from the careful imitation of other art).

Salgado, Sebastião (b. 1944) One of the foremost documentary photographers working today. The Brazilian-born Salgado undertakes extensive photographic projects that last for years at a time. He established his own photography agency (Amazonas Images) that allows him the freedom to

coordinate these projects, which often involve famine, displaced popula-
tions due to war or drought, and working conditions (industry, guest
workers, etc.) throughout the world. In the 1970s and 1980s Salgado
began working on these themes that have remained a constant in his
work. His 1986 book *Sahel: Man in Distress* focuses on an African geo-
graphical area that includes Ethiopia and Sudan, one hard hit by famine
and disaster. These images were commissioned by Magnum, and they
present us with an unflinching, shocking views of what occurred there.
Salgado's work fully entered the discourse of photographic theory and
history with his *Workers: An Archaeology of the Industrial Age* (1993). This
series includes images of the Serra Pelada goldmine in Brazil, ones on
which Susan Sontag, Jacques Rancière, and others have commented. His
latest book *Migrations: Humanity in Transition* (2000) captures the plight
of refugees across the globe in what Salgado calls "the reorganization of
the human family." Currently Salgado is working on an ecological pro-
ject entitled *Genesis* in which he is photographing untouched vestiges
of nature that chronicles the effects of modern life and industry on the
environment. But what he presents are not the direct effects of industrial
causes such as global warming; instead, he gives us natural areas, animals,
and peoples that have "escaped or recovered from" such transformations.
The eight-year project is now more than half completed.

Simulacrum/Simulacra A term from ancient philosophy, particularly
Plato, that defines a representation that is not necessarily tied to an object
in the world. As a copy without an original, a simulacrum is often used
in cultural criticism to describe the status of the image in our society of
spectacle: mass-media, consumerism, commodity consumption, leisure,
and images. Such images, even as they appear to be representations, dis-
solve the truth-claims of representation. Much postmodern photography
(Richard Price, James Welling, Cindy Sherman) plays on the concept of
the simulacrum. Key texts include Guy Debord's *Society of the Spectacle*
(1967) and Jean Baudrillard's *Simulacra and Simulation* (1981).

Smith, W. Eugene (1918–78) One of the greatest photojournalists
of the twentieth century. Smith worked for *Life, The New York Times,
Newsweek,* and was a member of Magnum Photos in the 1950s. Most
of his work was done with a 35 mm camera, including the work that
first brought him attention, the South Pacific during the Second World
War. Smith was injured there and remained in hospital for two years.
After the war, he made a series of iconic photo-essays for *Life* including
Country Doctor and *Spanish Village.* In the mid-1950s he won a pair of
Guggenheim fellowships that allowed him to undertake larger scale pro-
jects such as his massive multi-year photo-documentation of Pittsburgh,
PA. From 1971–3, Smith and his wife Aileen lived in Minamata, Japan,
where they documented the ill health effects on the local population that
resulted from mercury poisoning in the town's water supply. The Chisso
corporation was responsible for this industrial waste and went to lengths

to intimidate (Smith was physically attacked) them and stop the project. It did not work. Photographs such as *Tomoko Uemura in Her Bath* (Minamata, 1972) exposed the irreparable effects on human life caused by the industrial environmental disaster. See W. Eugene Smith and Aileen M. Smith, *Minamata* (1975).

Snapshot aesthetic An approach to photography that we see in Walker Evans's *Many Are Called* (1938), for example, but that really becomes a centerpiece of contemporary photographic practice with Robert Frank's *The Americans* (1958–9). For Frank, this approach required fast film, quick and spontaneous reactions to the world around him; the photographs have a casual, everyday feel. In fact, they *suggest* that anyone could have taken these images. This approach is continued by Lee Friedlander, William Eggleston, and others.

Spectacle A concept best defined by Guy Debord in his text *Society of the Spectacle* (1967). He used it to address a new stage of advanced capitalism in the postwar period in which consumption, leisure, and the image (simulacrum) become indissolubly linked and determinative of society and culture. Spectacle exposes new forms of power (media, etc.), but also new possibilities for artistic strategies of subversion.

Stereograph Invented by David Brewster in 1849. It was chief among low-priced photography of the late nineteenth century; stereograph images were often representations of exotic places and urban scenes. They were both educational and entertaining, and extremely popular. Resulted in a desire to collect "stereos." A stereograph is a set of two nearly identical photographs, one each for the right and left eye, mounted on thick card stock. To view one required a special viewer called a stereoscope, which replicates human binocular vision (the brain combines the slightly different images produced by each eye); therefore, two images merge into one creating an illusion of spatial depth (three-dimensionality) and crisp detail.

Stieglitz, Alfred (1864–1946) A key figure in the history of modernism. Through his own photography and his work as an editor and gallerist, Steiglitz played a crucial role in presenting photography as a modern medium as well as in introducing American audiences to European modern art. Upon returning from Germany in 1890, Stieglitz's photography still bore the undeniable traces of Pictorialism. However, as part of the Camera Club of New York, he began to argue that photography is as expressive as traditional artistic media such as painting and sculpture. As editor of the club's journal, *Camera Work*, Stieglitz was able to interact with other photographers who shared his ideas, notably Edward Steichen. In 1902, Steiglitz and others seceded from the club, forming the Photo-Secession. Through "The Little Galleries of the Photo-Secession," commonly known as the 291 Gallery, Stieglitz began to present photographic work that abandoned the painterly artifice of Pictorialism for "straight photography." This shift is discernible in his own photography as well; for example, see his *The Steerage* (1907). Stieglitz was intent on

using photography to express himself as an artist, which included trying to reconcile a spiritual aspect with a mechanical apparatus (the camera). This is evident in his *Equivalents*, a series of photographs of the sky over Lake George, NY from the 1920s, and even in one of his last photographs, *From the Shelton. Looking West* (c. 1935).

Structuralism An approach to the study and analysis of culture and meaning that was dominate in the 1950s and 1960s. It originates in the linguistic theory of Ferdinand de Saussure (see his *Course on General Linguistics* (1916)), who sought the underlying, universal structure of language as a constructed system of rules. Saussure's key idea is that relation of the signifier to the signified is arbitrary. Thus, the connection between the linguistic signifier d/o/g and the signified concept "dog" is entirely arbitrary. The word "dog" has no attributes of a living, breathing mammal (a "real" dog); instead, it is the result of an agreed upon convention. Every language has a different signifier for this same concept or idea of "dog." However, Saussure's idea of arbitrary signifier applies less to speech (*parole*, social conventions, communication, individual utterances, etc.) than to language as such (*langue*), language as a functional system, one that pre-exists us as individual subjects. Semiology, for Saussure, was the science of signs, with an emphasis on *science* (meaning order, reason, objectivity, systematicity). Structrualists of the 1950s and 1960s such as Claude Levi-Strauss (anthropology), Roland Barthes, and Jacques Lacan (psychoanalysis) took semiology from linguistics and applied it to all manner of social and cultural sign-systems. They conceived of the world as a series of interlocking binary sign-systems to which human beings respond in predictable ways. All phenomena are treated as if they were linguistic phenomena. For instance, Lacan's famous dictum that "the unconscious is structured like a language." The ultimate wager of structuralism is that under the surface of all sign-systems there is a "deep structure," which dictates how the surface-effects (daily use, contingent meanings, etc.) of such systems operate. In many ways, the work of Karl Marx, which predicated everything (social relations, history) on an underlying economic structure, anticipates Structuralist thought.

Structuralism also helped promote the notion of the "death of man" (or the subject) thesis. The idea being that our traditional notion of "modern man" as the center of cultural processes, as being capable of creating and controlling, and exerting domination over its environment through reason, is a fiction. It is a fiction, a wish, because in very real ways, structuralist thinkers argue, we are controlled by the structure of these systems. Hence language speaks through us rather than it being a mere instrument for our use. We become a subject through a language-system that pre-exists us. Structuralism forces a reconsideration of an entire cultural tradition based on a commitment to individual self-realization and self-expression (whether in artistic or economic domains).

The shortcomings and aporias of structuralism were exposed by post-structuralism, which begins to take hold with Michel Foucault's *The Order of Things* (1966) and *The Archaeology of Knowledge* (1969), and the work of Jacques Derrida, particularly his *Of Grammatology* and *Writing and Difference* (both 1967). Structuralism claimed to be able to explain anything and everything about human affairs and the world around us because everything became a sign-system, nothing could escape. However, as Foucault, Derrida, and others begin to demonstrate, there is always a remainder that escapes or has no fixed place within the structure. Moreover, to a new generation of thinkers, formed against a backdrop of the socio-political events of the late 1960s, structuralism seemed too orderly, neat, and authoritarian even. The factor of difference and excess (surplus) within any system became the focus instead of the smooth functioning of the system of meaning. As Derrida argues in *Writing and Difference*, "it is always something like an *opening* which will frustrate the structuralist project. What I can never understand, in a structure, is that by means of which it is not closed." Post-structuralism set out to undermine this concept of a closed system.

Of course, post-structuralist positions have in turn been critiqued as well. Critiques by Jürgen Habermas and Frederic Jameson stress the lack of political agency that may be enfolded within the post-structuralist project. Further, post-colonial and gender theory have critiqued and inflected post-structuralist concepts to allow for more collective political agency.

Surrealism A twentieth-century European avant-garde group initially based in Paris. The group was introduced by the "First Manifesto of Surrealism," which was written by the group's leader André Breton in October 1924. The group sought to attain an "absolute reality" in which contradictions or opposites cease to be so, that is, they desired a synthesis of opposites (dream and reality, fantastic and the mundane, unconscious and conscious) into a *surreality*. The group thought this state was obtainable through techniques such as trances, automatic writing, collective activities, and an attention on outmoded commodities and spaces. Photography was of interest to them, particularly the characteristics of objective chance (shock), doubling, and the index.

Tableau photographs The "tableau form" refers to contemporary photographic projects that share a large scale, a use of color, a "directorial mode" (photographer as director of near-cinematographic scenes), and a relation to the viewer (an immersive experience often heightened by backlighting these Cibachrome prints). This term is used to characterize work by Jeff Wall, Luc Delahaye, Andreas Gursky, Jean-Marc Bustamente, Gregory Crewdson, and others. Photographers shifted to the tableau form in the 1970s. It was first identified and addressed in Jean-François Chevrier's "The Adventures of the Picture Form in the History of Photography" (1989). As Bustamante has said, "I wanted not to make photographs that would be art, but art that would be photography. I refused the small format and the craft aspect of black and white. I wanted to move into color,

in a format for the wall, in order to give photography the dimensions of a tableau, to transform it into a object." For many, the tableau form reasserts aesthetics into the discourse of contemporary photography.

Talbot, William Henry Fox (1800–77) Produced the first negative–positive photographic process that allowed for multiple copies from a single negative. After experimenting and growing dissatisfied with a camera obscura, he began to make photogenic drawings in 1834. In 1840, as a response to Daguerre, he produced a calotype: the first truly negative–positive photographic process, one which remains the basis of all pre-digital photographic processes. It lacked the detail of a daguerreotype, but its greatest asset was multiple prints. The first one was *Latticed Window at Lacock Abbey* (1835), which required two hours of exposure time. His photogenic drawing was done with a silver nitrate and salt solution applied to light-sensitive paper. Objects (leaves, lace, etc.) were then placed directly on it and exposed to sunlight, producing a reverse image. His book *The Pencil of Nature* was published in 1844.

Wall, Jeff (b. 1961) One of the most acclaimed and influential artists of his generation. The Vancouver-based photographer initially studied art history, grounding much of his photographic practice in the discipline. Wall frequently refers to Charles Baudelaire's phrase "the painting of modern life" in discussions of his own. His first major work was *The Destroyed Room* (1978), a work that exhibits many of the characteristics that have become synonymous with Wall: a staged hyperrealism, tableau format (photographic transparencies mounted in an aluminum light box), large print size (on average his prints measure 6×8 ft), and the use of analogue and digital processes (Wall scans his film and then creates a digital montage of it). He called *The Destroyed Room* "cinematographic," and it certainly has the qualities of the directorial mode. The hyperrealism in Wall's work steps beyond the limitations of the snapshot aesthetic that dominated art photography in the 1950s to 1970s. As such Wall's practice, which includes his own scholarship on Conceptual art and photography, instigated a return to aesthetics in the discourse of photography. See, for example, *A Sudden Gust of Wind (after Hokusai)* (1993). In 2007, Wall was given a solo retrospective at the Museum of Modern Art.

Weston, Edward (1886–1958) Weston's name is synonymous with high modernist photography. His early work was marked by Pictorialism, but by 1922 he made a photograph of the smokestacks of the Armco Steel works in Ohio that shows an affinity for straight photography, particularly as it was being developed in Europe with New Objectivity. Weston's life and career connect Alfred Steiglitz, Paul Strand, Tina Modotti, Ansel Adams, and others. He participated in the famous New Objectivity-dominated *Film und Foto* exhibition in Stuttgart in 1929. Weston's images are renowned for their detail and clarity as well as their bold planar structure. Weston used a 8×10 camera on a tripod and contact-printed his negatives, without cropping his final prints, so as to

enact a creative process that involved his "vision" as an artist (what he called "pre-visualization"). All of his iconic photographs, from *Excusado* (a photograph of the lower half of his toilet bowl from 1925), to his many nudes, reveal a strong desire to extract formal beauty from the world. Weston was the first photographer to win a Guggenheim Memorial Foundation Fellowship in 1937. He also played a central role in the formation and aesthetics of the F.64 group in 1932.

Winogrand, Garry (1928–84) A major postwar American photographer. His interest in photography began at Columbia University and in his studies in photojournalism with Alexey Brodovitch at The New School for Social Research in 1951. A pivotal moment for Winogrand was seeing Walker Evans's book *American Photographs* (1938). In addition, like several photographers of his generation, Winogrand was also inspired by Robert Frank's *The Americans* (1959). Winogrand gives us odd, idiosyncratic, slightly unnerving photographs such as *New York City* (before 1976) with a mother and two children blankly staring at a lit trashcan. Works like this have been included in some of the most significant photography exhibitions, including *Toward a Social Landscape* (1966) and *New Documents* (1967, curated by John Szarkowski), which included Lee Friedlander and Diane Arbus. Whether in photographs taken in the El Morocco nightclub in 1955 or on the Santa Monica Pier in 1982–3, Winogrand's photographs are amusing and disconcerting at once. He claimed that he never had a preconceived image in mind before he shot, unlike Edward Weston and others; instead, he framed the photograph for content not pictorial quality. Winogrand's work is part of the "snapshot aesthetic." He shot with a 35 mm Leica, often with a wide-angle lens. His photography books *The Animals* (1969) and *Women Are Beautiful* (1975) are indicative of his practice as a whole. "Photography is not about the thing photographed," he said, "it is about how that thing looks photographed."

Notes

Introduction

1 Siegfried Kracauer, "Photography," *Classic Essays on Photography*, ed. Alan Trachtenberg, New Haven: Leete's Island Books, 1980, p. 254. This selection is from the first chapter of Kracauer's 1960 book *Theory of Film: The Redemption of Physical Reality*, Princeton: Princeton University Press, 1997.

2 Diarmuid Costello and Jonathan Vickery, *Art: Key Contemporary Thinkers*, Oxford: Berg, 2007, p. ix.

3 Wells, "General Introduction," *The Photography Reader*, London and New York: Routledge, 2003, p. 3.

4 Viktor Shklovsky cited in Manfredo Tafuri, *The Sphere and the Labyrinth: Avant-Gardes and Architecture from Piranesi to the 1970s*, trans. Pellegrino d'Acierno and Robert Connolly, Cambridge, MA: MIT Press, 1987, p. 16. See Shklovsky, *Knight's Move*, trans. Richard Sheldon, Champaign, IL and London: Dalkey Archive Press, 2005. As Shklovsky states, "the knight is not free; it moves sideways because the direct road is closed to it beforehand."

5 As Robin Kelsey and Blake Stimson explain, the "*October* moment" "transformed the humanities and social sciences generally" through a "broad-based intellectual paradigm shift" that is unimaginable without the insights offered by critical theory. See *The Meaning of Photography*, Williamstown, MA: Sterling and Francine Clark Art Institute and New Haven: Yale University Press, 2008, p. ix. Photography is key to this "paradigm shift." See "Photography: A Special Issue," *October*, vol. 5, Summer 1978, which includes essays by Rosalind Krauss, Craig Owens, Douglas Crimp, Theirry de Duve, and others.

6 Sekula, "The Traffic in Photographs," *Art Journal*, vol. 41, no. 1, Spring 1981, p. 23.

7 Batchen, *Burning with Desire: The Conception of Photography*, Cambridge, MA: MIT Press, 1997, p. xiii.

8 He adds: "On one side are those who believe that photography has no singular identity because all identity is dependent on context. On the other are those who identify photography by defining and isolating its most essential attributes, whatever they may be. One group sees photography as an entirely cultural phenomenon. The other speaks in terms of photography's inherent nature as a medium. One approach regards photography as having no history of its own; the other happily provides an historical outline within which all photographs are thought to have a place determined in advance. One stresses mutability and contingency; the other points to eternal values. One is primarily interested in social practice and politics, the other in art and aesthetics," p. 20.

9 He states that he desired "to rewrite the traditional history of photography's origins" via "a mode of historical criticism informed by Michel Foucault's genealogy and Jacques Derrida's deconstruction" in order "to show that history inhabits the present

in very real ways; that the practice of history is always an exercise of power; that history *matters* (in all senses of this word)," p. viii. To do so he constructs a genealogy of "proto-photographers" who all shared in the conception of photography as a concept because "the medium's earliest proponents offer a far more equivocal articulation that incorporates but declines to rest at either pole [that is, postmodern or formalist positions that have split contemporary discourse on photography]," p. x.

10 Batchen, *Burning with Desire*, pp. 20–1.
11 Ibid., p. 176.
12 Ibid., p. 202.
13 This is precisely what we are seeing in the work done by Georges Didi-Huberman, Jacques Rancière, and many others. Even the theorists themselves (Jacques Derrida, Jean-Luc Nancy) have given us texts that challenge earlier ones, thereby instigating a rethinking of photography. For example, see Derrida's *Copy, Archive, Signature: A Conversation on Photography*, ed. Gerhard Richter, trans. Jeff Fort, Stanford: Stanford University Press, 2010; and Louis Kaplan's "Photograph/Death Mask: Jean-Luc Nancy's Recasting of the Photographic Image," *Regarding Jean-Luc Nancy*, special issue of *Journal of Visual Culture*, vol. 9, no. 1, April 2010.
14 My work is part of the return to aesthetics that began in the 1990s. I have been particularly inspired by recent work that addresses aesthetics in the fullest form, especially as it relates to an ethics of history, subjectivity, and memory. See, in particular, *The Life and Death of Images*, eds Diarmuid Costello and Dominic Willsdon, Ithaca: Cornell University Press, 2008; and Michael Kelly, *Iconoclasm in Aesthetics*, Cambridge: Cambridge University Press, 2003.
15 Alain Badiou, "Gilles Deleuze (1925–1995)," *Pocket Pantheon: Figures of Postwar Philosophy*, trans. David Macey, London and New York: Verso, 2009, p. 116.
16 *Photography Theory*, ed. James Elkins, London and New York: Routledge, 2007, p. 199.
17 Georges Didi-Huberman, *Confronting Images: Questioning the Ends of a Certain History of Art*, trans. John Goodman, University Park, Penn.: The Pennsylvania State University Press, 2005, p. 194.
18 See "Intellectuals and Power: A Conversation Between Michel Foucault and Gilles Deleuze" in Foucault, *Language, Counter-Memory, Practice: Selected Essays and Interviews*, ed. Donald F. Bouchard, Ithaca: Cornell University Press, 1977, p. 206.
19 Within this historical relation an image-event (each photograph) is not simply an effect of discourse; rather, it reveals the transformative capability of the relation itself.
20 Op cit., p. 208.
21 Daniel W. Smith, "Introduction" to Gilles Deleuze, *Essays Critical and Clinical*, trans. Daniel W. Smith and Michael A. Greco, Minneapolis: University of Minnesota Press, 1997, p. xxviii.
22 Deleuze, *The Logic of Sense*, trans. Constantine Boundas, New York: Columbia University Press, 1990, p. 60.
23 Barthes, *Camera Lucida: Reflections on Photography*, trans. Richard Howard, New York: Hill and Wang, 1981, p. 66.
24 Kelsey and Stimson, *The Meaning of Photography*, p. xiv.
25 Joel Snyder and Neil Walsh Allen, "Photography, Vision, and Representation," *Critical Inquiry*, vol. 2, no. 1, Autumn 1975, p. 149.
26 Ibid.
27 Ibid., p. 151.
28 Ibid., p. 152.
29 Ibid.
30 Benjamin, "Little History of Photography," *Selected Writings Volume 2, 1927–1934*, eds Michael W. Jennings, Howard Eiland, and Gary Smith, Cambridge, MA: The Belknap Press of Harvard University Press, 1999, p. 510.

31 There are many sources to cite, but a touchstone remains T. J. Clark's *The Painting of Modern Life: Paris in the Art of Manet and His Followers*, Princeton, NJ: Princeton University Press, 1999.

32 These quotations on spectacle are from Guy Debord's *Society of the Spectacle*, Detroit: Black & Red, 1983, unpaginated. See sections 215, 158, and 193.

33 Benjamin, "Experience and Poverty," *Selected Writings Volume 2. 1927–1934*, p. 734.

34 "Politics and Aesthetics: An Interview with Peter Hallward and Jacques Rancière," *Angelaki: Journal of the Theoretical Humanities*, vol. 8, no. 2, August 2003, p. 206.

35 There are many readings and contending interpretations of Kant's *Critique of Judgment* (1790), one of the founding texts of aesthetics. I always begin with Paul de Man's reading wherein he argues that, contrary to common understanding, aesthetic judgments are *not* "free from cognitive and ethical consequences" (thus people too broadly interpret Kant's concept of "disinterest"); that aesthetics for Kant are "epistemological as well as political through and through"; and that the treatment of the aesthetic in Kant is far from conclusive, even Kant himself knew he had more to do on the subject. Following de Man's lead, aesthetics is epistemological and political/ ethical; it is never merely about beauty or taste. See his essay "Hegel on the Sublime," *Aesthetic Ideology*, ed. Andrzej Warminski, Minneapolis: University of Minnesota Press, 1996. See also Diarmuid Costello, "Greenberg's Kant and the Fate of Aesthetics in Contemporary Art Theory," *The Journal of Aesthetics and Art Criticism*, vol. 65, no. 2, Spring 2007, pp. 217–28.

36 Doane, "Indexicality and the Concept of Medium Specificity," *The Meaning of Photography*, p. 4.

37 This includes aesthetics as it is commonly done in the analytic (as opposed to the continental) tradition, wherein the labor is to arrive at an *a priori* definition of art and then attempt to understand all artworks as instances or examples of that ontological definition.

38 See Arthur Danto's *The Abuse of Beauty: Aesthetics and the Concept of Art*, Chicago and La Salle, IL: Open Court, 2003.

39 "Postmodernism: A Preface," *The Anti-Aesthetic: Essays on Postmodern Culture*, ed. Hal Foster, New York: The New Press, 1983, p. xv.

40 Kelsey and Stimson, *The Meaning of Photography*, p. xxii.

41 See Deleuze, *Foucault*, trans. Seán Hand, Minneapolis: University of Minnesota Press, 1988, p. 69. I have also addressed these issues in a review of John Tagg's *The Disciplinary Frame: Photographic Truths and the Capture of Meaning* in *Journal of Visual Culture*, vol. 9, issue 2, 2010, pp. 1–7.

42 Deleuze and Félix Guattari, *What Is Philosophy?*, trans. Hugh Tomlinson and Graham Burchell, New York: Columbia University Press, 1994, pp. 59, 50–1.

43 Deleuze, *Cinema II: The Time Image*, trans. Hugh Tomlinson and Robert Galeta, Minneapolis: University of Minnesota Press, 2001, p. 97.

44 Kelly, *Iconoclasm in Aesthetics*, p. 204. I would also like to thank Michael for many conversations about aesthetics and art history, I know the traces of those conversations are present within these pages.

1 The thing itself

1 The epigraphs are from Weston's *Daybooks*, see *Photography in Print: Writings from 1816 to the Present*, ed. Vicki Goldberg, Albuquerque: University of New Mexico Press, 1981, p. 311. Derrida, *Speech and Phenomena and Other Essays on Husserl's Theory of Signs*, trans. David Allison, Evanston: Northwestern University Press, 1973, p. 104.

2 See the edition of Talbot's *The Pencil of Nature* with an introduction by Beaumont Newhall published in 1969, which replicates its original publication format. All reproduced parts from the original are unpaginated in this 1969 version. Talbot's book was originally published in June 1844 by Longman, Brown, Green & Longmans (London) in six paper-covered installments from June 1844 to April 1846.

3 Baudelaire, "The Modern Public and Photography," *Classic Essays on Photography*, ed. Alan Trachtenberg, New Haven: Leete's Island Books, 1980, pp. 86–7. Baudelaire is writing a bit too late to intervene fully as by the mid-1860s photography in various forms fully entered popular visual culture. On the importance of this period for modernism as a whole, see Walter Benjamin, "Paris, Capital of the Nineteenth Century" (1939) in *The Arcades Project*, trans. Howard Eiland and Kevin McLaughlin, Cambridge, MA: The Belknap Press of Harvard University Press, 1999, pp. 14–26.

4 Baudelaire, "The Modern Public and Photography," p. 88.

5 Ibid.

6 See Jürgen Habermas, "Modernity – An Incomplete Project," *The Anti-Aesthetic: Essays on Postmodern Culture*, ed. Hal Foster, New York: The New Press, 1983, pp. 3–15.

7 David Llewellyn Phillips, "Photography, Modernity, and Art," *Nineteenth-Century Art: A Critical History*, ed. Stephen Eisenman, London: Thames & Hudson, 2007, p. 292.

8 See Erwin Panofsky, *Perspective as Symbolic Form*, trans. Christopher S. Wood, New York: Zone Books, 1993.

9 Sontag, *On Photography*, New York: Picador, 1977, pp. 129, 86.

10 Ibid., pp. 86, 110.

11 Her position here is dependent on Benjamin's conclusion in "The Author as Producer" (1934) and "A Little History of Photography" (1931), wherein he writes that there has been a shift from "photography as a form of art" to "art as a form of photography." This conclusion is central to Sontag's entire argument and although she was very familiar with Benjamin's work (see her *Under the Sign of Saturn*), she never explicitly cites this essay and its conclusion in *On Photography*. Both Benjamin essays are in *Walter Benjamin: Selected Writings Volume 2, 1927–1934*, eds Michael W. Jennings, Howard Eiland, and Gary Smith, Cambridge, MA: The Belknap Press of Harvard University Press, 1999, pp. 768–82 and 507–30. It is important to note that an English translation of Benjamin's original German-language essay appeared in *Artforum* in February 1977 as "Short History of Photography."

12 Sontag, *On Photography*, pp. 147–8.

13 Ibid., p. 148.

14 Ibid.

15 Douglas Nickel, "History of Photography: The State of Research," *Art Bulletin*, vol. LXXXIII, no. 3, September 2001 p. 553.

16 This description is given by Joel Snyder in *Photography Theory*, ed. James Elkins, London and New York: Routledge, 2007, p. 187.

17 Ibid.

18 For example, John Werge, *The Evolution of Photography* (1890). Early histories such as W. Jerome Harrison, *A History of Photography* (1888), and R. Colson, *Mémoires Originaux des Créateurs de la Photographie* (1898) are discussed in Josef Maria Eder's *History of Photography* (1905 edition), trans. Edward Epstean, New York: Dover Publications, 1978. The Dover edition is an unabridged and unaltered version of the first English publication in 1945 by Columbia University Press. In his "Preface to the Third Edition" (1905), Eder concludes: "Although I believe my *Geschichte der Photographie* [*History of Photography*] to be the most complete work of its kind thus far attempted, I realize that it cannot be entirely exhaustive, since the space allotted to me does not suffice for a broader treatment. The pursuit of too-minute detail, however, would doubtless have affected my plan of presenting a general view…in the treatment of the whole subject," p. viii. His book is 860 pages long! An example of a history of an individual photographer would be Heinrich Schwarz, *David Octavius Hill – Master of Photography*, trans. Helen E. Fraenkel, New York: Viking, 1931.

19 See Peter Galassi, *Before Photography: Painting and the Invention of Photography*, New York: The Museum of Modern Art, 1981.

20 The exhibition and catalogue were, however, more overdetermined, much less traditionally art historical, than the later editions of the book. The exhibition and

catalogue represent the first institutional survey of photographic history to take place within the confines of an art museum. As Nickel explains, the exhibition closely followed the schema of the *Film und Foto* exhibition at the Deutsches Werkbund in Stuttgart in 1929, a primary moment in the history of modern photography in that it exemplified Bauhaus thinking by not privileging so-called art photography over technical and scientific photography.

21 Nickel, "History of Photography: The State of Research," p. 552. Formalists, such as Newhall, never adequately address "why this particular ability came to be privileged or why the 'poetic' idea of photography emerged in the early nineteenth century…It was instead, so it seems, the inevitable product of an artistic sensibility whose own origins lie in the fifteenth century. In other words, photography's identity is founded in history (or, at least, in art history)," as Geoffrey Batchen writes. See his *Burning with Desire: The Conception of Photography*, Cambridge, MA: MIT Press, 1999, p. 19. Yet, the outcome of constructing this relation between painting (Renaissance perspective and eighteenth-century landscape painting) and photography is both "the formal isolation and cultural legitimation" that the museum, notably MoMA abets. "Thus endowed with a privileged origin—in painting—and a inherent nature that is modernist *avant la lettre*, photography is removed to its own aesthetic realm…[but] this version of history is, in truth, a flight from history, from history's reversals, repudiations, and multiple determinations," as Christopher Phillips rightly concludes. Phillips's essay "The Judgment Seat of Photography" is the most insightful reference on photography and MoMA. Originally published in *October* (1982) but is included in Richard Bolton's edited anthology *The Contest of Meaning: Critical Histories of Photography*, Cambridge, MA: MIT Press, 1989. I will discuss Bolton's text in some detail below.

22 Sontag, *On Photography*, p. 136.

23 On the problematics of this relationship see a fine postmodern, feminist reading by Roberta McGrath, "Re-Reading Edward Weston: Feminism, Photography and Psychoanalysis," *The Photography Reader*, ed. Liz Wells, London and New York: Routledge, 2003, pp. 327–37.

24 Nickel, "History of Photography: The State of Research," p. 552.

25 In "The Judgment Seat of Photography," Phillips asserts that Szarkowski was no "acolyte" of Newhall or Steichen, who "personally chose him as a successor." Rather, Szarkowski "trained as an art historian, held no affection for Steichen's casting of photography in the role of social instrument and 'universal language'. Instead, he represented an aestheticizing reaction against Steichen's identification of photography with mass media…What [he] sought, rather than a repetition of Newhall's attempt to cordon off a 'high' art photography more or less independent of the medium's everyday uses, was the theoretical salvaging of photography in its entirety from the encroachments of mass culture…he set about reconstructing a resolutely modernist aesthetic for photography and remapping a 'main tradition'," pp. 34–5.

26 Szarkowski quoted in Maren Strange, "Photography and the Institution: Szarkowski at the Modern," *Photography: Current Perspectives*, ed. Jerome Liebling, Rochester, NY: Light Impressions, Corp, 1978, p. 72.

27 Szarkowski, *The Photographer's Eye*, New York: The Museum of Modern Art, 2007, unpaginated.

28 Batchen, *Burning with Desire*, p. 176.

29 In the acknowledgments for *The Photographer's Eye* Szarkowski is very clear about his—and the field's as a whole—debt to Newhall: "Finally, any attempt to consider photography critically must acknowledge its basic debt to the fundamental work of Beaumont Newhall, whose scholarship and judgment are so fine that they serve equally well critical approaches very different from his own."

30 For painting, Greenberg identified three aspects of the "fate" of the medium: flatness, addressing the material support of the painting (two-dimensional flat canvas stretched over a wooden frame), and purity of color. Photography is hard to understand in these

terms and Greenberg seldom addressed photography directly; see his essay "Four Photographers" (1964) in *The Collected Essays and Criticism, Vol. 4, Modernism with a Vengeance 1957–1969*, ed. John O'Brian, Chicago: University of Chicago Press, 1995. Here he discusses work by Atget, Evans, and others, as "masterpieces of photography" that "transcended documentary."

31 Batchen, *Burning with Desire*, p. 15. This agenda did not, however, necessitate a move toward abstraction, as it does in Greenberg's assessment of painting and sculpture. As Phillips writes, Szarkowski's concern with "locating photography's formal properties signaled no incipient move toward abstraction. The formal characteristics he acknowledges were all modes of photographic *description*: instead of stressing (as had Clement Greenberg in his formalist essays on painting) the necessary role of the material support in determining the essential nature of the medium, Szarkowski wished to reserve unexamined for photography that classical system of representation that depends on the assumed transparency of the picture surface," pp. 36–7.

32 Szarkowski in *The Photographer's Eye*, unpaginated. See also Batchen, *Burning with Desire*, pp. 14–15. For another critique of Szarkowski and formalism, see Jonathan Green, "Surrogate Reality," *American Photography: A Critical History 1945 to the Present*, New York: Harry N. Abrams, 1984.

33 Cited in Batchen, *Burning with Desire*, p. 14.

34 Szarkowski, *The Photographer's Eye*, "Introduction," unpaginated.

35 Ibid.

36 Ibid.

37 Ibid.

38 On the relation between Szarkowski and Winogrand, see Szarkowski's *Figments from the Real World*, New York: The Museum of Modern Art, 1988.

39 Cited in Crimp. "The Museum's Old, The Library's New Subject," *On the Museum's Ruins*, Cambridge, MA: MIT Press, 1993, pp. 71–2.

40 Op cit.

41 David Llewellyn Phillips, "Photography, Modernity, and Art," *Nineteenth-Century Art: A Critical History*, pp. 37, 38.

42 This point, directly referencing Szarkowski and the Museum of Modern Art, is made by Richard Bolton in the opening paragraph of his edited anthology *The Contest of Meaning: Critical Histories of Photography*: "We no longer need to argue for photography's acceptance as a form of art. Since its invention, enormous personal and institutional energy has been devoted to legitimizing the medium; in fact, during most of the key moments of modernist photography, the *production* of photography and the *promotion* of photography have been inseparable…Such enthusiastic promotion has borne much fruit, and photography is now a respected member of the museum and the marketplace."

43 Ibid., p. x.

44 However, much like the formalist positions they sought to bankrupt, many members of this group were also supported by influential academic institutions. See Amelia Jones's review of *Art Since 1900: Modernism, Antimodernism, Postmodernism* by Hal Foster, Rosalind Krauss, Yve-Alain Bois, and Benjamin Buchloh in *Art Bulletin*, vol. LXXXVIII, no. 2, June 2006.

45 Lyotard's text was first published in French in 1979, an English translation followed in 1984. See *The Postmodern Condition: A Report on Knowledge*, trans. Geoff Bennington and Brian Massumi, Minneapolis: University of Minnesota Press, 1984. His arguments spurred much debate within the humanities and social sciences. Gary Aylesworth astutely explicates one of Lyotard's key points about postmodernism in relation to representation (art and literature) as presented in "What is Postmodernism?," an essay found as an appendix to the English edition of *The Postmodern Condition*: "Lyotard addresses the importance of avant-garde art in terms of the aesthetic of the sublime. Modern art, he says, is emblematic of a sublime sensibility, that is, a sensibility that

there is something non-presentable demanding to be put into sensible form and yet overwhelms all attempts to do so. But where modern art presents the unpresentable as a missing content within a beautiful form, as in Marcel Proust, postmodern art, exemplified by James Joyce, puts forward the unpresentable by forgoing beautiful form itself, thus denying what Kant would call the consensus of taste. Furthermore, says Lyotard, a work can become modern only if it is first postmodern, for postmodernism is not modernism at its end but in its nascent state, that is, at the moment it attempts to present the unpresentable, and this state is constant," p. 79. The postmodern, then, is a continuation, repetition, and difference.

46 Bolton, *The Contest of Meaning*, p. xiii.
47 Batchen, *Burning with Desire*, p. 5.
48 The primary artistic practice for these critics is the "Pictures Generation," a name that refers to artists such as Robert Longo, Jack Goldstein, Sherrie Levine, as well as Cindy Sherman, Louise Lawler, Barbara Kruger, Richard Price, and others. *Pictures* was the title of a 1977 exhibition at Artists Space in New York City that included Longo, Goldstein, Levine, and Tony Brauntuch. The moniker was applied to artists who showed in this space in subsequent exhibitions. They all shared a fascination with images from popular, consumer culture; thus, they appropriated imagery from mass media and transformed them into their own work in various ways, notably as surfaces for the production and projection of desire and meaning, which Douglas Crimp called the picture's usurpation, rather than interpretation, of reality. See Douglas Eklund, *The Pictures Generation. 1974–1984*, New York: Metropolitan Museum of Art, 2009.
49 Bolton, *The Contest of Meaning*, p. xvii. For instance, Batchen describes his methodology in *Burning with Desire* as an attempt "to rewrite the traditional history of photography's origins" via "a mode of historical criticism informed by Michel Foucault's genealogy and Jacques Derrida's deconstruction" in order "to show that history inhabits the present in very real ways; that the practice of history is always an exercise of power; that history *matters* (in all senses of this word)," p. viii.
50 See James Bohman, "Critical Theory," *The Stanford Encyclopedia of Philosophy* and Jae Emerling, "Theodor W. Adorno," *Theory for Art History*.
51 Horkheimer, *Critical Theory: Selected Essays*, trans. Matthew J. O'Connell, New York: Seabury Press, 1982, p. 244.
52 Benjamin, *Selected Writings Volume 2*, p. 775.
53 Ibid.
54 Both of these refer to how artistic performance and language render the familiar and the commonplace strange or alien; they defamiliarize the world around us. For both Brecht and Schklovsky, this ability is one of the powers of artistic/poetic language as opposed to practical, communicative (everyday) language; it is a power that the modernist avant-garde tried to translate into political consciousness.
55 Moholy-Nagy, "Photography," *Photography in Print*, p. 347. "New vision" is a complex term. As Christopher Phillips notes, it "does not refer to any organized photographic movement. *The New Vision* was the title of the 1930 American translation of Moholy-Nagy's book *Von Material zu Architektur* (1929), which summarized his famous Bauhaus preliminary course. In the U.S. 'new vision' has come to designate the kind of experimental photography that he and other avant-garde photographers advocated," *Photography in the Modern Era: European Documents and Critical Writings*, 1913–1940, New York: The Metropolitan Museum of Art and Aperture, 1989, note 1, p. 348.
56 Moholy-Nagy, "From Pigment to Light," *Photography in Print*, pp. 347–8.
57 Renger-Patzsch, "Aims" (1927), *Photography in Print*, p. 105.
58 Benjamin, *Selected Writings Volume 2*, p. 775. See also William J. T. Mitchell's "Benjamin and the Political Economy of the Photograph" in *The Photography Reader*, pp. 53–8. This is an excerpt from Mitchell's well-known book on the relation between image and text *Iconology: Image. Text. Ideology*, Chicago: University of Chicago Press, 1986.

59 I will discuss Rosler's work in detail in the chapter "Documentary, or instants of truth." However, in relation to Rosler's work, if we take it as symptomatic of a form of critical postmodern photographic practice, it is interesting the distance between it and formal postmodern photography such as that of Friedlander and Winogrand, who both featured prominently in Szarkowski's exhibition *Mirrors and Windows* (1978), which advocated "an untroubled transparency that could be used for both descriptive and self-expressive ends" and celebrated the narrative poverty of photography. It is this latter curatorial and photography work that I believe Sontag has in mind when she comments that the "anti-intellectual declarations of photographers, commonplaces of modernist thinking in the arts, have prepared the way for the gradual tilt of serious photography toward a skeptical investigation of its own powers," *On Photography*, p. 117.

60 Bolton, *The Contest of Meaning*, p. xii.

61 See Adorno and Benjamin, *The Complete Correspondence 1928–1940*, ed. Henri Lonitz, trans. Nicholas Walker, Cambridge, MA: Harvard University Press, 2001. Also, note Giorgio Agamben's essay "The Prince and the Frog: The Question of Method in Adorno and Benjamin," *Infancy and History: Essays on the Destruction of Experience*, trans. Liz Heron, London and New York: Verso, 1993, pp. 108–24.

62 Mark Reinhardt, "Picturing Violence: Aesthetics and the Anxiety of Critique," *Beautiful Suffering: Photography and the Traffic in Pain*, Williamstown, MA: Williams College Museum of Art and Chicago: University of Chicago Press, 2007, p. 24. One would also note here Benjamin's admiration for Karl Blossfeldt's photographs of magnified parts of plants, and August Sander, both of whom are part of New Objectivity, which admittedly is difficult to define. See Benjamin, "Little History of Photography," pp. 512, 520. I discuss Sander further in the chapter "The archive as producer."

63 Bolton, *The Contest of Meaning*, p. viii.

64 Ibid., p. xi.

65 One remarkable example is Jonathan Crary's work in *Techniques of the Observer: On Vision and Modernity in the Nineteenth Century*, Cambridge, MA: MIT Press, 1990. Note his shift from examining modernity and photography to a wider discursive transformation of the "observer" in the nineteenth century: "The photograph becomes a central element not only in a new commodity economy but in the reshaping of an entire territory of which signs and images, each severed from a referent, circulate and proliferate…Photography is an element of a new and homogenous terrain of consumption and circulation in which an observer becomes lodged. *To understand the 'photography effect' in the nineteenth century one must see it as a crucial component of a new cultural economy of value and exchange, not as part of a continuous history of visual representation*…[However] crucial as photography may be to the fate of visuality in the nineteenth century and beyond, its invention is secondary to the event I intend to detail here. My contention is that a reorganization of the observer occurs in the nineteenth century before the appearance of photography," italics mine, pp. 13–14. Georges Didi-Huberman gives a reading with other possibilities in his *Invention of Hysteria: Charcot and the Photographic Iconography of the Salpêtrière*, trans. Alisa Hartz, Cambridge, MA: MIT Press, 2004.

66 Barthes, "The Photographic Message" (1961), *Image-Music-Text*, trans. Stephen Heath, New York: Hill and Wang, 1977, pp. 24, 31.

67 Ibid., p. 31.

68 Batchen, *Burning with Desire*, p. 5.

69 Interestingly, this is not Barthes's starting point, at all. See *Camera Lucida*.

70 The best explanations of this anti-aesthetic position and its blind spots are Michael Kelly, *Iconoclasm and Aesthetics*, Cambridge: Cambridge University Press, 2003, and Christophe Menke, *The Sovereignty of Art: Aesthetic Negativity in Adorno and Derrida*, trans. Neil Solomon, Cambridge, MA: MIT Press, 1999. Both the anti-aesthetic position and its critiques are engaged in contending interpretations of critical theorists such as Adorno, Benjamin, and others. This work is ongoing and the theorists in question continue to offer insights and new readings that are far from being exhausted.

71 Hal Foster, "Introduction," *The Anti-Aesthetic*, p. xv.

72 Benjamin's work on the dissolution of the artwork's aura in the age of technological reproducibility, for instance photography, has played a crucial role. As Batchen summarizes Benjamin's position in "The Work of Art" essay: Benjamin "argues that photography would hasten the demise of capitalism itself by inexorably transforming the aura of authenticity into a commodity form…In his dialectical tale of sacrifice and resurrection, aura would have to die at the hand of photography before any authentic social relations could be brought back to life," p. 210.

73 Foucault: "In the descriptions for which I have attempted to provide a theory, there can be no question of interpreting discourse with a view to writing a history of the referent…[W]hat we are concerned with here is not to neutralize discourse, to make it a sign of something else, and to pierce through its density in order to reach what remains silently anterior to it, but on the contrary to maintain it in its consistency, to make it emerge in its own complexity…To substitute for the enigmatic treasure of 'things' anterior to discourse, the regular formation of objects that emerge only in discourse," *The Archaeology of Knowledge*, trans. A. M. Sheridan Smith, New York: Pantheon Books, 1972, pp. 47–8.

74 Challenging the anti-aesthetic position along these lines is what Diarmuid Costello has been doing over the past few years in a series of invaluable works. See his "Greenberg's Kant and the Fate of Aesthetics in Contemporary Art Theory," *The Journal of Aesthetics and Art Criticism*, vol. 65, no. 2, Spring 2007, pp. 217–28, and the edited volume *The Life and Death of Images*. Costello is also producing a short volume *On Photography* to be published by Routledge in the next year.

75 Tagg, *The Disciplinary Frame: Photographic Truths and the Capture of Meaning*, Minneapolis: University of Minnesota Press, 2009, p. xxviii. See also my review in *Journal of Visual Culture*, vol. 9, no. 2, 2010, pp. 1–7.

76 Tagg, *The Disciplinary Frame*, p. xxix.

77 Ibid., p. xxx.

78 Ibid., p. 180.

79 Ibid., p. 245.

80 Ibid., p. 179–80.

81 Gilles Deleuze and Claire Parnet, *Dialogues II*, trans. Hugh Tomlinson and Barbara Habberjam, New York: Columbia University Press, 2002, pp. 9–10.

82 Deleuze, *Foucault*, trans. Seán Hand, Minneapolis: University of Minnesota Press, 1988, p. 61.

83 Ibid., p. 59.

84 Tagg, *The Disciplinary Frame*, p. 178.

85 Ibid., p. 176. See Michael Ann Holly, "The Melancholy Art" and the responses to it, *Art Bulletin*, vol. LXXXIX, no. 1, March 2007, pp. 7–44.

86 Deleuze, *Foucault*, p. 20.

87 Ibid., p. 87.

88 Ibid., p. 117.

89 Ibid., p. 44.

90 I would like to be clear that Batchen neither simply critiques formalism nor postmodernism individually; instead, he reads them together. As he writes, both postmodernists and formalists "presume to know what photography is (and what it isn't). Their argument is about the *location* of photography's identity, about its boundaries and limits, rather than about identity per se." He accepts that "the postmodern critique of formalism is convincing on virtually all levels (and this book therefore takes it as a given). But this still leaves an important question unanswered. By what exactly is photography 'engendered', if not by art (or, at least, by the Western picture-making tradition)? What is this thing we call photography?" See p. 17.

91 Batchen, *Burning with Desire*, pp. 20–1.

92 Derrida, *Of Grammatology*, trans. Gayatri Chakravorty Spivak, Baltimore: Johns Hopkins University Press, 1998, p. 48.

93 As Jacques Derrida argues in his groundbreaking *Of Grammatology* (1967), the logic of the supplement pierces "the mirage of the thing itself, of immediate presence, of originary perception," p. 157. Derrida's concept of "supplementarity" is defined by Batchen as "a desiring that comes neither before nor after this origin because it resides both inside and outside any delimitable moment in time," p. 118. In a later text, Derrida adds, "Neither life nor death, it is the haunting of the one by the other... Ghosts: the concept of the other in the same, the *punctum* in the studium, the dead other alive in me. This concept of the photograph *photographs* all conceptual oppositions, it traces a relationship of haunting which perhaps is constitutive of all logics," see "The Deaths of Roland Barthes" (1981) in *The Work of Mourning*, eds Pascale-Anne Brault and Michael Nass, Chicago: University of Chicago Press, 2001, pp. 41–2.

94 See Derrida, *Memoirs of the Blind: The Self-Portrait and Other Ruins*, trans. Pascale-Anne Brault and Michael Naas, Chicago: University of Chicago Press, 1993; Batchen, *Burning with Desire*, p. 119.

Gloss on Walter Benjamin

1 Benjamin, "Little History of Photography" (1931) in *Selected Writings Volume 2, 1927–1934*, eds Michael W. Jennings, Howard Eiland, and Gary Smith, Cambridge, MA: The Belknap Press of Harvard University press, 1999, pp. 507–530.

2 Louis Aragon, *Paris Peasant*, trans. Simon Watson Taylor, Boston: Exact Change, 1971, p. 14. Aragon's book was originally published in 1926.

3 Theodor Adorno and Walter Benjamin, *The Complete Correspondence 1928–1940*, p. 88.

4 Benjamin's writings on Surrealism center on this concept of "profane illumination," which he calls "a materialistic, anthropological inspiration." See "Surrealism: The Last Snapshot of the European Intelligentsia" (1929) and "Dream Kitsch" (1927) in *Selected Writings Volume 2, 1927–1934*. For an examination of how Surrealism influenced Benjamin's philosophy see Margaret Cohen's *Profane Illumination: Walter Benjamin and the Paris of Surrealist Revolution*, Berkeley and Los Angeles: University of California Press, 1993.

5 Benjamin, letter to Gershom Scholem dated January 20, 1930. See *The Correspondence of Walter Benjamin 1910–1940*, eds Gershom Scholem and Theodor W. Adorno, trans. Manfred R. Jacobson and Evelyn M. Jacobson, Chicago: University of Chicago Press, 1994, p. 359.

6 Agamben, *The Idea of Prose*, trans. Michael Sullivan and Sam Whitsitt, Albany: State University of New York Press, 1995, p. 64.

7 De Man, *Allegories of Reading: Figural Language in Rousseau, Nietzsche, Rilke, and Proust*, New Haven: Yale University Press, 1979. See also de Man's essay "Sign and Symbol in Hegel's *Aesthetics*," *Aesthetic Ideology*, ed. Andrzej Warminski, Minneapolis: University of Minnesota Press, 1996.

8 Owens, "The Allegorical Impulse: Toward a Theory of Postmodernism," *Art After Modernism: Rethinking Representation*, ed. Brian Wallis, New York: The New Museum of Contemporary Art, 1984, p. 203.

9 Ibid., p. 215.

10 Owens's concept of critical postmodernism is invaluable and quite unthinkable without deconstruction. He argues that postmodernism works to deny transcendent meaning and any hierarchy of speech (artistic or authorial) over writing/reading.

11 Ibid., p. 216.

12 Benjamin, *Selected Writings Volume 2*, p. 785.

13 Benjamin, *Selected Writings Volume 1, 1913–1926*, eds Marcus Bullock and Michael W. Jennings, Cambridge, MA: The Belknap Press of Harvard University Press, 1996, p. 341.

14 These issues are discussed by Benjamin in his essay "Goethe's Elective Affinities" (1924–5) and in the introduction to *The Origin of German Tragic Drama*, trans. John Osborne, London and New York: Verso, 1999. The expressionless is a central concept of Benjamin's early writings and it is intimately connected with his distinction between commentary and critique. Commentary seeks the material content (*Sachgehalt*) of a work of art; critique seeks the truth content (*Wahrheitsgehalt*). He writes that "the material content and the truth content, united at the beginning of a work's history, set themselves apart from each other in the course of its duration, because truth content always remains to the same extent hidden as the material content comes to the fore" (see *Selected Writings Volume 1*, p. 297). The truth content is the openness to language as such, that is, the full unadulterated creative force of *poiesis*, that must be crafted into a form, a material content. Material content or form is the semblance (*Schein*) of the truth content. The expressionless is what "arrests this semblance, spellbinds this movement." This truth-content is not something that can be represented or wielded as power or knowledge, rather it is an auto-exhibition of truth. He insists that the expressionless completes the work; it interrupts it, creating a caesura in its beautiful semblance so that "every expression simultaneously comes to a standstill, in order to give free reign to an expressionless power inside all artistic media." Therefore, it is something beyond the artist or poet that interrupts the language of artistic production.
15 Benjamin, *Selected Writings Volume 1*, p. 340.
16 Benjamin, *Selected Writings Volume 2*, p. 508.
17 Ibid., p. 510.
18 Ibid.
19 Benjamin, *The Arcades Project*, trans. Howard Eiland and Kevin McLaughlin, Cambridge, MA: The Belknap Press of Harvard University Press, 1999, p. 476.
20 Ibid., p. 474.
21 Benjamin, *Selected Writings Volume 2*, p. 510.
22 Ibid., p. 512.
23 For instance, although the same three essays by Benjamin have become well-worn, there has been little attention paid to Convolute Y on photography in *The Arcades Project*. The essential exception remains Eduardo Cadava's *Words of Light: Theses on the Photography of History*, Princeton: Princeton University Press, 1997.
24 Benjamin's concept of origin (*Ursprung*) is developed in the "Epistemo-Critical Prologue" of *The Origin of German Tragic Drama*. An "origin" is not something that occurs once and is then transcended; rather, it is what remains present and latent (but not as a result of its coming before) throughout each subsequent appearance or articulation. The "origin" of modernity is thus caught up in an ebb and flow, in a rhythmic motion of memory and oblivion, permanence and transience. Rejecting any attempt to simply return to an origin, Benjamin devises a critical praxis that empties the notion of a "return" of any linear, regressive denotation. What he forwards instead is a philosophical task: a reading of phenomena that divulges the immanence of origin and the ways in which it becomes legible through later, historically specific, appearances. See *The Origin of German Tragic Drama*, pp. 27–56.
25 Benjamin, "Theses on the Philosophy of History," *Illuminations: Essays and Reflections*, ed. Hannah Arendt, New York: Schocken Books, 1969, p. 254.
26 Ibid. The original German reads: "Die Vergangenheit führt einen heimlichen Index mit, durch den sie auf die Erlösung verwiesen wird" (see *Gesammelte Schriften*, eds Rolf Tiedemann and Hermann Schweppenhäuser, Frankfurt am Main: Suhrkamp, 1991, vol. I:2, p. 693). See also Rebeccca Comay, "Redeeming Revenge: Nietzsche, Benjamin, Heidegger, and the Politics of Memory," *Nietzsche as Postmodernist: Essays Pro and Contra*, ed. Clayton Koelb, Albany: State University of New York Press, 1990.
27 Scholem, "Walter Benjamin and His Angel," *On Walter Benjamin: Critical Essays and Recollections*, ed. Gary Smith, Cambridge, MA: MIT Press, 1991, p. 77.

28 Agamben, "The Face," *Means Without End: Notes on Politics*, trans. Vincenzo Binetti and Cesare Casarino, Minneapolis: University of Minnesota Press, 2000, p. 80.

29 See Agamben's *The Coming Community*, especially "Appendix: The Irreparable," trans. Michael Hardt, Minneapolis: University of Minnesota Press, 1993, pp. 89–106.

30 "Extimacy" is a concept created by the psychoanalyst Jacques Lacan in *The Seminar of Jacques Lacan Book VII: The Ethics of Psychoanalysis 1959–1960*, ed. Jacques-Alain Miller, trans. Dennis Porter, New York: W. W. Norton, 1992, p. 71. Here Lacan states that the other is "something strange to me, although it is at the heart of me." Hence the other is an intimate exterior, or "extimacy," of the subject; the subject is thus dislocated from within, ex-centric.

31 Italics mine. Italo Calvino, *Six Memos for the Next Millennium*, New York: Vintage, 1993, p. 76. This extraordinary statement by Calvino is from his posthumously published Charles Eliot Norton lectures at Harvard University. Unfortunately, he died before giving them.

2 Frame (matter and metaphor)

1 The epigraphs are from *The Photographer's Eye* and Sander, "Remarks On My Exhibition at the Cologne Art Union" (1927), *Photography in the Modern Era: European Documents and Critical Writings, 1913–1940*, ed. Christopher Phillips, New York: The Metropolitan Museum of Art and Aperture, 1989, p. 107.

2 John Szarkowski, *The Photographer's Eye*, New York: The Museum of Modern Art, 1966, p. 9. © The Museum of Modern Art, 1966, 1980, 2007.

3 For a comprehensive look at Friedlander's work see the catalogue that accompanied his 2005 retrospective at MoMA, Peter Galassi, *Lee Friedlander*, New York: The Museum of Modern Art, 2005.

4 Friedlander, *The Little Screens*, San Franciso: Fraenkel Gallery, 2001.

5 Szarkowski has written much on Friedlander's work, including for the landmark exhibition *New Documents* that included Garry Winogrand and Diane Arbus in 1967 at MoMA. See Friedlander, *Self Portrait* (1970), New York: The Museum of Modern Art, 2005.

6 The essay appears in his anthology of essays *On the Museum's Ruins* (1993); it is also reprinted in Bolton's edited anthology *The Contest of Meaning*.

7 Crimp, *On the Museum's Ruins*, p. 72.

8 Ibid., p. 73.

9 Ibid., p. 77.

10 Ibid.

11 This question was posed by Robin Kelsey in his *Art Journal* review of James Elkins, ed., *Photography Theory* (2007). Kelsey's overview of the seminar and the assessments that follow in the book are invaluable. See "Indexomania," *Art Journal*, vol. 66, no. 3, Fall 2007.

12 I am thinking of Gilles Deleuze's closing statement in an essay entitled "How Do We Recognize Structuralism?" where he writes that "Books against structuralism…are strictly without importance; they cannot prevent structuralism from exerting a productivity which is that of our era. No book *against* anything ever has any importance; all that counts are books *for* something, and that know how to produce it." See *Desert Islands and Other Texts 1953–1974*, ed. David Lapoujade, trans. Michael Taormina, New York: Semiotext(e), 2004, p. 192. The critical postmodernism position that Crimp represents is impossible to imagine without post-structuralist thought, which Deleuze implicates in this statement. Simply opposing something, existing only as a mode of critique, can never be creative, that is, for Deleuze, it will not produce anything new, anything with affirmation and joy.

13 Christopher Wilk, "Introduction: What was Modernism?" in *Modernism: Designing a New World 1914–1939*, London: V&A Publications, 2006, p. 13.

14 Costello, "Clement Greenberg (1909–1994)," *Art: Key Contemporary Thinkers*, eds Costello and Jonathan Vickery, Oxford and New York: Berg Publishers, 2007, p. 77. See also

Costello and Dominic Willsdon's introduction to *The Life and Death of Images*, Ithaca: Cornell University Press, 2008.

15 Ibid. See also Costello's more in-depth discussion of these issues in "Greenberg's Kant and the fate of Aesthetics in Contemporary Art Theory," *Journal of Aesthetics and Art Criticism*, vol. 65, no. 2, Spring 2007, pp. 217–28.

16 Working to offer a fuller, more complex view of aesthetics as not just formalism, but as critical thinking about art and society (culture, politics, ethics) is not limited to Costello's work. Recently, W. J. T. Mitchell and several others have given us inspired work on this front, work that often returns to and gives readings of theory and philosophy, namely Foucault, Derrida, and others, that is at odds with the readings operative in the anti-aesthetic position. My work has gained much from reading their work and I hope my own studies are read as part of this "return to aesthetics" however varied that return must be.

17 See Costello, "Greenberg's Kant," p. 218. He adds that Krauss also frequently gives "anti-modernist readings" of canonical modernist artists, often ones Greenberg himself championed, such as Jackson Pollock. See Krauss's *The Optical Unconscious*, Cambridge, MA: MIT Press, 1994.

18 Krauss, *The Originality of the Avant-Garde and Other Modernist Myths*, Cambridge, MA: MIT Press, 1996, p. 9.

19 Ibid.

20 Ibid., p. 10.

21 Ibid., p. 12.

22 Much of the essay's opening addresses Duchamp. Krauss admits that in her mind "it is Duchamp who first establishes the connection between the index (as a type of sign) and the photograph," p. 199. Consider his last painting *Tu M'* (1918).

23 Krauss, *The Originality of the Avant-Garde*, p. 198.

24 See Charles Sanders Peirce, *The Philosophy of Peirce: Selected Writings*, ed. Justus Buchler, London and New York: Routledge, 2010, and "The Icon, Index, and Symbol" in *The Collected Papers of Charles Sanders Peirce*, vol. 2, eds Charles Hartshorne and Paul Weiss, Cambridge, MA: Harvard University Press, 1932, pp. 156–73. On the complexities of Peirce's semiotics, see François Brunet, "'A better example is a photograph': On the Exemplary Value of Photographs in C. S. Peirce's Reflection on Signs," *The Meaning of Photography*, eds Robin Kelsey and Blake Stimson, Williamstown, MA: Sterling and Francine Clark Art Institute and New Haven: Yale University Press, 2008, pp. 34–49.

25 Krauss, *The Originality of the Avant-Garde*, p. 203.

26 Sabine T. Kriebel, "Theories of Photography: A Short History," *Photography Theory*, ed. James Elkins, London and New York: Routledge, 2007, p. 27. Krauss explains that, for Jakobson, a "shifter" is "that category of linguistic sign which is 'filled with signification' only because it is 'empty'. The word 'this' is such a sign, waiting each time it is invoked for its referent to be supplied. 'This chair', 'this table', or 'this…' and we point at something lying on the desk…I am the referent of 'I' only when I am the one who is speaking. When it is your turn, it belongs to you," *The Originality of the Avant-Garde*, p. 197.

27 Krauss, *The Originality of the Avant-Garde*, p. 208.

28 Ibid.

29 Ibid., p. 115.

30 Ibid., p. 110.

31 The contact print or photogram "only forces, or makes explicit, what is the case of *all* photography," Krauss argues. See *The Originality of the Avant-Garde*, p. 203.

32 Ibid., p. 115.

33 Krauss addresses this concept and its centrality to Surrealism as a whole in a 1985–6 traveling exhibition and accompanying catalogue she made with Jane Livingston entitled *L'Amour fou: Photography and Surrealism*, New York: Abbeville Press, 1985. It is here that she begins to privilege Georges Bataille's ideas over those of Breton's. This

leads ultimately to work on another exhibition and catalogue, this time undertaken with Yve-Alain Bois, entitled *Informe*. Krauss and Bois curated a large exhibition at the Pompidou Centre in 1996 that was supplemented by a theoretical text elaborating on Bataille's concept of the "formless," the *informe*. Both texts read a drive or compulsion towards the "formless" in modern and contemporary art that counters Greenberg's formalism ("good visual form"). See Krauss and Bois, *Formless: A User's Guide,* New York: Zone Books, 1997. As Costello notes, "Krauss is forced to resort to such blatant inversions—the tactile for the optical, the material for the virtual, the horizontal for the vertical, production for reception, and so on" because she "remains trapped *within* the terms of the very theory she means to oppose," "Greenberg's Kant," p. 219.

34 Krauss, *The Originality of the Avant-Garde*, p. 113.

35 Krauss, "A Note on Photography and the Simulacral," *October*, vol. 31, Winter, 1984, p. 56. See Bourdieu, *Photography: A Middle-Brow Art*, trans. Shaun Whiteside, Stanford: Stanford University Press, 1990.

36 Krauss, "A Note on Photography and the Simulacral," p. 58. In a note, Krauss points to Barthes, perhaps the central theoretical figure for her work in its entirety, "irritation" with Bourdieu's approach. See his *Camera Lucida*. However, Krauss does not attempt to explain the "irritation" in relation to her own work. Does she side with Bourdieu or Barthes? It must not even be that simple of a choice, but it is curious that Krauss lets, at times, extreme differences between the theorists she cites stand without comment.

37 Ibid., p. 59.

38 See Hal Foster's review of Krauss's Surrealism exhibition in "L'Amour faux," *Art in America*, January 1986, pp. 116–28. Foster extends Krauss "double movement" by ending with contemporary art practices that cite Surrealist ones such as Cindy Sherman (masquerade), James Welling (the *informe*), and Victor Burgin (fetishism). Foster concludes that Krauss's work on Surrealism and photography gives us two things: the knowledge that "any new theory of a past art, or any revision of a historical period, derives from insights earned from the present, a moment which is then privileged (or disavowed) as the prism of that theory or history" and that "much contemporary criticism and art, much theory and practice of our postmodernist present is partly, genealogically, a theory and practice of 'Surrealism'," pp. 127–8.

39 There is a large body of critical and theoretical writing on Sherman's work. See Cindy Sherman, *The Complete Untitled Film Stills*, New York, Museum of Modern Art, 2003 and Johanna Burton, ed., *Cindy Sherman*, OCTOBER Files 6, Cambridge, MA: MIT Press, 2006.

40 Michael Fried, *Why Photography Matters as Art*, p. 7.

41 Crimp, "The Photographic Activity of Postmodernism," *On the Museum's Ruins*, p. 122.

42 Ibid.

43 Krauss, "A Note on Photography," pp. 59, 62.

44 See Burgin's canonical edited volume *Thinking Photography*, London and Basingstoke: Macmillan Press and New Jersey: Humanities Press International, 1982; *The End of Art Theory: Criticism and Postmodernity*, London and Basingstoke: Macmillan Press and New Jersey: Humanities Press International, 1986; and "Photography, Phantasy, Function" (1980) in an anthology of his writings ed. Alexander Streitberger entitled *Situational Aesthetics, Selected Writing by Victor Burgin*, Leuven: Leuven University Press, 2009. In "Photography, Phantasy, Function," Burgin directly takes on Szarkowski's formalist approach to photography.

45 A term from ancient philosophy, particularly Plato, that defines a representation that is not necessarily tied to an object in the world. As a copy without an original, a simulacrum is often used in cultural criticism to describe the status of the image in our society of spectacle: mass-media, consumerism, commodity consumption, leisure, and images. In the history of art, this concept can be seen in the work of Rene Magritte and Andy Warhol where we see images that, even as they appear to be representations, dissolve the truth-claims of representation. Much postmodern art (Richard Price, Cindy Sherman, etc.)

plays with and on the concept of the simulacrum. See Guy Debord, *Society of the Spectacle* (1967) and Jean Baudrillard, *Simulacra and Simulation* (1981).

46 Krauss, "A Note on Photography," p. 62. The relation between Burgin's *Photopath* and Baudrillard's discussion of the simulacrum is evident when the latter refers to the Argentine writer Jorge Luis Borge's fable in which "cartographers of the Empire draw up a map so detailed that it ends up covering the territory exactly...the map...precedes the territory—procession of simulacra—that engenders the territory," *Simulacra and Simulation*, trans. Sheila Faria Glaser, Ann Arbor: University of Michigan, 1994, p. 1.

47 This statement is from Liz Kotz's excellect essay "Image and Text: Reconsidering Photography in Contemporary Art," *A Companion to Contemporary Art Since 1945*, ed. Amelia Jones, London: Blackwell, 2006, pp. 512–33. These passages are to be found on pp. 523, 525.

48 Burgin, *Thinking Photography*, p. 9.

49 Freud discusses fetishes in a 1927 article "Fetishism." Here he forwards his idea that the "fetish is a penis-substitute" that helps him explain how sexual desire is displaced onto inanimate objects. See Freud, *The Standard Edition*, vol. XXI, ed. James Strachey, London: Hogarth, 1964, pp. 152–9.

50 Whereas desire is productive for Deleuze and Félix Guattari. See *Anti-Oedipus: Capitalism and Schizophrenia*, trans. Robert Hurley Mark Seem and Helen R. Lane, Minnespolis: University of Minnesota Press, 1983.

51 Burgin, "Looking at Photographs," *Thinking Photography*, p. 144.

52 "Extimacy" is a concept created by the psychoanalyst Jacques Lacan in *The Seminar of Jacques Lacan Book VII: The Ethics of Psychoanalysis 1959–1960*, ed. Jacques-Alain Miller, trans. Dennis Porter, New York: W. W. Norton, 1992, p. 71. Here Lacan states that the other is "something strange to me, although it is at the heart of me." Hence the other is an intimate exterior, or "extimacy," of the subject; the subject is thus dislocated from within; it is ex-centric. In addition, as Lacan explained in his discussion of the "Mirror Stage": "What determines me, at the most profound level, in the visible, is the gaze that is outside. It is through the gaze that I enter light and it is from the gaze that I receive its effects. Hence it comes about that the gaze is the instrument through which light is embodied and through which—if you will allow me to use a word, as I often do, in a fragmented form—I am *photo-graphed*." See *The Seminar of Jacques Lacan Book XI: The Four Fundamental Concepts of Psychoanalysis*, ed. Jacques-Alain Miller, trans. Alan Sheridan, New York: W. W. Norton, 1998, p. 106.

53 Italics mine, Krauss, "A Note on Photography," p. 59.

54 Batchen, *Burning with Desire: The Conception of Photography*, Cambridge, MA: MIT Press, 1999, p. 197.

55 Krauss, "A Note on Photography," p. 63.

56 Trachtenberg, "Introduction," *Classic Essays on Photography*, New Haven: Leete's Island Books, 1980, p. vii.

57 Eric Rosenberg, "Photography is Over, if You Want it," in *The Meaning of Photography*, eds Robin Kelsey and Blake Stimson, Williamston, MA: Sterling and Francine Clark Art Institute and New Haven: Yale University Press, 2008, p. 190.

58 Bernd Stiegler, "Photography as the Medium of Reflection," *The Meaning of Photography*, p. 195.

59 Ibid., p. 197.

60 Rosalind Krauss, "Notes on the Obtuse," *Photography Theory*, ed. James Elkins, London and New York: Routledge, 2007, p. 340.

61 See Krauss, *A Voyage on the North Sea: Art in the Age of the Post-Medium Condition*, London: Thames & Hudson, 1999.

62 Abigail Solomon-Godeau, "Ontology, Essences, and Photography's Aesthetics: Wringing the Goose's Neck One More Time," *Photography Theory*, p. 268. Solomon-Godeau is referring to the brilliant work done by Alex Potts. See his "Tactility: The Interrogation of Medium in Art in the 1960s," *Art History*, vol. 27, no. 2, April 2004.

63 Doane, "Indexicality and the Concept of Medium Specificity," *The Meaning of Photography*, p. 4.
64 Idid.
65 Ibid., p. 9.
66 Martin Lefebvre, "The Art of Pointing: On Peirce, Indexicality, and Photographic Images," *Photography Theory*, p. 223.
67 Ibid., p. 240.
68 Manovich, "The Paradoxes of Digital Photography," *The Photography Reader*, ed. Liz Wells, London and New York: Routledge, 2003, p. 240. See also his *The Language of New Media,* Cambridge, MA: MIT Press, 2001. Throughout "The Paradoxes of Digital Photography" Manovich directly engages the conclusions reached by W. J. T. Mitchell in *The Reconfigured Eye: Visual Truth in the Post-Photographic Era*, Cambridge, MA: MIT Press, 1992.
69 Manovich, "The Paradoxes of Digital Photography," p. 241.
70 Ibid., p. 245.
71 Ibid, p. 241.
72 Costello, "On the Very Idea of a 'Specific' Medium: Michael Fried and Stanley Cavell on Painting and Photography as Arts," *Critical Inquiry*, vol. 34, Winter 2008, p. 306.
73 Ibid.
74 This shift to tableau photographs in color came soon after the acceptance of color photography as "art photography." Black-and-white film had signified "art," especially in the dictates of the F.64 group. Key to gaining this acceptance was the work in the 1970s by William Eggleston, Stephen Shore, and others whose work positioned color photography as a viable form of art photography. Eggleston's winning of a Guggenheim Fellowship in 1974 allowed him to produce the work that would comprise *William Eggleston's Guide* (1976), an idiosyncratic travel guide that won him a solo show at MoMA curated by John Szarkowski in 1976. This exhibition is regarded as the moment when color photography entered the language and institutions of art photography. The introduction written by Szarkowski helped frame the acceptance of color photography in the art world.
75 The shift to this type of work in terms of scale, color, relation to the viewer—the "tableau form"—was first addressed in Jean-François Chevrier's "The Adventures of the Picture Form in the History of Photography" (1989) in *The Last Picture Show: Artists Using Photography 1960–1982*, ed. Douglas Fogle, Minneapolis: Walker Arts Center, 2003. As Bustamante has said, "I wanted not to make photographs that would be art, but art that would be photography. I refused the small format and the craft aspect of black and white. I wanted to move into color, in a format for the wall, in order to give photography the dimensions of a tableau, to transform it into a object," cited in Fried, *Why Photography Matters as Art as Never Before*, p. 22.
76 Ibid., p. 311.
77 Ibid., p. 278.
78 Wall: "So it seems to me that the general programme of the painting of modern life (which doesn't have to be painting, but could be) is somehow the most significant evolutionary development in Western modern art." See his "Representation, Suspicions, and Critical Transparency: Interview with T. J. Clark, Serge Guilbaut, and Anne Wagner" (1990) in Theirry de Duve, *Jeff Wall*, London: Phaidon, 2002, p. 124. On Wall's arrival at this idea and its differences from how photography was used in Conceptual art practice, see his essay "'Marks of Indifference': Aspects of Photography in, or as, Conceptual Art," *Reconsidering the Object of Art: 1965–1975*, eds Ann Goldstein and Anne Rorimer, Los Angeles: The Museum of Contemporary Art and Cambridge, MA: MIT Press, 1995, pp. 246–67.
79 Wall, "'Marks of Indifference'," p. 266.
80 Ibid.
81 Costello, "On the Very Idea of a 'Specific' Medium," p. 296.

82 Ibid., p. 296.

83 Ibid., p. 299.

84 See his *Absorption and Theatricality: Painting and Beholder in the Age of Diderot*, Chicago: University of Chicago Press, 1986 and *Manet's Modernism. or The Face of Painting in the 1860s*, Chicago: University of Chicago Press, 1996 as well as his canonical essay "Art and Objecthood," *Art and Objecthood: Essays and Reviews*, Chicago: University of Chicago Press, 1998, pp. 148–72.

85 Fried, *Why Photography Matters as Art as Never Before*, p. 7.

86 For a related, but different discussion, see A. D. Coleman's "The Directorial Mode: Notes Toward a Definition" (1976), *Photography in Print: Writings from 1816 to the Present*, ed. Vicki Goldberg, Albuquerque: University of New Mexico Press, 1981, pp. 480–91.

87 Ibid., pp. 35, 43.

88 This is a contentious point. See the heated debate on this issue in *Photography Theory*, roughly pp. 182–96. Note particularly Joel Snyder's position that "it is pointless to talk about 'Gursky's medium'" because questions of medium are not of interest to the audience and because, as he admits not understanding: "If you can be medium specific and have no interest in the history of your medium, then people like Gursky are medium specific," p. 190. In the course of the argument, which is hard to follow, Costello contends that Struth and Gursky "never fail to talk about the way they have both inherited and departed from the Becher legacy," p. 192. Costello is referring to Bernd and Hilla Becher, whose students from the Kunstakademie Düsseldorf have included Gursky, Struth, Höfer, Thomas Ruff, and others. The Bechers are discussed in detail in the chapter "The archive as producer." See also Stefan Gronert, *The Düsseldorf School of Photography*, New York: Aperture, 2010.

89 Deleuze, *Cinema I: The Movement-Image*, trans. Hugh Tomlinson and Barbara Habberjam, Minneapolis: University of Minnesota Press, 2001, p. 12.

90 Ibid., p. 17.

91 Ibid., pp. 16–17.

92 Ibid.

93 Ibid., p. 160.

94 Ibid., p. 161.

95 Deleuze and Félix Guattari, *What Is Philosophy?*, trans. Hugh Tomlinson and Graham Burchell, New York: Columbia University Press, 1994, p. 188.

96 Ibid.

97 Derrida, *Copy. Archive. Signature: A Conversation on Photography*, ed. Gerhard Richter, trans. Jeff Fort, Stanford: Stanford University Press, 2010, p. 2.

98 Ibid., pp. 8, 9.

99 Ibid., p. 12. Derrida is drawing on Martin Heidegger's work, wherein temporality is auto-affective, a synthesis in which activity itself is passivity. See Herschberger, *Kant and the Problem of Metaphysics*, trans. Richard Taft, Bloomington: Indiana University Press, 1990. Derrida discusses this directly on p. 14.

100 Ibid., p. 14.

101 His main contributions are *The Truth in Painting* and *Memoirs of the Blind: The Self-Portrait and Other Ruins*. See also his work on architecture with Peter Eisenman, *Chora L Works*, eds Jeffrey Kipnis and Thomas Lesser, New York: The Monacelli Press, 1997; "The Spatial Arts: An Interview with Jacques Derrida," trans. Laurie Volpe, in *Deconstruction and the Visual Arts: Art. Media. Architecture*, eds Peter Brunette and David Wills, Cambridge: Cambridge University Press, 1994; and his essay "Videor," trans. Peggy Kamuf, in *Resolutions: Contemporary Video Practices*, eds Michael Renov and Erika Suderburg, Minneapolis: University of Minnesota Press, 1996.

102 See also his essays in Frédéric Brenner, *Diasporas: Homelands in Exile*, vol. 2, *Voices*, New York: Harper Collins, 2003 and his essay on the Belgian photographer Marie-Françoise Plissart in *Right of Inspection*, trans. David Wills, New York: The Monacelli Press, 1998.

103 Richter, "Between Translation and Invention: The Photograph in Deconstruction," Jacques Derrida, *Copy, Archive, Signature: A Conversation on Photography*, p. xxi.
104 Derrida, *Copy, Archive, Signature*, p. 13.
105 Derrida arrived at this name by trying to translate the German philosopher Martin Heidegger's words *Destruktion* and *Abbau* into French. As Gerhard Richter explains, "Derrida hoped to capture the double movement of Heidegger's notion of a mode of building (*bauen*) that also is a form of un-building (*ab-bauen*)." It is a de-structuring that "exposes the internal tensions that both enable and vex it." See Richter, "Between Translation and Invention," pp. x–xi.
106 Richter, "Between Translation and Invention," p. xi.
107 Ibid., p. xv.
108 Derrida, *Memories for Paul de Man*, trans. Jonathan Culler, New York: Columbia University Press, 1989, p. 73.
109 In fact, Pliny's multi-volume *Natural History* recounts both fables. Pliny discusses art and art history in volumes XXXIII–XXXV of his work. The psychoanalyst Jacques Lacan interprets the Zeuxis and Parrhasius fable in *The Four Fundamental Concepts of Psychoanalsysis*. The fable of Dibutade has been represented many times over. For instance, Jean Baptiste Regnault's neoclassical oil painting *Origin of Painting* (1785) or Karen Knorr's *The Pencil of Nature* (1994), a photograph that circumscribes both Talbot and Pliny's fable—as Derrida himself often does by linking the fable of Dibutade to Talbot's notion of *skiagraphia*, shadow-writing.
110 Derrida, *Copy, Archive, Signature*, p. 15.
111 Ibid., pp. 16–17.
112 Ibid., p.18.
113 Here is how he puts it: "*on the one hand*, invention as a discovery or revelation of what is already there (in the invention of the other, one discovers the other: photography takes and overtakes [*prend et sur-prend*] the other as he is, the referent, as one says, by a sort of gaze, a sort of intuition or artificial eye—that is at least what is thought or said); and then, *on the other hand*, invention as a technical intervention, as the production of a new technical apparatus that constitutes the other instead of simply receiving him. So of course there is a concept of photography as the simple recording of the other as he was, as he appeared there, but it is immediately contaminated by invention in the sense of production, creation, productive imagination…These two concepts of invention lie at the heart of photography," ibid., p. 43.
114 Derrida, "Letter or a Japanese Friend" (1983) in *A Derrida Reader: Between the Blinds*, ed. Peggy Kamuf, New York: Columbia University Press, 1991, p. 272.
115 Barbara Johnson, "Translator's Introduction" in *Dissemination*, Chicago: University of Chicago Press, 1981, p. xv.
116 Cited in Richter, "Between Translation and Invention," p. xxxviii.

Gloss on Roland Barthes

1 Barthes, *Image-Music-Text*, trans. Stephen Heath, New York: Hill and Wang, 1977. There is much secondary literature on Barthes and photography, but a touchstone remains Nancy Shawcross, *Roland Barthes on Photography*, Gainesville: University Press of Florida, 1997. See also Diana Knight, ed., *Critical Essays on Roland Barthes*, New York: G. K. Hall, 2000. See also *The Barthes Reader*, ed. Susan Sontag, New York: Hill and Wang, 1982.
2 Ibid., pp. 44–5.
3 Ibid., p. 32.
4 I am paraphrasing and directly referring to the series of questions Barthes asks in "The Photographic Message" and "Rhetoric of the Image," see *Image-Music-Text*, pp. 28, 32.
5 Ibid., p. 43.
6 Ibid.

7 Ibid., p. 33.
8 Ibid., p. 36.
9 Ibid., p. 46. Italics mine.
10 Ibid., p. 39.
11 Ibid., p. 26.
12 Ibid., p. 19.
13 Ibid., p. 23.
14 Ibid., p. 26.
15 Ibid., p. 45.
16 Ibid., p. 42. Italics mine.
17 Ibid.
18 Ibid., p. 50.
19 Barthes, "The Third Meaning," *Image-Music-Text*, p. 54. This essay is about film, but in it Barthes gives much attention to the film still as a photographic image. See also Martin Jay, "The Camera as Memento Mori: Barthes, Metz, and the Cahiers du Cinéma," *Downcast Eyes: The Denigration of Vision in Twentieth-Century French Thought*, Berkeley and Los Angeles: University of California Press, 1993.
20 Ibid., p. 61.
21 Barthes, *Camera Lucida: Reflections on Photography*, trans. Richard Howard, New York: Hill and Wang, 1981, p. 55. Of course, Barthes's concept of the *punctum* is also the subject of much interest and debate. It will be discussed further here in the chapter "Time-images." For further discussions of the concept, see also Jacques Derrida's "The Deaths of Roland Barthes" in *The Work of Mourning*, eds Pascale-Anne Brault and Michael Naas, Chicago: University of Chicago Press, 2001, and *Photography Degree Zero: Reflections on Roland Barthes's Camera Lucida*, ed. Geoffrey Batchen, Cambridge, MA: MIT Press, 2009. In the latter, see Michael Fried's "Barthes's Punctum" (which is also a chapter of his book *Why Photography Matters as Art as Never Before*) and the response penned by James Elkins, "What Do We Want Photography To Be?"
22 Ibid., p. 21.
23 Barthes, "The Third Meaning," p. 62.
24 This concept of a "minority practice" is developed and altered by Gilles Deleuze and Félix Guattari in their *Kafka: Toward a Minor Literature*, trans. Dana Polan, Minneapolis: University of Minnesota Press, 1986. Deleuze and Guattari's short book was first published in France in 1975, five years after Barthes's essay "The Third Meaning" first appeared.
25 Barthes, "The Third Meaning," p. 63.
26 Barthes, *Camera Lucida*, pp. 88–9.

3 Documentary, or instants of truth

1 The epigraphs are: Lady Eastlake, "Photography" (1857), *Classic Essays on Photography*, ed. Alan Trachtenberg, New Haven: Leete's Island Books, 1980, p. 65; Georges Didi-Huberman *Images in Spite of All: Four Photographs from Auschwitz*, trans. Shane B. Lillis, Chicago: University of Chicago Press, 2008, p. 3; and Judith Butler, *Frames of War: When Is Life Grievable?*, London and New York: Verso, 2009, p. 52.
2 Ian Jeffrey, *Photography: A Concise History of Photography*, London: Thames & Hudson, 1989.
3 See Kozloff, *Photography and Fascination*, Danbury, NH: Addison House, 1980 and *The Privileged Eye: Essays on Photography*, Albuquerque: University of New Mexico Press, 1987.
4 Cartier-Bresson called the famous agency "a community of thought, a shared human quality, a curiosity and a respect for what is going on in the world, and a desire to transcribe it visually." Cited in Brett Abbott, "Engaged Observers in Context," *Engaged Observers: Documentary Photography Since the Sixties*, Los Angeles: The J. Paul Getty Museum, 2010, p. 13.

5 The distinctions between photojournalism and documentary are far from clear. I agree with Abbott's reading: "There has been a tendency to speak of photojournalism and documentary as clearly separate forms of photography. The trend to separate the two became pronounced during the 1960s and 1970s as a way of distinguishing what were regarded as more commercial endeavors (dubbed 'photojournalism') from those with artistic, or museum, ambitions (dubbed 'documentary'). Certainly the two are not exactly one in the same, but their divisions are fuzzy and differences are not exactly hierarchical in relation to the realm of independently conceived art. Photojournalism need not be considered exclusively an endeavor associated with commercial media. Instead, it might be better understood as an end (a particular kind of journalistic report composed of pictures and related text), with documentary as a related approach to photography encompassing a much wider range of outcomes," *Engaged Observers: Documentary Photography Since the Sixties*, p. 10.

6 See Newhall, "Documentary Approach to Photography" (1938).

7 Abbott, *Engaged Observers: Documentary Photography Since the Sixties*, p. 27.

8 Ibid., p. 25.

9 The phrase "the civil contract of photography" is from Ariella Azoulay's *The Civil Contract of Photography*, trans. Rela Mazali and Ruvik Danieli, New York: Zone Books, 2008. Azoulay explains that although her "claim is that the civil contract of photography is as old as photography itself (and although a lot has been written about citizens and citizenship), civil contracts and photography have been mostly kept apart in the theoretical discourses. Photography, its history, and its philosophy belong to the study of visual culture, media, or art history; contracts and citizens are the business of political theory or political science, sociology, or jurisprudence. *The Civil Contract of Photography* seeks to develop a concept of citizenship through the study of photographic practices and to analyze photography within the framework of citizenship as a status, an institution, and a set of practices," p. 24.

10 Ibid., p. 14.

11 Ibid., pp. 311–12.

12 Ibid., p. 14.

13 Ibid., p. 311.

14 Note two fine books: Louis Kaplan, *The Strange Case of William Mumler, Spirit Photographer*, Minneapolis: University of Minnesota Press, 2008 and Jennifer Tucker, *Nature Exposed: Photography as Eyewitness in Victorian Science*, Baltimore: John Hopkins University Press, 2005.

15 "Autoethnography" is a complex concept defined by Mary Louise Pratt as "instances in which colonized subjects undertake to represent themselves in ways that *engage with* the colonizer's own terms. If ethnographic texts are a means by which Europeans represent themselves to their (usually subjugated) others, authethnographic texts are those that others construct in response to or in dialogue with those metropolitan representations." See Pratt, *Imperial Eyes: Travel Writing and Transculturation*, London and New York: Routledge, 1992, p. 7. I am suggesting that this activity (ethnography) is turned on poor, immigrant, and other Europeans in the first decades of documentary practice in the nineteenth century. Moreover, outside of the colonial context Pratt explicates, it appears as if documentary photographers such as Jacob Riis and others attempt to facilitate the "autoethnography" of the marginalized within Euro-American society. Hence the discourse of non-intervention, objectivity, and neutrality that enters documentary practice. The phrase "the great age of photographic Orientalism" is from Sontag, *On Photography*, p. 89. A classic example of Orientalist photography that informs art history in particular are the photographs taken by Maxime Du Camp during his Grand Tour of the Middle East in 1849–51. See also *Colonialist Photography: Imag(in)ing Race and Place*, ed. Eleanor Hight and Gary Sampson, London and New York: Routledge, 2002 and Anne Maxwell, *Colonial Photography and Exhibitions: Representations of the Native and the Making of European Identities*, Leicester: Leicester University Press, 2000.

16 Thomson is a perfect example of this extension of Orientalist photography to a form of documentary (autoethnography). He traveled and photographed extensively throughout Asia between 1862 and 1872. He maintained a commercial photography studio during this time, first in Singapore, then in Hong Kong.

17 Lewis Hine, "Social Photography" (1909), *Classic Essays on Photography*, p. 110.

18 As Geoffrey Batchen notes, Bayard's "own notebook indicates that he had undertaken his first attempts on January 20 [1839], well before the details of either Daguerre's or Talbot's method had been revealed." Bayard made at least twenty self-portraits in a variety of poses and settings. See Batchen, *Burning with Desire: The Conception of Photography*, Cambridge, MA: MIT Press, 1999 , pp. 157–73.

19 Ibid., p. 158. Batchen adds that the pose itself has art historical resonances because Bayard "self-consciously put himself in a place occupied in another photograph [he made] by a statuette of Antonious, the beautiful young boy of Roman legend who, it is said, drowned himself in order to prolong the life of his lover, the emperor Hadrian," p. 162. He also discusses how Bayard "cleverly parodies" Jacques-Louis David's painting *Death of Marat* (1793).

20 Ibid., pp. 167, 171.

21 Ibid., p. 171.

22 Ibid., pp. 171–3.

23 Ibid., p. 181.

24 Ian Jeffery, *How to Read a Photograph*, New York: Abrams, 2009, p. 150. This critique of Brassaï is given by Martha Rosler, "In, Around, and Afterthoughts (On Documentary Photography), *The Photography Reader*, ed. Liz Wells, London and New York: Routledge, 2003, p. 270. She cites John Szarkowski's words "pictures in the service of a social cause." See also her *Decoys and Disruptions: Selected Writings. 1975–2001*, Cambridge, MA: MIT Press, 2004.

25 John Tagg gives a much fuller reading of this photograph in *The Disciplinary Frame: Photographic Truths and the Capture of Meaning*, Minneapolis and London: University of Minnesota Press, 2009, pp. 102–28.

26 Ibid., p. 109.

27 The photographer's name, in this case, did not appear until the contents page at the back of the magazine, Tagg explains.

28 Ibid., p. 110.

29 Ibid., p. 110. Tagg's position here draws on the notion of "interpellation" as defined by the Marxist theorist Louis Althusser. In an important essay, one that orients much critical postmodernist writing on photography, "Ideology and Ideological State Apparatuses" (1969), Althusser explains that ideology affects every individual by rendering him a "subject." Interpellation describes the way ideology hails and positions individuals within particular discourses. As he puts it, "ideology 'acts' or 'functions' in such a way that it…'transforms' the individuals into subjects," *Lenin and Philosophy and Other Essays*, trans. Ben Brewster, New York: Monthly Review Press, 1971, p. 174. We are "hailed" and "captured" by ideology; we assume our interpellated position, identify with and locate ourselves within received social meanings, and act as if we have the freedom to choose these things in the first place. Interpellation is how Althusser describes a subject being subjected to ideology, that is, a subject who misrecognizing it as the actions of a freely choosing individual. Ideology transforms us into subjects that think and behave in socially proscribed ways, Althusser argues. See my chapter on Althusser in *Theory for Art History*, pp. 59–64. This concept underlies Tagg's reading of documentary photography. Amid the collapse of the economy that marked the Great Depression, Tagg insists that the documentary projects, particularly the Farms Security Administration project under the direction of Roy Stryker, was part of a complex socio-political, paternalistic, ideological strategy. During this period of US history documentary, he argues, "constituted a concerted attempt to forestall a crisis in the field of meaning and the field of the subject [i.e. the political subject]. It worked explicitly as a means of recruitment whose

mobilization sought to incorporate its targeted audiences in an identification with the imaginary coherence of its system—an identification that enacted and secured a particular regime of truth, of subjectivity and of sense, closing down the openness and disputability of reality, which is always dangerously prone to erupt at times of crisis." See Tagg, "In the Valley of the Blind," *The Meaning of Photography*, eds Robin Kelsey and Blake Stimson, Williamstown, MA: Sterling and Francine Clark Art Institute and New Haven: Yale University Press, pp. 125–6.

30 See especially the entire third chapter of Tagg's *The Disciplinary Frame*, entitled "Melancholy Realism: Walker Evans's Resistance to Meaning."

31 From a March 1964 lecture Evans gave at Yale University. Cited in Gilles Mora and John T. Hill, *The Hungry Eye*, New York: Abrams, 2009, note 7, p. 13.

32 Evans, "The Reappearance of Photography," *Classic Essays on Photography*, p. 188.

33 Berenice Abbott, "Photography at the Crossroads" (1951), *Classic Essays on Photography*, p. 183.

34 *The Hungry Eye*, p. 11. Mora continues by adding that Evans was "the first to understand this, before Pop Art, the New Realists, Ed Ruscha, the Bechers, William Christenberry, Lewis Baltz, and New Topography."

35 Susan Sontag, *On Photography*, p. 30.

36 Ibid.

37 Stomberg, "A Genealogy of Orthodox Documentary," *Beautiful Suffering: Photography and the Traffic in Pain*, eds Mark Reinhardt, Holly Edwards, and Erina Duganne, Williamstown, MA: Williams College Museum of Art and Chicago: University of Chicago Press, 2007, p. 37.

38 Ibid., p. 37. In short, Evans argued that work like Bourke-White's was simply too much about her and her point of view, or that it was too literal and moralistic as photojournalism. The relationship between Evans and Bourke-White has received a lot of attention, some of which supports Evans's claims of ethical superiority. The best summaries of this contentious pairing are to be found in Stomberg and Tagg. As Tagg notes, Evans's friends and supporters denigrated Bourke-White "for her personal vanity and…her luridly theatrical and manipulative photographic work," *The Disciplinary Frame*, p. 171. I agree with Tagg that more than personal attacks, the difference between Bourke-White and Evans must be addressed on how each frames an image and its message/meaning differently. Tagg does this brilliantly in his chapter "Melancholy Realism."

39 Tagg, *The Disciplinary Frame*, p. 173.

40 Ibid., p. 171.

41 In 1936 Evans and Agee were commissioned by Henry Luce's *Fortune* magazine to explore and document the lives of Southern sharecroppers in Hale County, Alabama. They lived with a poor, tenant farming family for two months. Ultimately, Evans's images and Agee's text were not published by *Fortune* but in book form by Houghton Mifflin publishers as *Let Us Now Praise Famous Men: Three Tenant Families*. There have been many editions since this initial publication, many of which vary in the number of Evans's photographs that are reproduced (ranging from sixteen to sixty-two). Note as well the essay by Howell Raines, "Let Us Now Praise Famous Folk" that was published in the *New York Times Magazine*, May 25, 1980. Rosler also discusses this essay and Evans's project in her "In, Around, and Afterthoughts (On Documentary Photography)."

42 Winogrand cited in *The Hungry Eye*, p. 12.

43 Cited in *The Hungry Eye*, p. 10. Szarkowski curated 1971 Evans retrospective at MoMA.

44 Sontag, *On Photography*, p. 29.

45 Ibid.

46 Ibid., p. 47.

47 See Plato, *Phaedrus and Letters VII and VII*, trans. Walter Hamilton, London and New York: Penguin Books, 1973.

48 Sontag, *On Photography*, p. 47.

49 Ibid., p. 48.

50 Although there are ties to earlier photographers even in terms of subject matter such as Lewis Hine and August Sander. See the former's *Idiot Children in an Institution. New Jersey* (1924) and the latter's *Children Born Blind* (1930–1).

51 Op cit., p. 34.

52 *Diane Arbus: An Aperture Monograph* (1972), eds Doon Arbus and Marvin Israel, New York: Aperture, 2005, pp. 2–3. On Arbus, see Patricia Bosworth, *Diane Arbus: A Biography*, New York: W. W. Norton, 2006.

53 Sontag, *On Photography*, p. 47.

54 Ibid., p. 42.

55 Rosler, "In, Around, and Afterthoughts (On Documentary Photography)," p. 262.

56 Ibid., p. 261.

57 Ibid.

58 Ibid., p. 268.

59 Ibid.

60 Italics mine; Rosler, "In, Around, and Afterthoughts (On Documentary Photography)," p. 270.

61 Ibid., p. 269.

62 Abbott, *Engaged Observers*, p. 26.

63 Ibid., p. 25. Rosler's review of Meiselas's *Nicaragua* originally appeared in 1981; it can be found in her *Decoys and Disruptions*, pp. 245–58. Abbott draws our attention to Rosler's note in which she expresses, at a remove of twenty-three years, "her admiration for Meiselas's commitment, skill, and resourcefulness, despite the criticisms elaborated," p. 34, note 84.

64 Sekula, "On the Invention of Photographic Meaning" (1975): "the ills of photography are the ills of aestheticism."

65 Sontag, *On Photography*, p. 119.

66 Ibid.

67 Rosler, "In, Around, and Afterthoughts (On Documentary Photography)," p. 271.

68 Ibid.

69 Johanna Burton, "Not the Last Word: Reflections on Sherrie Levine's 'After Walker Evans Negative'," *Artforum*, September 2009, pp. 270.

70 Cited in Mary Warner Marien, *Photography: A Cultural History*, Upper Saddle River, NJ: Prentice Hall, 2011, p. 438. On "new social documentary," see Grant Kester, "Toward a New Social Documentary," *Afterimage*, March 1987, pp. 10–14.

71 Sontag discusses both in some detail in her *Regarding the Pain of Others*. See also Natalie M. Hudson "Reading the Victorian Souvenir: Sonnets and Photographs of the Crimean War," *The Yale Journal of Criticism*, vol. 14, no. 2, Fall 2001 and Ulrich Keller's *The Ultimate Spectacle: A Visual History of the Crimean War*, London and New York: Routledge, 2001. For a larger perspective see Caroline Brothers's *War and Photography*, London and New York: Routledge, 1997. On Brady, see Mary Pranzer, *Matthew Brady and The Image of History*, Washington, DC: Smithsonian Books, 2004.

72 Holmes, "The Stereoscope and the Stereograph" (1859), *Classic Essays on Photography*, p. 82. The stereograph was invented by David Brewster in 1849. It was chief among low-priced, popular photography in the late nineteenth century. "Stereos," as the horizontal cards with two different images of the same location were called, were often representations of exotic places and urban scenes. As such they were both educational and entertaining; they were extremely popular, which resulted in a craze to collect them. Stereos replicate human binocular vision (the brain combines the slightly different images produced by each eye); therefore, there are two images that merge into one, creating an illusion of spatial depth (three-dimensionality) and crisp detail. Stereographs required a special viewer called a stereoscope. The modern version is the Fisher-Price View-Master.

73 Reinhardt, "Picturing Violence," *Beautiful Suffering*, p. 14.
74 Ibid., p. 22.
75 Sekula, "Dismantling Modernism," *Photography Against the Grain: Essays and Photo Works, 1973–1983*, Halifax, Canada: Press of the Nova Scotia College of Art and Design, 1984, pp. 56, 58.
76 Ibid., p. 57.
77 Ibid., p. 62.
78 Reinhardt, "Picturing Violence," p. 24.
79 Ibid., p. 25.
80 Ibid., p. 24.
81 Ibid., p. 33.
82 Ibid., p. 27.
83 Rancière, *The Emancipated Spectator*, trans. Gregory Elliott, London and New York, Verso, 2009, pp. 93, 95.
84 Ibid., p. 85.
85 Ibid.
86 Ibid., p. 96.
87 Ibid., p. 103. Italics mine.
88 Ibid., p. 102.
89 Ibid., p. 99.
90 Ibid., p. 100.
91 Ibid., p. 102.
92 Rancière, "The Work of the Image," preface to Esther Shalev-Gerz, *Menschliche Dinge: The Human Aspect of Objects*, Weimar: Stiftung Gedenkstätten Buchenwald, 2006, p. 23.
93 Didi-Huberman, *Images in Spite of All*, p. 6. Didi-Huberman adds: "The SS knew in advance that a single word from a surviving member of the *Sonderkommando* would quash any denials, any subsequent cavils with respect to the massacre of the European Jews…The first *Sonderkommando* at Auschwitz was created on July 4, 1942, during the 'selection' of a convoy of Slovakian Jews for the gas chamber. Twelve squads succeeded each other from that date; each was eliminated at the end of a few months, and 'as its initiation, the next squad burnt the corpses of its predecessors'," p. 4. A fine essay on Didi-Hubmeran, Rancière, and even Michael Fried that I have found valuable is Michael S. Roth, "Why Photography Matters to the Theory of History," *History and Theory*, vol. 49, February 2010, pp. 90–103.
94 Ibid., p. 12.
95 Ibid., p. 13.
96 Ibid., p. 16.
97 Didi-Huberman, *Confronting Images: Questioning the Ends of a Certain History of Art*, trans. John Goodman, University Park, Penn.: The Pennsylvania State University Press, 2005, p. 157.
98 Op cit., p. 3.
99 Ibid., p. 39.
100 Ibid., p. 36.
101 Ibid.
102 Rancière, *The Emancipated Spectator*, p. 89.
103 Op cit., p. 26.
104 Ibid., p. 30.
105 Jonathan Bordo has written that amidst Cohen's photographs "we are allowed to be witnesses to these photographic traces only by reflecting upon the paradox of photographs offering traces by subliming them, and upon our own insufficiency, if not our very ineligibility, to be witnesses to the overwhelming conditions of modernity…especially for an interpretative community still sifting for sense amid the collective ruins we have inherited," *On European Ground*, Chicago: University of Chicago Press, 2001, p. 95.

Gloss on Susan Sontag

1 Sontag, *Regarding the Pain of Others*, New York: Farrar, Strauss, and Giroux, 2002. My thinking and reading of Sontag owes much to Michael Kelly, who addresses the complexities of Sontag's thought and the changes in her position on photography in relation to images of suffering in his forthcoming *A Hunger for Aesthetics*. Kelly has identified ways to supplement Sontag's ideas through a reading of Judith Butler's *Frames of War: When is Life Grievable?* that will undoubtedly add much to the discussion of art and politics. See Butler, *Frames of War: When is Life Grievable?*, London and New York: Verso, 2009.

2 Sontag, *On Photography*, New York: Picador, 1977, pp. 19–20.

3 Sontag's position is not entirely identical to the one espoused by critical postmodernism. See her interview with Fritz J. Raddatz entitled "Does a Photograph of the Krupp Works Say Anything about the Krupp Works," *Conversations with Susan Sontag*, ed. Leland Pogue, Jackson, MI: University Press of Mississippi, 1995, pp. 88–96. The title refers to Benjamin's comment in "The Author as Producer." Sontag is very familiar with Benjamin's work; see her *Under the Sign of Saturn: Essays*, New York: Picador, 2002.

4 Ibid., pp. 20–1.

5 For instance, see her "The Imagination of Disaster," *Against Interpretation: And Other Essays*, New York: Picador, 2001, pp. 209–25.

6 Ibid., p. 24.

7 Sontag, *Regarding the Pain of Others*, pp. 114–15.

8 Sontag traveled with the famed photographer Annie Leibovitz, who has commented that in Sarajevo in 1993 "death was random." Leibovitz's striking photograph *Bloody Bicycle* (Sarajevo, 1993), a black-and-white image of a toppled bicycle to the right of a crescent-shaped skid mark on sand smeared in blood, is symptomatic of the experiences they had. Ones that make Sontag rethink her ideas about photography. See Leibovitz and Sontag, *Women*, New York: Random House, 2000.

9 Ibid., p. 115.

10 Ibid., p. 109.

11 These photographs were first brought to my attention in Fred Ritchin's *After Photography*, New York: W. W. Norton, 2009. See Chapter 5, "Image, War, Legacy," pp. 79–95.

12 Ibid., p. 76. See also her "A Photograph is Not an Opinion. Or is it?," *Where the Stress Falls*, New York: Vintage, 2003, pp. 238–53.

13 Ibid., p. 123.

14 Ibid., pp. 121–2.

4 The archive as producer

1 The epigraphs are from Benjamin, "Little History of Photography," *Selected Writings Volume 2*, 1927–1934, pp. 508–9; Hal Foster, "An Archival Impulse," *The Archive*, ed. Charles Merewether, London: Whitechapel and Cambridge, MA: MIT Press, p. 143

2 As Andy Grundberg explains, "Modernism required that photography cultivate the photographic—indeed, that it invent the photographic—so that its legitimacy would not be questioned. In a nutshell, two strands—Alfred Stieglitz's [straight photography] and Moholy-Nagy's experimental formalism conspired to cultivate the photographic, and together they wove the shape of modernism." See his "The Crisis of the Real: Photography and Postmodernism," *The Photography Reader*, ed. Liz Wells, London and New York: Routledge, 2003, p. 175. Photographers from Charles Sheeler to Rodchenko all play a role in creating the photographic, which is distinct from documentary as much as it is from art as traditionally defined, that is, before reproducibility. "All agreed that representation needed to be mechanical if it was to be modern; all agreed that art needed to be somehow sober, objective, *sachlich*, at a remove from any simple expressiveness unto itself and at a remove from any claim that the art

object might be a bearer of value in and of itself," as Blake Stimson writes in *The Pivot of the World: Photography and Its Nation*, Cambridge, MA: MIT Press, 2006, p. 146.

3 Merewether, "Introduction, Art and the Archive," *The Archive*, p. 10.

4 Ibid.

5 George Baker, "Photography between Narrativity and Stasis: August Sander, Degeneration, and the Decay of the Portrait," *October*, vol. 76, Spring 1996, p. 82.

6 James E. Young, *At Memory's Edge: After-Images of the Holocaust in Contemporary Art and Architecture*, New Haven: Yale University Press, 2000, p. 66. Note Chapter 3 "Sites Unseen," Shimon Attie's *Acts of Remembrance*, 1991–96, pp. 62–89.

7 Cited in Young, *At Memory's Edge*, p. 67.

8 Mark Reinhardt, "Picturing Violence: Aesthetics and the Anxiety of Critique," *Beautiful Suffering: Photography and the Traffic in Pain*, Williamstown, MA: Williams College Museum of Art and Chicago: University of Chicago Press, 2007, pp. 29–30.

9 Sekula, "The Traffic in Photographs," *Art Journal*, vol. 41, no. 1, Spring 1981, p. 15.

10 Ibid.

11 Sekula, "Reading an Archive: Photography Between Labour and Capital," *The Photography Reader*, p. 444.

12 Ibid., p. 447.

13 Ibid., pp. 444, 446.

14 Ibid., p. 445.

15 Ibid., p. 449.

16 The Atlas Group, "Let's Be Honest, The Rain Helped," *The Archive*, pp. 179–80.

17 Charlotte Cotton, *The Photograph as Contemporary Art*, London: Thames & Hudson, 2004, p. 201.

18 Op cit., p. 180.

19 Sekula, "The Traffic in Photographs," p. 16.

20 Ibid., p. 19.

21 Steichen cited in Louis Kaplan, "Photo Globe: The Family of Man and the Global Rhetoric of Photography," *American Exposures: Photography and Community in the Twentieth Century*, Minneapolis: University of Minnesota Press, 2005, p. 58.

22 Sekula, "The Traffic in Photographs," p. 20.

23 Note Kaplan's discussion of the "ring-around-the-rosy" section: the exhibition had a total of eighteen photographs purporting to show children around the world playing the game. MoMA press release called it a "universal pastime of the young is equally enjoyed in 12 countries." It is debatable if the children are even playing the same game. Global symmetry is what is most important for the exhibition. However, Kaplan shows how this game takes on an awful aspect: the game "originated as a response to the Great Plaque that swept through Europe in the 1600s, and the game allows children to act out the fatal consequences of the disease when singing the last two lines, 'Ashes, ashes we all fall down'. This indicates the Euro-American sources of this nursery rhyme and the way in which death—the falling down of All—becomes the basis of the communal myth ('we') that guides *The Family of Man*. In the wake of the horrific genocides of Hiroshima and the bombing of Hiroshima, Steichen unconsciously turns to this grim nursery rhyme that commemorates death and destruction," p. 63.

24 Benjamin H. D. Buchloh, "Gerhard Richter's Atlas: The Anomic Archive," *The Archive*, p. 91. See also his invaluable essay "From Faktura to Factography," *The Contest of Meaning*, ed. Richard Bolton, Cambridge, MA: MIT Press, 1989, pp. 49–85.

25 Buchloh, "Gerhard Richter's Atlas," pp. 91–2. See also Maud Lavin, *Cut with the Kitchen Knife: The Weimar Photomontages of Hannah Höch*, New Haven: Yale University Press, 1993.

26 In 1925 Bayer devised an experimental typeface he called "universum." In 1936 he designed a brochure for the Deutschland Ausstellung, an exhibition for tourists in Berlin for the Olympic Games. It presented positive images of life in the Third Reich. He left Germany in 1938 for New York, where he worked at the Museum of Modern Art. See Arthur A. Cohen, *Herbert Bayer: The Complete Works*, Cambridge, MA: MIT Press, 1984.

27 The other facets of this context include the hysterical anti-communism in the USA led by Sen. Joseph McCarthy and Rep. George Dondero (blacklists, hearings, House Un-American Activities Committee; homosexuals ousted from government agencies and jobs); Jim Crow law in the South (racial segregation, lynching, etc.); as well as the compensatory optimism of postwar consumer culture. The United States Information Agency was busy promoting the "American Way of Life" via culture, including exporting Abstract Expressionism around the globe to counter Soviet Socialist Realism. During the Cold War both used culture as propaganda—including art and its institutions. Each side wanting to impose a way of seeing the world over the entire globe. Of note is the racial unrest and violence that plagued the USA in the 1950s and how it contradicted its ideological claims abroad. See Blake Stimson, "Photographic Being and The Family of Man," *The Pivot of the World: Photography and Its Nation*, Cambridge, MA: MIT Press, 2006, pp. 59–104.

28 This emphasis on universalism was prevalent at the time. It was a reaction to the human crisis after the full atrocities of the Second World War were made clear.

29 See Sekula, "The Traffic in Photographs" and his later "Between the Net and the Deep Blue Sea: Rethinking the Traffic in Photographs," *October*, vol. 102, Fall 2002.

30 This term is from Roland Barthes. I will discuss it fully in Chapter 5 "Time-images," but here are the basic definitions of the terms Barthes gives in *Camera Lucida*. *Punctum*: (prick, sting, wound) which arrests attention; animates from some detail in the image. It is a trivial photographic detail that disrupts the studium. (The *punctum* in the discourse of *The Family of Man* is certainly not trivial, however.) It is what wounds the viewer. Barthes's examples include a boy's crooked teeth and a woman's pearl necklace. This concept is paired with the studium: general enthusiasm for images and indeed polite interest which may be expressed when confronted with any particular photograph. The "field of cultural interest," p. 94. Elements one can study and explain.

31 The exhibition is an exhibition of mass media images not photographs because the photos are cropped and interchangeable; they serve only to justify a predetermined thesis. This takes aesthetic questions out of the equation. Photographers whose work was included objected to Steichen's use of their work because it lessened the value of the medium of photography just at the moment when it was struggling for acceptance in art museums and galleries.

32 Jacques Rancière, *The Future of the Image*, trans. Gregory Elliott, London and New York: Verso, 2007, p. 10.

33 Barthes, *Mythologies*, trans. Annette Lavers, New York: Hill and Wang, 1972, p. 101.

34 This phrase is from Benedict Anderson's influential study *Imagined Communities: Reflections on the Origin and Spread of Nationalism*, London and New York: Verso, 1991.

35 See *Ni Haifeng: No Man's Land* with essays by Marianne Brouwerand and Roel Arkesteijn, Amsterdam: Artimo, 2004 and *Ni Haifeng: The Return of the Shreds*, eds Kitty Zijlmans and Ni Haifeng with essays by Marianne Brouwerand and Zijlmans, Leiden: Valiz and Museum De Lakenhal, 2008.

36 Orientalism is a term for the attitude of racial superiority adopted by many white Europeans and Americans toward Middle-Eastern, North African, and Asian peoples. Nineteenth-century Europe is marked by a near mania for Orientalist representations, at first paintings and later photographs as well. In 1978 Edward Said published a widely influential text entitled *Orientalism* that focuses on how Western (Occidental) European culture is defined against and through its supposed antithesis: the Orient. In short, European culture is created through a dialectic (a dialogue between contending or opposing forces that tries to reach a resolution or synthesis) or power-relation with its non-European others.

37 Sekula, "The Traffic in Photographs," p. 18.

38 It is prevalent throughout the arts during this period; note Gericault's *Portrait of a Kleptomaniac* (c. 1820).

39 The *Oxford English Dictionary* gives the definition of "coquetry" that was operative around the time of Duchenne's work. It defines a "woman (more or less young) who uses arts to gain the admiration and affection of men, merely for the gratification of vanity or for a desire of conquest, and without any intentions of responding to the feelings aroused." See Shelley King and Yaël Rachel Schlink, *Refiguring the Coquette: Essays on Culture and Coquetry*, Cranbury, NJ: Associated University Press, 2008. On how these issues operate in Duchenne's work, see Robert Sobieszek, *Ghost in the Shell: Photography and the Human Soul*, Los Angeles: Los Angeles County Museum of Art and Cambridge, MA: MIT Press, 1999.

40 Duchenne and Oscar Rejlander created photographs to illustrate Charles Darwin's book *The Expression of the Emotions* (c. 1872). Darwin argued that physical signs of emotion were inherently the same in all humans, and that animals had emotions that they expressed in similar ways. Natural selection and evolution could perhaps be borne out by examining human and animal expression. The photograph of a crying baby from the book became a huge hit with the British public and was known as the "Ginx Baby," the print sold c. 300,000 copies.

41 Both ideas of physiognomy coexist into the late nineteenth century. See Francis Galton's *Inquires into Human Faculty and Development* (1883). Note Galton's bizarre composite photographs in which several portraits of criminals (of varying degree) are superimposed in order to present a composite of shared physiognomic traits. Galton also played a role in developing fingerprinting in India while it was under British colonial rule. Giorgio Agamben has addressed Bertillon's work; see his *Nudities*, trans. David Kishik and Stefan Pedatella, Stanford: Stanford University Press, 2011, pp. 48–53.

42 Geoffrey Batchen, *Burning with Desire*, p. 7.

43 In 1861 C. Jabez Hughes wrote an essay on what he termed "art" photography. In it he distinguished between three levels of photography. These levels were deemed a strict hierarchy. First, mechanical photography: "aim[s] at a simple representation of the objects to which the camera is pointed." Basic recording depicting whatever is before the camera "as it is." Second, art-photography: here a photographer "determines to diffuse his mind into [objects] by arranging, modifying, or otherwise disposing them, so that they may appear in a more appropriate or beautiful manner." Third, the highest echelon of photography practice, for Hughes, was high-art photography: "certain pictures which aim at a higher purpose than the majority of art-photographs, and whose purpose is not merely to amuse but to instruct, purify, and ennoble." The assumption that art was an edifying, moral, and social instrument was common in the nineteenth century.

44 Preziosi, *Brain of the Earth's Body: Art, Museums, and the Phantasms of Modernity*, Minneapolis: University of Minnesota Press, 2003, pp. 96, 98.

45 Of course, this is a complicated history that requires in-depth study by anyone interested in the history of photography. One of the best collections of essays on the subject is *Anthropology and Photography 1860–1920* ed. Elizabeth Edwards, New Haven: Yale University Press, 1992, which was published in association with The Royal Anthropological Institute in London. See especially the essays by Christopher Pinney and James C. Farris: "The Parallel Histories of Anthropology and Photography," pp. 74–95 and "A Political Primer on Anthropology/Photography," pp. 253–63.

46 Marien, *Photography: A Cultural History*, Upper Saddle River, NJ: Prentice Hall, 2011, p.31. See also pp. 479 and 481.

47 There are 540 images in total. But Sander's archives have tens of thousand of negatives. Although we only have sixty photos from the first volume, we can see the larger project in Ulrich Keller and Gunther Sander's reconstruction of *Citizens*, Cambridge, MA: MIT Press, 1986. Issues of cropping and sequencing must be approached with caution, but Keller has followed instructions for the ordering of photos that Sander himself wrote.

48 Sekula, "The Traffic in Photographs," p. 17. Sander gave five individually titled lectures in 1931; the set was entitled "The Nature and Growth of Photography."

49 Baker, "Photography between Narrativity and Stasis," p. 80.

50 Sekula, Buchloh, and Baker critique Sander's attempt to continue the viability of the traditional portrait in the 1920s and 1930s. Their criticism extends the radical avant-garde critique of the portrait, see Alexander Rodchenko "Against the Synthetic Portrait, for the Snapshot" (1928), *Photography in the Modern Era: European Documents and Critical Writings. 1913–1940*, ed. Christopher Phillips, New York: The Metropolitan Museum of Art and Aperture, 1989, pp. 238–42.

51 In his "Photography as a Universal Language" (1931) Sander stated: "The field in which photography has so great a power of expression that language can never approach it, is physiognomy."

52 For general background on New Objectivity see Jost Hermand, "Unity within Diversity? The History of the Concept 'Neue Sachlichkeit'," *Culture and Society in the Weimar Republic*, Manchester: Manchester University Press, 1977, pp. 166–82. See also Ute Eskildsen, "Photography and the Neue Sachlichkeit Movement," *Neue Sachlichkeit and German Realism of the Twenties*, London: Hayward Gallery, 1979. The name "Neue Sachlichkeit" was coined by Gustav Friedrich Hartlaub as the title for a 1925 exhibition at the Mannheim art gallery. It signified art that rejected fragmentation of Impressionism and Expressionism in favor of tangible reality. The nature of Sander's relation to New Objectivity is complicated. Baker posits that "ambivalence… perfectly describes Sander's historical position as a Neue Sachlichkeit photographer," p. 112. Sander's work has been "embraced since its initial reception as an exemplar of the socially engaged wing of Neue Sachlichkeit photography, in opposition to the more aesthetic (one could substitute fetishistic) explorations of a Karl Blossfeldt or Albert Renger-Patzsch," p. 76. For Baker and others, it is "countermodernist," even reactionary, when compared to the avant-garde practices between the wars. Yet Sander does montage two different photographs into a single one, more composite photography than avant-garde montage; see *Farm Children* (c. 1927–8), which Baker discusses on p. 99. There is a tie here to Diane Arbus's photography of twins; see Carol Armstrong, "Biology, Destiny, Photography: Difference According to Diane Arbus" *October*, vol. 66, Fall 1993 and Max Kozloff, "The Uncanny Portrait: Sander, Arbus, Samaras," *Artforum*, June 1973, pp. 58–66. It is also interesting to note, as Baker does, that the main exception to Benjamin's invective against New Objectivity is Sander. Precisely why Benjamin exempted Sander remains an intriguing problem for future work.

53 Alfred Döblin, "About Faces, Portraits, and Their Reality: Introduction to August Sander, Antlitz der Zeit" (1929), *Germany: The New Photography. 1927–33*, ed. David Mellor, London: Arts Council of Great Britain, 1978, p. 58.

54 Sekula, "The Traffic in Photographs," p. 18.

55 The Nazi Ministry of Culture also repeatedly ordered searches of Sander's archives, confiscated some negatives, and forced him to abandon the entire project. The reasons for this attention are varied. Some commentators note that Sander's eldest son Erich was a committed Marxist, who was imprisoned for ten years beginning in 1943, suggesting that it may have been retaliation for Erich's political activities. Note as well that even "the concept of the 'type', the universal characteristic to which many lesser phenomena correspond, was both a common and a highly debated idea during the Weimar period." This includes the Nazi emphasis on the *Stämme*, the originary Germanic tribes, rooted in the earth," the *Volk* as an Ur-type. See Baker, p. 84.

56 Op cit., p. 19.

57 Ibid.

58 Baker, "Photography between Narrativity and Stasis," p. 77.

59 Ibid., p. 73.

60 Baker astutely adds that there is no simple, agreed upon understanding of the relation between narrativity and stasis, for stasis has been theorized as both force that disrupts the repressions of narrativity and as a force of repression itself.

61 Ibid., p. 98.

62 Ibid., p. 112.

63 Ibid., p. 90.

64 Ibid., p. 83.

65 Ibid., p. 85. See Szarkwoski, "August Sander: The Portrait as Prototype," *Infinity*, vol. 12, no. 6, June 1963.

66 Ibid., p. 113.

67 Baker claims this without referring the reader to any arguments that show this political function of Struth and Bechers. Earlier in his essay he refers to Benjamin Buchloh's essay "Thomas Struth's Archive," *Thomas Struth: Photographs*, Chicago: Renaissance Society at the University of Chicago, 1990. This appears to be the justification for his concluding remarks.

68 For a comprehensive history of the Bechers's work see Susanne Lange, *Bernd and Hilla Becher: Life and Work*, trans. Jeremy Gaines, Cambridge, MA: MIT Press, 2007.

69 Many commentators make the connection between the Bechers's use of typology and nineteenth-century archival and typological photographic projects in a variety of contexts, including criminology, medicine, or botany. As Blake Stimson explains, "The term they generally use to describe their method is typological, and they freely state that it has 'much to do with the 19th century', that is, they say, with 'the encyclopedic approach' used, for example, in botany or zoology or, we might add, various psychophysiological approaches used in medicine and criminology." See his *The Pivot of the World*, p. 146. This ties to Sekula's work on the archive.

70 Cited in Michael Fried, *Why Photography Matters as Art as Never Before*, New Haven: Yale University Press, 2008, p. 306.

71 Stimson, *The Pivot of the World*, p. 146.

72 Anne-Moeglin-Delcroix, "The Model of the Sciences," *The Archive*, pp. 109–10.

73 Fried, *Why Photography Matters as Art as Never Before*, p. 309.

74 Cited in ibid., p. 322.

75 Ibid., pp. 327–8.

76 Stimson, *The Pivot of the World*, p. 137.

77 Cited in ibid., p. 152.

78 Ibid., p. 167.

79 Here is Stimson's wager in full: "the manner in which serial photography inscribes a point of view or grammar constitutive of political subjectivity, the manner in which it creates the lived experience of social form. To put this another way, we can ask whether the movements of body and machine required to take a picture can become conventionalized and therefore shift from being not only the instrumental movement necessary to perform an operation to something that takes on the cultural expressiveness and conventionality of comportment," p. 170.

80 Ibid., p. 149.

81 Ibid., p. 160.

82 Cited in Fried, *Why Photography Matters*, p. 309.

83 Consider Walid Ra'ad and Akram Zaatari's *Mapping Sitting*, an atlas made from archival portrait photographs from the Arab Image Foundation's archives, which maps Arab diversity. The concept of an atlas helps construct a line through some of these archival projects from different time periods and cultural contexts. Hence it is worth noting Benjamin's discussion of Sander's project, which he called an "*Übungsatlas*," literally an "atlas of exercise," a training manual. See Benjamin Buchloh, "Gerhard Richter's Atlas: The Anomic Archive," *Archive*, note 3, pp. 100–1. Buchloh's essay was first published in the exhibition catalogue *Deep Storage: Collecting, Storing and Archiving in Art*, eds Ingrid Schaffner and Andreas Winzen, Munich: Prestel Verlag, 1998. Note also Anne Halley, "August Sander," *Massachusetts Review*, Winter 1978, who discusses Benjamin's calling it a "training atlas." Baker adds that the best-selling photographic training manuals of the time were those of proto-fascist racial theorists.
Benjamin was well-aware that at the time of his essay (1931) Sander's work had a precarious position. "Work like Sander's could overnight assume unlooked-for topicality.

Sudden shifts of power such as are now overdue in our society can make the ability to read facial types a matter of vital importance…Sander's work is more than a picture book. It is a training manual," he wrote. See *Selected Writings Volume 2*, p. 520. Buchloh understands both the advent of photomontage and archival projects in the 1920s and 1930s as symptomatic of a "memory crisis," as such he reads the art historian Aby Warburg's *Mnemosyne Atlas* (1928–9), which unfinished comprised over sixty panels with over one thousand photographs (reproductions of art, images from celebrity magazines, postage stamps, etc.) that attempted to map the "afterlife" (*Nachleben*) of antiquity. Buchloh contrasts Warburg's montage project presenting cultural transmission with Gerhard Richter's *Atlas* in 1961. Richter's *Atlas* is discussed in full by Buchloh. An atlas was a key concept in the nineteenth century, Buchloh explains, as it "had been increasingly deployed to identify any tabular display of systematized knowledge and one could have encountered an atlas in almost all fields of the empirical sciences," p. 87.

84 Snyder, "Territorial Photography," *Landscape and Power*, ed. W. J. T. Mitchell, Chicago: University of Chicago Press, 1994, p. 182.
85 See Snyder, *American Frontiers: The Photographs of Timothy O'Sullivan. 1867–1874*, New York: Aperture, 1981.
86 Kelsey, "Viewing the Archive: Timothy O'Sullivan's photographs for the Wheeler Survey, 1871-74," *Art Bulletin*, vol. 85, no. 4, December 2003, pp. 702–23.
87 Ibid.
88 Ibid.
89 Krauss's essay has had this stature since its original publication in the 1982 issue of *Art Journal*. The essay's reprinting in her *The Originality of the Avant-Garde and Other Modernist Myths* (1985) and again in Bolton's *The Contest of Meaning* (1989) undoubtedly assured this stature. Andrew E. Herschberger unpacks all of this and, more importantly, Krauss's misreading of Foucault's conception of the archive in his invaluable essay "Krauss's Foucault and the Foundations of Postmodern History of Photography," *History of Photography*, vol. 30, no. 1, Spring 2006, pp. 55–67. He shows that another key text by Abigail Solomon-Godeau entitled "Canon Fodder: Authoring Eugène Atget" shares Krauss's assumptions and misinterpretations of Foucault, particularly on the notion of an artist/author. See Solomon-Godeau's *Photography at the Dock: Essays on Photographic History. Institutions, and Practices*, Minneapolis: University of Minnesota Press, 1991, pp. 28–51.
90 As the premise for *Before Photography*, a MoMA exhibition in 1981, Peter Galassi wrote: "The object here is to show that photography was not a bastard left by science on the doorstep of art, but a legitimate child of the Western pictorial tradition," p. 12.
91 Krauss, *The Originality of the Avant-Garde*, p. 134.
92 Ibid.
93 Ibid.
94 Herschberger, "Krauss's Foucault," p. 63.
95 Ibid., p. 58. Foucault, *The Archaeology of Knowledge*, p. 37.
96 Krauss, *The Originality of the Avant-Garde*, p. 150.
97 Foucault, *The Archaeology of the Knowledge*, p. 130.
98 Herschberger, "Krauss's Foucault," p. 65.
99 Ibid., p. 66.
100 Foucault, *The Archaeology of Knowledge*, p. 205.
101 Derrida, *Archive Fever: A Freudian Impression*, trans. Eric Prenowitz, Chicago: University of Chicago Press, 1995, pp. 33, 36.

Gloss on Michel Foucault

1 Foucault, *The Archaeology of Knowledge and The Discourse on Language*, trans. A. M. Sheridan Smith, New York: Pantheon Books, 1972. On Foucault see Gary Gutting, ed., *The Cambridge Companion to Foucault*, Cambridge: Cambridge University Press, 1994;

Sara Mills, *Michel Foucault*, London and New York: Routledge, 2003; and Gary Shapiro *Archaeologies of Vision: Foucault and Nietzsche on Seeing and Saying*, Chicago: University of Chicago Press, 2003. I would also like to direct the reader's attention to the special Fall 2007 issue of *Afterimage*, ed. David Brittain, entitled "Photography and the Archive." It includes a well-written essay by David Bate, "The Archaeology of Photography: Rereading Michel Foucault and *The Archaeology of Knowledge*," *Afterimage*, vol. 35, no. 3, September–October 2007, pp. 3–6.

2 Donald F. Bouchard, "Introduction," *Language, Counter-Memory, Practice: Selected Essays and Interviews*, trans. Donald F. Bouchard and Sherry Simon, Ithaca: Cornell University Press, 1977, p. 17.

3 Foucault, *The Archaeology of Knowledge*, p. 131.

4 Foucault, "On the Ways of Writing History," *Aesthetics, Method, and Epistemology: Essential Works of Foucault 1954–1984 Volume 2*, ed. James D. Faubion, New York: The New Press, 1998, p. 292.

5 Op cit., p. 130.

6 Ibid., p. 209.

7 Foucault, "On the Archaeology of the Sciences: Response to the Epistemology Circle," *Aesthetics, Method, and Epistemology: Essential Works of Foucault 1954–1984 Volume 2*, ed. James D. Faubion, New York: The New Press, 1998, p. 311.

8 As Hayden White explains, "Foucault's suspicion of reductionism in all its forms is manifested in his professed lack of interest in the relation of a work or corpus of works to its social, economic, and political contexts. For example, to purport to 'explain' transformations of consciousness between the eighteenth and nineteenth centuries by appealing to the 'impact' of the French Revolution on social thought would be, for him, a form of *petitio principii* [literally, "begging the question," meaning it would be circular reasoning]. For what we call the 'French Revolution' was actually a complex of events which occurred extrinsically to the 'formalized consciousness' of the age in which it occurred...And this means, for Foucault, that the formalized consciousness of an age does not change in response to 'events' occurring in its neighborhood or in the domain staked out by its various human sciences...what 'life', 'labor', and 'language' *are* is nothing but what the relationship presumed to exist between words and things permits them to appear to be in a given age." See White, "Foucault Decoded: Notes from Underground," *Tropics of Discourse: Essays in Cultural Criticism*, Baltimore: Johns Hopkins University Press, 1978, p. 237.

9 Ibid., p. 234.

10 Paul A. Bové, "Discourse," *Literary Terms for Critical Study*, eds Frank Lentricchia and Thomas McLaughlin, Chicago: University of Chicago Press, 1990, p. 60.

11 Foucault, "On the Ways of Writing History," p. 293.

12 Foucault, *The Archaeology of Knowledge*, p. 120.

13 Ibid., p. 129.

14 Ibid.

15 Foucault, "On the Archaeology of the Sciences," p. 309.

16 Ibid.

17 White, "Foucault Decoded," p. 239.

18 Ibid., p. 240.

19 Foucault, "On the Archaeology of the Sciences," p. 309.

20 Foucault, *The Archaeology of Knowledge*, p. 130.

21 Ibid., p. 122.

22 Deleuze, "Michel Foucault's Main Concepts," *Two Regimes of Madness: Texts and Interviews 1975–1995*, ed. David Lapoujade, trans. Ames Hodges and Mike Taormina, New York: Semiotext(e), 2007, p. 248. See also Deleuze, *Foucault*, trans. Seán Hand, Minneapolis: University of Minnesota Press, 1988.

23 See Foucault, *The Order of Things: An Archaeology of the Human Sciences*, trans. Alan Sheridan, New York: Vintage, 1970, Chapter 1 "Las Meninas." Foucault gave a series of lectures on

Manet while he was teaching at the University of Tunis in 1971. He planned a book on Manet that never came to fruition, although parts of his thinking on Manet are to be found in the conclusion of *The Archaeology of Knowledge* and in the transcriptions of his lectures from Tunis published as *Le Peinture de Manet*, Paris: Éditions du Seuil, 2004. Foucault did publish an amazing small study on René Magritte entitled *This Is Not A Pipe*, trans. James Harkness, Berkeley and Los Angeles: University of California Press, 1983.

24 Op cit.
25 Ibid., p. 253.
26 Deleuze, *Foucault*, p. 34
27 Ibid., p. 35.
28 Ibid., p. 119.
29 Deleuze and Guattari, *What Is Philosophy?*, trans. Hugh Tomlinson and Graham Burchell, New York: Columbia University Press, 1994, p. 112.

5 Time-images

1 The epigraphs are from Evans, "The Reappearance of Photography" (1931), *Classic Essays on Photography*, p. 185; Wollen, "Fire and Ice," *The Photography Reader*, p. 76.
2 Gilles Deleuze, *Proust and Signs: The Complete Text*, trans. Richard Howard, Minneapolis: University of Minnesota Press, 2000, p. 97.
3 Georges Didi-Huberman, *Confronting Images: Questioning the Ends of a Certain History of Art*, trans. John Goodman, University Park, Penn.: Pennsylvania State University Press, 2005. He writes: "A history of images, it should be clear, cannot be the same thing as a history of artists—something with which the history of art still identifies itself much too often…we must also think a history of impossible objects and unthinkable forms, bearers of a destiny, critiquing appearances. Is this to turn our backs on art images?…I don't think so…I imagine a history of imperious and sovereign exceptions that would develop the counter-subject of the visual in a melody of the visible, a *history of symptomatic intensities*…in which the expanse of the great mimetic fabric is partially rent. This would be a history of the limits of representation," p. 194.
4 Here my thinking is indelibly colored by the work of Aby Warburg. See his *The Renewal of Pagan Antiquity: Contributions to the Cultural History of the European Renaissance*, trans. David Britt, Los Angeles: Getty Research Institute, 1999; *Art History as Cultural History: Warburg's Projects*, ed. Richard Woodfield, London and New York: Routledge, 2001; and Philippe-Alain Michaud, *Aby Warburg and the Image in Motion*, trans. Sophie Hawkes, New York: Zone Books, 2007. My interpretation of Warburg has been greatly informed by Didi-Huberman's brilliant readings of Warburg, particularly "Artistic Survival: Panofsky vs. Warburg and the Exorcism of Impure Time," *Common Knowledge*, vol. 9, no. 2, 2003, p. 282. See also his "Before the Image, Before Time: The Sovereignty of Anachronism," *Compelling Visuality: The Work of Art In and Out of History*, eds Claire Farago and Robert Zwijnenberg, Minneapolis: University of Minnesota Press, 2003, pp. 31–44.
5 Deleuze and Félix Guattari, *A Thousand Plateaus: Capitalism and Schizophrenia*, trans. Brian Massumi, Minneapolis: University of Minnesota Press, 1987, p. 293.
6 Elizabeth Grosz, *Chaos. Territory. Art: Deleuze and the Framing of the Earth*, New York: Columbia University Press, 2008, p. 7.
7 Cited in Philip Gefter, "Keeping His Eye on the Horizon (Line)" *The New York Times*, April 6, 2008, p. 30.
8 Ibid.
9 Deleuze and Guattari, *What Is Philosophy?*, trans. Hugh Tomlinson and Graham Burchell, New York: Columbia University Press, 1994, p. 176.
10 Wollen, "Fire and Ice," p. 78.
11 Ibid.

12 Ibid., p. 80.
13 Ibid., p. 79.
14 Ibid.
15 David Campany, "Safety in Numbness: Some Remarks on Problems of 'Late Photography'," *The Cinematic*, ed. D. Campany, London: Whitechapel and Cambridge, MA: MIT Press, 2007, p. 186. See also Campany, *Art and Photography*, London: Phaidon, 2003.
16 Talbot gives us this phrase as a caption to *Plate I. Part of Queen's College, Oxford.* "This building presents on its surface the most evident marks of the injuries of time and weather," he writes. See *The Pencil of Nature*, New York: Da Capo Press, 1969. Note also the collection of essays ed. Scott Walden, *Photography and Philosophy: Essays on The Pencil of Nature*, Malden, MA: Wiley-Blackwell, 2010.
17 Barthes, *Image-Music-Text*, p. 73.
18 This misunderstanding applies even to John Szarkowski, who introduced the section "Time" in *The Photographer's Eye* by writing: "More subtle was the discovery of that segment of time that Cartier-Bresson called the *decisive moment*: decisive not because of the exterior event (the bat meeting the ball) but because in that moment the flux of changing forms and patterns was sensed to have achieved balance and clarity and order—because the image became, for an instant, a *picture*." My work through this chapter and book has been to reverse this logic: to arrive at a sense of an image not as a picture or even as a photograph. An image with an ontology and a set of functions that is not grounded in any specific medium. An image has a privileged relation to photography, but it is not reducible to it.
19 See Cartier-Bresson's 1952 preface in *The Cinematic*, pp. 43–7. Campany provides the possible translations I have cited above. He also adds that Cartier-Bresson "came to feel that the English title unduly influenced the reading of his work" and concluding that he left the title of preface in its original French at the request of Cartier-Bresson's family, see note 1, p. 47.
20 Ibid., p. 47.
21 De Duve, "Time Exposure and Snapshot: The Photograph as Paradox," *The Cinematic*, p. 60.
22 Ibid.
23 Ibid., p. 52.
24 Ibid.
25 Ibid., p. 53.
26 Ibid.
27 Ibid.
28 Ibid., p. 55.
29 Ibid., p. 52.
30 The importance of an index as a type of sign stems from the semiotic work of Charles Sanders Peirce. Focusing on the indexical nature of photography, above all others, has become a canonical approach since Rosalind Krauss's two-part essay "Notes on the Index: Seventies Art in America," *October*, vols 3 and 4, Spring 1977. See her *The Originality of the Avant-Garde and Other Modernist Myths*.
31 Op cit., p. 53.
32 Ibid.
33 Ibid., p. 56.
34 Ibid., p. 57.
35 Ibid., p. 57. He adds: "But photography is probably the only image-producing technique that has a mourning process built into its semiotic structure, just as it has a built-in trauma effect. The reason is again that the referent of an index cannot be set apart from its signifier," p. 59.
36 Sontag, *On Photography*, p. 164.
37 Ibid., p. 71.

38 Benjamin, *The Arcades Project*, p. 458. Benjamin repeatedly refers to the concept of a "threshold" through *The Arcades Project*. He writes: "The threshold must be carefully distinguished from the boundary. A *Schwelle* [threshold] is a zone. Transformation, passage, wave action are in the work *schwellen*, swell, and etymology ought not to overlook these senses. On the other hand, it is necessary to keep in mind the immediate tectonic and ceremonial context which has brought the word to its current meaning," p. 494. His understanding of a "threshold" becomes clear when, defining the dialectical image, he insists that there must by no point of temporal contiguity between a moment of the past and a moment of the present, but only a threshold between them. The dialectical image presents itself in this threshold; see p. 214.

39 Benjamin, *Selected Writings Volume 1. 1913–1926*, eds Marcus Bullock and Michael W. Jennings, Cambridge, MA: The Belknap Press of Harvard University Press, 1996, pp. 104, 109.

40 This logic reinforces Benjamin's discussion of origin (*Ursprung*). He asserts that the type of critical history he desires "distinguishes that which concerns us as originary in historical experience from the pieced-together findings of the factual. 'What is original [*ursprünglich*] never allows itself to be recognized in the naked, obvious existence of the factual; its rhythm is accessible only to a dual insight. This insight…concerns the fore-history and after-history of the original'," *The Origin of German Tragic Drama*, trans. John Osborne, London and New York: Verso, 1999, p. 45.

41 Italics mine. Benjamin, *Selected Writings Volume 3. 1935–1938*, eds Howard Eiland and Michael W. Jennings, Cambridge, MA: The Belknap Press of Harvard University Press, 2002, p. 344. This concept of the "necessary social irretrievability of the past" was central to my *The Gesture of Collecting: Walter Benjamin and Contemporary Aesthetics*, dissertation, UCLA, 2006. See also my "An Art History of Means: Arendt-Benjamin," *Journal of Art Historiography*, vol. 1, December 2009.

42 Benjamin, *Selected Writings Volume 2*, p. 487.

43 Ibid., p. 487. Benjamin's understanding of "renewal" is directly alluded to in a passage from "Berlin Childhood around 1900." In the 1934 version of the text he writes: "After every Christmas and birthday celebration, I had to single out one of my presents to be donated to the 'new cabinet', whose key my mother would put aside for me. Whatever was stored away kept its newness longer. I, however, had something else in mind: *not to retain the new but to renew the old*. And to renew the old—in such a way that I myself, the newcomer, would make what was old my own—was the task of the collection that filled my drawer. Every stone I discovered, every flower I picked, every butterfly I captured was for me the beginning of a collection and, in my eyes, all that I owned made for one unique collection…It was thus that the things of childhood multiplied and masked themselves, " [italics mine] p. 403. Benjamin relates a telling memory here. The phrase "to renew the old" directly relates "renewal" to "the irretrievability of the past."

44 Sontag, *On Photography*, p. 76.

45 Deleuze and Guattari, *What Is Philosophy?*, pp. 33–4.

46 Mark Haward-Booth, *Photography: An Independent Art. Photographs from the Victoria and Albert Museum 1839–1996*, London, V&A Publications, 1997, p. 104. In 1925, while acting as Man Ray's assistant in Paris, Berenice Abbott rediscovered Atget's work. She salvaged a large number of prints, negatives, and memorabilia that would have otherwise been lost. Abbott's rescue of Atget is mentioned by Benjamin in "Little History of Photography" and Beaumont Newhall in "A Documentary Approach to Photography." Abbott helped organize the first publication of Atget's work, *Atget Photographe de Paris* in 1930 and in 1964 she published *The World of Atget*. On the contentious history of Atget in postmodern photographic discourse see Abigail Solomon-Godeau's "Canon Fodder: Authoring Eugène Atget," *Photography at the Dock: Essays on Photographic History. Institutions. and Practices*, Minneapolis: University of Minnesota Press, 1991. See also Molly Nesbit's *Atget's Seven Albums*, New Haven: Yale University Press, 1993.

47 Benjamin, *Selected Writings Volume 2*, p. 518.

48 Ibid., p. 519. The Place de Tertre is the square in Montmartre in Paris where many poor, struggling bohemian artists lived at the turn of the century, including Pablo Picasso and Utrillo.

49 Benjamin's reading of Atget's photographs as being "without mood" contrasts with de Duve's reading of the manic-depressive vector of photography wherein "mood" is considered presymbolic, thus the aphasia he discusses and, by extension, the trauma we purportedly experience before a photograph; see De Duve, "Time Exposure and Snapshot," p. 60. In Benjamin's reading, "without mood" means that Atget's work is neither manic nor depressive; they are ellipses, slight pauses in language, stutters or gestures that point (not solely by Atget's doing) to forces outside the picture.

50 My reading here borrows from Deleuze's understanding of Peirce's indexical sign as given in *Cinema I: The Movement-Image*, trans. Hugh Tomlinson and Barbara Habberjam, Minneapolis: University of Minnesota Press, 2001. See Chapter 2 for a full discussion of this concept.

51 Benjamin, *Selected Writings Volume 2*, p. 510.

52 Ibid.

53 Ibid., p. 527.

54 Benjamin, *The Arcades Project*, p. 456. This is Benjamin's definition of his famous concept of the "dialectical image": "It's not that what is past casts its light on what is present, or what is present its light on what is past; rather, image is that wherein what has been comes together in a flash with the now to form a constellation. In other words, image is dialectics at a standstill…Only dialectical images are genuinely historical— that is, not archaic—images. The image that is read—which is to say, the image in the now of its recognizability—bears to the highest degree the imprint of the perilous critical moment on which all reading is founded," pp. 462, 463.

55 It is the potentiality of recollection to render the incomplete-complete, the accomplished-unaccomplished. Benjamin's use of the German word *"Eingedenken"* signifies not merely a remembrance, but a "bearing or a calling in mind." This "bearing in mind" is an openness, an attentiveness (*Aufmerksamkeit*). Recollection bears oblivion in mind, thereby distorting any and every relation between memory and forgetting. For this reason, Benjamin views the "turn of recollection" as a radical alteration of our liberal humanist, even scientific, conception of knowledge.

56 Giorgio Agamben notes that Proust was "obsessed with photography" in his *Profanations*, trans. Jeff Fort, New York: Zone Books, 2007, p. 27.

57 Beryl Schlossman, "Proust and Benjamin: The Invisible Image," *Benjamin's Ground: New Readings of Walter Benjamin*, ed. Rainer Nägele, Detroit: Wayne State University Press, 1989, pp. 107–8. Her essay is pp. 105–17. For her reference to Jacques Lacan see his comments on the gaze and the mirror stage in the section "What is a Picture?" in *The Seminar of Jacques Lacan Book XI: The Four Fundamental Concepts of Psychoanalysis*, trans. Alain Sheridan, New York: W. W. Norton, 1998, pp. 105–22.

58 Deleuze, *Cinema I*, p. 207.

59 Deleuze, *Proust and Signs*, p. 27.

60 Ibid., p. 32. He adds: "And when we protest against an art of observation and description, how do we know if it is not our incapacity to observe, to describe, that inspires this protest, and our incapacity to understand life?"

61 Ibid., p. 54.

62 "Time wasted, lost time—but also time regained, recovered time. To each kind of sign there doubtless corresponds a privileged line of time. The worldly signs imply chiefly a time wasted; the signs of love envelop especially a time lost. The sensuous signs often afford us the means of regaining time, restore it to us at the heart of time lost. The signs of art, finally, give us a time regained, an original absolute time that includes all the others," Deleuze, *Proust and Signs*, p. 24.

63 Deleuze, *Cinema I*, p. 214; *Proust and Signs*, p. 27.

64 Deleuze, *Proust and Signs*, p. 57.
65 Proust cited in ibid., p. 54.
66 Ibid., p. 60.
67 Ibid., pp. 60–1.
68 Ibid., p. 55.
69 Ibid., p. 161.
70 Ibid.
71 Ibid., p. 110.
72 Ibid., p. 62.
73 Ibid., p. 152.
74 Ibid., p. 117.
75 Ibid., p. 153.
76 Ibid., p. 155.
77 Ibid., p. 122.
78 Ibid., p. 114.
79 Ibid., p. 115.
80 Ibid., p. 30.
81 Ibid., p. 94.
82 Benjamin, *Selected Writings Volume 1*, p. 481.
83 Op cit., pp. 95, 97.
84 Deleuze, *Foucault*, trans. Seán Hand, Minneapolis: University of Minnesota Press, 1988, p. 108.
85 This transition does not end the discussion of Proust. On the contrary, Mieke Bal demonstrates that Barthes's *Camera Lucida* has a central place in any discussion of Proust. In "Vision in Fiction: Proust and Photography," Bal writes: "The reader no doubt remembers the opening of Barthes's *Camera Lucida*…The concept of photography that Barthes develops further in the book is already present: it is a vision, by definition in the present, of an irretrievably past vision. There is no exchange of eye contact, but nonetheless two gazes confront each other, the one dead, the other alive. Between these two gazes the gulf of past time has carved itself out," *Looking In: The Art of Viewing*, Australia: G+B Arts International, 2001, p. 209.
86 Barthes, *Camera Lucida*, p. 63.
87 Ibid., p. 82.
88 Ibid., p. 90.
89 Ibid., p. 91.
90 Ibid., p. 3.
91 Ibid., p. 5.
92 On the distinction between similitude and resemblance see Michel Foucault, *This Is Not A Pipe*, trans. James Harkness, Berkeley and Los Angeles: University of California Press, 1983.
93 Op cit., p. 6
94 Ibid., p. 7.
95 Note the intriguing relation between what he termed "the third meaning" in a discussion of film in *Image-Music-Text* and the *punctum*. These concepts are not identical, but they share a terrain. See *Image-Music-Text*, pp. 60–5.
96 Op cit., p. 7.
97 Ibid., p. 26. "The *studium* is of the order of *liking*, not of *loving*; it mobilizes a half desire, a demi-volition; it is the same sort of vague, slippery, irresponsible interest one takes in the people, the entertainments, the books, the clothes one finds 'all right'," p. 27. Love, as an event that transforms subject and object, is certainly central to Barthes's concept of the *punctum*. "For it is not indifference which erases the weight of the image—the Photomat always turns you into a criminal type, wanted by the police—but love, extreme love," p. 12.
98 Ibid., p. 27. Note Deleuze on chance in the work of the painter Francis Bacon. In the "Afterword," Tom Conley explains something that I view as pertinent to photography as well: "For Deleuze and Bacon an accident or an event is a result of a manipulation of

things given, of affective investment made through a selection taken from thousands of clichés saturating a prepictorial field. Out of it emerges a painting, an image, that is both within and beyond the creator's control," *Francis Bacon: The Logic of Sensation*, trans. Daniel W. Smith, Minneapolis: University of Minnesota Press, 2003, p. 142.

 99 Barthes, *Camera Lucida*, p. 49.
100 Ibid., p. 76.
101 Ibid., p. 21.
102 Ibid., p. 20.
103 Ibid., p. 87.
104 Ibid.
105 Ibid., pp. 95–6.
106 Ibid., p. 71.
107 Ibid., p. 88.
108 Ibid., p. 89.
109 Mitchell, *What Do Pictures Want? The Lives and Loves of Images*, Chicago: University of Chicago Press, 2005, p. 9.
110 Ibid., p. 8.
111 Ibid., pp. 8–9.
112 Ibid., p. 10.
113 Ibid., p. xv.
114 Deleuze and Claire Parnet, *Dialogues II*, trans. Hugh Tomlinson and Barbara Habberjam, New York: Columbia University Press, 2002, p. 7.
115 Deleuze, *Cinema II: The Time-Image*, trans. Hugh Tomlinson and Robert Galeta, Minneapolis: University of Minnesota Press, 2001, p. 115.
116 Deleuze and Guattari, *What Is Philosophy?*, p. 177. Deleuze clarifies his meaning of the "virtual" by writing: "A life contains only virtuals. It is made up of virtualities, events, singularities. What we call virtual is not something that lacks reality but something that is engaged in a process of actualization following the place that gives it its particular reality," *Pure Immanence: Essays on A Life*, trans. Anne Boyman, New York: Zone Books, 2001, p. 31. In addition, Brian Massumi adds that the "virtual, as such, is inaccessible to the senses. This does not, however, preclude figuring it, in the sense of constructing images of it. To the contrary, it requires a multiplication of images…Images of the virtual make the virtual appear not in their content or form, but in fleeting…the appearance of the virtual is in the twists and folds of formed content," *Parables for the Virtual: Movement, Affect, Sensation*, Durham, NC: Duke University Press, 2002, p. 133.
117 In *Profanations*, Giorgio Agamben includes a short essay entitled "Judgment Day." Writing of Daguerre's *Temple du Boulevard*, he intimates that "I could not have ever invented a more adequate image of the Last Judgment…But there is another aspect of the photographs I love that I am compelled to mention. It has to do with a certain exigency: the subject shown in the photo demands something from us…Even if the person photographed is completely forgotten today, even if his or her name has been erased forever from human memory—or, indeed, precisely because of this—that person and that face demand their name; they demand not to be forgotten," pp. 24, 25. Echoes here of Proust, who wrote, "I thought of names not as an inaccessible ideal but as a real and enveloping atmosphere into which I was about to plunge, the life not yet lived, the life, intact and pure," *Swann's Way*, p. 554.

Gloss on Vilém Flusser

 1 Flusser's short book was originally published in German as *Für eine Philosophie der Fotografie* in 1983; the English translation was published in 2000 by Reaktion Books, with an afterword by Hubertus von Amelunxen. Flusser, *Towards a Philosophy of Photography* (1983), trans. Anthony Mathews, London: Reaktion Books, 2000. See

also his "Photography and History," *Writings*, ed. Andreas Ströhl, trans. Erik Eisel, Minneapolis: University of Minnesota Press, 2002 and *Into the Universe of Technical Images*, trans. Nancy Roth, Minneapolis: University of Minnesota Press, 2011.

2 To see the connections, note Baudrillard, *Simulacra and Simulation*, trans. Sheila Faria Glaser, Ann Arbor: University of Michigan, 1994; Virilio, *The Vision Machine*, trans. Julie Rose, London: British Film Institute and Bloomington: Indiana University Press, 1994; and McLuhan, *Understanding Media: The Extension of Man*, Cambridge, MA: MIT Press, 1994.

3 Hubertus von Amelunxen, "Afterword," *Towards a Philosophy of Photography*, p. 86.

4 Ibid., p. 90.

5 Flusser, *Towards a Philosophy of Photography*, p. 10.

6 Ibid.

7 Ibid., p. 17.

8 Ibid., p. 15.

9 Ibid., p. 14.

10 Ibid., p. 16.

11 Ibid., p. 64.

12 Ibid., p. 47.

13 See Heidegger, *The Question Concerning Technology and Other Essays*, trans. William Lovitt, New York: Harper & Row, 1977.

14 Op cit., p. 47–8.

15 Ibid., p. 57.

16 Ibid., p. 58.

17 Ibid.

18 This conversation is found in Chapter 3, pp. 12–13 of the novel. See Don Delillo, *White Noise*, New York: Penguin Books, 1985.

19 Op cit., p. 59.

20 Ibid., p. 70.

21 Ibid., p. 36.

22 Ibid., p. 37.

23 Ibid., p. 80.

24 Ibid., pp. 80–1.

25 Ibid., p. 75.

26 Benjamin, *Selected Writings Volume 2. 1927–1934*, eds Michael W. Jennings, Howard Eiland and Gary Smith, Cambridge, MA.: The Belknap Press of Harvard University Press, 1999, p. 735.

27 Op cit., p. 58.

28 Ibid., p. 75.

29 Giorgio Agamben links our obsession with gestures to the eternal return: "*Thus Spake Zarathustra* is the ballet of a humanity that has lost its gestures. And when the age became aware of its loss (too late!) it began its hasty attempt to recuperate its lost gestures *in extremis*. Isadora and Diaghilev's ballets, Proust's novel, Rilke and Pascoli's great Jugendstil poetry, and, finally, in the most exemplary fashion, silent film—all these trace the magic circle in which humanity tried to evoke for the last time what it was soon to lose irretrievably." See *Potentialities: Collected Essays in Philosophy*, trans. Daniel Heller-Roazen, Stanford: Stanford University Press, 1999, p. 83.

30 Benjamin, *Selected Writings Volume 2. 1927–1934*, p. 596.

Bibliography

Abbott, B., *Engaged Observers: Documentary Photography Since the Sixties*, Los Angeles: The J. Paul Getty Museum, 2010.

Adorno, T., *Aesthetic Theory*, trans. Robert Hullot-Kellor, Minneapolis: University of Minnesota Press, 1997.

Adorno, T. and M. Horkheimer, *Dialectic of Enlightenment*, London and New York: Continuum, 1972.

Adorno, T. and W. Benjamin, *The Complete Correspondence 1928–1940*, ed. Henri Lonitz, trans. Nicholas Walker, Cambridge, MA: Harvard University Press, 2001.

Agamben, G., *Infancy and History: Essays on the Destruction of Experience*, trans. Liz Heron, London and New York: Verso, 1993.

—, *The Coming Community*, trans. Michael Hardt, Minneapolis: University of Minnesota Press, 1993.

—, *The Idea of Prose*, trans. Michael Sullivan and Sam Whitsitt, Albany: State University of New York Press, 1995.

—, *Potentialities: Collected Essays in Philosophy*, trans. Daniel Heller-Roazen, Stanford: Stanford University Press, 1999.

—, *Remnants of Auschwitz: The Witness and the Archive*, trans. Daniel Heller-Roazen, New York: Zone Books, 1999.

—, *Means Without End: Notes on Politics*, trans. Vincenzo Binetti and Cesare Casarino, Minneapolis: University of Minnesota Press, 2000.

—, *Profanations*, trans. Jeff Fort, New York: Zone Books, 2007.

—, *Nudities*, trans. David Kishik and Stefan Pedatella, Stanford: Stanford University Press, 2011.

Agee, J. and W. Evans, *Let Us Now Praise Famous Men: The American Classic*, Boston: Mariner Books, 2001.

Alloula, M., *The Colonial Harem*, Minneapolis: University of Minnesota Press, 1986.

Althusser, L., *Lenin and Philosophy and Other Essays*, trans. Ben Brewster, New York: Monthly Review Press, 1971.

Anderson, B., *Imagined Communities: Reflections on the Origin and Spread of Nationalism*, London and New York: Verso, 1991.

Aragon, A., *Paris Peasant*, trans. Simon Watson Taylor, Boston: Exact Change, 1971.

Arbus, D. and M. Israel, eds, *Diane Arbus: An Aperture Monograph* (1972), New York: Aperture, 2005.

Arendt, H., *Eichmann in Jerusalem: A Report on the Banality of Evil*, New York: Penguin, 1977.

—, *The Human Condition*, Chicago: University of Chicago Press, 1998.

Arkesteijn, R., *Ni Haifeng: No Man's Land*, Amsterdam: Artimo, 2004.

Armstrong, C., "Biology, Destiny, Photography: Difference According to Diane Arbus," *October*, vol. 66, Fall 1993.

Aylesworth, G., "Postmodernism," *The Stanford Encyclopedia of Philosophy*, Winter 2010, ed. Edward N. Zalta, Online available HTTP: http://plato.stanford.edu/archives/win2010/entries/postmodernism.

Azoulay, A., *The Civil Contract of Photography*, trans. Rela Mazali and Ruvik Danieli, New York: Zone Books, 2008.

Badiou, A., *Pocket Pantheon: Figures of Postwar Philosophy*, trans. David Macey, London and New York: Verso, 2009.

Baer, U., *Spectral Evidence: The Photography of Trauma*, Cambridge, MA: MIT Press, 2005.

Baier, L., "Visions on Fascination and Despair: The Relation between Walker Evans and Robert Frank," *Art Journal*, vol. 41, no. 1, Spring 1981.

Baker, G., "Photography between Narrativity and Stasis: August Sander, Degeneration, and the Decay of the Portrait," *October*, vol. 76, Spring 1996.

—, "The Artwork Caught by Its Tail," *October*, vol. 97, Summer 2001.

—, "Photography's Expanded Field," *The Lure of the Object*, ed. Stephen Melville, Williamstown, MA: Sterling and Francine Clark Art Institute and New Haven: Yale University Press, 2005.

Bal, M., "Vision in Fiction: Proust and Photography," *Looking In: The Art of Viewing*, Australia: G+B Arts International, 2001.

Barthes, R., *Mythologies*, trans. Annette Lavers, New York: Hill and Wang, 1972.

—, *Image-Music-Text*, trans. Stephen Heath, New York: Hill and Wang, 1977.

—, *Camera Lucida*, trans. Richard Howard, New York: Hill and Wang, 1981.

Batchen, G., *Burning with Desire: The Conception of Photography*, Cambridge, MA: MIT Press, 1997.

—, *Each Wild Idea: Writing. Photograph. History*, Cambridge, MA: MIT Press, 2002.

—, ed., *Photography Degree Zero: Reflections on Roland Barthes's Camera Lucida*, Cambridge, MA: MIT Press, 2009.

Bate, D., "The Archaeology of Photography: Rereading Michel Foucault and *The Archaeology of Knowledge*," *Afterimage*, vol. 35, no. 3, September–October 2007.

—, *Photography and Surrealism: Sexuality. Colonialism and Social Dissent*, London and New York: I. B. Tauris, 2009.

—, *Photography: The Key Concepts*, Oxford and New York: Berg Publishers, 2009.

Baudrillard, J., *Simulacra and Simulation*, trans. Sheila Faria Glaser, Ann Arbor: University of Michigan, 1994.

Behdad, A., "Orientalist or Orienteur? Antoin Sevruguin and the Margin of Photography," *Sevruguin and The Persian Image*, ed. Fredrick Bohrer, Washington, DC: Sackler Gallery Series, Smithsonian Museum, 1999.

Beloff, H., *Camera Culture*, Oxford: Blackwell, 1985.

Benjamin, W., *Illuminations: Essays and Reflections*, ed. Hannah Arendt, New York: Schocken Books, 1969.

—, *Gesammelte Schriften*, eds Rolf Tiedemann and Hermann Schweppenhäuser, Frankfurt am Main: Suhrkamp, 1991, 7 vols.

—, *The Arcades Project*, trans. Howard Eiland and Kevin McLaughlin, Cambridge, MA: The Belknap Press of Harvard University Press, 1999.

—, *The Origin of German Tragic Drama*, trans. John Osborne, London and New York: Verso, 1999.

—, *Selected Writings Volume 1. 1913–1926*, eds Marcus Bullock and Michael W. Jennings, Cambridge, MA: The Belknap Press of Harvard University Press, 1996.

—, *Selected Writings Volume 2. 1927–1934*, eds Michael W. Jennings, Howard Eiland and Gary Smith, Cambridge, MA: The Belknap Press of Harvard University Press, 1999.

—, *Selected Writings Volume 3. 1935–1938*, eds Howard Eiland and Michael W. Jennings, Cambridge, MA: The Belknap Press of Harvard University Press, 2002.

Bennett, J., *Emphatic Vision: Affect. Trauma. and Contemporary Art*, Stanford: Stanford University Press, 2005.

Benson, R., *The Printed Picture*, New York: The Museum of Modern Art, 2008.

Berger, J., *About Looking*, New York: Pantheon, 1980.

Berman, M., *All That Is Solid Melts Into Air: The Experience of Modernity*, New York: Penguin, 1988.

Bernstein, J., *Against Voluptuous Bodies: Late Modernism and the Idea of Painting*, Stanford: Stanford University Press, 2006.

Bewell, A., "Portraits at Greyfairs: Photography, History and Memory in Walter Benjamin," *Clio*, vol. 12, no. 1, 1982.

Blanchot, M., *The Writing of the Disaster*, trans. Ann Smock, Lincoln: University of Nebraska Press, 1995.

Bohman, J., "Critical Theory," *The Stanford Encyclopedia of Philosophy*, Spring 2010, ed. Edward N. Zalta, Online available HTTP: http://plato.stanford.edu/archives/spr2010/entries/critical-theory.

Bolton, R., ed., *The Contest of Meaning: Critical Histories of Photography*, Cambridge, MA: MIT Press, 1989.

Bosworth, P., *Diane Arbus: A Biography*, New York: W. W. Norton, 2006.

Bourdieu, P., *Photography: A Middle-Brow Art*, trans. Shaun Whiteside, Stanford: Stanford University Press, 1990.

Braun, M., *Picturing Time: The Work of Étienne-Jules Marey (1830–1904)*, Chicago: University of Chicago Press, 1992.

Brennen, B. and H. Hardt, eds, *Picturing the Past: Media, History & Photography*, Urbana and Chicago: University of Illinois Press, 1999.

Brenner, F., *Diasporas: Homelands in Exile*, vol. 2, *Voices*, New York: Harper Collins, 2003.

Bright, S., *Art Photography*, New York: Aperture, 2006.

Brothers, C., *War and Photography*, London and New York: Routledge, 1997.

Brunette, P. and D. Wills, eds, *Deconstruction and the Visual Arts: Art, Media, Architecture*, Cambridge: Cambridge University Press, 1994.

Buchler, J., ed., *The Philosophy of Peirce: Selected Writings*, London and New York: Routledge, 2010.

Buchloh, B., "Thomas Struth's Archive," *Thomas Struth: Photographs*, Chicago: Renaissance Society at the University of Chicago, 1990.

Burgin, V., *Thinking Photography*, London and Basingstoke: Macmillan Press and New Jersey: Humanities Press International, 1982.

——, *The End of Art Theory: Criticism and Postmodernity*, London and Basingstoke: Macmillan Press and New Jersey: Humanities Press International, 1986.

Burton, J., "Not the Last Word: Reflections on Sherrie Levine's 'After Walker Evans Negative'," *Artforum*, September 2009.

——, ed., *Cindy Sherman*, OCTOBER Files 6, Cambridge, MA: MIT Press, 2006.

Butler, J., *Frames of War: When is Life Grievable?*, London and New York: Verso, 2009.

Cadava, E., *Words of Light: Theses on the Photography of History*, Princeton: Princeton University Press, 1997.

Caldwell, E. and M. Bourke-White, *You Have Seen Their Faces*, Athens, GA: University of Georgia Press, 1995.

Calvino, I., *Six Memos for the Next Millennium*, New York: Vintage, 1993.

Campany, D., *Art and Photography*, London: Phaidon, 2003.

——, *The Cinematic*, London: Whitechapel and Cambridge, MA: MIT Press, 2007.

——, *Catherine Opie: American Photographer*, New York: Solomon R. Guggenheim Museum, 2008.

Caygill, H., *Walter Benjamin: The Colour of Experience*, London and New York: Routledge, 1998.

Chare, N., *Auschwitz and Afterimages: Abjection, Witnessing and Representation*, London: I. B. Tauris, 2011.

Clark, T. J., *The Painting of Modern Life: Paris in the Art of Manet and His Followers*, Princeton, NJ: Princeton University Press, 1999.

Cohen, A., *On European Ground*, Chicago: University of Chicago Press, 2001.

—, *Herbert Bayer: The Complete Works*, Cambridge, MA: MIT Press, 1984.

Cohen, M., *Profane Illumination: Walter Benjamin and the Paris of Surrealist Revolution*, Berkeley and Los Angeles: University of California Press, 1993.

Comay, R., ed., *Lost in the Archives*, Toronto: Alphabet City Media, 2002.

—, "Redeeming Revenge: Nietzsche, Benjamin, Heidegger, and the Politics of Memory," *Nietzsche as Postmodernist: Essays Pro and Contra*, ed. Clayton Koelb, Albany: State University of New York Press, 1990.

Corbus, L., *Photography and Politics in America: From the New Deal into the Cold War*, Baltimore: Johns Hopkins University Press, 1999.

Costello, D., "Greenberg's Kant and the Fate of Aesthetics in Contemporary Art Theory," *The Journal of Aesthetics and Art Criticism*, vol. 65, no. 2, Spring 2007.

—, "On the Very Idea of a 'Specific' Medium: Michael Fried and Stanley Cavell on Painting and Photography as Arts," *Critical Inquiry*, vol. 34, Winter 2008.

Costello, D. and M. Iversen, *Photography After Conceptual Art*, Oxford: Wiley-Blackwell, 2010.

Costello, D. and J. Vickery, eds, *Art: Key Contemporary Thinkers*, Oxford and New York: Berg Publishers, 2007.

Costello, D. and D. Willsdon, eds, *The Life and Death of Images*, Ithaca: Cornell University Press, 2008.

Cotton, C., *The Photograph as Contemporary Art*, London: Thames & Hudson, 2004.

Cotton, C. and A. Klein, eds, *Words Without Pictures*, Los Angeles: Los Angeles County Museum of Art, 2009.

Crary, J., *Techniques of the Observer: On Vision and Modernity in the Nineteenth Century*, Cambridge, MA: MIT Press, 1990.

Crimp, D., *On the Museum's Ruins*, Cambridge, MA: MIT Press, 1993.

Crow, T., "Profane Illuminations: The Social History of Jeff Wall," *Modern Art in the Common Culture*, New Haven: Yale University Press, 1996.

Danto, A., *Playing with the Edge: The Photographic Achievement of Robert Mapplethorpe*, Berkeley and Los Angeles: University of California Press, 1996.

—, *The Abuse of Beauty: Aesthetics and the Concept of Art*, Chicago and La Salle, IL: Open Court, 2003.

Debord, G. *Society of the Spectacle*, Detroit: Black & Red, 1983.

De Duve, T., *Jeff Wall*, London: Phaidon, 2002.

Deleuze, G., *Foucault*, trans. Seán Hand, Minneapolis: University of Minnesota Press, 1988.

—, *The Logic of Sense*, trans. Constantine Boundas, New York: Columbia University Press, 1990.

—, *Difference and Repetition*, trans. Paul Patton, New York: Columbia University Press, 1994.

—, *Essays Critical and Clinical*, trans. Daniel W. Smith and Michael A. Greco, Minneapolis: University of Minnesota Press, 1997.

—, *Proust and Signs: The Complete Text*, trans. Richard Howard, Minneapolis: University of Minnesota Press, 2000.

—, *Cinema I: The Movement-Image*, trans. Hugh Tomlinson and Barbara Habberjam, Minneapolis: University of Minnesota Press, 2001.

—, *Cinema II: The Time Image*, trans. Hugh Tomlinson and Robert Galeta, Minneapolis: University of Minnesota Press, 2001.

—, *Pure Immanence*, trans. Anne Boyman, New York: Zone Books, 2001.

—, *Francis Bacon: The Logic of Sensation*, trans. Daniel W. Smith, Minneapolis: University of Minnesota Press, 2003.

—, *Desert Islands and Other Texts 1953–1974*, ed. David Lapoujade, trans. Michael Taormina, New York: Semiotext(e), 2004.

—, *Two Regimes of Madness: Texts and Interviews 1975–1995*, ed. David Lapoujade, trans. Ames Hodges and Mike Taormina, New York: Semiotext(e), 2007.

Deleuze, G. and F. Guattari, *Anti-Oedipus: Capitalism and Schizophrenia*, trans. Robert Hurley Mark Seem, and Helen R. Lane, Minneapolis: University of Minnesota Press, 1983.

——, *Kafka: Toward a Minor Literature*, trans. Dana Polan, Minneapolis: University of Minnesota Press, 1986.

——, *A Thousand Plateaus: Capitalism and Schizophrenia Vol. 2*, trans. Brian Massumi, Minneapolis: University of Minnesota Press, 1987.

——, *What Is Philosophy?*, trans. Hugh Tomlinson and Graham Burchell, New York: Columbia University Press, 1994.

Deleuze, G. and C. Parnet, *Dialogues II*, trans. Hugh Tomlinson and Barbara Habberjam, New York: Columbia University Press, 2002.

Delillo, D. *White Noise*, New York: Penguin, 1985.

De Man, P., *Allegories of Reading: Figural Language in Rousseau, Nietzsche, Rilke, and Proust*, New Haven: Yale University Press, 1979.

——, *Aesthetic Ideology*, ed. Andrzej Warminski, Minneapolis: University of Minnesota Press, 1996.

Derrida, J., *Speech and Phenomena and Other Essays on Husserl's Theory of Signs*, trans. David Allison, Evanston: Northwestern University Press, 1973.

——, *Writing and Difference*, trans. Alan Bass, Chicago: University of Chicago Press, 1980.

——, *Dissemination*, trans. Barbara Johnson, Chicago: University of Chicago Press, 1981.

——, *The Post Card: From Socrates to Freud and Beyond*, trans. Alan Bass, Chicago: University of Chicago Press, 1987.

——, *The Truth in Painting*, trans. Geoff Bennington and Ian McLeod, Chicago: University of Chicago Press, 1987.

——, *Memories for Paul de Man*, trans. Jonathan Culler, New York: Columbia University Press, 1989.

——, *Memoirs of the Blind: The Self-Portrait and Other Ruins*, trans. Pascale-Anne Brault and Michael Naas, Chicago: University of Chicago Press, 1993.

——, *Specters of Marx: The State of the Debt, the Work of Mourning, and the New International*, trans. Peggy Kamuf, New York and London: Routledge, 1994.

——, *Archive Fever: A Freudian Impression*, trans. Eric Prenowitz, Chicago: University of Chicago Press, 1995.

——, *Of Grammatology*, trans. Gayatri Chakravorty Spivak, Baltimore: Johns Hopkins University Press, 1998.

——, *Right of Inspection*, trans. David Wills, New York: The Monacelli Press, 1998.

——, *The Work of Mourning*, eds Pascale-Anne Brault and Michael Nass, Chicago: University of Chicago Press, 2001.

——, *Athens, Still Remains: The Photographs of Jean-François Bonhomme*, trans. Pascale-Anne Brault and Michael Naas, New York: Fordham University Press, 2010.

——, *Copy, Archive, Signature: A Conversation on Photography*, ed. Gerhard Richter, trans. Jeff Fort, Stanford: Stanford University Press, 2010.

Dickerman, L., "The Fact and the Photograph," *October*, vol. 118, Fall 2006.

——, "Bauhaus Fundaments," *Bauhaus: Workshops for Modernity*, eds Barry Bergdoll and Leah Dickerman, New York: Museum of Modern Art, 2009.

Didi-Huberman, G., "Artistic Survival: Panofsky vs. Warburg and the Exorcism of Impure Time," trans. Vivian Rehberg and Boris Belay, *Common Knowledge*, vol. 9, no. 2, Spring 2003.

——, *Invention of Hysteria: Charcot and the Photographic Iconography of the Salpêtrière*, trans. Alisa Hartz, Cambridge, MA: MIT Press, 2004.

——, *Confronting Images: Questioning the Ends of a Certain History of Art*, trans. John Goodman, University Park, Penn.: The Pennsylvania State University Press, 2005.

——, *Images in Spite of All: Four Photographs from Auschwitz*, trans. Shane B. Lillis, Chicago: University of Chicago Press, 2008.

Dyer, G., *The Ongoing Moment*, New York: Pantheon, 2005.

Eder, J. *History of Photography*, trans. Edward Epstean, New York: Dover Publications, 1978.

Edwards, E., *Anthropology and Photography 1860–1920*, New Haven: Yale University Press, 1992.

Edwards, S., "'Profane Illumination': Photography and Photomontage in the USSR and Germany," *Art of the Avant-Gardes*, eds Steve Edwards and Paul Wood, New Haven: Yale University Press, 2004.

Eisenman, S., ed., *Nineteenth-Century Art: A Critical History*, London: Thames & Hudson, 2007.

—, *The Abu Ghraib Effect*, London: Reaktion Books, 2007.

Eklund, D., *The Pictures Generation. 1974–1984*, New York: Metropolitan Museum of Art, 2009.

—, *The Pictures Generation. 1974–1984*, New York: Metropolitan Museum of Art, 2009.

Elkins, J., ed., *Photography Theory*, London and New York: Routledge, 2007.

Emerling, J., *Theory for Art History*, New York and London: Routledge, 2005.

—, "The Immemorial, or the Pit of Babel: On W. G. Sebald's Photographs, *Deixis*, vol. 1, Spring 2007.

—, "Camera Obscura: Photography as Critique," *X-TRA: Contemporary Art Quarterly*, vol. 10, no. 1, 2007.

—, "On Jacques Rancière and The Future of the Image," *Journal of Visual Culture*, vol. 7, no. 3, 2008.

—, "An Art History of Means: Arendt-Benjamin," *Journal of Art Historiography*, vol. 1, December 2009.

—, "The Vestige of Time: With Wylie and Deleuze in Carrara," *X-TRA: Contemporary Art Quarterly*, vol. 12, no. 1, 2009.

—, "Review of John Tagg, *The Disciplinary Frame: Photographic Truths and the Capture of Meaning*," *Journal of Visual Culture*, vol. 9, no. 2, 2010, pp. 1–7.

—, "A Becoming Image: Candida Höfer's Architecture of Absence," *Architectural Strategies in Contemporary Art*, eds Isabelle Wallace and Nora Wendl, London: Ashgate, 2012.

Eskildsen, U., "Photography and the Neue Sachlichkeit Movement," *Neue Sachlichkeit and German Realism of the Twenties*, London: Hayward Gallery, 1979.

Farago, C. and R. Zwijnenberg, eds, *Compelling Visuality: The Work of Art in and out of History*, Minneapolis: University of Minnesota Press, 2003.

Flusser, V., *Towards a Philosophy of Photography*, trans. Anthony Mathews, London: Reaktion Books, 2000.

—, *Writings*, ed. Andreas Ströhl, trans. Erik Eisel, Minneapolis: University of Minnesota Press, 2002.

—, *Into the Universe of Technical Images*, trans. Nancy Roth, Minneapolis: University of Minnesota Press, 2011.

Fogle, D., ed., *The Last Picture Show: Artists Using Photography 1960–1982*, Minneapolis: Walker Arts Center, 2003.

Foster, H., ed., *The Anti-Aesthetic: Essays on Postmodern Culture*, New York: The New Press, 1983.

—, "L'Amour faux," *Art in America*, January 1986.

—, *The Return of the Real: Art and Theory at the End of the Century*, Cambridge, MA: MIT Press, 1996.

Foster, H., R. Krauss, Y-A. Bois, and B. Buchloh, *Art Since 1900: Modernism. Antimodernism. Postmodernism*, 2 vols, Cambridge, MA: MIT Press, 2005.

Foucault, M., *The Order of Things: An Archaeology of the Human Sciences*, trans. Alan Sheridan, New York: Vintage, 1966.

—, *The Archaeology of Knowledge and The Discourse on Language*, trans. A. M. Sheridan Smith, New York: Pantheon Books, 1972.

—, *Language. Counter-Memory. Practice: Selected Essays and Interviews*, ed. Donald F. Bouchard, trans. Donald F. Bouchard and Sherry Simon, Ithaca: Cornell University Press, 1977.

—, *This Is Not A Pipe*, trans. James Harkness, Berkeley and Los Angeles: University of California Press, 1983.

—, *Aesthetics, Method, and Epistemology: Essential Works of Foucault 1954–1984 Volume 2*, ed. James D. Faubion, New York: The New Press, 1998.

—, *Le Peinture de Manet*, Paris: Éditions du Seuil, 2004.

Freedberg, D., *The Power of Images: Studies in the History and Theory of Response*, Chicago: University of Chicago Press, 1991.

Freud, S., *Civilization and Its Discontents*, ed. and trans. James Strachey, New York: W. W. Norton & Co., 1961.

—, "Fetishism," *The Standard Edition*, vol. XXI, ed. James Strachey, London: Hogarth, 1964.

—, The Basic Writings of Sigmund Freud, trans. A. A. Brill, New York: The Modern Library, 1995.

Fried, M., *Absorption and Theatricality: Painting and Beholder in the Age of Diderot*, Chicago: University of Chicago Press, 1986.

—, *Manet's Modernism, or The Face of Painting in the 1860s*, Chicago: University of Chicago Press, 1996.

—, *Art and Objecthood: Essays and Reviews*, Chicago: University of Chicago Press, 1998.

—, *Why Photography Matters as Art as Never Before*, New Haven: Yale University Press, 2008.

Friedlander, L., *The Little Screens*, San Franciso: Fraenkel Gallery, 2001.

Galassi, P., *Before Photography: Painting and the Invention of Photography*, New York: The Museum of Modern Art, 1981.

—, *Lee Friedlander*, New York: The Museum of Modern Art, 2005.

Gefter, P., "Keeping His Eye on the Horizon (Line)," *The New York Times*, April 6, 2008, p. 30.

Gernsheim, H., *A Concise History of Photography*, New York: Dover Publications, 1986.

Gilbert-Rolfe, J., *Beauty and the Contemporary Sublime*, New York: Allworth Press, 1999.

Goddard, D., "Review of Jan Dibbets: Early Works at the Barbara Gladstone Gallery," *New York Art World*, February 2001.

Goldberg, V., ed., *Photography in Print: Writings from 1816 to the Present*, Albuquerque: University of New Mexico Press, 1981.

Goldstein, A. and A. Rorimer, eds, *Reconsidering the Object of Art: 1965–1975*, Los Angeles: The Museum of Contemporary Art and Cambridge, MA: MIT Press, 1995.

Green, J., "Surrogate Reality," *American Photography: A Critical History 1945 to the Present*, New York: Harry N. Abrams, 1984.

Greenberg, C., *The Collected Essays and Criticism, Vol. 4, Modernism with a Vengeance 1957–1969*, ed. John O'Brian, Chicago: University of Chicago Press, 1995.

Greenough, S., ed., *Looking In: Robert Frank's The Americans*, Washington, DC: National Gallery of Art, 2009.

Gronert, S., *The Düsseldorf School of Photography*, New York: Aperture, 2010.

Grosz, E., *Chaos, Territory, Art: Deleuze and the Framing of the Earth*, New York: Columbia University Press, 2008.

Groys, B., *Going Public*, Berlin: Sternberg Press, 2010.

Guattari, F., *The Anti-Oedipus Papers*, ed. Stéphane Nadaud, trans. Kélina Gotman, New York: Semiotext(e), 2006.

Gutting, G., ed. *The Cambridge Companion to Foucault*, Cambridge: Cambridge University Press, 1994.

Halley, A., "August Sander," *Massachusetts Review*, Winter 1978.

Hardt, M. and A. Nergi, *Commonwealth*, Cambridge, MA: Belknap Press of Harvard University Press, 2009.

Hartshorne, C. and P. Weiss, eds, *The Collected Papers of Charles Sanders Peirce*, vol. 2, Cambridge, MA: Harvard University Press, 1932.

Haworth-Booth, M., *Photography: An Independent Art. Photographs from the Victoria and Albert Museum 1839–1996*, London: V & A Publications, 1997.

Heidegger, M., *The Question Concerning Technology and Other Essays*, trans. William Lovitt, New York: Harper & Row, 1977.

Hermand, J., "Unity within Diversity? The History of the Concept 'Neue Sachlichkeit'," *Culture and Society in the Weimar Republic*, Manchester: Manchester University Press, 1977.

Herschberger, A., "Krauss's Foucault and the Foundations of Postmodern History of Photography," *History of Photography*, vol. 30, no. 1, Spring 2006.

——, *Kant and the Problem of Metaphysics*, trans. Richard Taft, Bloomington: Indiana University Press, 1990.

Hight, E. and G. Sampson, *Colonialist Photography: Imag(in)ing Race and Place*, London and New York: Routledge, 2002.

Holly, M. A., "'The Melancholy Art' and the responses to it," *Art Bulletin*, vol. LXXXIX, no. 1, March 2007.

Horak, R., ed., *Rethinking Photography I + II: Narration and New Reduction in Photography*, Salzburg: Fotohof, 2003.

Horkheimer, M., *Critical Theory: Selected Essays*, trans. Matthew J. O'Connell, New York: Seabury Press, 1982.

Hudson, N. M., "Reading the Victorian Souvenir: Sonnets and Photographs of the Crimean War," *The Yale Journal of Criticism*, vol. 14, no. 2, Fall 2001.

Hüppauf, B., "Emptying the Gaze: Framing Violence through the Viewfinder," *New German Critique*, no. 72, Autumn 1997.

Iversen, M., "The Surrealist Situation of the Photographed Object," *The Lure of the Object*, ed. Stephen Melville, Williamstown, MA: Sterling and Francine Clark Art Institute and New Haven: Yale University Press, 2005.

Jay, M., *Downcast Eyes: The Denigration of Vision in Twentieth-Century French Thought*, Berkeley and Los Angeles: University of California Press, 1993.

Jeffrey, I., *Photography: A Concise History of Photography*, London: Thames & Hudson, 1989.

——, *How to Read a Photograph*, New York: Abrams, 2009.

Jones, A., ed., *A Companion to Contemporary Art Since 1945*, London: Blackwell, 2006.

Kamuf, P., ed., *A Derrida Reader: Between the Blinds*, New York: Columbia University Press, 1991.

Kant, I., *Critique of Judgment*, ed. Nicholas Walker, trans. James Creed Meredith, Oxford: Oxford University Press, 2007.

Kaplan, B., *Unwanted Beauty: Aesthetic Pleasure in Holocaust Representation*, Champaign: University of Illinois Press, 2007.

Kaplan, L., *Laszlo Moholy-Nagy: Biographical Writings*, Durham, NC: Duke University Press, 1995.

——, *American Exposures: Photography and Community in the Twentieth Century*, Minneapolis: University of Minnesota Press, 2005.

——, "Out of the Picture: Maurice Blanchot and the Refusal of Photography," *Cabinet Magazine*, vol. 21, Spring 2006.

——, *The Strange Case of William Mumler, Spirit Photographer*, Minneapolis: University of Minnesota Press, 2008.

——, "Unknowing Susan Sontag's *Regarding*: Recutting with Georges Bataille," *PMC: Postmodern Culture*, vol. 19, no. 2, January 2009/10.

——, "Photograph/Death Mask: Jean-Luc Nancy's Recasting of the Photographic Image," *Regarding Jean-Luc Nancy*, special issue of *Journal of Visual Culture*, vol. 9, no. 1, April 2010.

Keller, U., *The Ultimate Spectacle: A Visual History of the Crimean War*, London and New York: Routledge, 2001.

Kelly, M., *Iconoclasm and Aesthetics*, Cambridge: Cambridge University Press, 2003.

Kelsey, R., "Viewing the Archive: Timothy O'Sullivan's photographs for the Wheeler Survey, 1871–74," *Art Bulletin*, vol. 85, no. 4, December 2003.

—, "Indexomania," *Art Journal*, vol. 66, no. 3, Fall 2007.

Kelsey, R. and B. Stimson, eds, *The Meaning of Photography*, Willliamstown, MA: Sterling and Francine Clark Art Institute and New Haven: Yale University Press, 2008.

Kester, G., "Toward a New Social Documentary," *Afterimage*, March 1987.

King, S. and R. Schlink, *Refiguring the Coquette: Essays on Culture and Coquetry*, Cranbury, NJ: Associated University Press, 2008.

Kipnis, J. and T. Lesser, eds, *Jacques Derrida and Peter Eisenman: Chora L Works*, New York: The Monacelli Press, 1997.

Knight, D., ed., *Critical Essays on Roland Barthes*, New York: G. K. Hall, 2000.

Kozloff, M., "The Uncanny Portrait: Sander, Arbus, Samaras," *Artforum*, June 1973.

—, *Photography and Fascination*, Danbury, NH: Addison House, 1980.

—, *The Privileged Eye: Essays on Photography*, Albuquerque: University of New Mexico Press, 1987.

Kracauer, S., *The Mass Ornament: Weimar Essays*, trans. and ed. Thomas Y. Levin, Cambridge, MA: Harvard University Press, 1995.

—, *Theory of Film: The Redemption of Physical Reality*, Princeton: Princeton University Press, 1997.

Krauss, R., "A Note on Photography and the Simulacral," *October*, vol. 31, Winter 1984.

—, *The Optical Unconscious*, Cambridge, MA: MIT Press, 1994.

—, *The Originality of the Avant-Garde and Other Modernist Myths*, Cambridge, MA: MIT Press, 1996.

—, "Reinventing the Medium," *October*, vol. 25, Winter 1999.

—, *A Voyage on the North Sea: Art in the Age of the Post-Medium Condition*, London: Thames & Hudson, 1999.

—, *Bachelors*, Cambridge, MA: MIT Press, 2000.

Krauss, R. and Y-A. Bois, *Formless: A User's Guide*, New York: Zone Books, 1997.

Krauss, R. and J. Livingston, *L'Amour fou: Photography and Surrealism*, New York: Abbeville Press, 1985.

Kubler, G., *The Shape of Time: Remarks on the History of Things*, New Haven: Yale University Press, 1962.

Lacan, J., *The Seminar of Jacques Lacan Book VII: The Ethics of Psychoanalysis 1959–1960*, ed. Jacques-Alain Miller, trans. Dennis Porter, New York: W.W. Norton, 1992.

—, *The Seminar of Jacques Lacan Book XI: The Four Fundamental Concepts of Psychoanalysis*, ed. Jacques-Alain Miller, trans. Alan Sheridan, New York: W. W. Norton, 1998.

Lange, S., *Bernd and Hilla Becher: Life and Work*, trans. Jeremy Gaines, Cambridge, MA: MIT Press, 2007.

Lavin, M., *Cut with the Kitchen Knife: The Weimar Photomontages of Hannah Höch*, New Haven: Yale University Press, 1993.

Leibovitz, A. and S. Sontag, *Women*, New York: Random House, 2000.

Lemagny, J-C. and A. Rouille, eds, *A History of Photography*, Cambridge: Cambridge University Press, 1987.

Lentricchia, F. and Thomas McLaughlin, eds, *Literary Terms for Critical Study*, Chicago: University of Chicago Press, 1990.

Levi Strauss, D., *Between the Eyes: Essays on Photography and Politics*, New York: Aperture, 2003.

Liebling, J., ed., *Photography: Current Perspectives*, Rochester, NY: Light Impressions, 1978.

Liss, A., *Trespassing Through Shadows: Memory, Photography, and the Holocaust*, Minneapolis: University of Minnesota Press, 1998.

Lyotard, J-F., *The Postmodern Condition: A Report on Knowledge*, trans. Geoff Bennington and Brian Massumi, Minneapolis: University of Minnesota Press, 1984.

—, *The Inhuman: Reflections on Time*, trans. Geoffrey Bennington and Rachel Bowlby, Stanford: Stanford University Press, 1992.

Manovich, L., *The Language of New Media*, Cambridge, MA: MIT Press, 2001.

Marien, M. W., *Photography: A Cultural History*, Upper Saddle River, NJ: Prentice Hall, 2011.

Massumi, B., *Parables for the Virtual: Movement. Affect. Sensation*, Durham, NC: Duke University Press, 2002.

Maxwell, A., *Colonial Photography and Exhibitions: Representations of the Native and the Making of European Identities*, Leicester: Leicester University Press, 2000.

McLuhan, M., *Understanding Media: The Extension of Man*, Cambridge, MA: MIT Press, 1994.

Mellor, D., *Germany: The New Photography. 1927–33*, David Mellor, London: Arts Council of Great Britain, 1978.

Menke, C., *The Sovereignty of Art: Aesthetic Negativity in Adorno and Derrida*, trans. Neil Solomon, Cambridge, MA: MIT Press, 1999.

Merewether, C., ed., *The Archive*, London: Whitechapel and Cambridge, MA: MIT Press, 2006.

Metz, C., "Photography and Fetish," *October*, vol. 34, Fall 1985.

Michaud, P-A., *Aby Warburg and the Image in Motion*, trans. Sophie Hawkes, New York: Zone Books, 2007.

Mills, S., *Michel Foucault*, London and New York: Routledge, 2003.

Mitchell, W. J. T., *Iconology: Image. Text. Ideology*, Chicago: University of Chicago Press, 1986.

—, *The Reconfigured Eye: Visual Truth in the Post-Photographic Era*, Cambridge, MA: MIT Press, 1992.

—, *Landscape and Power*, Chicago: University of Chicago Press, 1994.

—, *What do Pictures Want? The Lives and Loves of Images*, Chicago: The Chicago University Press, 2005.

Mora, G. and J. T. Hill, *The Hungry Eye*, New York: Abrams, 2009.

Nancy, J-L., *The Muses*, trans. Peggy Kamuf, Stanford: Stanford University Press, 1996.

Nesbitt, M., *Atget's Seven Albums*, New Haven: Yale University Press, 1993.

Newhall, B., "Documentary Approach to Photography," *Parnassus*, vol. 10, no. 3, March 1938.

—, ed., *Daybooks of Edward Weston*, New York: Aperture, 1981.

—, *The History of Photography: From 1839 to the Present*, New York: The Museum of Modern Art, 2006.

Nickel, D., "History of Photography: The State of Research," *Art Bulletin*, vol. LXXXIII, no. 3, September 2001.

Osborne, P., *The Politics of Time: Modernity and Avant-Garde*, London and New York: Verso, 1995.

Owens, C., *Beyond Recognition: Representation. Power. and Culture*, eds Scott Bryson, Barbara Kruger, Scott Bryson, Lynne Tillman, and Jane Weinstock, Berkeley and Los Angeles: University of California Press, 1992.

Panofsky, E., *Perspective as Symbolic Form*, trans. Christopher S. Wood, New York: Zone Books, 1993.

Phillips, C., ed., *Photography in the Modern Era: European Documents and Critical Writings. 1913–1940*, New York: The Metropolitan Museum of Art and Aperture, 1989.

Plato, *Phaedrus and Letters VII and VII*, trans. Walter Hamilton, London and New York: Penguin, 1973.

Pogue, L., *Conversations with Susan Sontag*, Jackson, MI: University Press of Mississippi, 1995.

Potts, A., "Tactility: The Interrogation of Medium in Art in the 1960s," *Art History*, vol. 27, no. 2, April 2004.

Pranzer, M., *Matthew Brady and The Image of History*, Washington, DC: Smithsonian Books, 2004.

Pratt, M. L., *Imperial Eyes: Travel Writing and Transculturation*, London and New York: Routledge, 1992.

Preziosi, D., *Brain of the Earth's Body: Art, Museums, and the Phantasms of Modernity*, Minneapolis: University of Minnesota Press, 2003.

Price, M., *The Photograph: A Strange Confined Space*, Stanford: Stanford University Press, 1994.

Proust, M., *In Search of Lost Time*, vol. 1, *Swann's Way*, trans. C. K. Scott Moncrieff and Terence Kilmartin, New York: The Modern Library, 2003.

Purbrick, L., *The Great Exhibition of 1851: New Interdisciplinary Essays*, Manchester: Manchester University Press, 2001.

Raines, H., "Let Us Now Praise Famous Folk," *New York Times Magazine*, May 25, 1980.

Rajchman, J., "Postmodernism in a Nominalist Frame: The Emergence and Diffusion of a Cultural Category," *Flash Art*, no. 137, 1987.

Rancière, J., "Politics and Aesthetics: An Interview with Peter Hallward and Jacques Rancière," *Angelaki: Journal of the Theoretical Humanities*, vol. 8, no. 2, August 2003.

—, *Aesthetics and its Discontents*, trans. Steven Corcoran, Malden, MA: Polity Press, 2004.

—, *The Politics of Aesthetics: The Distribution of the Sensible*, trans. Gabriel Rockhill, London and New York: Continuum, 2004.

—, *The Future of the Image*, trans. Gregory Elliott, London and New York: Verso, 2007.

—, *The Emancipated Spectator*, trans. Gregory Elliott, London and New York: Verso, 2009.

Reinhardt, M., H. Edwards, and E. Duganne, eds, *Beautiful Suffering: Photography and the Traffic in Pain*, Williamstown, MA: Williams College Museum of Art and Chicago: University of Chicago Press, 2007.

Renov, M. and E. Suderburg, eds, *Resolutions: Contemporary Video Practices*, Minneapolis: University of Minnesota Press, 1996.

Ritchin, F., *After Photography*, New York: W. W. Norton, 2009.

Rosenblum, N., *A World History of Photography*, New York: Abbeville Press, 2008.

Rosler, M., *Decoys and Disruptions: Selected Writings, 1975–2001*, Cambridge, MA: MIT Press, 2004.

Roth, M. S., "Why Photography Matters to the Theory of History," *History and Theory*, vol. 49, February 2010.

Said, E., *Orientalism*, New York: Vintage, 1979.

Salgado, S., *Workers: An Archaeology of the Industrial Age*, New York: Aperture, 2005.

Sandeen, E., *Picturing an Exhibition: The Family of Man and 1950s America*, Albuquerque: University of New Mexico Press, 1995.

Sander, G., ed., *August Sander: Citizens of the Twentieth Century*, trans. Linda Keller, Cambridge, MA: MIT Press, 1986.

Saussure, F., *Course in General Linguistics*, eds Charles Bally and Albert Sechehaye, trans. Albert Reidlinger, New York: Philosophical Library, 1959.

Schaffner, I. and A. Winzen, *Deep Storage: Collecting, Storing and Archiving in Art*, Munich: Prestel Verlag, 1998.

Schlossman, B., "Proust and Benjamin: The Invisible Image," *Benjamin's Ground: New Readings of Walter Benjamin*, ed. Rainer Nägele, Detroit: Wayne State University Press, 1989.

Schoen, K., "The Serial Attitude Redux," *X-TRA: Contemporary Art Quarterly*, vol. 12, no. 2, Winter 2009.

Scholem, G. and T. W. Adorno, eds, *The Correspondence of Walter Benjamin 1910–1940*, trans. Manfred R. Jacobson and Evelyn M. Jacobson, Chicago: University of Chicago Press, 1994.

Schwarz, H., *David Octavius Hill: Master of Photography*, trans. Helen E. Fraenkel, New York: Viking, 1931.

Schweizer, N., ed., *Alfredo Jaar: La politique des images*, Zürich: JPR and Lausanne: Musée cantonal des Beaux-Arts, 2007.

Sekula, A., "The Traffic in Photographs," *Art Journal*, vol. 41, no. 1, Spring 1981.

—, *Photography Against the Grain: Essays and Photo Works. 1973–1983*, Halifax, Canada: Press of the Nova Scotia College of Art and Design, 1984.

—, "Between the Net and the Deep Blue Sea: Rethinking the Traffic in Photographs," *October*, vol. 102, Fall 2002.

Shalev-Gerz, E., *Menschliche Dinge: The Human Aspect of Objects*, Weimar: Stiftung Gedenkstätten Buchenwald, 2006.

Shapiro, G., *Archaeologies of Vision: Foucault and Nietzsche on Seeing and Saying*, Chicago: University of Chicago Press, 2003.

Shawcross, N., *Roland Barthes on Photography*, Gainesville: University Press of Florida, 1997.

Sherman, C., *The Complete Untitled Film Stills*, New York: Museum of Modern Art, 2003.

Shklovsky, V., *Knight's Move*, trans. Richard Sheldon, Champaign, IL and London: Dalkey Archive Press, 2005.

Silverman, K., "Photography By Other Means," *Flesh of My Flesh*, Stanford: Stanford University Press, 2009.

Smith, G, ed., *On Walter Benjamin: Critical Essays and Recollections*, Cambridge, MA: MIT Press, 1991.

Smith, W. and A. Smith, *Minamata*, New York: Holt, Rinehart, and Winston, 1975.

Snyder, J., *American Frontiers: The Photographs of Timothy O'Sullivan. 1867–1874*, New York: Aperture, 1981.

—, "Benjamin on Reproducibility and Aura: A Reading of 'The Work of Art in the Age of its Technical Reproducibility'," *Benjamin: Philosophy. Aesthetics. History*, ed. Gary Smith, Chicago: University of Chicago Press, 1989.

Snyder, J. and N. Walsh Allen, "Photography, Vision, and Representation," *Critical Inquiry*, vol. 2, no. 1, Autumn 1975.

Sobieszek, R., *Ghost in the Shell: Photography and the Human Soul*, Los Angeles: Los Angeles County Museum of Art and Cambridge, MA: MIT Press, 1999.

Solomon-Godeau, A., *Photography at the Dock: Essays on Photographic History. Institutions. and Practices*, Minneapolis: University of Minnesota Press, 1991.

Sontag, S., *On Photography*, New York: Picador, 1977.

—, ed., *The Barthes Reader*, New York: Hill and Wang, 1982.

—, *Against Interpretation: And Other Essays*, New York: Picador, 2001.

—, *Under the Sign of Saturn: Essays*, New York: Picador, 2002.

—, *Regarding the Pain of Others*, 1st edn, New York: Farrar, Straus and Giroux, 2002.

—, *Where the Stress Falls*, New York: Vintage, 2003.

Squiers, C., ed., *Overexposed: Essays in Contemporary Photography*, New York: The New Press, 2000.

Stafford, A., *Photo-texts: Contemporary French Writing on the Photographic Image*, Liverpool: Liverpool University Press, 2010.

Stein S., "Making Connections with the Camera: Photography and Social Mobility in the Career of Jacob Riis," *Afterimage*, vol. 10, no. 10, May 1983.

Stiegler, B., *Theoriegeschichte der Photographie*, Munich: Fink, 2006.

Stimson, B., *The Pivot of the World: Photography and Its Nation*, Cambridge, MA: MIT Press, 2006.

Strange,. M., *Symbols of Ideal Life: Social Documentary in America 1850–1950*, Cambridge: Cambridge University Press, 1989.

Streitberger, A., ed., *Situational Aesthetics. Selected Writing by Victor Burgin*, Leuven: Leuven University Press, 2009.

Sutton, D., *Photography. Cinema. Memory: The Crystal Image of Time*, Minneapolis: University of Minnesota Press, 2009.

Swinnen, J., ed., *The Weight of Photography: A Theoretical Basis for Photographic Humanity*, Brussels: University Press of Brussels, 2010.

Szarkowski, J., "August Sander: The Portrait as Prototype," *Infinity*, vol. 12, no. 6, June 1963.

—, *Mirrors and Windows*, New York: The Museum of Modern Art, 1978.

—, *Figments from the Real World*, New York: The Museum of Modern Art, 1988.

—, *The Photographer's Eye*, New York: The Museum of Modern Art, 2007.

Talbot, W. H. F., *The Pencil of Nature*, New York: Da Capo Press, 1969.

Tafuri, M., *The Sphere and the Labyrinth: Avant-Gardes and Architecture from Piranesi to the 1970s*, trans. Pellegrino d'Acierno and Robert Connolly, Cambridge, MA: MIT Press, 1987.

Tagg, J., *The Burden of Representation: Essays on Photographies and Histories*, Amherst: University of Massachusetts Press, 1988.

—, *The Disciplinary Frame: Photographic Truths and the Capture of Meaning*, Minneapolis: University of Minnesota Press, 2009.

Thomas, A., *The Expanding Eye: Photography and the Nineteenth-Century Mind*, London: Croom Helm, 1978.

Trachtenberg, A., ed., *Classic Essays on Photography*, New Haven: Leete's Island Books, 1980.

Tucker, J., *Nature Exposed: Photography as Eyewitness in Victorian Science*, Baltimore: Johns Hopkins University Press, 2005.

Van Lier, H., *Philosophy of Photography*, Leuven: Leuven University Press, 2007.

Virilio, P., *The Vision Machine*, trans. Julie Rose, London: British Film Institute and Bloomington: Indiana University Press, 1994.

Walden, S., ed., *Photography and Philosophy: Essays on The Pencil of Nature*, Malden, MA: Wiley-Blackwell, 2010.

Wallis, B., ed., *Art After Modernism: Rethinking Representation*, New York: The New Museum of Contemporary Art, 1984.

Warburg, A., *The Renewal of Pagan Antiquity: Contributions to the Cultural History of the European Renaissance*, trans. David Britt, Los Angeles: Getty Research Institute, 1999.

Wells, L., ed., *Photography: A Critical Introduction*, London and New York: Routledge, 2000.

—, ed. *The Photography Reader*, London and New York: Routledge, 2003.

White, H., *Tropics of Discourse: Essays in Cultural Criticism*, Baltimore: Johns Hopkins University Press, 1978.

Wilk, C., ed., *Modernism: Designing a New World 1914–1939*, London: V & A Publications, 2006.

Willet, J., *Art and Politics in the Weimar Period: The New Sobriety 1917–1933*, New York: Pantheon, 1978.

Williams, R., *Art Theory: An Historical Introduction*, Oxford: Wiley-Blackwell, 2004.

Witkovsky, M., "Another History. On Photography and Abstraction," *Artforum*, March 2010.

Wolf, S., ed., *Ed Ruscha and Photography*, London: Steidl and New York: Whitney Museum of American Art, 2004.

—, *The Digital Eye: Photographic Art in the Electronic Age*, New York: Prestel, 2010.

Woodfield, R., *Art History as Cultural History: Warburg's Projects*, London and New York: Routledge, 2001.

Young, J. E., *At Memory's Edge: After-Images of the Holocaust in Contemporary Art and Architecture*, New Haven: Yale University Press, 2000.

Zelizer, B., ed., *Visual Culture and the Holocaust*, New Brunswick, NJ: Rutgers University Press, 2001.

Zijlmans, K. and Ni Haifeng, *Ni Haifeng: The Return of the Shreds*, Leiden: Valiz and Museum De Lakenhal, 2008.

Index

Note: Page numbers followed by 'f' refer to figures and followed by 'n' refer to notes.

Abbott, Berenice 92, 177, 251n
Abbott, Brett 84, 92, 236n
Abu Ghraib prison 118
Adams, Ansel 28, 49–50, 51, 154
Adorno, Theodor W. 12, 30, 34, 42
aesthetics 4, 7, 13–15, 49, 74, 116, 158; aesthetic distance 115, 116, 119; aesthetic strategies 83, 99, 107, 125, 152, 209; aestheticization of pain of others 85, 103, 105, 116; in documentary photographs 84, 93, 99–102, 103–7; and ethics 93, 105, 109; in *The Family of Man* 127; of Greenberg 13, 52–3; meaning for Sekula 124–5; misreading of Kantian 13, 74; return to 103, 215; *see also* anti-aesthetics
Agamben, Giorgio 30, 47, 121, 254n, 255n
Alex *(Sonderkommando)* 83, 95, 238n
Alloula, Malek 140
American Photographs 83, 93, 95
The Americans 85, 205, 206, 212
analogue and digital photography 6, 7, 62, 64, 65
Ancient Ruins in the Canon de Chelle. New Mexico 153, 154f, 155
Anonymous Sculptures 148
anti-aesthetics 13–14, 23, 31, 35; Burgin's practice of 59, 60–1; Costello's challenge to 53; Krauss' work on photography and 53–61; link between critical postmodernism and 36, 53, 54; position regarding documentary photography 99–102; Rancière's challenge to 107–9; rethinking of position 103–5, 106; Sherman's practice of 59–60; Sontag and establishment of discourse of 23, 115
appropriation art 101–2, 130, 197
Aragon, Louis 42
Arbus, Diane 96–8, 100, 114, 205

The Arcades Project 42, 45–6, 179, 251n, 252n
The Archaeology of Knowledge 159–64
archives 21, 120–1; *The Atlas Project* 125–6; Bechers' industrial structures project 148–53; contemporary projects 121–2, 134–5, 136, 142–3; Derrida on 158; *The Family of Man see The Family of Man*: Foucault's concept of 153, 159–64; and landscape photography 153–6; nineteenth century projects 121, 134, 136–42, 144, 201; Sander's German society project 144–7; Sekula's critical Marxist project 123–5
Arendt, Hannah 114
Articles of China 134, 135f
Atget, Eugène 46, 92–4, 95, 178f, 180, 251n; Benjamin's reading of 177–9
The Atlas Project 125–6
Attie, Shimon 121–2
aura 11, 42, 46, 225n
Auschwitz 109–14, 110f
authenticity 11, 102
"The Author as Producer" 2, 30, 31, 105
autoethnography 85, 141, 236n
automaticity 10–11, 18, 55, 56, 191, 194, 196
avant-garde 32–3, 36, 52, 120, 197–8; display techniques 128–9, 131; photomontage 102, 129, 131
Azoulay, Ariella 84, 236n

Baker, George 145, 146, 147, 245n
Barthes, Roland 35, 55, 62, 134, 142, 171; *Camera Lucida* xii, 10, 76, 80, 81, 186–9; critique of *The Family Man* 132–3; "The Rhetoric of the Image" 76–81
Batchen, Geoffrey 4, 40, 61, 87, 88
Baudelaire, Charles 20–1, 22, 43, 66, 67, 198
Bauhaus 33, 36, 131, 198
Bayer, Herbert 131, 242n
Baynard, Hippolyte 86–8, 87f, 181, 181f
Beato, Felice 136, 168

Becher, Bernd and Hilla 95, 148–53, 148f, 203
Benjamin, Walter 2, 3, 10, 11, 12, 30, 31,
 32, 33, 34, 42–7, 120, 179, 196, 252n;
 citation 175–7, 179; discussion of origin
 (*Ursprung*) 227n, 251n; photographs of 2f,
 46–7; reading Atget's photographs 177–9
Bergen-Belsen concentration camp 103, 105,
 114–15
Bertillon, Alphonse 138, 139f
Bibliothèque Nationale 178f
Bolton, Richard 29, 34, 222n
Bourdieu, Pierre 58–9
Bourke-White, Margaret 83, 90–1, 90f; antag-
 onistic relationship with Evans 93, 238n
*The Bowery in Two Inadequate Descriptive
 Systems* 34, 100f, 101, 101f
Brady, Matthew 102, 103f
Brassaï 89–90, 89f, 93, 100
Brecht, Bertolt 2, 2f, 3, 32, 102, 198–9
Breton, André 58, 60, 229n
Bringing the War Home 102, 108
Buchloh, Benjamin 129, 247n
Burgin, Victor 59, 60–1
Burning with Desire 4–5
Butler, Judith 82

Cabinet of Abstract Art 130, 130f
Cadava, Eduardo xiii
Cahun, Claude 55–6, 56f
Callejon of the Valencia Arena 172f
calotypes 18, 199, 215
Camera Lucida xii, 10, 76, 80, 81, 186–9
camera obscura 10, 21, 199
Canale della Giudecca I, Venezia 168, 168f
Canyon de Chelly, Az (1942) and (1983) 49–50
Capa, Robert 86, 89, 169–70
Cape Horn near Celilo, Oregon 167
captions, photograph 33, 150
Cartier-Bresson, Henri 100, 171–2, 172f
Charcot, Jean-Martin 138
cinematic codes 65, 68, 69, 215
Claudet, Antione 1, 1f
Clouds—Mexico 25
Cohen, Alan 113, 113f
The Colonial Harem 140
colonialism 85, 134, 136, 140, 140–2
color 100, 132, 232n
Conceptual art 14, 67, 101, 200, 209, 232n;
 Burgin's work in 60; of Dibbets 74;
 Krauss' interpretation of photography in
 54; post- 14, 62, 109; relation of Bechers'
 work to 148, 149, 152
connotation 79–80, 142, 192
The Contest of Meaning 29
copies: fake 61, 73, 74; and originals 61

Costello, Diarmuid 7, 8, 53, 54
Crary, Jonathan 224n
Crewdson, Gregory 65–6, 68
criminology 138–40
Crimp, Douglas 52
critical postmodernism 4, 106; challenge
 to position of 34; critique of formal-
 ism 28–9, 34–6, 51–2, 209; critique of
 Greenberg 13, 52–3, 54; and history of
 photography 29–39; and Krauss' anti-
 aesthetics position 53–61; and link with
 anti-aesthetics 36, 53, 54; Rancière's
 challenge to concept and deployment of
 images in 107–9; review of Tagg's work
 36–40; and tensions and irreconcilability
 with formalism 4, 5, 40–1
critical theory 5, 6, 13, 30–1, 36, 58, 192,
 200–1
Crystal Palace exhibition 1851 140–2, 201

Dada 129, 201–2
Daguerre, Louis-Jacques-Mande 18, 87, 134,
 190f, 202
Dali, Salvadore 57, 57f
De Duve, Thierry 172–5
de Man, Paul 43, 219n
Dead Troops Talk 118–19, 119f
"decisive moment" 171–2, 250n
deconstruction 43, 61, 72, 73–4
Deleuze, Gilles xiii, 6, 9, 38, 40, 41, 163, 190;
 frames 68–70; images and signs 181–4, 185
Delillo, Don 194–5
denotation 35, 76, 77–8, 79–81, 142, 192
Derrida, Jacques xii–xiii, 5, 17, 30, 37, 43,
 88; on the archive 158; on frames 49,
 70–4; Krauss' reading of 58
design, exhibition: *see* exhibition design
Dibbets, Jan 74, 75f
Didi-Huberman, Georges xiii, 82, 109–12
digital/analogue photography 6–7, 62, 64, 65
Dijsktra, Rineke 144
"directorial mode" of photography 3, 65, 68,
 214, 215
The Disciplinary Frame 36, 37–40
discourse, Foucault on 158, 159–2
discourse of photography: in context of art his-
 tory 7–8; metaphor of 2–3, 194; origins of 5
Doane, Mary Ann 13, 63–4
documentary photography 37, 82–5, 202–3;
 of the absent 101; and aesthetics 84, 93,
 99–102, 103–7; of Auschwitz 109–14;
 "civil contract" in 84, 236n; context 89;
 distinctions between photojournalism and
 236n; ethics and aesthetics 93, 105, 109;
 Evans' work 92–5; images of suffering

85–8; Jaar's work 105, 106–7, 109; Levine's critique 101–2; Newhall on 83–4; "radical" 99, 100; Rosler's critique 98–101, 102; Sekula on 106; simultaneously a document and a work of art 84, 88–92, 118; as "social documentary" 85; Sontag's critique of postwar "new documents" 95–8; use of image in contemporary 107–9; war photography 102–3

Duchenne de Boulogne, Guillaume 138
Durheim, Carl 138

Eastlake, Lady 82, 85
Eggleston, William 232n
Eichmann, Adolf 114
"end of photography" debate 62, 64
ensemble, photograph as an 16, 17, 38, 41, 73–4
ethics: and aesthetics 93, 105, 109; ethical fragility of content of photographs 115; "ethics of seeing" 114; obligation to acknowledge suffering 111, 117; photographs as ethical reference points 115, 116; of race as a pseudoscientific category 142; remembering as an ethical act 117–18, 119; repetition and effect on our ethical sensibilities 115, 116
On European Ground 113, 113f
Evans, Walker 39, 39f, 51, 83, 92–5, 94f, 165; antagonistic relationship with Bourke-White 93, 238n
exhibition design: *Cabinet of Abstract Art* 130, 130f; *The Family of Man* 127–8, 128f, 131; *The Road to Victory* 131
The Eyes of Gutete Emerita 105, 106–7, 109

F.64 group 24, 203–4
The Face of Our Time (Antlitz der Zeit) 145–6
The Family of Man 126–9, 147, 152, 204; critiques of 132–3; early instance of globalism 132; exhibition design 127–8, 128f, 131; *The Great Exhibition* 1851 anticipating and refracting 142; photographic discourse 134, 140; "ring-around-the-rosy" 242n; universalism in 127–8, 131, 132, 152
Farms Security Administration (FSA) 83, 92, 101
Fenton, Roger 102, 208
Fiction Film 60
The Flatiron Building 96
Flusser, Vilém 191–6
formalism 4, 5, 13, 24, 27, 146; Crimp's attack on 52; critical postmodernism critique of 28–9, 34–6, 51–2, 209; debate on O'Sullivan's work in MoMA 155,

156; and false equivalence with aesthetics 99–100; of Greenberg 4, 13, 26, 52–3; of Newhall 24–5; Russian 32, 199; and tensions and irreconcilability with critical postmodernism 4–5, 40–1
Foster, Hal 14, 36, 119
Foucault, Michel 5, 37, 38, 101; *The Archaeology of Knowledge* 159–64; Krauss' use of archive concept 157–8
frames 48–9; Deleuze and movement-image 68–70; and Derrida 59, 70–4; and Dibbets 74–5; and edges of photographs 49, 51–2; and formalist history of photography 51–3; Friedlander's photographs 49–51; in Kant 74; and Krauss' work 53–61; medium of photography and indexicality 54–5, 62–6, 68–9; as a metaphor for medium-specificity 51–2, 62; out of frame and within 66, 67; read as a sign in photography 58; Surrealist photography 55–8; Szarkowski on 49, 51
Frank, Robert 85, 95, 96, 152, 204–5
Frankfurt School 30, 36, 105, 192
Freud, Sigmund 5, 60, 205
Freund, Gisele 46–7
Fried, Michael 66–7, 150–1, 153
Friedlander, Lee 49–51, 95
Front and Profile Views of a Malayan Man 142

Genthe, Arnold 85
Goldin, Nan 97, 205–6
Of Grammatology 72
The Great Exhibition 1851 140–2, 201
Greek fable of Dibutade 72–3
Greenberg, Clement 4, 12, 26, 36, 52–3, 53; misreading of Kantian ethics 13, 53
Greene, John Bulkley 166–7, 166f, 168
the "grid" 54, 55, 57
grid-tableaux 149, 151

Haifeng, Ni 134–6, 135f
Haussmann, Georges-Eugène 12, 121
Hawkhurst Church, Kent 18, 19f, 20
Heartfield, John 102
From Here I Saw What Happened and I Cried 143f
Herschberger, Andrew 157
Hill, David Octavius 45, 119
Hine, Lewis 85, 92, 94
Horkheimer, Max 30, 200
How the Other Half Lives 85, 140

Iconic Photography From Salpêtrière 138
identity: construction 59–60, 144; of photography 40–1
"image of thought" 3, 9, 16, 165, 185

images: analyzing Panzani advertising 78–9;
crafting of 11; dialectical 134, 251n, 252n;
Dibbets' interpretation of 74–5; doing
work of critique 105–6; exceptionalism of
photographic 35–6; in history and theory of
photography 15–16; as images 36, 38, 102,
156; and language 112; learning to become
a spectator of 165; as lines of time 167, 169,
170; "living" 189–90; magical effect of 189,
191–2; "naked" 133–4; openings to past
111–12, 122, 180–1; and photographic
portraits 45–6, 47; "precious images" as
fragments 184–5; Rancière's challenge to
postmodern conception and deployment
of 107–9; redundant 194; repetition of an
115–16; sent ahead 109, 165; and signs
181–5; of suffering *see* suffering, images of;
technical 192–5; -text 87, 88, 101, 102,
106; "unimaginable" 103, 109–14
Images in Spite of All 109, 110f
indexes 10–11, 112, 174, 192, 206; De Duve
on 174–5; Deleuze's interpretation of
69–70; Freid's opposition to 66; medium
and 54–5, 62–6, 68–9; as traces 11, 56,
61, 64, 68; in work of Cahun 55–6
"Indexicality and the Concept of Medium
Specificity" 13, 63
Industrial Forms and Smokestacks 149
Instructions Signaletiques 139f
Italian Vogue 118

Jaar, Alfredo 105, 106–7, 109
*Jack (Driver), frontal, Guinea Plantation of
B.F. Taylor, Esq.* 143f
Jakobson, Roman 55

Kant, Immanuel 13, 49, 53, 58, 74, 219n
Kelly, Michael 16
Kelsey, Robin 62, 153, 155–6
kitsch 26, 53, 124, 145, 206
Krauss, Rosalind: anti-aesthetic position of
53–61; critique of O'Sullivan 156–7;
Herschberger's critique of 157; medium
and indexicality 62–3; use of Foucault's
concept of archive 157–8

landscape photography 123, 153–6, 154f
Lange, Dorothea 86, 92
Lavater, Johann Kasper 136, 137f, 138, 146
Leda and the Swan 129, 130f
Leica camera 83, 206
Leong, Sze Tsung 168, 168f
Lessing, Gotthold Ephraim 170–1
Let Us Now Praise Famous Men 83, 95, 238n
Levine, Sherrie 101–2

Lissitzky, El 130
"Little History of Photography" 30, 33,
42–7, 193
Little Screens 50–1
Lyotard, Jean-François 29, 30, 209, 222–3n

The Madeleine, Paris 181, 181f
Man Ray 56, 177
Man Standing Next to Wooden Shack 39, 39f
Manet, Edouard 52, 163, 198, 249n
Manovich, Lev 64–5
Marx, Karl 12, 36, 213
Marxism 12, 13, 30, 200–1
The Meaning of Photography 62
Measuring the Ear of a Criminal 139f
Mécanisme de la physiognomie humaine 138
medium of photography 10, 12–13, 21, 25,
66–8, 212; critique of formalist ontologi-
cal construction of 51–2; and indexicality
54–5, 62–6, 68–9; as an intersection of
lines 65–6
medium specificity 13, 14, 53; frame as a
metaphor for photography's 51–2, 62
Meisel, Steven 118
Meiselas, Susan 100
melancholy 39–40, 96–7, 146, 173
Memoirs of the Blind 41, 72
memory: act of remembering 117–18, 119;
camera 194–5; collective 122, 125–6,
191; photograph as an aide/obstacle to
170; preserving historical and social
123–4; and renewal of past 186; and
"turn of recollection" 177, 179, 252n;
voluntary and involuntary 183
Merewether, Charles 121
message without a code, photographs as 76,
77–8, 79–81
Migrant Mother 86, 92
Minimalism 67, 149; relation of Bechers'
work to 149, 150–1, 152
"The Modern Public and Photography" 20–1
modernism 13, 14, 21, 177; difference
between postmodernism and high 28;
Greenberg's theory of 26, 52–3; photog-
raphy symptomatic of end of 52
"Modernist Painting" 26, 52
modernity, photography an epochal event of
11–12, 15
Moholy-Nagy, Laszlo 31f, 32–3, 36, 92,
120, 129, 130f
Morning Cleaning 67
movement, photographic studies of 122–3
mugshots 138
Museum of Modern Art (MoMA), New York
4, 24, 93, 95, 126, 131, 155, 156, 171

Muybridge, Eadweard 122–3, 124
myths of photography 7, 35, 76, 80, 142

Nadar 24, 206
Naked City 97
narrative poverty 27, 28, 33, 34, 35, 65
New Documents 95, 99, 203, 216
"new documents" photography 95–8, 99
New Objectivity 31, 145, 146–9, 153, 245n
New Vision 33, 92, 151–2, 153, 223n
New York City 50, 50f
Newhall, Beaumont 51, 95, 154, 155, 167,
 221n; on documentary photography 83–4;
 on history of photography 24–5, 28
Nickel, Douglas 24
Niépce, Niécephore xii, 206–7
The Nile in Front of the Theban Hills 166f, 167

ontology of photography 17, 166, 192;
 addressing "historical and ontological
 complexity" of photography 5, 6, 41;
 Barthes' 186–8; critique of constructions
 of 51–2
Opie, Catherine 142, 144
The Order of Things 156, 163
Orientalism 85, 140, 207
Orientalist photography 136, 236n, 237n
O'Sullivan, Timothy 153–7, 154f
Owens, Craig 43

Paris at Night 89–90
past: and future 45, 169, 176; "hope in" 45,
 46; images as openings to 111–12, 122,
 180–1; photographs as fragments of 165,
 175; and relation with present 5–6, 12,
 45, 46, 121, 122, 134, 175, 179, 185
Peirce, Charles Sanders 63–4
The Pencil of Nature 1, 18, 19f, 134, 135f, 219n
People of the 20th Century 144
Perspective Correction 74, 75f
*Petersburgh, Va. Dead Confederate Soldier, in
 Trench Beyond a Section of Chevaux-de-frise*
 103f
The Phenomenon of Ecstasy 57, 57f
photo-essays 83, 131, 211
Photo-Secession 92, 96, 207, 212
photogenic drawing 33, 56, 215
The Photographer's Eye 4, 25–6, 27, 48, 124,
 250n
A Photographic Truth 18, 19f, 20
On Photography 114, 116, 118
photojournalism 83, 120, 143f, 236n
photomontage 128, 129, 130, 131
Photopath 60
physiognomy 136–40, 144–5, 207–8

Pictorialism 32, 92, 144, 208, 212
Pliny the Elder 72
portrait photography 44–7, 72, 142–4
post-structuralism 30, 36, 37, 158, 214
postmodernism 3, 5–6, 14–15, 29, 208–9;
 criticism of O'Sullivan's inclusion in
 MoMA 155, 156; difference between
 high modernism and 28; *see also* critical
 postmodernism
Preziosi, Donald 141–2
propaganda 130, 131, 243n
Proust and Signs 181–2
Proust, Marcel 9, 179, 180, 181, 182, 183,
 184, 185, 186, 190
punctum 81, 186, 187, 189

Queen's College, Oxford 18–20, 19f

Ra'ad, Walid 125–6, 125f
race 142; Nazi theory of 145–6, 245n
Railway Officers 145f
Rancière, Jacques 12, 107–9, 112, 133–4
realism, photographic 23, 24, 25, 32, 62,
 65, 142, 209–10
Regarding the Pain of Others 114–19
Reinhardt, Mark 105, 106–7, 122
Renaissance 21–2, 33, 52
Renger-Patzsch, Albert 31–2, 31f, 33, 92,
 120, 149
repetition 115–16, 152–3
representation 14; photography as mimetic
 17, 20–1, 22, 78, 79, 80
"The Rhetoric of the Image" 76–81
Riis, Jacob 85, 98, 140, 210
The Road to Victory 131
Robinson, Henry Peach 88
Rodchenko, Alexander 36, 120
Rodger, George 103, 105
Rosler, Martha 34, 98–101, 100f, 101f, 102,
 108
Ruff, Thomas 88–9, 105
Russian Constructivism 36, 204
The Rwanda Project 105, 106–7

Said, Edward 85, 140
Salgado, Sebastião 104f, 105, 210–11
Sandburg, Carl 126–7
Sander, August 48, 92, 95, 97, 144–7, 145f,
 245n
In Search of Lost Time 180, 183
Sekula, Allan 4, 106, 123–5, 126, 144, 170
self-portraiture 55–6, 144; *Self-portrait as a
 Drowned Man* 86–7, 87f, 88; *Self-Portrait as
 a Part of Porcelain Export History (no. 1)* 134,
 135f; *Self-portrait Lying on Sand* 56, 56f

semiotics: Barthes approach to photography 35, 55, 132–3; Peirce's system of 64; of Structuralism 213–14
Serra Pelada, Brazil 104f, 105
Sherman, Cindy 59–60, 67, 68
Shoemaking Irons, Fagus Works, Alfeld 31, 31f
signs: Deleuze's function of 182; images and 181–5; and objects 181, 182, 184; photographs as 58, 64, 84, 171–4; *see also* indexes
Silhouette Machine 137f
simulacrum/simulacra 60, 211
Sleeping Tramp in Marseilles 89, 89f, 90
Smith, W. Eugene 211–12
snapshots 183, 194, 196; "snapshot aesthetic" 94, 212; and time exposures 171–5
Snyder, Joel 11, 24, 153
Sontag, Susan 22–3, 93, 100, 175, 177; critique of "new documents" photographers 95–8; *Regarding the Pain of Others* 114–19
spectacle 12, 132, 133, 212
statements and visibilities 7, 15, 38–40, 68, 163–4
Steichen, Edward 92, 126, 127, 132, 133, 140
Steinstrasse 22 (Berlin) 121–2
Stieglitz, Alfred 95, 96, 212–13
Stimson, Blake 62, 152
Stomberg, John 93
stop-motion photography 122–3
Strand, Paul 93, 95
structuralism 77, 157, 158–9, 213–14
Struth, Thomas 168, 179–80
studium 187, 188
suffering, images of 85–8; and criticisms of "aestheticizing" pain of others 85, 103, 105, 116; desire to view 102–3; and effect on our ethical sensibility 116; and ethical responsibility to acknowledge 111, 117; Sontag on 114–19
Surrealism 54, 55, 100, 101, 214; photography 55–8, 57f
Szarkowski, John 4, 28, 95, 147, 232n, 250n; critiques of 52, 99; curation of *The Photographer's Eye* 25–8, 124; on the frame 49, 51

tableaux photographs 3, 66, 67, 118–19, 119f, 151, 214, 215, 232n
Tagg, John 36–40, 91, 92, 93
Talbot, Eugene S. 140
Talbot, William Henry Fox 1, 1f, 3, 18, 41, 56, 134, 135f, 141, 170–1, 215
technics 48–9, 71–4
time-images: of Atget 177–9; concept of citation 175–7, 179; and irretrievability 176; living images 189–90; photographs

simultaneously now and then 166–8; of Proust 180, 184; and reading of *Camera Lucida* 186–9; and renewal of existence 177; and signs 181–5; snapshots and time exposures 171–5; Struth's work 179–80; Talbot and Lessing's contrasting views of visual arts and time 170–1; and "turn of recollection" 179, 252n; unmooring with passage of time 175; as a vertigious opening on past 179–80; and the what-has-been 46, 175, 176, 177, 178, 179
At the Time of the Louisville Flood 90–1, 90f
Torn Movie Poster 93, 94f
trace: index as a 11, 56, 61, 64, 68; originary 72, 73, 74, 80, 81; of a trace 101
Trachtenberg, Alan 62
The Truth in Painting 49, 74
Turner, Benjamin Brecknell 18, 19f

universal language of photography 124, 127, 133–4, 142, 144; theme in *The Family of Man* 127–8, 131, 132, 151
Untitled 31f, 33
Untitled (After Walker Evans) 101
Untitled Film Stills 59–60, 67
Untitled (Ophelia) 65

Via Medina, Naples 179–80
View from the Window at Gras xii
View of the Boulevard du Temple 190f
viewpoint: Proust on 184; Tagg on 91
voyeurism 85, 97–8

Wall, Jeff 66, 67, 118–19, 119f, 215
war photography 102–3, 103f; "visionary photo-work" 118–19, 119f
Warhol, Andy 115
Water Towers 148f
Watkins, Carleton 155, 167
Weegee 97
Weems, Carrie Mae 142, 143f
Weston, Edward 17, 24–5, 215–16
White Noise 194–5
Whitman, Walt 95, 96
Why Photography Matters as Art as Never Before 66, 150
Winogrand, Garry 28, 95, 99, 216
Winter Garden photograph xii, 186, 188–9
Wollen, Peter 165, 169
Words of Light xiii
"The Work of Art in the Age of Its Technical Reproducibility" 2, 11, 30, 31
The Work of Mourning xii–xiii

Zealy, Joseph T. 143f

Made in the USA
Middletown, DE
22 February 2018